RUBENS *A Master in the Making*

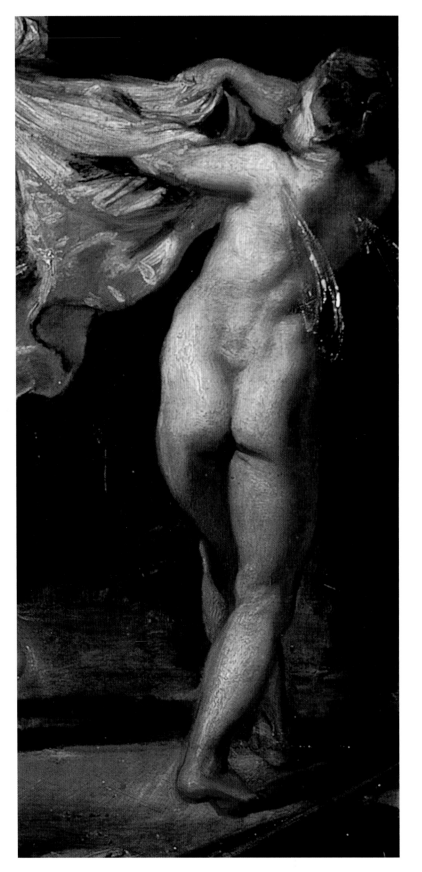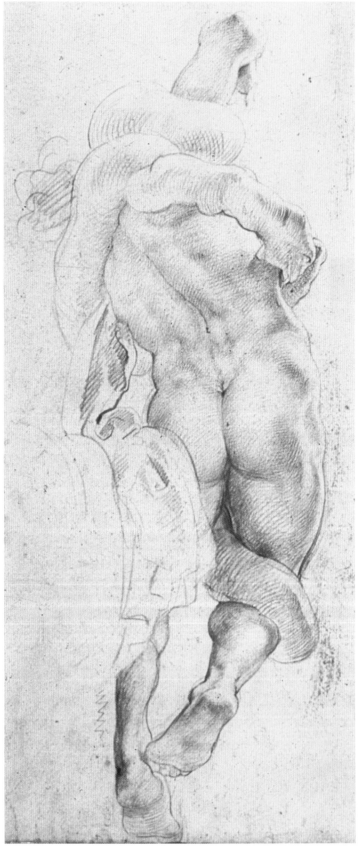

RUBENS *A Master in the Making*

ESSAYS: *David Jaffé and Elizabeth McGrath*
with contributions from Amanda Bradley and Minna Moore Ede

CATALOGUE: *David Jaffé with Minna Moore Ede*
and Ulrich Heinen, Veronika Kopecky and Elizabeth McGrath
with contributions from Delfina Bergamaschi and Amanda Bradley

National Gallery Company, London
Distributed by Yale University Press

This book was published to accompany the exhibition
Rubens: A Master in the Making
at the National Gallery, London
from 26 October 2005 – 15 January 2006

Sponsored by Shell

First published in Great Britain in 2005 by
National Gallery Company Limited
St Vincent House, 30 Orange Street, London WC2H 7HH
www.nationalgallery.co.uk

ISBN 1 85709 371 2 Hardback
525484

ISBN 1 85709 326 7 Paperback
525479

British Library Cataloguing-in-Publication Data
A catalogue record is available from the British Library
Library of Congress Catalog Card Number 2005928886

Publisher Kate Bell
Project Editor Tom Windross
Designer Peter Campbell
Production Jane Hyne, Penny Le Tissier
Picture Researcher Xenia Corcoran

Colour reproduction by Altaimage Ltd, London
Printed and bound in Italy by Mondadori

All measurements give height before width

Contributors to the catalogue:
AB – Amanda Bradley
DB – Delfina Bergamaschi
UH – Ulrich Heinen
DJ – David Jaffé
VK – Veronika Kopecky
EM – Elizabeth McGrath
MME – Minna Moore Ede

Entries by DJ/MME unless otherwise noted

FRONT COVER AND JACKET
Saint George (detail), 1605–7 (cat. 21)

FRONTISPIECE
The Judgement of Paris (detail, left), 1606–8 (cat. 11) and
The Younger Son of Laocoön (detail, right), about 1601–2 (cat. 24)

Contents

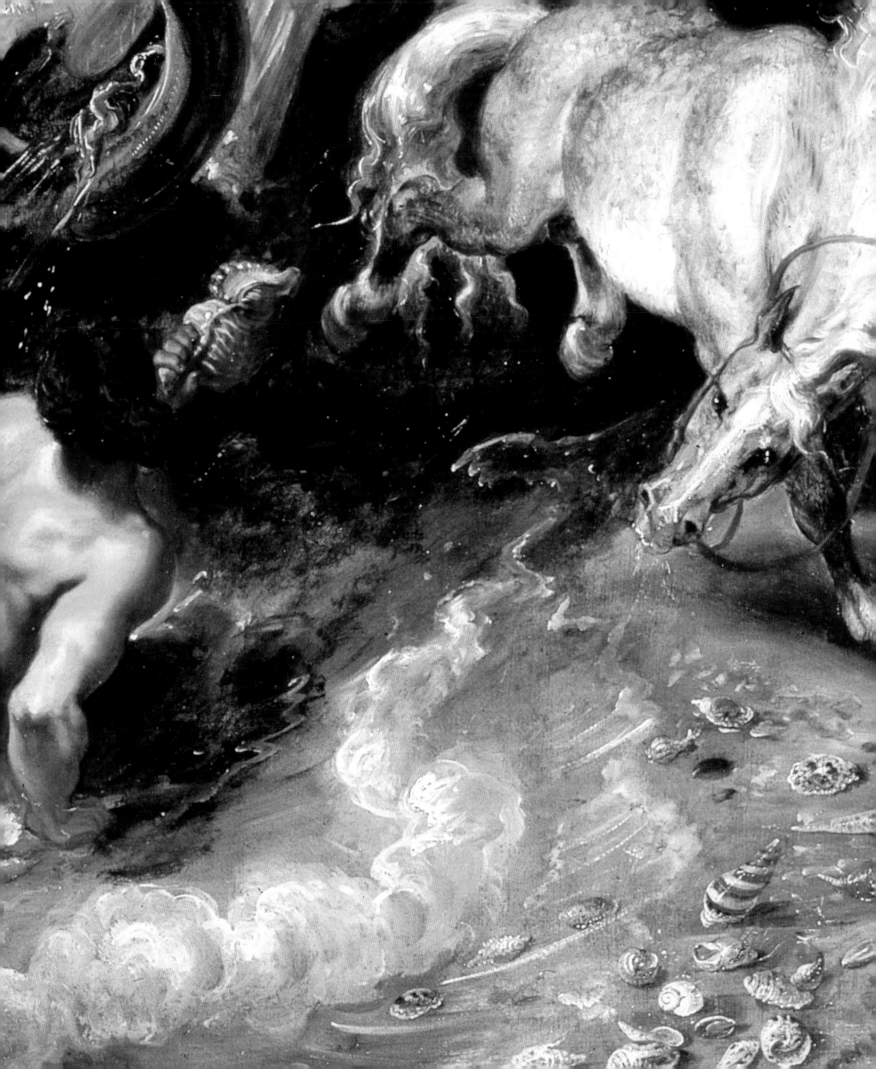

Sponsor's Foreword

Shell is delighted to support the National Gallery by sponsoring the exhibition *Rubens: A Master in the Making*.

Peter Paul Rubens rose from being a pupil of a minor Antwerp artist to become the dominant international painter of his time. He was a brilliant linguist and skilled courtier and diplomat, known at all the great courts of Europe. It is interesting that despite the often bellicose subject matter of his paintings, Rubens was in fact a pacifist and was sent on a mission to London in 1629 to secure peace between Spain and Britain. He was knighted by two kings, Charles I of Britain and Philip IV of Spain.

It is particularly appealing to Shell, as an international organisation, to make possible a display of the work of such a skilful, cosmopolitan and diplomatic artist. Our commitment to quality is something we share with the National Gallery and we are delighted to be working with Charles Saumarez Smith and his colleagues on such a dazzling and beautiful exhibition.

Shell is proud of its extensive work in the community through the Shell Education Service, Shell LiveWire, Shell STEP and Shell Connections. We are pleased that our sponsorship is helping the National Gallery to mount a significant and perceptive exhibition. This will help make Rubens more accessible to both residents and visitors to London, the home of Shell's global downstream business.

James Smith
Chairman, Shell U.K. Limited

Sponsored by Shell

66 (detail)

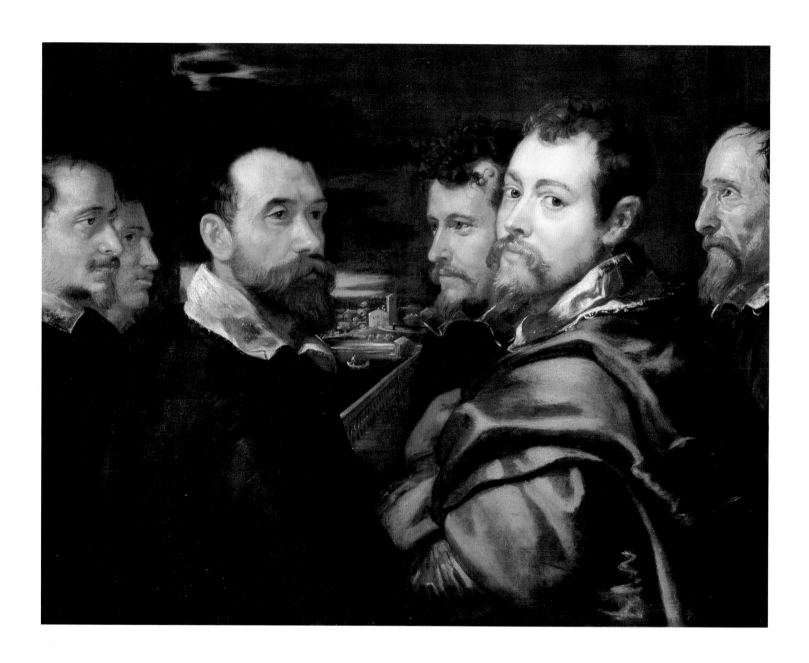

Fig. 1 **Self Portrait with Friends,** about 1602
Oil on canvas, 77.5 × 101 cm
Wallraf-Richartz-Museum, Cologne (248)

Curator's Acknowledgements

Work on *Rubens: A Master in the Making* began in earnest on 19 May 2004, and it is only due to much hard work that it has been possible to mount the exhibition. I am grateful to the National Gallery staff, in particular the Exhibitions Department, for their determination and labour.

In addition, a catalogue such as this requires contributions of different kinds from a great number of sources, and I am indebted to Arnout Balis, Katherine Mary Brinson, Allan Chin, Lucy Davis, George Gordon, Ulrich Heinen, Benedict Hunting, Martin Royalton-Kisch, Anthony Speelman, Nic Swert, Alexander Vergara, Arthur Wheelock and, particularly, Veronika Kopecky who provided invaluable help with the German literature. All generously responded to urgent requests. Echoes of the voices of my colleagues in London, Christopher Brown, Gregory Martin, Christopher White and especially Elizabeth McGrath can be heard throughout the text. I am indebted to Katherine Mary Brinson and Minna Moore Ede for shaping the text, and to the book's designer and editor, Peter Campbell, for refreshing everything so enthusiastically.

This show takes up a lifetime pursuit of Michael Jaffé: Rubens's extraordinary absorption, emulation and transmission of his artistic heritage. The artist's ability to integrate ideas seamlessly into his own narrative is an alchemical journey, revealing industry marvellously transformed into great art by the power of imagination.

By focusing on Rubens's pocketbook one becomes aware of how notional his 'doodles' were. These, often schematic and abbreviated, jottings of motifs and poses explain how Rubens's spectacular variety of sources, whether they were antiquities, relatively mundane prints, flayed models or choice excerpts from classical literature, could trigger his imagination and be recycled into convincing and persuasive compositions.

Much thanks are due to all of the generous lenders to the exhibition, in particular the Kupferstichkabinett, Berlin, whose sheet from Rubens's pocketbook (fig. 18), arrived too late to be included in the catalogue proper, but which we are delighted to be able to show.

Finally, thank you to Shell U.K. Limited, James Smith and John Kerr for providing sponsorship and support.

David Jaffé
Senior Curator
The National Gallery, London

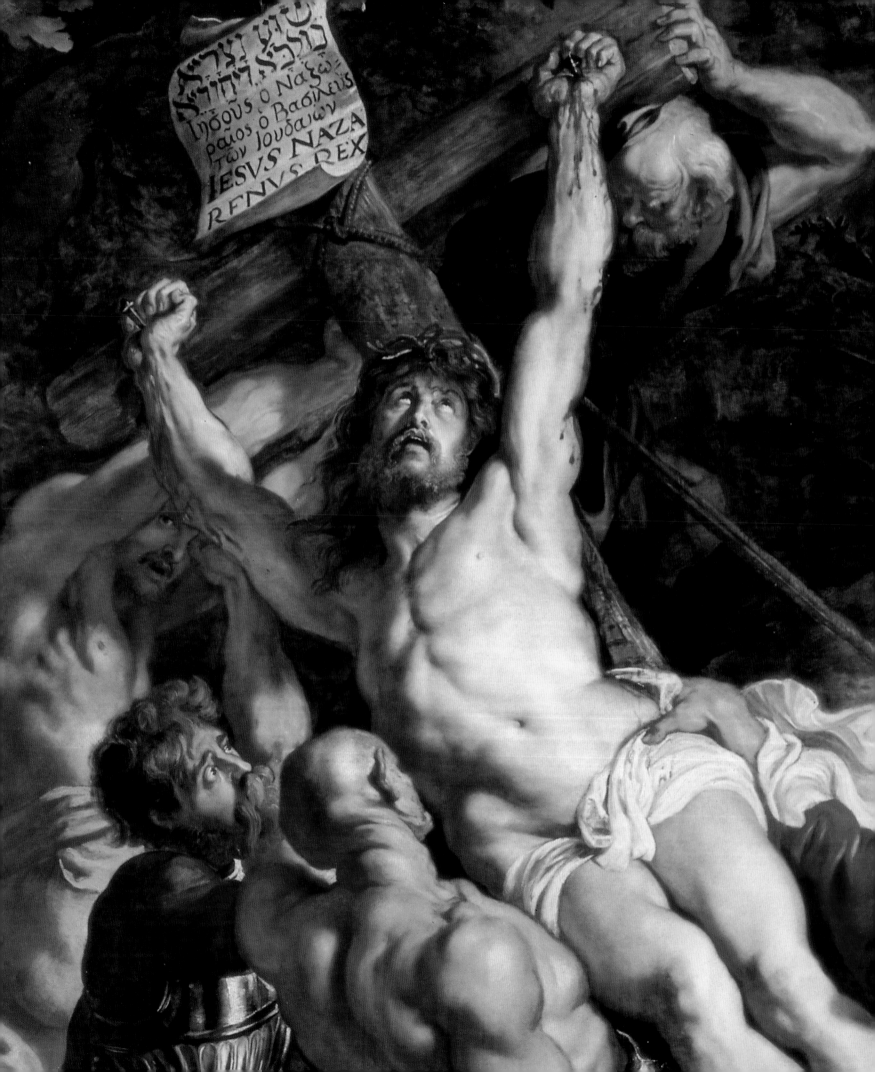

Rubens: *A Master in the Making*

David Jaffé and Minna Moore Ede

It is Rubens's early years that are the key to understanding his genius. Over the course of the first fifteen years of his career Rubens transformed himself from an awkward Northern apprentice to an internationally known virtuoso. Focusing on this period, from 1597 to about 1614, which includes his crucial time in Italy, enables us to see exactly how he became Antwerp's dominant painter by his mid-30s. He was born with remarkable talents, but his greatness as a painter was attained through meticulous and methodical copying; in absorbing the inventions of others he evolved a pictorial language that was entirely his own.

Rubens's beginnings

Peter Paul Rubens (fig. 1) was born on 28 June 1577, the son of Jan Rubens, an Antwerp lawyer and alderman, and his wife Maria Pypelincx.[1] He spent the first eleven years of his childhood in Germany, first in Siegen and then in Cologne, where his father took refuge with his family because of his Calvinist sympathies. After Rubens's father died in 1587, Maria Pypelincx moved back to Antwerp with her three children (a fourth died in infancy), having already returned to Catholicism.[2] Peter Paul, her second child, was sent to a Latin school where he received the thorough education in the classics that was to prove fundamental to his approach to his art. He learnt Latin and maybe some Greek, and acquired a familiarity with classical texts including Virgil's *Aeneid*, but his schooling ended when he was thirteen. He then spent a brief period as a page to the Comtesse de Lalaing. Although he may not have enjoyed his first experience of court life, this shortlived episode gave him a taste of the circles he would move in and out of throughout his career.

Rubens's training as an artist began in Antwerp in the 1590s. Initially apprenticed to a distant relative, landscape painter Tobias Verhaecht, he then trained in the studio of the figure painter Adam van Noort where he probably stayed four years.[3] Van Noort was an artist with marked Protestant sympathies (he was recorded as a Lutheran in 1585) and this may have encouraged Rubens's interest in German prints, such as Holbein's *Dance of Death* (fig. 18).

Rubens's most significant teacher was Otto van Veen (1556–1629) whose studio he entered in about 1594. Van Veen was one of the most successful and scholarly painters in Antwerp at the time. His paintings decorated prominent sites around the city and he specialised in the didactic religious works which were in demand in the years following the Council of Trent. Into these pictures he would insert pictorial borrowings from High-Renaissance artists. Van Veen had studied in Italy for about five years, principally in Rome, where he reportedly spent time as a pupil of Federico Zuccaro (about 1541–1609).

Rubens qualified as a painter with the Antwerp Guild in 1598, and remained in Van Veen's studio, probably as his assistant, until 1600. There is little from which to reconstruct his first three years as a painter. In her will of 1606 his mother mentions many beautiful works belonging to her son, although none are identified.[4] The only dated painting attributed to Rubens prior to his departure for Italy in 1600 is a small *Portrait of a Man* on copper (1597, Metropolitan Museum of Art, New York)[5] that clearly reveals Northern training. However, there is a handful of works usually assigned to the years 1596–9 from which one can draw some conclusions: *Adam and Eve* (Rubenshuis, Antwerp, if indeed this is by Rubens rather than Van Veen), *The Battle of the Amazons* (cat. 1), *The Conversion of Saint Paul* (cat. 67) and *The Judgement of Paris* (cat. 9).

The compositions of *Adam and Eve* and *The Judgement of Paris* are based on prints by Marcantonio Raimondi, after Raphael. Van Veen drew on Raphael's designs when making his own and it is very likely that Raphael prints were among the material that students were encouraged to copy. Rubens's training would also have included copying casts after the antique, and perhaps *écorché* (flayed figure) statuettes, as well as sculptures of horses.

Leonardo da Vinci made the theme of equestrian combat a prime subject of painting, and it had become traditional in artists' academies in Florence and Rome for this subject matter to be tackled by artists in training. Rubens's first attempts at history painting, drawing on classical sources his contemporaries would have recognised, show fecundity of invention, but not the painterly skill needed to realise fully their complex multifigure compositions. *The Battle of the Amazons* and *The Conversion of Saint Paul* are executed in an energetic but somewhat graceless manner, and neither these nor *The Judgement of Paris*, perhaps Rubens's most ambitious work before his departure for Rome, suggest that he would, twenty years later, have become such a dominant figure in European painting.

By the late sixteenth century there was nothing unusual about a Flemish painter travelling to Italy to complete his education. The traffic of art between the two countries was constant; there was even a club in Antwerp that called itself 'The Romanists', where 'art pilgrims' met to keep themselves up to date on news from Rome, whether it be new painters or paintings, or newly discovered antiquities. Jan Brueghel the Elder (1568–1625), the

Fig. 7 (detail)

A MASTER IN THE MAKING 11

Fig. 2 Titian (about 1487–1576)
Ecce Homo, 1543 (detail)
Oil on canvas, 242 × 361 cm
Kunsthistorisches Museum, Vienna (1543)

Fig. 3 **The Tormenting of Christ**, about 1601–2
Oil on panel, 224 × 180 cm
Grasse Cathedral
Conseil général des Alpes-Maritimes, Nice (42 FI 3/193)

Fig. 4 **The Resurrection of Christ**, 1611–12 (central panel of triptych)
Oil on panel, central panel 138 × 98 cm
Antwerp Cathedral (11.1913)

Fig. 2

most talented son of Pieter Bruegel and an accomplished landscape painter, returned from Italy in 1596, the classicising painters Wenceslas Cobergher and Abraham Janssen in 1601, and the battle painter Sebastian Vranx in 1602. Artists, of course, brought back with them works of art, which were supplemented by a steady flow of prints, drawings and sculptural models.

From Antwerp to Mantua

Following in their footsteps the twenty-two-year-old Rubens left Antwerp for Italy on 9 May 1600, probably at the suggestion of Van Veen. He departed his native city in search of new horizons but presumably arrived with some useful introductions to potential patrons. Accompanying him on his travels was Deodate del Monte (1582–1644), a younger artist from Antwerp about whose early career we know little.[6] It is possible he travelled as a pupil and assistant to Rubens.

The precise itinerary of Rubens's journey south from Antwerp is not known. Did he come through France via Fontainebleau, visiting *en route* the château that Francis I had filled with

antiquities and Renaissance paintings? Or did he travel through Germany?[7] Either way, in July of 1600 Rubens arrived in Venice. Judging from his earliest Italian productions, he was struck particularly by Titian's large *Ecce Homo* of 1543 (fig. 2), which was painted for a Flemish merchant resident in Venice, Giovanni d'Anna, to whom Rubens presumably had an introduction. Titian's depiction of this subject would inform Rubens's *Tormenting of Christ* (fig. 3) two years later and, more than ten years after that, the shouting boy in the bottom left-hand corner of Titian's painting reappears in Rubens's *Resurrection* (fig. 4). He must also have been struck by the dazzling light effects in the work of Tintoretto, perhaps having seen his decoration of the Venetian Scuola Grande di San Rocco, completed only thirty years earlier, as Tintoretto became an important influence on Rubens's work in these early years.

Soon after his arrival, Rubens obtained an introduction to Vincenzo Gonzaga (died 1612), Duke of Mantua, who was visiting Venice. The duke happened to be looking for a court painter and Rubens immediately found work. He may have been recommended by Otto van Veen, who had worked for Archduke Albert of Austria and his wife Isabella, Governors of the Spanish Netherlands, whom Gonzaga visited in 1599. Rubens initially set to work on a portrait series of beautiful women. For this purpose the duke also recruited another Antwerp painter to the Mantuan court, Frans Pourbus (1569–1622). Pourbus was in residence between 1600 and 1609, and Rubens probably had time to install himself in Mantua alongside his fellow countryman before being sent on his first assignment for the duke: to join the delegation to the wedding of Maria de' Medici to Henri IV, by proxy, in Florence on 5 October 1600.

While staying in Florence, he would have immersed himself in the works of Michelangelo, perhaps visiting the Casa Buonarotti and the Medici Chapel in San Lorenzo.[8] Although there are no drawings that are securely datable to this first Florentine trip, it is plausible that Rubens's drawing after Michelangelo's marble relief of the *Battle of Lapiths and Centaurs* (cat. 31) dates from this visit.

A base in Mantua

Duke Vincenzo Gonzaga was a passionate patron of the arts and devoted to the glorification of his city. As well as Rubens, he called to his court the musicians Monteverdi and Jacopo Peri and the poet Torquato Tasso. Nonetheless he seems to have left Rubens somewhat to his own devices, enabling the young artist to travel alone around Italy. We know Rubens spent two long periods in Rome

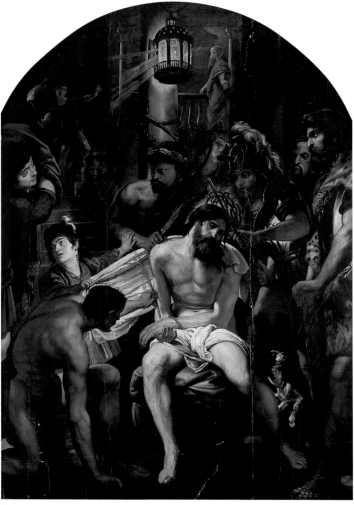

Fig. 3

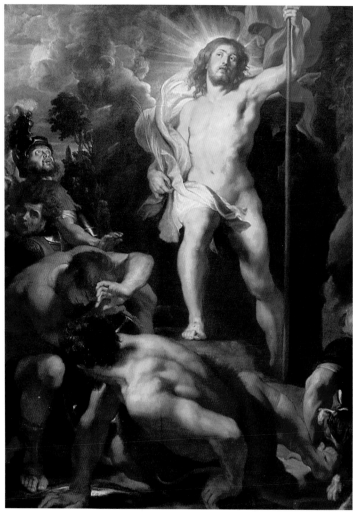

Fig. 4

during his eight years in the duke's service, as well as ten months in Spain at Gonzaga's request (March 1603–early 1604), and that he made trips to Florence and Genoa, as well as Padua, Verona, Treviso, Parma, Bologna and Milan.

Rubens first visited Rome in late July 1601, and stayed for about six months. He arrived with a letter from the duke to Cardinal Montalto, a nephew of Pope Sixtus V, which placed him under Montalto's protection. Rome offered the chance to study at first hand the work of celebrated living artists – notably Caravaggio and the Carracci – as well as the great monuments of the Renaissance, such as Michelangelo's Sistine Ceiling and Raphael's *Stanze* in the Vatican. Rubens could now also see original antique sculptures that he would previously have known only through engravings or bronze and plaster replicas. Montalto, who lived in the Villa Medici, would have been able to help Rubens gain access to the city's private collections.

The scale and vitality of antique sculpture were a revelation for Rubens. The *Laocoön* (fig. 30) and the *Belvedere Torso* were in the papal sculpture courtyard, the Cortile Belvedere, which since the Renaissance had been frequented by artists.[9] Among the private

collections Rubens must have had access to was that of Scipione Borghese, where from 1605 he could have seen the *African Fisherman* (then called *Seneca*) and the *Centaur tormented by Cupid* (fig. 64). He would have drawn the colossal *Farnese Hercules* (fig. 44) in the courtyard of the Palazzo Farnese, where he was able to scrutinise the sculpture from all angles. One can almost feel Rubens's excitement and enthusiasm in these drawings. He worked close up, often scrupulously recording breaks and losses and clearly fascinated by anatomical details such as veins.[10] He enjoyed animating sculptures and would sometimes add hair or dramatise an expression. His drawings after classical sculpture (see cats 23–9) reveal that his interest lay in capturing their monumental three-dimensionality, as he carefully records the fall of light across their surfaces. Copying was essential to the way he taught himself to draw and paint the human body, and he came to compose paintings almost as if they were assemblages of sculpture.

His first stay in Rome provided Rubens with his first major public commission. Archduke Albert wanted to present an altarpiece to Santa Croce in Gerusalemme, which had been his titular

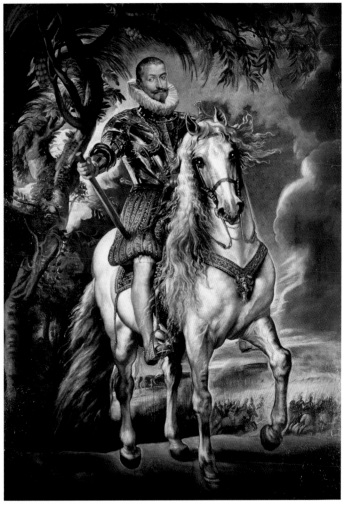

Fig. 5

Fig. 5 The Duke of Lerma on Horseback, 1603
Oil on canvas, 284 × 205 cm
Museo Nacional del Prado, Madrid (3137)

Fig. 6 The Transfiguration, 1605
Oil on canvas, 407 × 670 cm
Musée des Beaux-Arts, Nancy (71)

well as assimilating a plethora of other Italian influences. He had, by this date, been in Italy less than a year and a half.

By April 1602 Rubens was back in Mantua. It must have been at this point that he painted *Aeneas preparing to lead the Trojans into Exile* (cat. 8) and the *Council of the Gods* (cat. 12). They were possibly part of an undocumented decorative cycle showing the story of Aeneas, in celebration of Mantua's most famous son, Virgil. Rubens's thorough knowledge of Virgil's *Aeneid* closely informs his portrayals (see cats 8 and 12).

Spain and Genoa

In March 1603 Rubens's employer sent him to the King of Spain's court in the city of Valladolid. He took with him gifts for the king and his powerful minister, the Duke of Lerma. During the arduous journey some of the paintings he carried were damaged, two irrevocably, and Rubens elected to replace them with a work of his own, *Democritus and Heraclitus* (cat. 18). This close-up, realistic portrayal of two classical philosophers, in which veins, sinews and muscles are delineated, is another reflection of Rubens's interest in the classical sculpture he saw in Rome. The picture must have met with success as Rubens was commissioned to paint what can be justly described as the first masterpiece of his career: a majestic equestrian portrait of the *Duke of Lerma* (fig. 5).

In Rubens's portrait the duke rides confidently out into our space, his costume glitters, his arm, thrust boldly towards us, is a consummate display of foreshortening.[13] The charger's tail sweeps in a flash of strands to counter the rising cloud of dust on the opposite side. In the background of the painting, visible between the legs of the horse, mounted riders emerge from and disappear into the fog of war (fig. 5 and detail on p. 50). With brilliant economy Rubens picks out the soldiers with a few white brush-strokes, while the massed lances with pennants recall Albrecht Altdorfer's paintings of battles, as well as those by Rubens's friend Jan Brueghel.[14]

In the course of the nine or ten months that Rubens was in Spain he reported that he had been much impressed by the Titians he had seen in the Escorial and the other Royal Collections in Valladolid and Madrid.[15]

Rubens returned to Italy early in 1604, disembarking at the port of Genoa in order that he might be refunded by Duke Vincenzo's banker, Niccolò Pallavicini, for expenses he incurred in Spain. However, he also made contacts in the city that would generate commissions later in the year. Arriving back in Mantua,

church before he resigned his cardinal's hat to marry. Although Rubens was perhaps an obvious choice because of his nationality, the commission must have been a major challenge for a young artist working in a foreign city.

Before Easter 1602 (when he was recalled to Mantua to attend the Easter ceremonies), Rubens had completed three impressive panels for the chapel of Saint Helena in Santa Croce: *The Tormenting of Christ* (fig. 3) flanked by *Saint Helena Discovering the True Cross* (both Grasse Cathedral) and the *Raising of the Cross* (destroyed; copy in Grasse Cathedral, fig. 52).[11]

In *The Tormenting of Christ* Rubens may have been responding to Caravaggio's celebrated paintings in the church of San Luigi dei Francesi, which had been unveiled in 1600. The way the blood-splattered white cloth, which has been caught as it is torn off Christ's shoulders, acts as a reflective foil to Christ's broken body and shadowed face is reminiscent of Caravaggio's use of white to emphasise flesh in his *Saint Matthew*.[12] The incandescent lighting and dramatic foreshortening of the Santa Croce paintings, on the other hand, recall Tintoretto. It is remarkable how quickly Rubens merged his own style with that of artists such as Caravaggio, as

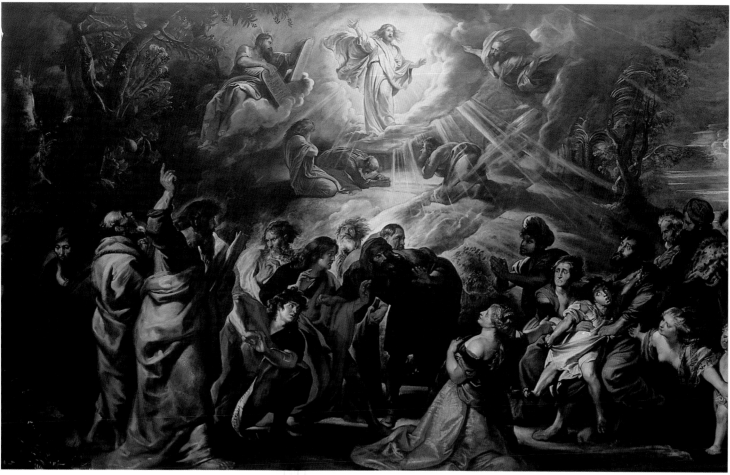

Fig. 6

he decorated, at the request of Duke Vincenzo, the main chapel of the Jesuit church dedicated to the Holy Trinity. It was completed by 5 June 1605, the feast day of the Trinity.

The style of the three ambitious canvases Rubens made for the chapel is reminiscent of the energy and attack of Tintoretto. Over the main altar was the *Gonzaga Family worshipping the Holy Trinity* (now dismembered; fragments in Mantua, Palazzo Ducale and elsewhere), with the *Transfiguration* (fig. 6) on one side and the *Baptism* (Koninklijk Museum voor Schone Kunsten, Antwerp) on the other. The *Transfiguration* is a powerful critique of Raphael's most celebrated painting of the subject (today in the Pinacoteca, Vatican), revisited through a technique that resembles Tintoretto's,[16] and incorporating gesturing female figures taken from Correggio. The *Baptism* is a homage to Michelangelo and the antique, with the right half of the composition devoted to half-naked male figures arranged in poses reminiscent of Michelangelo's *Battle of Cascina*. The man leaning against the tree holding his foot is a free variant of the antique sculpture known as the *Spinario* (or *Thorn Puller*, Capitoline Museums, Rome).

For the High Altarpiece, which showed the *Gonzaga Family worshipping the Holy Trinity*, Rubens relied on richly chromatic Flemish portrait traditions, while the boldly foreshortened flying angels are from Correggio's repertoire. Rubens emerges from the commission as an artist full of confidence, one who is willing to rework Raphael and Michelangelo, but who has not yet established a coherent style of his own.

In the summer and autumn of 1605 Rubens painted a *Circumcision* (still *in situ*) for the Jesuit church of Sant'Ambrogio e Andrea in Genoa. The commission came, in late 1604, from Father Marcello Pallavicini, the church's founder and elder brother of Niccolò Pallavicini, Gonzaga's banker whom Rubens had met on his return from Spain. Rubens accompanied the painting from Rome in late 1605, ready to be unveiled under his supervision in time for the Feast of the Circumcision on 1 January 1606.

In this altarpiece, Rubens uses a much tighter compositional structure than in his earlier work, employing figures to frame the focus of the scene. A preparatory *modello* (cat. 46) testifies to the careful thought he gave it. There is a static grandeur to the work,

Fig. 6 (detail)

perhaps reflecting the taste for the artists Roncalli, Cigoli and Pomarancio, whose paintings for the new St Peter's Rubens would have seen in Rome. The figures surrounding the Christ Child become the equivalent of clothed antique statues, whose voluminous vestments give them a sense of monumentality. The authority of the figure of the Virgin is also developed by the massing of her blue drapery, rather than the reflected light effects we have come to expect from Rubens. Her presence is strengthened by the artist's decision to base her graceful and distinctive gesture of her arm on that of an antique Vestal Virgin.

At the same time Rubens painted a series of portraits of Genoese aristocrats (see cat. 22). Rubens's skill with a paintbrush by this date is evident, particularly in his female portraits. His sitters' dresses have a dazzling vibrancy and metallic lustre, their jewels glitter; rarely before in Western portraiture had women been portrayed so glamorously.

By November 1605 Rubens was back in Rome, this time living near the Piazza di Spagna with his elder brother Philip, who was now librarian to Cardinal Ascanio Colonna. Philip, who had studied under the Flemish Humanist and philologist, Justus Lipsius, was immensely learned and Peter Paul would have enjoyed deepening his knowledge of antiquity and the classics in exchanges with his brother, while carrying on his own visual explorations. Although he made forays outside the papal city, he would be based there for much of the next three years.

Rome 1606–8

In the early autumn of 1606 Rubens won the most prestigious artistic commission in Rome at the time, competing against native Italian artists. Describing it in a letter he wrote '...when the finest and most splendid opportunity in all Rome presented itself, my ambition urged me to avail myself of the chance'.[17] He was only twenty-nine and his success was certainly a testimony to his infiltration of the Roman art scene.

The commission, which was to be beset by complications and delays, was to paint an altarpiece for the Oratorian fathers of the church of Santa Maria in Vallicella.[18] It was an enormously popular church, home to the order founded by Saint Philip Neri in 1564, and much visited, not least because it housed a miraculous fourteenth-century fresco of the Virgin and Child. In August of 1606 the Oratorians had petitioned to have their miracle-working image moved to the High Altar of their newly rebuilt church (the 'Chiesa Nuova'). Rubens was to design his altarpiece around this image.

The altarpiece he produced, *Saints Gregory, Domitilla and other Saints*, shows them adoring the miraculous image beneath which it was to be placed. The painting (today in the Musée de Grenoble) was rejected, despite the fact that Rubens had presented the fathers with a *modello* first. They complained that the painting was not properly visible in the church, and Rubens was asked to submit another design by 13 May 1608, this time incorporating the miraculous fresco into his painting. His solution was to paint three paintings on slate, which would absorb light and prevent reflection problems: a *Virgin and Child* in the centre, flanked by *Saints Gregory, Maurus and Papinianus* on the left and *Saints Domitilla, Nereus and Achilleus* on the right (all still *in situ*). Rubens sketched his ideas before making a *modello*.[19] In the central panel he cut an opening into which the miraculous fresco was set. This was then covered – as it still is today – by another work showing a pastiche of the miraculous *Madonna della Vallicella*. This 'cover' can be raised to reveal the true image.

Return to Antwerp

The Oratorians were finally pleased but Rubens had little time to bask in his success. He was suddenly recalled to his mother's bedside, arriving in Antwerp in October 1608, ten days after she had died. Her death must have been a great loss; he placed his first, rejected, Oratorian altarpiece above her tomb.

Artistically, however, his arrival back in Antwerp was well timed. The 1609 Twelve-Year Truce with Spain was about to be signed, and there was an optimism and vibrancy long lacking from the city. Churches everywhere in the Southern Netherlands were being decorated in the spirit of triumphant Catholicism. Rubens, who had come straight from papal Rome, the city at the heart of Christendom, was ideally placed to respond to the call for assertive religious paintings.

If Rubens had doubts about whether or not to return to Italy the discovery that he was much in demand at home must have helped convince him to stay. He mixed with the powerful, wealthy intellectual élite of the city, who provided much patronage: Nicolaas Rockox, the Burgomaster of Antwerp, commissioned *Samson and Delilah* (cat. 77) to hang as the chimney-piece in his home. He was a connoisseur and collector who would have fully appreciated Rubens's Italianate touch. In July 1609 Rubens was appointed court painter to Archduke Albert and his wife the Infanta Isabella, although he was still free to accept commissions from elsewhere. Pictures painted during this period include: *The*

Fig. 7 The Raising of the Cross, 1609–1610
Oil on panel, central panel 460 × 340 cm, wings 460 × 150 cm
Antwerp Cathedral

Fig. 7 (detail from left wing)

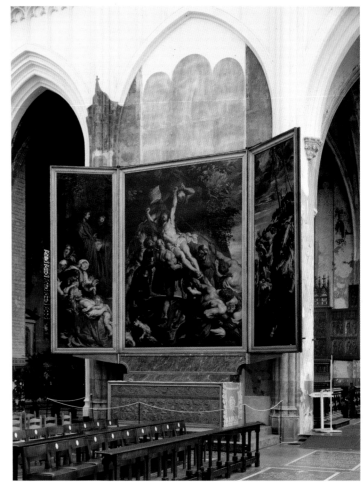

Fig. 7

Assumption of the Virgin (see cats 61–2) and the magisterial Adoration of the Magi (fig. 57), which was commissioned by Rockox for the Stadhuis, or city hall, in Antwerp. The Resurrection triptych (fig. 4), which Rubens painted for the tomb of the father of his childhood friend, Balthasar Moretus, also dates to this period. In 1610 Moretus became head of the Antwerp printing house, the Plantin Press. Founded by his grandfather it was, at that time, the most famous printing house in Europe and a centre of humanist learning. Moretus employed Rubens to produce plates and illustrations; Rubens described this as 'Sunday work', but the intellectual atmosphere of the publishing house must have stimulated and suited his humanist-trained mind.

The Raising of the Cross

In June 1610 Rubens signed a contract to paint a triptych of the Raising of the Cross (fig. 7) for the port-side church of St Walburga's (destroyed). Cornelis van der Geest, a wealthy spice merchant and a church warden of St Walburga's, contributed to the cost of the vast altarpiece (462 × 341 cm), which was completed within a year. Its great size meant that Rubens had to paint it on site, but he was provided with a ship's sail to give him a degree of privacy.[20]

While respecting the traditional Flemish format of the triptych, the Raising of the Cross boldly declared Rubens as the ultimate modern painter; the scene is populated by figures who seem to quiver and tremble with energy. It is an extraordinarily dynamic rendition of the subject that shows Christ being lifted up onto his cross by an army of Herculean, larger-than-life men. Christ's body forms a diagonal that cuts across the picture surface; the female figures on the left wing shrink away from the central scene of terror (see detail, opposite). The emotional impact of the work extends to the growling, salivating dog at the bottom left-hand corner of the central panel, and to the baby on the left panel who clings to its mother and wails. There are a number of drawings (see cats 51–2) for the athletic men who raise the weight of the cross; one can imagine Rubens finding models among the sailors at work in the port outside the church.

The Descent from the Cross

Even before he had completed the Raising of the Cross Rubens was approached by one of the city's Guilds, the Arquebusiers (the civic guard), to paint an altarpiece for their chapel in Antwerp Cathedral, this time of the Descent from the Cross (1611–14, fig. 23).

Nicolaas Rockox was patron of the guild and must have been instrumental in Rubens being awarded the commission. The Descent is a response to the Raising; this time Rubens produced a far more contemplative and restrained work. While the Raising was a very public display of what he had learned in Italy, in the Descent Rubens incorporates his sources in a much more subtle way. Less an arresting portrayal of physicality, the Descent is a moving account of the lowering of Christ's dead body that would have been seen by the devout as they participated in the Mass beneath the altarpiece, accepting the bread as the body of Christ.

Once again Rubens painted a three-panelled altarpiece: the Descent was flanked by a Visitation on the left and a Presentation in the Temple on the right. These wings could be closed, and were painted on the exterior with the figures of Saint Christopher carrying the Christ Child (see cat. 54) and a Hermit carrying a Lantern. Saint Christopher was the Guild's patron saint and because the name 'Christopher' is derived from the Greek word meaning 'Christ Bearer', each scene referred in some way to the carrying of Christ – by the pregnant virgin in the Visitation, to the temple in the Presentation, and by Saint Christopher who carried the Christ Child across the water. The massive figure of Saint Christopher is based on the Farnese Hercules (fig. 44), one of the antiques Rubens made studies

after in Rome (cats 27–8). In this context the strong man of antiquity was an appropriate model, as according to legend the Christ Child became heavier and heavier, so that Saint Christopher felt that he was carrying the weight of the world on his shoulders.

Stylistically, the *Descent* marks a new stage in Rubens's career, which sees his youthful pictorial language fully evolved. His return to Antwerp also marked a new stage in his personal life, and in 1609 Rubens married Isabella Brant, the eighteen-year-old daughter of a city clerk. In March 1611 their first child, Clara Serena, was baptised. A few years later she became the subject of perhaps Rubens's most enchanting portrait (cat. 91), painted with a lightness of touch that befitted its youthful subject.

Although close in date, the contrast between the intimate *Clara Serena* and the *Descent from the Cross* altarpiece is testament to Rubens's remarkable versatility as an artist.[21] What is common to both paintings is the virtuoso manner in which they – however different – are painted. Perhaps the greatest triumph of Rubens's eight years in Italy was the genius he aquired with a paint brush. It renders him, still today and above all, a painter's painter.

1 On Rubens's life, see the carefully documented account by Nils Büttner in Brunswick 2004, p. 13ff. See also Baudouin 2005.
2 Rubens's father also returned to Catholicism before he died. See Baudouin 2005, p. 47.
3 On Rubens's early training see White 1987, p. 7. On Van Noort see Baudouin 2005, p. 60.
4 Held 1983, p. 17, n. 10.
5 Inscribed on the *verso* of the copper plate, possibly by Rubens, are the words 'PETRVS PAVLVS RVBENS / PI'. See Liedtke 1984, 2, plate XVI, p. 73; 1 pp. 187–91.
6 See entry, under 'Monte', in J. Turner, *Dictionary of Art*, 22.
7 Eighteenth-century writers record that Rubens travelled via Paris, and therefore presumably Fontainebleau. White 1987, p. 11.
8 Jaffé 1977, p. 10.
9 For a discussion of how the *Laocoön* was displayed in the Belvedere, on a pedestal in a niche, see Van der Meulen 1994, II, pp. 94–5.
10 Especially those he traced around the arms and neck in the *African Fisherman*, formerly known as *Seneca Dying*.
11 See Weppelmann 1998.
12 Curiously, the torch-bearer rushing down the stairs repeats a figure in Aegidius Sadeler II's engraving after Palma Giovane (Bartsch 1997, 72, part 1, no. 7201), a composition Rubens was to explore more fully later.
13 Giambologna's bronze of *Cosimo Medici on Horseback* in Piazza della Signoria (Florence) is a possible model.
14 See Altdorfer's *Battle of Alexander* in the Alte Pinakothek, Munich, datable to 1529, and Brueghel's *Battle of Issus* of 1602 in the Musée du Louvre, Paris.
15 Rubens may have seen the work of El Greco in Madrid, perhaps even his *Saint Martin and the Beggar* (National Gallery of Art, Washington, DC), which was then in Toledo. Although there is a convincing visual connection between the Greek's *Saint Martin* and Rubens's *Duke of Lerma on Horseback*, the former was in a private family chapel in Toledo and Rubens may not have had access to it. However, it is possible that Rubens met El Greco, who was still living in Toledo. The quivering brushwork and flickering light effects in El Greco's equestrian portrait were a legacy from Tintoretto, whom Rubens also obviously admired. Further, the manner in which Rubens's *Lerma* appears in a flash of light, with the sky parting to create a frame around him, may well have been informed by El Greco's visionary style.
16 Rubens may have made a quick return trip to Venice before beginning this commission. One could travel by boat from Mantua to Venice in a day. Magurn 1955, p. 38.
17 Magurn 1955, p. 39; Correspondance de Rubens 1887–1909, I, p. 354.
18 For a full discussion of the commission see Held 1980, pp. 537–45.
19 See New York 2005, no. 18.
20 See White 1987, p. 86.
21 These different modes of painting may have been necessitated by the fact that Rubens established a workshop whose task it was to reproduce his style. See further Vlieghe, Balis and Van de Velde 2000.

Rubens's 'Pocketbook': *An Introduction to the Creative Process*

David Jaffé with Amanda Bradley

Fig. 8 **Two Apostles greeting**, 1601–3
Pen and ink, 21.5 × 31.1 cm
Collection Frits Lugt, Institut Néerlandais,
Paris (3986 *verso*)

Presiding over the garden portico of Rubens's house in Antwerp stood the figures of Mercury and Minerva. It can be no coincidence that these tutelary gods – representing learning and the arts – appear on the frontispiece of a copy of Rubens's sketchbook or 'pocketbook' as it is commonly called, the ethos of which they eloquently symbolise.[1] Indeed, the critic Bellori – from whom we first hear of the existence of the book in 1672 – defined it in similar terms: 'pratico, ma erudito' ('practical but scholarly').[2] The book demonstrates how Rubens evolved ideas and metamorphosed sources, accompanying images with text, creating 'building blocks' from which paintings were eventually formed.

Unfortunately, the original notebook was destroyed in a fire at the Louvre in 1720, while in the possession of André-Charles Boulle, cabinet-maker to the Louis XIV.[3] The loss was much lamented at the time, notably by the critic, the Comte de Caylus and the connoisseur Pierre-Jean Mariette.[4] It is some consolation that various fragmentary records of the book exist, from which we can partially reconstruct its content. Only two original sheets survived the fire: that in the Courtauld Institute depicting the stereometric possibilities of the *Farnese Hercules* (cat. 27) and that in the Staatliche Museen, Berlin, showing studies after Raphael

and Holbein (fig. 18).[5] The trimmed edges of both sheets – perhaps necessitated by fire damage – are similar.[6] In addition to these sheets, four fragmentary records of the book exist, each different, but nevertheless invaluable for reconstructive purposes, particularly when studied together. Three of these are in manuscript: two later seventeenth-century copies, the Johnson manuscript in the Courtauld Institute Galleries and that formerly in the possession of the Marquis de Ganay; and a book discovered by Michael Jaffé at Chatsworth, which he identified as an early work by Van Dyck (these manuscripts will subsequently be referred to as: J.ms., G.ms., and C.ms.).[7] There also exists a printed source: *La théorie de la Figure Humaine*, printed in Paris by Charles-Antoine Jombert in 1773, in which much of Rubens's Latin text is translated into French and some of the sketches engraved by Pierre Aveline.

The relative value of these copies is a complex issue that cannot be resolved here.[8] But the Johnson manuscript (J.ms.), pedantic as it is, seems to be the most reliable record, while the Chatsworth version (C.ms.) has a more expressive style. It seems likely that these copies were made by young artists, seeking to learn from Rubens's example.[9] Michael Jaffé argued that the Chatsworth book was not only executed by Van Dyck, but also mostly his in design

Fig. 9 Copy after Rubens (attributed to Anthony Van Dyck)
C.ms. fol.66v & 67r
Devonshire Collection, Chatsworth

Fig. 10 Jacopo Caraglio (1505–1565) after Rosso Fiorentino (about 1494–1540)
Hercules killing the Centaur Nessus, about 1524
Engraving, 21.1 × 180 cm
The British Museum, London (B2802.045)

Fig. 9

Fig. 10

and concept. This claim has recently been refuted by Arnout Balis, who has argued that the first forty folios are direct copies after Rubens; this seems reasonable, as none of the images found in the sketchbook relate to any painted works by Van Dyck, whereas, as will be shown, numerous parallels can be found in Rubens's oeuvre.[10] The selective use of Latin inscriptions is further evidence that this copyist was unversed in the language (or at least did not naturally apply it in notes or headings), and was drawing on Rubens's own work.[11] Moreover, other sketches by Rubens – not linked to the pocketbook – are similar in temperament and method. For example, sheets exploring an encounter between two bearded men (fig. 8), and *Peasants Dancing* (British Museum, London) show fleeting moments captured in a cinematic sequence through a series of thumbnail sketches, as do some pocketbook pages.

This is not to say that the authors of these manuscripts did not fuse Rubens's sketches with their own ideas and motifs from later sources; they must be considered alongside one another.[12] In addition, the copies are incomplete, and it has been concluded that the original pocketbook – judging from the pagination of the Johnson version – once contained some 500 sheets.[13] That manuscript has, however, accumulated a number of pages since Rubens's death, so the original would probably have been smaller and less cumbersome as an addition to Rubens's luggage on his travels. Sheets have also been lost. Bellori describes features of the book, such as battles and shipwrecks, which cannot be found in any of the copies.[14] One can only surmise that these sheets were removed from the original, perhaps prized for their overtly dramatic content.

A striking feature of the book, as known from the copies, is a paucity of equine studies. Horses in action fascinated Rubens, as his studies for *The Conversion of Saint Paul* (cats 68–9) testify, but the sketches in the pocketbook copies are limited to comparative physiognomic studies; see, in particular, those after the groups of *Alexander and Buchephalus* on the Quirinal Hill in Rome. On one of the sheets (J.ms. fol.97r), the neck of an ancient statue of *Venus* (Uffizi, Florence) is compared to that of the horse from the same group,[15] and on another (C.ms. fol.66v and 67r, fig. 9) are the words 'pulchritudines equarum cum feminis coequales' ('the comparable beauties of mares and women') – such was Rubens's admiration of the equine form.[16]

It has also been proposed that a different sheet (cat. 5), also showing horses in action, is another lost original from the pocket-book on the grounds of its provenance and the 'exploratory nature of the drawing'.[17] The sheet does have a central fold, and the dimensions are exactly the size of the original Courtauld *Hercules* studies (cats 27–8), but the drawings of the *recto* and *verso* span the breadth of the sheet, and would, therefore, have been inappropriate for a bound format (although it might have been folded into the book). The handwriting – noting the effects of dust and light – has been dated to the 1590s and indeed it seems more careful and juvenile than Rubens's usual hand, and if the sheet is indeed autograph, it might demonstrate that Rubens was aware of Leonardo's *Libro di pittura* before he went to Italy (perhaps from Federico Zuccaro via Otto van Veen).[18] Judging by the paintings connected with it (*The Battle of the Amazons*, cat. 5, and *Hero and*

Fig. 11 Copies after Rubens
(attributed to Anthony Van Dyck)
C.ms. fol.40v & 41r
Devonshire Collection, Chatsworth

Fig. 11

Leander, cat. 17), it is possible that it is a copy of a missing page from the pocketbook, datable to 1602–5.[19] The tremulous delineation perceptible in some of the figures might indicate the tentativeness of the reproduction process, though if the sheet is a copy it is remarkable.

Despite numerous annotations the pocketbook was chiefly concerned with invention and the creative process, rather than constituting the draft of an treatise on art.[20] Often pages are themed, and offer various solutions to the subject in hand: the original pocketbook would have served as a compendium of ideas. The copies show how Rubens would on occasion pluck different motifs from the same print, but categorise each one on a separate sheet.[21] A print by Jacopo Caraglio (after Rosso Fiorentino) of *Nessus and Dejanira* (fig. 10) is a case in point: the fleeing centaur and Hercules' wife appear on one sheet (J.ms. fol.35v, and C.ms. 40v, fig. 11), and a river god on another (J.ms. fol.18r).[22]

Hans Holbein's celebrated publication the *Imagines Mortis* (or *The Dance of Death*, see fig. 19) was similarly treated. Rubens had initially copied Holbein's work in full at the beginning of his career,[23] but chose to explore particular figures more fully in the pocketbook.[24] On one sheet entitled '*trahentes*' ('those being pulled', C.ms. fol.54v, fig. 12) he has transformed Holbein's designs in numerous adaptations of figures being pushed and pulled. Ingeniously, the skeleton has become a man, and the monk a woman. This leads, on the consequent sheet (C.ms. fol.55v, fig. 13), to a further range of exciting free variants on the same theme. At the centre, a female figure is seized by the buttocks: it is astonishing

how Rubens – even in this perfunctory sketch which we see by way of a copy – can convey brutality. The pose clearly fascinated him, and it appears again in his painting of *Boreas abducting Oreithyia* (1616, Accademie, Vienna). A similarly animated female figure (top right of the sheet) is dragged forth by her drapery, or towel, and she too generated figures for other schemes: notably the swooning woman to the left of *The Martyrdom of Saint Ursula* (cat. 3), and on the far right in the drawing of an early drawing of *Rape of the Sabines* (present whereabouts unknown).[25]

The facing sheet (C.ms. fol.56r, fig. 13) shows Rubens copying the bent-double woman from Michelangelo's relief of *Lapiths and Centaurs* (see cat. 31). Above this quotation Rubens reverses her pose which, in an inspired variant, he inserted into the small *Last Judgement* (Alte Pinakothek, Munich, no. 186). At the top of the sheet he explores a seated woman turning towards us – which was adapted into his *Venus* (Hammer Collection, Los Angeles).

On the *recto* of the Berlin sheet (fig. 18), one finds no fewer than three of Holbein's figures (the *Miser*, *Sailor* and *Abbess*, quite faint above the central figures) all raising their arms in anguish and shock. The accompanying studies after Raphael's *Fire in the Borgo* (*Stanza dell'Incendio*, Vatican Palace) are of similar attitudes.[26] Holbein's motifs had an enduring appeal: a promenading man and woman, derived from the *Married Couple*, can be found in the Chatsworth manuscript (C.ms. fol.52v).[27] Much later in his career, Rubens refers back to this couple, and having rotated and adapted the motif he uses it in a drawing for a *Morning Walk*,[28] and the *Garden of Love* (about 1638, Museo Nacional del Prado, Madrid).[29]

Fig. 12

Fig. 14

Fig. 13

Prints were not the only images quarried in this process of selective copying: Tintoretto's *Miracle of the Slave* (Accademia, Venice) was subjected to rigorous artistic analysis and the mother and child (C.ms. fol.52v), and the body of Saint Mark (J.ms. fol.16r) extracted and 'filed' on different sheets.[30]

The Renaissance concept of *inventio* is, therefore, at the heart of the pocketbook: sources manipulated and sometimes rotated to create a startling, fresh concert of ideas. The Renaissance theorist Ludovico Dolce could have been talking about Rubens when, in his *Dialogo della Pittura* (Venice 1557), he described how the artist should 'not be satisfied with a single invention when it comes to his trying out in preliminary sketches the imaginative ideas inspired in his mind … but to evolve several of these'.[31] In fact he singles out Raphael as the master of inventiveness, and it is perhaps no coincidence that many copies after Raphael – in particular features from the Vatican *Stanze* – appear in the pocketbook.

Prime examples of this imaginative process are Rubens's studies of the ancient statue of *Laocoön* (a fully worked study can be seen in the exhibition, cat. 26). In the Johnson manuscript (J.ms. fol.65r, fig. 14) the sculpture has been drawn from the side – the pose is then repeated above, but with the serpents transformed into flowing drapery. On other sheets the essential pose of the *Laocoön* (arms and legs at opposing diagonals) has been given to other mythical figures: Atlas (C.ms. fol.40v, fig. 11), who supports the earth with his upper arm, and Samson (C.ms. fol.15v) who tears down the temple.[32] This figure can be found – suitably adapted – in a drawing in Edinburgh (cat. 5), and a version of *The Battle of the Amazons* (cat. 4), where two struggling women have replaced the serpents and columns.[33]

Another component of the group, Laocoön's long-haired son, has been analysed and metamorphosed on a separate sheet (C.ms. fol.56v, central figure, fig. 16).[34] This figure, now seemingly female,

Fig. 15 **Tarquin and Lucretia**, about 1612
Oil on canvas, 187 × 219 cm
Schloss Sanssouci Bildergalerie, Stiftung Preußische
Schlösser und Gärten Berlin-Brandenburg, Potsdam
Presently on display in
The State Hermitage Museum, St Petersburg,
Collection of Vladimir Logvinenko, Moscow

Fig. 16 Copy after Rubens (attributed to Anthony Van Dyck)
C.ms. fol.56v
Devonshire Collection, Chatsworth

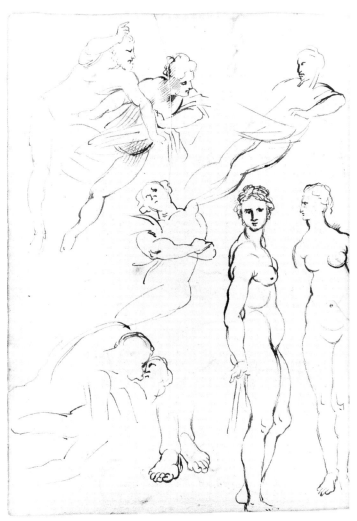

Fig. 16

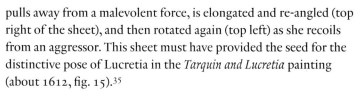

Fig. 15

pulls away from a malevolent force, is elongated and re-angled (top right of the sheet), and then rotated again (top left) as she recoils from an aggressor. This sheet must have provided the seed for the distinctive pose of Lucretia in the *Tarquin and Lucretia* painting (about 1612, fig. 15).[35]

The antique statue of the *Crouching Venus* (fig. 61) was also the inspiration for a series of ideas (see cat. 82). Rubens transforms marble into the living flesh of a somewhat shy bathing woman (C.ms. fols 58r and 58v, fig. 17). The central drawings show her naked, but in the upper two she hurriedly dries her hair, or pulls a robe over her head. It is easy to imagine how Rubens then transformed her into the biblical figure of Susanna (C.ms. fol.53r), startled by the Elders as she bathes. This pose is translated into paint in cat. 19, and adapted for the horae in cat. 65.

Behind these creative solutions (as Bellori had indicated) lay a rigorous, scholarly mind. Rubens strove to represent divine harmony in his art, as his entry in the *Album Amicorum* of Philip Valckenisse attests.[36] This quest for ideal, geometrical order is most evident on the original Courtauld sheet (cat. 27) and in the Johnson manuscript (J.ms. fol.3r). On the latter Rubens states that the human form is constituted of three elements: the triangle, the square and the circle.[37] It is no coincidence that he chose the *Farnese Hercules* on which to base his studies, a statue was thought to represent the ultimate robust male form (fig. 44). Rubens, appropriately, used an exceptionally thick pen, and vigorous strokes, to accent some of the angles here. Other sheets in the British Museum, and a copy after Rubens in Copenhagen (fig. 32) which shows the sculpture from different angles, attest to Rubens's fascination with it. In addition to studying the original, which was placed on a pedestal under the portico of the courtyard of the Palazzo Farnese in Rome, Rubens must have worked from a cast, especially in order to make the detailed studies of *Hercules's Head* (cat. 28).[38]

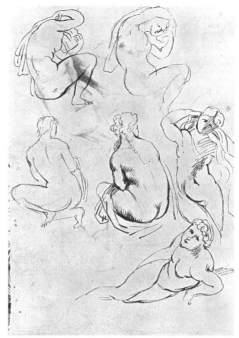

Fig. 17 Copy after Rubens
(attributed to Anthony Van Dyck)
C.ms. fol.58v
Devonshire Collection, Chatsworth

Fig. 17

The stereometric method applied to the *Hercules* was popular with German artists and artistic theorists whose printed works Rubens must have encountered in his early years. Prints by the likes of Erhard Schoen show jointed mannequins, broken down into geometric forms, in perspectively-constructed space. In the 1542 edition of his *Manual of proportion and the positioning of jointed mannequins* (Nuremberg, 1538), Schoen even added a chapter on horses.[39]

While the *Hercules* has been broken down into predominantly angular geometric shapes, the *Venus* (J.ms. fol.99r), as befits her femininity, is described in circles – circular, incised lines outline her breasts, abdomen and buttocks. The inscription tells us that Rubens worked from a wax model made after an original marble (it is not known which).[40] This technique – using small-scale models in various media to explore and create sculptural forms – was also, famously, employed by Tintoretto.[41] Rubens was particularly enamoured of Tintoretto's dynamic compositions, and various motifs from them appear in both the pocketbook and in finished works.[42] Rubens's artistic mentor in Rome, Adam Elsheimer, also made rotational studies, from statuettes and from life as a sheet in the Staatliche Museen, Berlin, attests.[43]

The ideal forms of antiquity were supplemented by studies from life. Facing *Samson* in the Chatsworth manuscript is a series of studies of galley slaves (C.ms. fol.16r); their features lack the gravitas of any ancient prototype, but their muscular physiques (in particular, the figure on the far right) must have provided Rubens with an engaging comment on ancient sources.[44] Indeed, galley slaves provided an important figural resource for contemporary artists: we know that Hendrick Goltzius (1558–1616) had taken the papal galley from Naples to Rome especially to study these slaves, renowned for their muscularity.[45]

Although it was undoubtedly begun before he went to Italy some of the pocketbook must have been executed during his years there.[46] It therefore charts his development as well as documenting the inspiration he found in artistic models.[47] In the Chatsworth manuscript (C.ms. fol.10v) we find the phrase 'vant inventeren' ('from invention'), an indication that its purpose was to create, not just record, and although we cannot be sure that all the free variations in these copies are Rubens's own – or indeed that some were not assembled from still unknown sources – the reappearance of motifs from the pocketbook copies in Rubens's work encourages the assumption that through them we are in touch with his thinking. Despite their limitations the pocketbook copies give a unique insight into Rubens's methods, and the agility of his creative mind.

1 The Johnson manuscript is in the Courtauld Institute of Art, London (see main text below). This book was sold at Sotheby's, 23–4 March 1970, lot 179. The original book apparently consisted of *recto* sheets only.
2 Bellori (1976), p. 266. The first unpublished mention of the pocketbook relates to its early provenance, when it belonged to Canon Antoon Tassis (died 11 May 1651). Arnout Balis has recently discovered that after Rubens's death in 1640, the book did not pass to his son, Albert, but to Canon Tassis. See Balis 2001, pp. 15–16).
3 See Jaffé 1966, p. 17. This was the first publication in which the pocketbook was discussed in any detail and Jaffé also produces a useful summary of the provenance of Chatsworth manuscript and the other copies.
4 Jaffé 1966, n. 7.
5 See Jaffé 1966, n. 7, *vis-à-vis* how these sheets might have been preserved from the fire. Curiously, the Berlin sheet is not copied in any of these manuscripts. It may never have been bound, and could have escaped from Rubens's studio at an early date. See Cologne 1977, pp. 50–7.
6 The drawings after the *Farnese Hercules* (cats 27–8) are 19.6 × 15.3 cm, the Berlin drawing (fig. 18) is 17.9 × 13.9 cm. The variation may be due to trimming.
7 The Johnson manuscript is named after Maurice Johnson of Ayscoughfee Hall, Lincolnshire, who acquired the book between 1742 and 1744 from an unknown source. The de Ganay sketchbook was sold at Sotheby's (Monaco) on 1 December 1989, lot 69.
8 We look forward to the publication of Arnout Balis's forthcoming study of the pocketbook for the *Corpus Rubenianum*, which will undoubtedly discuss these issues in greater depth. The Johnson manuscript would appear to be the most accurate copy judging from its slavish reproduction of the Courtauld sheet (cat. 27). It also seems to have been subject to less compression – see for example J.ms. fol.43r and C.ms. fol.41r.
9 It appears that Rubens had actually intended to publish at least parts of the pocketbook. See Balis 2001, p. 12.
10 This argument is indeed succinctly set out in Jaffé 1959, p. 321. Van Dyck's authorship of the copy is still plausible; however, we are here concerned with the author of the ideas transcribed, rather than the author of the transcriptions.
11 See McGrath's essay in this catalogue, p. 29, and also Belkin 1989, p. 249.

The images are sorted by subject and these groups have headings sometimes written in Latin, which is also used for captions. It seems unlikely that a copyist would introduce Latin into their version.

12 One particularly problematic sheet is that depicting the *Faun and a Scabillum* (meaning 'bellows', J.ms. fol.87r). It clearly does not follow Rubens's original composition, for the inscription derives from a text published by Rubens's son, Albert, after his father's death in 1665, entitled *De Re Vestaria Veterum* (see Van der Meulen 1994, II, no. 4, p. 32; III, fig. 10). Indeed, the sheet on which the faun has been traced from the *recto* onto the *verso* (139v) probably served as the engraver's model (Balis, by private correspondence, noted in Van der Meulen 1994, II, p. 131).

13 Balis 2001, p. 21.

14 See McGrath essay n. 8 for Bellori.

15 See Van der Meulen 1994, II, p. 72; III, fig. 106. This horse is used more literally in the British Museum study for the *Battle of the Amazons* (cat. 2). See Cologne 1977, no. 24, p. 181.

16 Anthropomorphic studies of bulls and horses are also made alongside the bust of *Julius Caesar*. See Van der Meulen 1994, II, p. 119; III, figs 192–4, p. 73.

17 See Logan in New York 2005, no. 10, pp. 83–5.

18 Belkin 1989, p. 246. See also McGrath 1997, II, no. 58, pp. 326–7.

19 See cat. 17.

20 We thus concur with the view presented in Balis 2001 article (p. 16ff.)

21 The issue is complicated somewhat by the fact that different aspects of these prints appear in different copies of the pocketbook.

22 Jaffé 1966, II, p. 233. Curiously, in the de Ganay manuscript Rosso's river god is placed above a group of studies after Correggio, but without the handle of the urn found in the original print – which is in the Johnson manuscript version. Rubens has similarly segmented Raimondi's print of *Trajan between the City of Rome and Victory* (after a relief on the Arch of Constantine). Three of the figures have been copied in the Chatsworth manuscript (C.ms. fol.33v and C.ms. fol.35r), see Jaffé 1966 pp. 228–9. Only the recumbent captive has been reproduced in the Johnson book (J.ms. fol.19r), among the slain figures.

23 Belkin has argued that they were probably started before his official training as an artist. See 'Rubens's copies after German and Netherlandish prints' in Antwerp 2000, p. 74.

24 Discovered by Pat Jaffé, and fully detailed in Jaffé 1966, II, p. 238.

25 The pose on C.ms. fol.55v has resonances of Giambologna's bronze of a *Rape of a Sabine*, Kunsthistorisches Museum, Vienna. See also McGrath 1997, II, p. 180, n.8.

26 Noted by Belkin 1989, p. 249. She dates the Berlin sheet (fig. 18) before Rubens sets off for Italy in 1600, arguing that the Raphael copies would have been known to him through prints. This is evident from the fact that Rubens's copies show the originals in reverse.

27 Jaffé 1966, II, p. 237.

28 The *Morning Walk* is in the Museum Boijmans van Beuningen, Rotterdam

29 Belkin 1989, p. 249.

30 Rubens may have copied from Tintoretto's canvas, then in the Scuole di San Marco, Venice, or the Matham print after it. For the slave (J.ms. fol.16r) see Balis 2001, fig. 2, p. 18. See also Belkin in Bauman and Liedtke 1992 for the suggestion that Hero's pose is inspired by the flying Saint Mark from the *Miracle of the Slave*. Rubens had copied this figure see C.ms. fol.32r (Jaffé 1966, II, p. 227).

31 Roskill 2000, p. 129.

32 It is tempting to imagine this as a Vitruvian conceit as the ancient architectural theorist gave genders to the architectural orders.

33 This figure has also been identified as Hercules, who did indeed carry two columns, but here the columns have been wrenched from pedestals; suggesting that they are the temple supports and he is Samson.

34 This figure must have been studied from a print – presumably before Rubens's Italian trip – as it is shown in reverse. A study of the back of the *Laocoön* (C.ms. fol.28v) must be a summary of one of Rubens's drawings (see that in the Ambrosiana, Milan) made on site, and which were kept separate from the pocketbook. This suggests that the copyist (possibly Van Dyck) had privileged access to *cantoor* (studio) material in Antwerp.

35 See McGrath 1997, II, no. 44, pp. 225–8.

36 On harmony Rubens wrote: 'Deus Marmonia nerum omnium, circulus includeus omnia, extra quem nihil est' ('God is the harmony of all things a circle embracing everything outside of which there is nothing'. This is fully discussed by Muller 2004, pp. 17–18.

37 'Qvare Figurae Humanae Elementa Tria constitantur.' This tripartite division also corresponds, following Aristotle, with the beginning, middle and end. See Muller 2004, p. 18.

38 As noted in Van der Meulen 1994, II, p. 45. See also Haskell and Penny, no. 46, pp. 229–32. Rubens incorporated a cast of the *Farnese Hercules* into his house.

39 Bartsch 1981, 13, p. 202. Schoen's chapter on horses was undoubtedly informed by H.S. Beham's *Von der proportion der Ross* ('of the proportion of horses'), Nuremberg 1528.

40 Van der Meulen 1994, II, p. 73, n. 9.

41 See, for example, his studies after a statuette of Michelangelo's *Day* (Christ Church Library, Oxford) and Michelangelo's *Samson and the Philistine* (Courtauld Institute of Art, London).

42 For an example in the pocketbook, see C.ms. fol.52v, where the mother and child to the left of the *Miracle of the Slave* (Galleria dell'Accademia, Venice) have been summarily reproduced.

43 This sheet shows a series of densely packed studies, most of which appear to be made from life, although the figure viewed *di sotto in su*, to the left, must surely have been a statuette. The 1615 will of Deodate del Monte, Rubens's earliest associate, also states that his collection included casts, sculpture and wax figures. See Duverger 1984–2004, II (1985), pp. 215–16.

44 Rubens appears to have made some studies from life to judge from the Johnson manuscript, but in general there is little further evidence of life drawing in the pocketbook copies.

45 See Amsterdam-New York-Toledo (Ohio) 2003, p. 121. We thank Paul Taylor for this reference. Grand Duke Ferdinando de' Medici instructed Pietro Tacca (1577–1640) to inspect the work after galley slaves for the slave figures on his monument at Livorno. Cited in a letter of 6 February 1607 from the duke to his agent, Lorenzo Usimbarchi; see Torriti 1984, p. 37, citing L. Bianchi, 'Note e documenti su Pietro Tacca', *Rivista d'Arte*, 1931, p. 133–88.

46 Held 1959 (1986), p. 66, under no. 7.

47 The Tintoretto *Miracle of the Slave* (see core text *supra*) must have been copied about 1600, and Paggi's *Massacre* (C.ms. fol.14v) in about 1605. The copy of Fernandez Navarrete's *Beheading of Saint Thomas* (San Lorenzo de El Escorial) copied on C.ms. fol.11r was probably made in Spain in 1603, but might have been known through a copy. Perhaps more remarkable is the way Rubens continued to draw on the ideas in the book throughout his career.

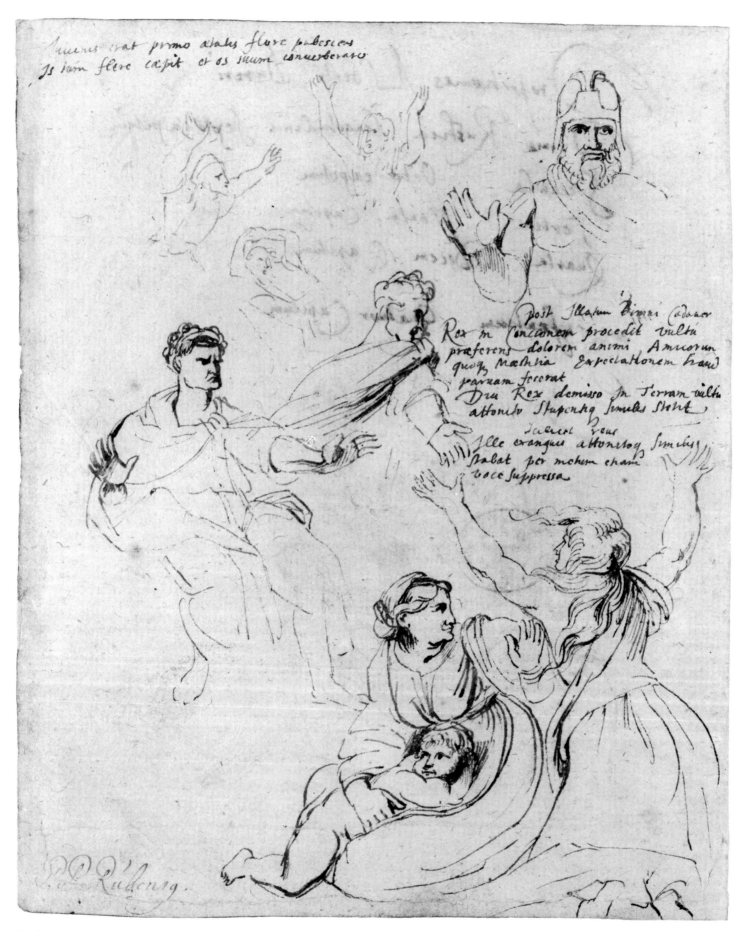

Fig. 18

Words and Thoughts in Rubens's Early Drawings

Elizabeth McGrath

Drawings have long been prized as traces of an artist's thinking: for the insights they give into creative processes, from tentative sketch to confident revision, and into the genesis of particular works of art. The drawings exhibited here provide vivid testimony to Rubens's fertility of invention, as literary sources feed into visual motifs to bring new life to familiar images and spark off novel themes and compositions. At times we also have the evidence of words jotted down by the artist as he worked, verbal pointers

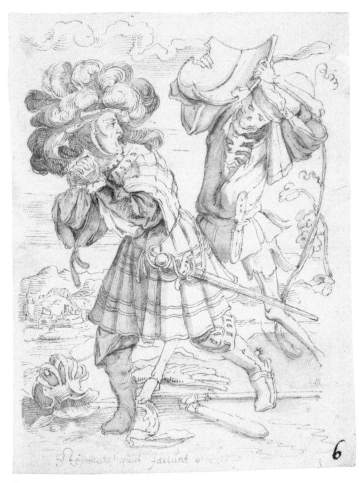

Fig. 19

Fig. 18 **Sheet with texts and studies after Raphael and Holbein and notes from Quintus Curtius,** about 1600
Pen and brown ink on paper, 20.2 × 15.9 cm
Kupferstichkabinett, Staatliche Museen zu Berlin-Preussischer Kulturbesitz (3240)

Fig. 19 Rubens, after Holbein's *Dance of Death*
Death and the Count, about 1593
Pen and brown ink on paper, 10.3 × 7.3 cm
Stedelijk Prentenkabinet, Antwerp Museums (P.257)

to ideas and intentions, fleeting notes, apparently to himself. In Rubens's earliest drawings these notes are generally in Latin (see cats 5, 16, 27, 55) a language he used quite naturally for all sorts of annotation; but increasingly, during his stay in Italy, as he plans compositions and works out their details, Rubens resorts instead to Italian phrases and expressions (see cat. 32).[1] In fact, although he never gave up writing in Latin on his drawings, one guide in assessing the date of inscribed sheets is the presence of Italian on them.[2]

Rubens arrived in Italy well educated in the classics, and used to dealing in words. His early attendance at Latin school was no formality but the same thorough grounding that prepared his friend Balthasar Moretus for his inheritance of the great publishing house, the Plantin Press; and he had been surrounded in Antwerp by humanists and books (his brother Philip was the star pupil of the great scholar Justus Lipsius). Rubens's early drawings after Holbein's *Dance of Death* show how he enjoyed the exercise of matching to the pictures, often wittily, Latin texts conjured up, it seems, from an already substantial store of memorised biblical and classical phrases. Thus his copy of *Death and the Count* (fig. 19), in which a knight is assaulted by Death with the heraldic shield that has been wrenched from him, is accompanied by the ironical 'Stemmata quid faciunt' ('what help are coats-of-arms?') from Juvenal's Eighth Satire.[3] The Holbein copies were probably executed in the early 1590s, just before Rubens left the studio of Adam van Noort to work under the painter Otto van Veen. This latter, a man so scholarly he was known by a Latinised name (Vaenius), devoted much intellectual energy to devising emblematic correlations of word and image. His crowning effort in this field, the *Emblemata Horatiana*, was published as a book only in 1607 while Rubens was away in Italy, but it was preceded by long preparation, much of it carried out during Rubens's years of apprenticeship.[4] Van Veen's enterprise of contriving pictorial versions of the conceits and imagery of the ancient poet Horace took off from his phrase 'ut pictura poesis' ('as for painting, so for poetry'), that rallying cry of literary painters of the sixteenth and seventeenth centuries, and Vaenius's 'Horatian emblems' had great success among the educated public of Europe, who could identify favourite snippets of the Epistles and Odes. Thus in the emblem entitled 'Punishment presses close behind a crime' (*Culpam poena premit comes*: fig. 20) the personification of Punishment, laden with Horatian implements, has a peg-leg to evoke the poet's reference to retribution coming limping after a villain.[5] The book is, however, as can perhaps be seen from this example, something of a learned

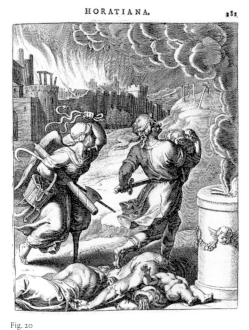

Fig. 20 **Punishment presses close behind a crime** (*Culpam poena premit comes*), Engraving, from Otto van Veen, *Emblemata Horatiana*, Antwerp 1607
Courtesy of the Warburg Institute, London

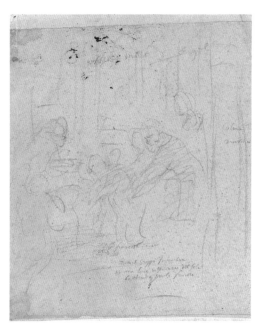

Fig. 21 **The Last Communion of Saint Francis**, 1618
Red chalk heightened with
white body colour, 28.5 × 23.5 cm
Collection untraced,
sold at Christie's 28 Jan 1999 (lot 95A)

Fig. 20

Fig. 21

curiosity, intriguing but often quaintly literal in its approach.[6] Rubens learned a lot from Van Veen – not least that an attempt to seek a direct equivalence between text and image was an artistic cul-de-sac.

It was when working in Van Veen's studio that Rubens began his own, very different, collection of complementary words and images, a collection he seems to have updated constantly while in Italy to make it more and more useful as an artistic resource, a starting point for his own inventions. This was a notebook, eventually a quite fat notebook, which, except for a stray folio (or maybe two: cat. 28 and fig. 18), was destroyed by fire in 1720, but can be partially reconstructed – to an extent that cruelly underlines the misfortune of its loss – from copies by Rubens's pupils and followers, and a French translation of some of its Latin text published in the late eighteenth century.[7] In Antwerp Rubens had trained himself, as apprentices did at the period, by copying figures and motifs from prints by or after the great masters (see cat. 6). From the start he evidently sought in his notebook (or 'pocketbook') to group together striking examples of gestures and expressions, and further, in a way that was remarkable and unique, to set down beside them passages and phrases from classical authors, particularly Virgil. This we learn from the seventeenth-century critic Bellori, who knew about the book and talks of how it included, among other things, episodes involving battles, shipwrecks, games and scenes of love.[8] Rubens's admirer Roger de Piles, who saw it for himself, expanded on Bellori, commenting that this 'unusual and interesting exploration of the principal human passions and actions' was 'derived from accounts of the poets, with exemplary drawings after the best artists, above all Raphael, so as to give painting its due by reference to poetry'; he tells us too that it included copies after the antique.[9] A sheet in Berlin which is probably a detached leaf from the book (fig. 18)

shows how Quintus Curtius's *Life of Alexander* seemed to Rubens to provide telling accounts of surprise and astonishment that could be set against details from engravings after Raphael and Holbein.[10]

In these pages the texts complemented and supplemented the images, so as to provide material for the generation of new ideas. Surviving copies of the lost book at times allow us to discern within it trains of association and invention that lead into motifs eventually adopted by Rubens in his paintings.[11] The inscriptions we find on Rubens's independent drawings, whether copies, free variations, or compositional sketches of his own, often have a similar function to those in the pocketbook, in the sense that they provide additional thoughts and pointers to follow up, with words sometimes substituting for a change to the sketch itself, perhaps obviating the need for a revised drawing.

This practice can be documented throughout Rubens's life. For example when planning the altarpiece of the *Last Communion of Saint Francis* in 1618 for the Franciscan church in Antwerp,[12] Rubens made a quick sketch, primarily to determine the pictorial effect he wanted to achieve with illumination (the rough disposition of the figures had been worked out already in another drawing).[13] Here (fig. 21) he showed the priest, the dying saint and his supporting brother monks (identified in Latin: 'fratres franciscani' or 'francisci') with, below the last, the comment in Italian 'the whole group in shadow and a strong sunlight coming through the window' ('tutto il gruppo in umbra et una luce vehemente del sole bastenda per la finestra').[14] Further inscriptions, this time in chalk and in Flemish, indicate, up above, the 'painted window' ('geschildert venster') important to the lighting, and an angel ('Engel') that will appear nearby (eventually multiplied to two in the painting); the note at the right referring to a column ('colum[..?]' with an adjective difficult to decipher, it being unclear even whether the words are in Flemish, Italian or Latin) may

Fig. 22 **Tomyris with the Head of Cyrus**,
about 1637
Pen and brown ink with black and red chalk,
27.2 × 47.2 cm
The Cleveland Museum of Art, Ohio
Delia E. Holden and L. E. Holden Funds
(1954.2.b)

Fig. 22

indicate the framing of the altar.[15] And in the late drawing (about
1637) for a composition of *Tomyris with the Head of Cyrus* (fig. 22),
probably an idea for a picture for Gaspar Roomer, the Flemish
collector based in Naples, a couple of words in Latin in
the middle ('plus spatii') indicate the way Rubens thinks he should
revise the composition to leave more space between the queen and
the turbaned bystanders.[16]

Naturally, however, Rubens's early drawings, in which he was
much concerned to improve on first efforts and learn from the
example of others, contain particular self-addressed instructions.
Thus the *Deposition* in the Hermitage (cat. 55), the style of which
dates it to the first year or so of Rubens's stay in Italy,[17] is accom-
panied by a message in Latin to bear in mind Daniele da Volterra's
motif of 'a man who while appearing to be holding on [to Christ]
yet is letting go. Likewise another who is coming down with
great care as if to bring help'.[18] The newly discovered painting of
the *Deposition* (fig. 51), a copy of a lost original which must have
been executed just after Rubens made and then annotated the
Hermitage drawing,[19] shows how the artist sought to profit
from his inscribed observations. In this composition, apparently
designed for the private chapel of Eleanora, Duchess of Mantua,[20]
Rubens abandoned the idea used in the drawing of leaving one of
Christ's hands nailed to the Cross,[21] so that the dead Saviour could
slump forward, his right arm slithering along the arm and through
the hand of a man who indeed appears to be supporting him while
actually letting go. As it is lowered the corpse is sustained by the
great winding sheet which, secured between the teeth of the man
above, fans out to twist back tightly around the arm of the helper
who is climbing the ladder. And Rubens remembered the lessons
of Daniele and improved spectacularly on his earlier invention,
partly reverting to the scheme of his drawing, when, years later,
he painted his great *Deposition* for Antwerp Cathedral (fig. 23; see

also cat. 55).[22] He made it appear as if the elderly man at the top
who has been holding onto the left arm of Christ has begun to let
it slip down the sweep of white shroud which, once again, flows
from reverently clenched teeth.[23] Daniele's man who descends
'with great care' (presumably the one behind the ladder to the
right) is now reinvented as the important helper on the right,
already making himself useful as he climbs down, though more
awkwardly than carefully.[24]

In another drawing made in the first years in Italy, the *recto* of
a double-sided sheet now in the Getty Museum (fig. 24),[25] some
ideas for a *Last Supper* are revised, possibly under the impact of the
bold naturalism of Caravaggio's *Supper at Emmaus*,[26] in the Latin
phrase inscribed by Rubens above one group: 'The gestures
[should be] broader and wider with arms outstretched' ('Gestus
magis largi longique brachiis extensis'). Again in a drawing made
some years later, the wildly excited battlescene now in the British
Museum (cat. 32) – a study clearly inspired by Leonardo's *Battle of
the Anghiari* and in part closely based on it[27] – we find, written in
chalk at the top left, now in Italian, a phrase ending in the words
'… the body should be raised on its feet above the stirrups to get
closer to the enemy' ('… il corpo si alsi su piedi sopra le staffe / per
avvincinare gli nemici'),[28] apparently advice by Rubens to himself
about how, by allowing the horseman to rise up in his stirrups, he
could make the encounter closer and more effective. (The splendid
oil-sketch for the *Lion Hunt* in the National Gallery, cat. 71, shows
how Rubens later exploited the idea of riders raising themselves
up to fight in this way.)

A fascinating early drawing in Edinburgh (cat. 5)[29] with studies
for a *Battle of the Amazons* has Latin inscriptions which should, I
think, be understood similarly, as self-addressed instructions.
At the top left corner is the word 'Sol' indicating the position of
the sun amid clouds; towards the centre, above the head of one

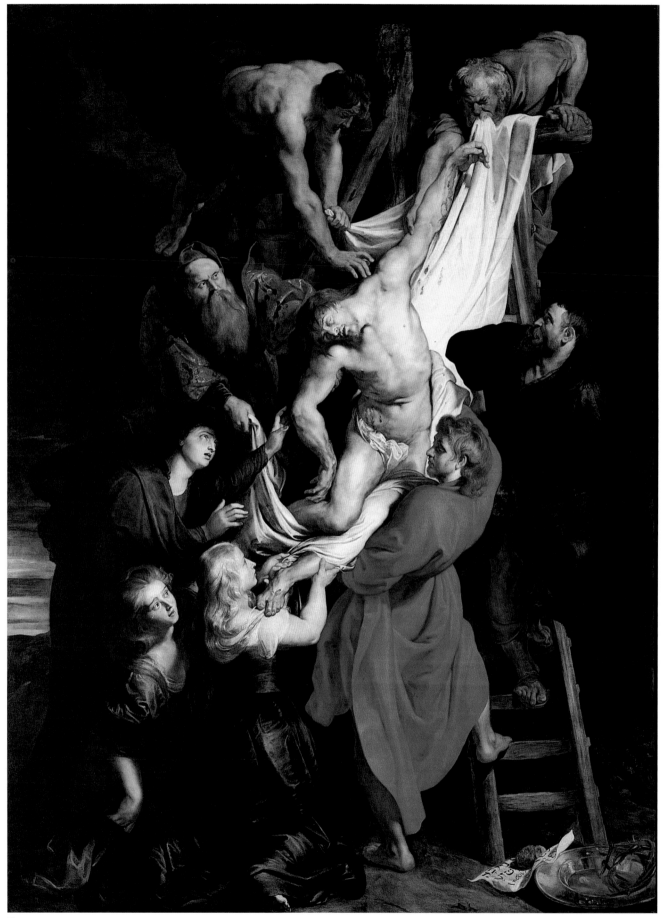

Fig. 23

Fig. 23 **The Descent from the Cross**, 1611–14 (central panel of triptych)
Oil on panel, central panel 421 × 311 cm
Antwerp Cathedral

horseman appears the phrase: 'Maxima pulvis nubis instar aut Caliginis' ('the greatest dust in the form of a cloud or fog'). Nearby, above another head, is: 'pulvis longo tractu a tergo albescit' ('dust from being drawn out in a trail becomes white at the rear'); lower, on the left is: 'ad pedes lux clarior' ('at their feet a brighter light'). This sheet might seem something of a puzzle, for the script, which looks to be in the same ink as the sketches, is rather careful and juvenile compared to Rubens's normal hand and therefore should have been made before 1600,[30] whereas the texts themselves appear to have affinities with certain of Leonardo's writings – which Rubens could have seen only some years after his arrival in Italy.[31] Moreover, the style of sketching and hatching, with an occasional quavering line, is slightly unusual. As a result the sheet has at times been pronounced a copy.[32] Yet what sort of copyist would have produced this drawing and the astonishing sea-storm on the reverse (cat. 16)? The answer is, in my view, Rubens himself.

The newly discovered painting of the *Battle of the Amazons* (cat. 4), in a private collection, includes a section which is directly related to the battlescene annotated in the drawing. And in this picture we also see precisely the features mentioned in Rubens's inscriptions: sunlight streams brightly down through the clouds at the upper left to illuminate the ground at the feet of men, writhing Amazons and plunging horses, and there is a great dust cloud that extends across the sky, rising from the battle and spreading out ('drawn out in a trail') to whiten at its edges. It seems to me that the drawing shows Rubens revising a crucial part of an existing Amazon composition – extracting the relevant figures and redrafting them with notes to himself – so as to plan improvements and indicate the effect that would be eventually achieved in the new painting (cat. 4). Perhaps this was done in the course of work on that canvas. More probably the group was drawn after an earlier Amazon picture very similar in composition (the present exhibition demonstrates just how much the subject fascinated the young artist) which Rubens had thought to revise, enhancing the drama of the scene with spectacular lighting effects; hence, for example, the rough hatching of the cast shadows in the drawing. (The figure of Hercules from an Amazon battle, with his pair of struggling women, has on the sheet become a column-bearing Samson, in a variation which will lead in other directions.)[33] Whether Leonardo is indeed relevant or Rubens arrived at his conception independently, the drawing illustrates how enthusiastically the artist worked at rethinking compositions and motifs and (if cat. 4 was indeed made in Italy) how his favourite youthful themes travelled with him from Antwerp.

At times Rubens's inscriptions on drawings point to iconographic rather than compositional afterthoughts. Such is the case for a drawing with studies of a woman dangling two dead infants as she rushes wildly along (fig. 25), the *verso* of the sheet with studies for a *Last Supper* (fig. 24). Evidently this is Medea, rejected by her husband Jason and maddened by jealousy into killing the offspring of their marriage. Her name indeed appears at the top in a line of Latin, but Rubens's inscription is not (as is sometimes implied) an identification of the drawing's subject. The first word already indicates that the artist is proposing a new idea, an alternative to what is depicted: '*or* Medea looking back at the burning Creusa and at Jason who is as if in pursuit' ('vel Medea respiciens Creusam ardentem et Iasonem velut insequen[tem]').[34] The crazed Medea, turning as she goes, might, Rubens thinks, be made to cast her eyes behind upon the other victim of her cruel vengeance: Jason's new bride, consumed in fire from the poisoned dress Medea had sent her. The attitude of Rubens's Medea in the drawing, as has often been pointed out, contains an echo of an ancient sarcophagus relief in which the murderess is shown turning as she takes off, infant corpses and all, in her dragon chariot. Rubens copied this ancient Roman motif in a drawing now in Rotterdam (fig. 26).[35] When he set down his own ideas for a flight of Medea in the Getty drawing (fig. 25) he perhaps had in mind – even in front of him – not only the copy he had made (fig. 26) but an engraving by Giulio Bonasone which is based on the whole sarcophagus composition, only reversing it (fig. 27);[36] for it seems that the writhing figure of Creusa contributed something to Rubens's dramatic formulation of Medea *furens*. With Creusa in mind, the artist evidently further reflected (as his inscription indicates) on how he might show her, 'burning', and moreover include Jason (who has no role in the sarcophagus scene)[37] coming in pursuit of Medea. The words 'Creusa ardens' can in fact be deciphered in chalk on the right. Still, Rubens's alternative version of the theme, proposed in his inscription, would have involved more than the addition of Creusa and Jason; it would have required a new formulation of the principal figure, to show Medea twisting right round so as to see the fire-engulfed bride; and this could also have entailed a suggestion of belated remorse. It has been observed that Rubens might have been encouraged to illustrate Medea's revenge by his knowledge of Seneca's bloody tragedy on the subject;[38] but I suspect Ovid's imaginary letter from Medea to Jason in his *Heroides* would have been important too, recording as it does a complex of contradictory emotions: jealousy, love and murderous rage. Rubens's interest in expressions of extreme passion, an interest

Fig. 24 Groups of Apostles, *recto* and
Fig. 25 Sketches for Medea, *verso*
about 1602
Pen and brown ink on paper,
29.7 × 43.8 cm
The J. Paul Getty Museum, Los Angeles
(84.GA.959)

Fig. 24

especially documented in the lost notebook (the 'Pocketbook'), probably prompted him to make this drawing; at any rate we have no record of his ever attempting a painting on the subject.

Ovid's *Heroides* also features an imaginary exchange of letters between Hero and Leander, on the eve of the latter's fatal swim across the raging night seas of the Bosphorus to meet his waiting lover. This text has some relevance to the splendid painting now in New Haven and apparently made while Rubens was in Mantua (cat. 17), a work which Rubens still valued enough years later to want to have it engraved along with examples of his current productions.[39] He described it then as 'A myth of Leander' ('una favola di Leandro').[40] But Rubens's composition did not begin from any reading of the classical tale, or indeed, I would argue, with the idea of Leander's fate at all; rather, as a related drawing and its annotation confirm, the subject emerged at a relatively late stage from a less specific notion of an ancient shipwreck. Some time before he began the painting – quite a long time if the drawing is, as I am convinced, a Rubens original[41] – Rubens sketched a sea-storm (see cat. 16), a swirl of water and figures, mostly sea-nymphs or nereids, swept along or swooping in the dips and curls of surging waves, riding and even clinging to the foamy crests. The study now in Edinburgh, the reverse of the sheet discussed above (cat. 5), has been taken for a preliminary illustration of the drowning of Leander, with reference to the

inscription on the upper right by, or according to sceptics after, Rubens: 'Leander natans Cupidine praevio' ('Leander swimming as Cupid leads the way'). Yet this Rubensian text is, once again, not an identification of the subject: in any case there is no guiding Cupid and no one much resembling a swimming Leander. The figure floating face-upwards near the bottom centre, who has been called Leander (and presumed already drowned), is not obviously male and arouses nothing of the expected concern from the surrounding nymphs. It seems to me that Rubens's drawing shows a shipwreck attended by nereids (note the nymph clinging to a piece of wreckage – a broken ship's mast? – a detail with no place in the story of Hero and Leander), perhaps a variation on one of the 'naufragi' from the lost notebook;[42] the most relevant classical text would seem to be Virgil's famous description of a sea-storm ('Quos ego …') in Book I of the *Aeneid* where, as it happens, a nereid accompanies Neptune as he rises to calm the waves. (Inspired by this passage, but multiplying the nereid by three, Rubens envisaged many years later the storm that disturbed the Cardinal-Infante Ferdinand's crossing from Spain to Italy in a painting for the entry into Antwerp of this new Hapsburg governor.)[43] It has been pointed out that the theme of Leander's body borne to the shore by sea-nymphs is the happy invention of Rubens, a piece of pictorial licence, related to no classical account of Hero and Leander.[44] It seems to me that Rubens thought of

Fig. 25

turning the scene into a Leander subject after he made his nereid and sea-storm drawing, at first imagining he should have the youth swimming with Cupid encouraging him on (as he suggests in his inscription), but then, when later he came to paint the picture, preferring the notion of sea-nymphs supporting and mourning the dead Leander, perhaps recalling too Homer's lamenting nereids first for Patroclus, and then for Achilles.[45]

Classical texts were for Rubens sources of inspiration, liberating rather than confining and restricting. One last example of an inscribed revision to a drawing vividly underlines this point. In the beautiful sketch made during the later part of the artist's stay in Italy, showing Venus bending over her dying lover Adonis (cat. 15), an early idea for a painting of the subject,[46] Rubens initially represented Venus with her head mournfully in her hand, but then, in an afterthought, made her draw her head nearer to Adonis for a last kiss, writing next to her 'spiritum morientis excipit ore' ('she receives his dying breath in her mouth'). In his *Lament for Adonis*, the Greek poet Bion had talked of how the dying Adonis was insensible to Venus's kiss.[47] Rubens would have known this text, but it was a phrase recalled from one of Cicero's speeches ('spiritum ore excipere', *Verrine Orations*, 5.45) of the last wish of mothers whose sons have been killed,[48] which evidently caught his imagination for its more apt expressiveness and solemnity. (In fact we know from a record of a lost account by

Rubens of what he saw in Rome that he had already thought of this phrase when he stood before an ancient sarcophagus of Venus and Adonis in a Roman collection.)[49] This sarcophagus was of course important in encouraging him towards the idea of an Adonis subject. But Rubens's sensitivity to texts as well as images made his vision of the death of the young hunter in Venus' arms an especially poignant one, and his own words have left us some hint of how he came to conceive it.

1 Rubens of course came to be fluent in Italian, at this period the language of diplomacy, and it is the medium of most of his surviving letters. For Rubens's extensive correspondance see *Correspondance de Rubens* 1887–1909; Magurn 1955.

2 On the inscriptions on Rubens's drawings in general (including notes made by the artist for the benefit of others, a category not considered in the present essay) see notably Held 1959, I, pp. 43–8 (Held 1959 (1986), pp. 38–40). Flemish words tend to be absent from Rubens's drawings made in Italy (the drawing related to the portrait of Marchesa Brigida Spinola: Held 1959, I, no. 73, p. 127; II, fig. 84; Held 1959 (1986), no. 29, p. 78 and fig. 32; has colour notes in Flemish, but some doubt has been raised about Rubens's authorship of this sheet), though they occur on early drawings and reappear, to alternate with Italian and Latin, on post-Italian sheets. For example see fig. 21. The subject of inscriptions on Rubens's drawings is now being studied for a PhD thesis at the University of Hamburg by Veronika Kopecky, to whom I am grateful for helpful comments.

3 See Belkin 1989, pp. 245–50, esp. p. 247 and pl. 55c, d; also Antwerp 2000, esp. pp. 89–90 and pl. 6. The book of copies is now in the Stedelijk Prentenkabinet, Antwerp.

Fig. 26

Fig. 27

Fig. 26 **The Flight of Medea**, about 1601–2
Pen and brown ink on paper, 15.7 × 15.7 cm
Museum Boijmans van Beuningen, Rotterdam (MB 5001.PK)

Fig. 27 Giulio Bonasone (1488–1574)
Medea and Creusa, early 1560s?
Engraving, 21.5 × 31.5 cm
The British Museum, London (B2803.098)

4 See esp. J. Müller Hofstede in Cologne 1977, 1, pp. 50–67.

5 Horace, *Odes*, III, ii, 31–2. See Vaenius 1607, pp. 180–1. For further Horatian allusions in this image see McGrath 1994, pp. 115–16, 124, n. 6.

6 See McGrath 1994; on the book see also Thøfner 2003.

7 See notably Balis 2001; also above, pp. 21–7.

8 Bellori 1672, p. 247: '...una ricerca dei principali affetti, ed attioni cavati da descrittioni di Poeti, con le dimostrationi de' pittori. Vi sono battaglie, naufragi, giuochi, amori & altre passioni & avvenimenti, trascritti alcuni versi di Virgilio, e d'altri, con rincontri principalmente di Rafaelle, e dell'antico.' Cf. Bellori (1976), p. 266.

9 de Piles 1677, pp. 219–20: '...une recherche tres-curieuse des principales passions de l'ame, et des actions tirées de quelques descriptions qu'en ont fait les Poëtes, avec des demonstrations à la plume d'aprés les meilleurs Maistres, et principalement d'aprés Raphaël, pour faire valoir la Peinture des uns par la Poësie des autres (soit que ces habiles Peintres eussent travaillé par principe, ou seulement par la bonté de leur génie.) Il y a des batailles, des tempestes, des jeux, des amours, des supplices, des morts differentes, et d'autres semblables passions et évenemens, dont il s'en voyoit aussi quelques-uns qu'il avoit dessinez d'aprés l'Antique.'

10 See J. Müller Hofstede in Cologne 1977, pp. 50–67; also Heinen in Brunswick 2004, no. 79, pp. 298–300; and also above, p. 23.

11 See above pp. 17–23.

12 Now Antwerp, Koninklijk Museum voor Schone Kunsten. See Vlieghe 1972, no. 102, pp. 156–9, fig. 178; Jaffé 1989, no. 501, p. 242.

13 Antwerp, Stedelijk Prentenkabinet. See Vlieghe 1972, no. 102a, pp. 159–60, fig. 180.

14 Sold Christie's 28 Jan. 1999, lot 95. Formerly Wolfgang Burchard Collection. See Vlieghe 1972, no. 102b, pl. 181, pp. 160–1, with this reading of the inscription which improves on earlier attempts. (But the inscription under Francis is perhaps '*fratres francisci*' rather than '*fratres francescani*'.)

15 Certainly no column is at the right of the painting. The ready shift from one language to another in the inscriptions seems to confirm that this drawing was not done to be shown to any patron.

16 Cleveland Museum of Art, Ohio. See McGrath 1997, I, fig. 17; II, no. 5, pp.

37–8; New York 2005, no. 112, pp. 300–2. The scene on the *verso* of the drawing (see also Burchard and d'Hulst 1963, I, no. 196, pp. 313, 315–16; II, no. 196) shows another gory beheading which certainly seems to have been the subject of a painting for Roomer, namely *Salome with the Head of John the Baptist*; the final picture is now in Edinburgh (Jaffé 1989, no. 1187, p. 346). The preparatory drawing for this also has annotations with Rubens's second thoughts, in this case recorded in Flemish.

17 The sheet has sometimes been dated later, to associate it with the planning of the triptych for Antwerp Cathedral (see fig. 7), but this notion rides roughshod over the stylistic evidence. See the analysis of A.-M. Logan and M.C. Plomp in Vienna 2004a, no. 7, pp. 145–7 and A.-M. Logan with M.C. Plomp in New York 2005, no. 9, pp. 80–2. The discovery of the copy of a related *Deposition* composition (fig. 51) confirms the early dating.

18 Various readings have been proposed for the first word of the inscription, now partly indistinct. The usual 'videtur', or 'videntur' ('it seems/they seem' or 'it is seen/they are seen') does not seem very apt. The word is, I think, 'Notetur' ('it should be noted'). Thus: 'Notetur ex Daniele Volterrano. Unus qui quasi tenens tamen relinquit. Item alius qui diligentissime descendit ut laturus opem.' (The translation of the last words in New York 2005, p. 80, is misleadling.) Rubens could have seen Daniele's altarpiece on his first visit to Rome (July 1601–April 1602). It has been claimed (G.M. Pilo in Pilo 1991, p. 106, n. 100) that Rubens's reference is to a lost painting by Daniele in Genoa, but the sense is perfectly consistent with the famous painting in Rome (in any case Rubens had not been to Genoa at this stage).

19 See below, under cat. 55, at n. 3. At present with Sotheby's, London.

20 See further below under cat. 55.

21 This motif recurs in the *Deposition* by Cigoli (Palazzo Pitti, Florence) a painting which has been suggested as an inspiration for Rubens's Hermitage drawing (see notably Jaffé 1977, pp. 51–2 and fig. 145). But this involves supposing that Rubens saw Cigoli's painting in preparation (it was delivered only in 1607) while passing through Florence in 1603, and even that date seems too late for the drawing.

22 Jaffé 1989, nos 189 A–E, p. 183.

23 This motif was probably suggested to Rubens by Battista Franco's print of

The Entombment (see below, under cat. 55, and A.W.F.M. Meij in Rotterdam 2001, p. 78, under no. 8). For Rubens's variations on the theme of the Deposition see Judson 2000.

24 For Rubens's admiration of Daniele see *Théorie* 1773, p. 26; also below under cat. 29.

25 The J. Paul Getty Museum, Los Angeles. See Logan and Plomp in Vienna 2004a, no. 6, pp. 142–4, with earlier literature.

26 See Jaffé 1977, p. 57, for the reference to Caravaggio.

27 British Museum, London. The figures at the lower left seem to have been cut out of another, more literal, copy of Leonardo. See esp. Wood 2002, no. 5, pp. 40–1, though there the dating of the drawing (about 1600) is in my view much too early. Also below, under cat. 32.

28 The first part of the inscription is difficult to decipher and has been rendered very differently: from '… sara Moderna far si che colui' (Müller Hofstede in Cologne 1977, 1, no. 28, p. 194) to '… sara medesima…' (Wood 2002, pp. 40–1). Alternatives are '…sara mediana…' (Glück and Haberditzl 1928, no. 8, pp. 11, 29) and 'guarda mediana….' (Rowlands 1977, no. 22, p. 34).

29 The drawing was published in Jaffé 1970; cf. Jaffé 1977, pp. 70–1, pl. 227; also Andrews 1985, I, no. D.4936, pp. 69–70; II, fig. 465; see also McGrath 1997, I, fig. 224; II, p. 326 and n. 34.

30 The character of the script, which resembles Rubens's writing on his *Dance of Death* copies more than any later example of his hand, features the accented 'u' (to distinguish it from the letter 'n') which is typical of Northern humanist Latin, and was something Rubens abandoned in Italy. See Belkin 1989, p. 246 (esp. n. 8) and pl. 52b; also Wood 2005, under no. 10, p. 282.

31 Leonardo talks, for example of how 'The smoke which is mingled with the dust-laden air will, as it rises to a certain height, look like a dark cloud; and at the top the smoke will be more distinctly visible than the dust'. He further remarks that the smoke will assume a bluish tinge, and that the cloud will look lighter from the side from which light comes. See Richter 1939, nos 601, 602, pp. 348–50; cf. McGrath 1997, II, pp. 329–30, n. 34; Logan with Plomp in New York 2005, p. 85. The Edinburgh drawing was dated about 1605 in Jaffé 1977, pp. 70–1, which allows for the possibility of Rubens seeing Leonardo's *Trattato* when it was in the possession of Pompeo Leoni; the first date at which he might have done this was in Spain in 1603; in New York 2005 it is dated 1601–3. But the drawing, if indeed by Rubens, cannot be even this late.

32 Müller Hofstede in Cologne 1977, pp. 149, 198, 201 (under no. 30), attributing it to a Rubens pupil; Held 1983, p. 23, judging that the inscriptions are not in Rubens's hand.

33 See the comments under cat. 4.

34 See Held 1959 (1986), no. 20, p. 73; Logan and Plomp in Vienna 2004a, no. 6 (*verso*), pp. 142–3 and New York 2005, no. 6 (*verso*), pp. 78–80, with earlier literature. Commentators often fail to translate or ignore the implications of the word 'vel'. As for the rest of the inscription, 'insequens' is the usual reading for the last word, but the end of the word is missing and 'insequentem' fits the sense better. Medea after all is not chasing anyone, whereas if Jason were to be included it would be natural to think he is trying to stop her. Müller Hofstede, presumably puzzled by the idea of Medea pursuing, rather than running away from Jason, imagined the word 'insequens' to mean 'chasing with words', i.e. reproaching (Cologne 1977, under no. 25, p. 183). But surely *insequi* has its primary meaning of 'to follow, chase after'.

35 Van der Meulen 1994, I, pp. 85–6; II, pp. 156–7, no. 137; III, fig. 266; also Meij in Rotterdam 2001, no. 5, pp. 70–2. Several ancient sarcophagi show variations on the composition. That in Ancona, which was in Rubens's time in the Belvedere, seems the closest to Rubens's drawing in terms of the curls of the serpent and the presence of the dangling legs of the baby in the chariot. But in Rubens's copy Medea is turning round more. This attitude corresponds rather to a Medea sarcophagus now in the Terme Museum in Rome. Rubens would also have been familiar with another sarcophagus in Mantua.

36 Bartsch 1854–90, XV, no. 98, p. 138; Rome 1983, I, no. 186, p. 113.

37 The bearded man next to Creusa is her father who, while trying to save her, also dies of burns; the younger man with a spear could be interpreted as Jason, but he is presented as separate from the episode.

38 Huemer 1996, p. 67.

39 A preliminary drawing by Lucas Vorsterman was prepared. For this see Sérullaz 1978, no. 167, p. 151, repr. In the event Rubens did not have the subject engraved. It may, however, be that the praise accorded his painting in Marino's *Galeria*, published in 1615, prompted Rubens to think of reproducing this early work. For the poetic compliments to the composition see Golahny 1990, pp. 19–37. See further below, under cat. 17.

40 See letter to Pieter van Veen, 23 January 1619: *Correspondance de Rubens*, II, pp. 199–200. Magurn 1955, pp. 36–7. The term *favola* (Latin: *fabula*; French/English: *fable*) is regularly employed at the period for a mythological subject. Rubens used the word for mythological scenes on ancient sarcophagi in a surviving fragment of his travel notes in Italy, the *Itinerarium*, for which see Van de Meulen 1994, I, pp. 154–5.

41 See above, at n. 29. Also below, cat. 16.

42 Michael Jaffé in fact suggested that the sheet, which is folded in the middle, might have been a page tipped into the pocketbook as a loose sheet, possibly the stray folio from the lost book that the collector Mariette once claimed to possess (Jaffé 1970, pp. 49–50: Mariette's mark is on the sheet); cf. New York 2005, p. 85.

43 For the painting, which survives from the temporary pageantry, and is now in Dresden, see Martin 1972, no. 3 and fig. 7, pp. 49–55.

44 See, for example, Golahny 1990, p. 22.

45 Homer, *Iliad*, XVIII, 35–51; *Odyssey*, XXIV, 45–9.

46 The painting of *Venus and Adonis* now in a private collection in Rome (Jaffé 1989, no. 25, p. 150, dating it to 1602; Genoa 2004, no. 67, pp. 33, 302–5) seems to me to be either drastically repainted or a copy of the original.

47 Bion, *Epitaphium Adonidis* 14.

48 See esp. A.-M. Logan in Wellesley-Cleveland 1993–4, no. 41, pp. 183–3. The echo of Cicero's text 'ut filiorum extremum spiritum ore excipere liceret' was already noted in Evers 1943, p. 135, where, however, the inscription on the drawing was read as 'spiritum morientis exceptura'.

49 A French copy of Rubens's Latin *Itinerarium* describes the Adonis sarcophagus now in Rome, Casino Rospigliosi, characterising the final episode represented as 'Luy expirant & rendant l'ame quasi dans la bouche de Venus qui s'approche pour la recevoir'. Cf. Van de Meulen 1994, I, pp. 84 and 155 for the text; for the sarcophagus see I, text ill. 37.

The Catalogue

1. Early Ambitions as a Battle Painter

Fig. 29 **The Battle of the Anghiari**, about 1615–16
Black chalk with pen and brown ink, 45.3 × 63.6 cm
Musée du Louvre, Paris (20271)

In his early career Rubens evolved an artistic language that was enriched – indeed to a large extent derived – from borrowings and adaptations. He drew particularly heavily on the vocabulary of Antique and Renaissance art to enhance and inform his youthful repertoire of ideas.

The process began while he was still an apprentice in Antwerp, when he copied engravings as an aid to constructing compositions, a well established technique to help young artists (cat. 6). Rubens also copied from three-dimensional sources – bronze statuettes and plaster casts – exploring poses by drawing them from different angles. He seems to have enjoyed animating them in his imagination, so that he was not merely copying but making studies that were in part his own inventions. Before long he could visualise figures from any angle.

Rubens was ambitious. Even before he left for Italy he took up the challenge of the equestrian battle scene, inspired by Italian examples and in particular Leonardo da Vinci, who had been fascinated with the theme of heroic violence between men and horses. Rubens drew particularly on Leonardo's motif of the biting horse from his celebrated wall painting in Florence of the *Battle of the Anghiari* (see cats 1–2). He must have known this composition from engravings or copies even before he left Antwerp for he seems to have begun copying it right at the outset of his career (fig. 29).

The biting horse motif features in his early Amazon paintings, one (cat. 1) made in Antwerp and the other (cat. 4) probably just after his arrival in Italy. At this stage, although such borrowings

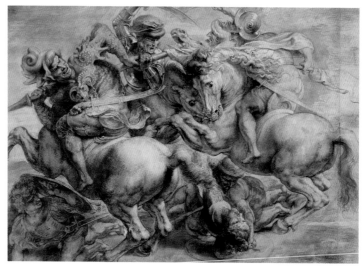

Fig. 29

would have revealed his application and study it is clear that he did not really have the skill to paint demanding multifigure groups like these. Figures and horses twist, overlap and intertwine – but not altogether convincingly.

Rubens began his activity as a battle painter not with warring Leonardesque men, but with a struggle to the death between men and women. The notion of such a combat, and one which further involved the association of women and horses, evidently appealed greatly to the youthful artist, and not simply as a theme of eroticised violence. He was clearly intrigued by the idea of the bravery of women, epitomised in the fierce but romantic Amazons.

Nevertheless, the stockpile of images he built up at this early stage of his career was to prove invaluable. The biting horse returns in 1616–7 in the *Death of Decius Mus* (fig. 28), this time incorporated with confidence in a complex composition, and then again a decade later in *Henri IV at the Battle of Ivry* (Uffizi, Florence), which is a masterpiece of figures and horses in action. By the time he painted the *Decius Mus* it is hard to believe that the biting horse, just to the left of the rearing white stallion, was not Rubens's own invention.

Spotting and tracking the recurrence of sources in Rubens's art is thus not just an art-historical exercise, for it provides a fascinating insight into his creative development. What began as typical Northern workshop practice for an artist in training achieved a new function and meaning during his eight years in Italy. The sources that he experienced firsthand were to be the lifelong ingredients of Rubens's art.

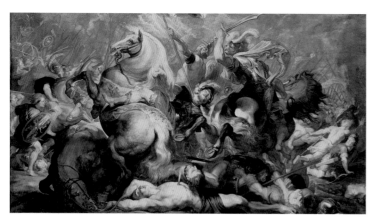

Fig. 28 **The Death of Decius Mus**, 1616–17
Oil on canvas, 289 × 518 cm
Sammlungen des Fürsten von und
zu Liechtenstein, Vaduz, Wien (GE51)

1 (detail)

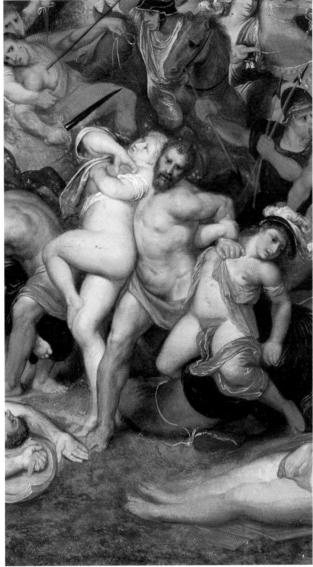

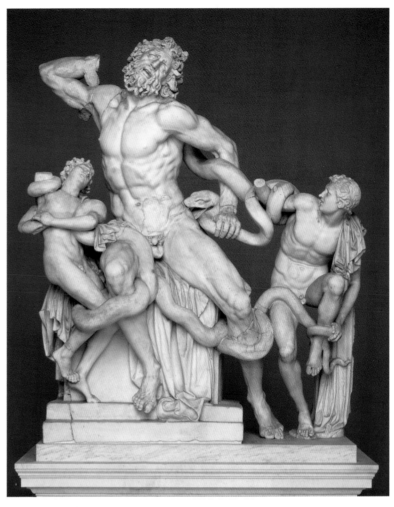

Fig. 30 Roman, first century AD?
Laocoön and his Sons
Marble, height 242 cm
Museo Pio-Clementino
Vatican Museums, Vatican City (1059)

1 (detail)

1. With Jan Brueghel the Elder (1568–1625) **The Battle of the Amazons** about 1598

Oil on panel, 97 × 124 cm
Schloss Sanssouci Bildergalerie,
Stiftung Preußische Schlösser und Gärten
Berlin-Brandenburg, Potsdam (GK 10021)

This painting, though made under the stylistic influence of Otto van Veen, is clearly by Rubens, and seems to be mentioned in a 1682 Antwerp inventory as 'By Peter Paul Rubens, a piece on panel, the defeat of the Amazons full of action in his early manner; the landscape or background is entirely by "Velvet" [Jan] Breughel'.[1] The background was indeed painted by Rubens's friend Jan Breughel, whom we know to have worked with Rubens on other occasions.[2]

The theme of the Battle of the Amazons was not a popular subject of Renaissance painting, though it had been a topic of ancient art. There the struggle between Greeks and the mythical tribe of warrior women who lived, apart from men (who were needed only for purposes of procreation) at the edge of the civilised world (in Thrace or Northern Asia Minor), seems somehow to have personified the combined attraction and repulsion of 'otherness', what the Greeks liked to call barbarism. Rubens may have known, through copies, some ancient sculptural reliefs of the subject,[3] but his principal iconographic inspiration for this early painting was probably literary. Most directly relevant to it would

seem to be the stories involving doomed romances between Greeks and Amazons: that of Hercules with Hippolyta, who was possessed of a girdle which the hero was required to wrest from her (eventually by killing her on the battlefield), and that of Theseus with her daughter Antiope, carried off to Athens but slain in the combat that ensued when her Amazon companions tried to bring her back. Still, there is no very specific reference in the painting to either of these myths,[4] although Hercules appears to be present, confounding (albeit with struggling women) the proverbial expression, popularised by Erasmus: 'Ne Hercules quidem contra duos' ('Even Hercules can't take on two men

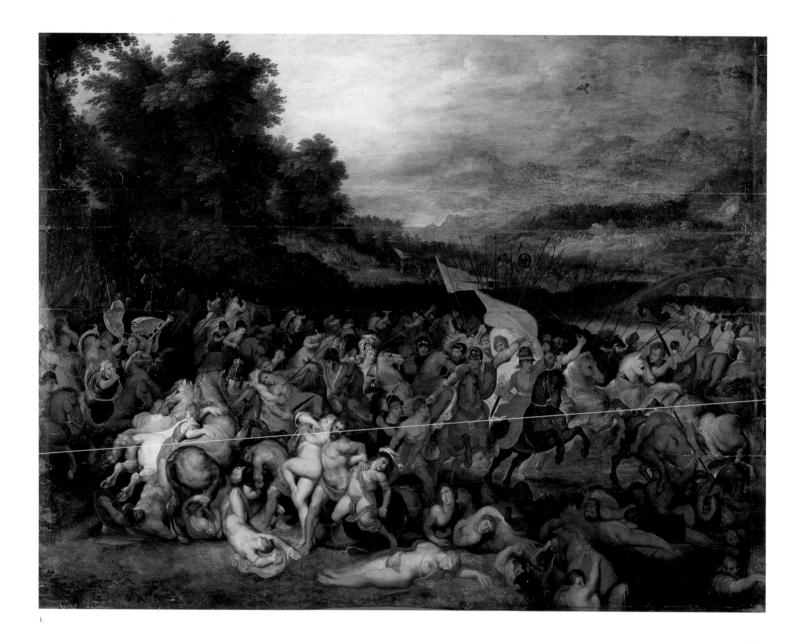

1

at once').[5] But perhaps still more important for Rubens's conception of the painting is Virgil's celebrated passage about the Amazons in Book XI of the *Aeneid* (648–63), in which he describes the entry into battle of the chaste virago Camilla, an enemy of Aeneas yet obviously a favourite character for Virgil. We know that Rubens treasured the poetry of the *Aeneid* and found its imagery a particular inspiration for early battlescenes (his pocket-book was full of Virgilian quotations, often set beside motifs of combat),[6] and the comparison of Camilla to the Amazons must have been specially prized.

Virgil describes how Camilla 'rode armed with her quiver, exulting like an Amazon, through the midst of the slaughter, having one breast exposed for freedom in the fight'. She and her companion maidens 'were like Amazons of Thrace who, warring in their brilliant accoutrements, make Thermodon's stream echo to the hoof-beats as they ride, be it with Hippolyta, or else when martial Penthesilea drives back in her chariot from war, and her soldier-women, shrieking wild battle cries, exult as they wave their crescent shields'.[7] The painting seems to make reference to the river Thermodon, the water bridged in the background, and the crescents, represented on a banner, probably allude to the final phrase 'lunatis... peltis', a reference to lunar crescent shields, but taken as lances with crescents by some early commentators.[8] Rubens must have thought of these as emblems of Diana, goddess of hunting and chastity.

In the foreground Hercules wrestles two Amazons in a pose which recalls that of the high priest Laocoön in the Vatican statue (fig. 30).[9] On Hercules' right a look-a-like, perhaps Theseus, bear-hugs another woman. The foreground is strewn with bodies. The fashionable plumed hat worn by one of the Amazons is so bizarre that one can reasonably wonder if Rubens introduced it as a joke. He used contemporary Antwerp costume later in the 1636 National Gallery *Rape of the Sabines* – perhaps the point was that nothing ever changes.

Fig. 31 Workshop of Raphael (1568-1625)
The Battle of Constantine, 1520-4
Fresco
Stanza di Constantino, Vatican Museums, Vatican City

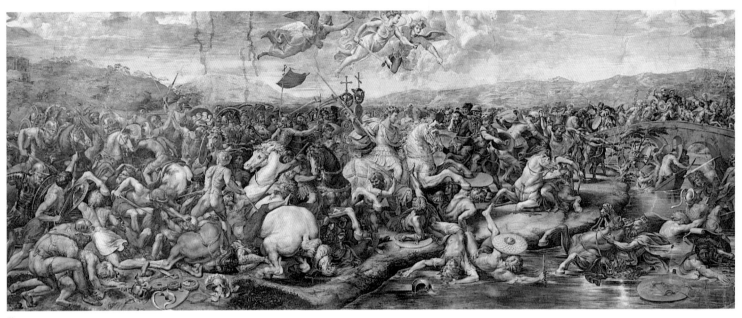

Fig. 31

Certain figures and animals are distinguished by an impressively bold use of colour: the crimson mane and tail of the white horse (detail, p. 40) and the touches of blue in the flesh of the fighters. Such startling colorific effects were characteristic of mid-sixteenth-century Mannerist painters. The handling of paint is confident: the face of the woman on the ground to Hercules' left, who looks up with an intense pleading stare, is done in careful, smooth strokes which, especially in the white, triangular highlights that cross iris and pupil, could be a reaction to Titian's Magdalens. The gilded helmets and mask-like faces of soldiers in the army behind the foreground fighters are painted broadly in a few quick strokes. Although it is not absolutely clear where Rubens's painting ends and where that of Jan Breughel begins, but the verve of these abbreviations suggests that they are Rubens's work. Beyond the advancing soldiers is a swirling cavalry engagement, and beyond that a bridge that crosses to a distant plain. Some of the painting in this area is more wooden and it is possible that another Otto van Veen pupil had a hand in it.

The two biting horses to the right are a version of those in Leonardo's *Battle of the Anghiari* (see fig. 29). Another canonical battle picture, the Raphael workshop *Battle of Constantine* (fig. 31), may have inspired the twisted pose of the slain figure in front of Hercules – it resembles the figure on the right of Raphael's fresco, which may also have been a source for the bridge, the combatants in the river, the decapitated head and the horns.[10]

There is copy of the painting in an Antwerp collection,[11] that shows what later over-painting covers in this work: Hercules' pubic hair and the private parts of slain women in the foreground. Rubens quickly adopted higher standards of modesty. EM/DJ

1 Held 1983, p. 22. Müller Hofstede had earlier attributed the work to Otto van Veen (Cologne 1977). This view is countered by Held, but is retained, for example, in Poeschel 2001.
2 Thus a 'Parnassus' executed jointly by Rubens, Jan Breughel and Otto van Veen is recorded in a seventeenth-century inventory. See Vlieghe 1998, p. 22. For later collaboration between Rubens and Jan Breughel see Ertz 1979, pp. 492-9.
3 See Bober and Rubinstein 1987, pp. 175-80. There is an Enea Vico print of a *Battle of the Amazons* after Perino del Vaga, made around 1540.
4 Poeschel supposes that Hippolyta is the woman brandishing the severed head as she is wearing a girdle (Poeschel 2001, p. 97) but if so she has not been noticed by Hercules.
5 Erasmus, *Adagia*, I.5.39.
6 For instance J.ms. fol.15r shows a slumped figure beside Virgil's description of the boxer Dares with a mouth full of gore (*Aeneid*, V). There is also a story of Duke Vincenzo coming across Rubens painting the *Death of Turnus* while reciting Virgil in Latin. See further McGrath in London 1981-2, p. 214.
7 Virgil (1964), *The Aeneid*, p. 299.
8 Because of a confusion between the words *pelta* and *palta*. The Greek *pelte* is used for a standard.
9 See Van der Meulen 1994, II, no. 76, for the *Laocoön* pose. Rubens recalled it again when he sketched out deeds of Hercules in the 1620s – see London 1977, no. 184. Garff and Pedersen 1988, II, pl. 246, records another composition of the whole battle.
10 To show severed heads was commonplace. They also occur on the drawing of Trajan's Column in the Albertina, which is sometimes given to Rubens (see Van der Meulen 1994, III, fig. 302), which may be a good attribution if it is dated to 1600.
11 See Essen-Vienna-Antwerp 1997-8, no. 68, p. 238-42.

ESSENTIAL BIBLIOGRAPHY
Cologne 1977, no. 24, pp. 181-2; Held 1983; Vienna 2004a, no. 11, pp. 158-60

2

2. The Battle of the Amazons 1600–2

Pen and brown ink, 25.1 × 42.8 cm
The British Museum, London
(P&D 1895.9.15.1045)

This drawing is usually dated to 1602–4, although it may be slightly earlier, and its combination of vigour and robust forms makes it one of Rubens's most impressive early drawings. The composition is built on a centre of energy that the horses circle around in a balanced rotation of poses, plunging towards and away from the viewer. The strong plastic quality suggests a three-dimensional model, or at least that Rubens pictured it as a sculpture. There is much play between female curves and equine rumps, but in this case it is the horses that dominate. The ultimate inspiration must have been Leonardo's mural of the *Battle of the Anghiari* (see fig. 29), to which Rubens returned throughout his career. His copies have come to be regarded as the most authoritative record we have of Leonardo's lost painting – although the horses in these may owe their vigour to Rubens's interpretation as well as to Leonardo's invention.[1]

There are some visible re-draftings in the drawing, for instance the left-hand horse with its clipped Roman mane has two snouts, and there is a faint black curve on the right-hand horse – perhaps an idea for his rider's crushed arm. The composition seems to have been lightly laid out in black chalk before being developed in brown pen. The deep hatching, a characteristic that appears to be a distinguishing feature of some early Rubens drawings, may be a legacy from copying engravings.[2] Some of the extremely ambitious twisted and foreshortened poses (the slumped man under the left-hand bucking horse or the kneeling man reaching up to the horse in the centre and the woman arched back from the hooves beside him) anticipate Rubens's style of 1603–6. The understanding of other elements, such as the breasts of the Amazon severing a man's head, is still rudimentary. Rubens had already copied tumbling horses from engravings such as Antonio Tempesta's and seems to have enjoyed drawing them. In fact, in some ways his equine anatomy is more confident than his human anatomy, but both

are pushed to the limit conveying the energy of the conflict. The rubbery noses of the horses (they are almost like softened duck beaks) also occur in the top left of the Rubens drawing after Raphael workshop *Battle of Constantine* (fig. 31) in the Louvre.

1 See Boccardo in Genoa 2004, pp. 5–11. Zöllner 1991, no. 36, p. 222, argues that Rubens is retouching a sixteenth-century drawn copy in the Louvre drawing.
2 There is similar hatching in the St Petersburg *Descent* drawing (cat. 55), and the Brunswick study for *The Mocking of Christ* (Held 1959 (1986). no. 13, fig. 12; Jaffé 1977, fig. 181). The kneeling figure grasping the rump of the bucking central horse in the *Amazons* drawing is rotated to become Christ's tormentor in the Brunswick drawing. A drawing showing a *Rape of the Sabines* in the Louvre (inv. no. 20303), first published by Evers and supported by Logan, includes a very similar foreshortened lunging figure – without a shield. Its *verso* shows *John the Baptist* preaching.

ESSENTIAL BIBLIOGRAPHY
London 1977, no. 21, p. 33; Cologne 1977, no. 24, pp. 181–2; Held 1959 (1986), no. 9; Vienna 2004a, no. 11, pp. 158–60; New York 2005, no. 12, pp. 88–90

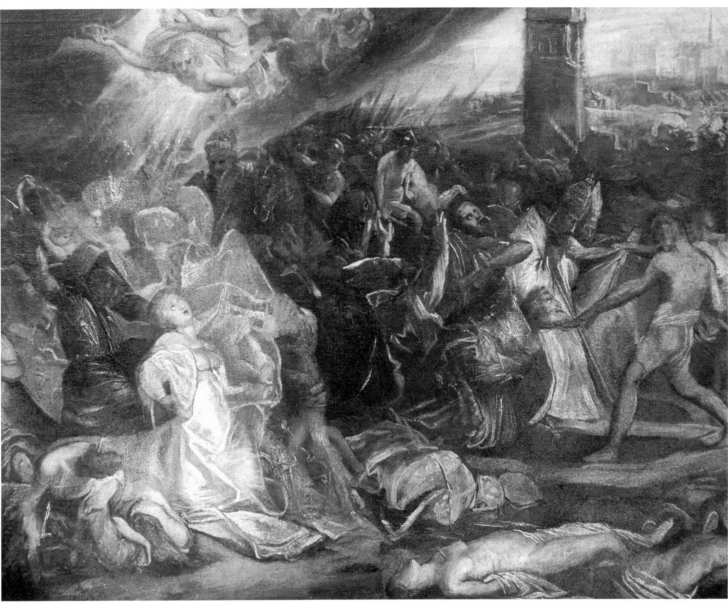

3 (detail)

3. The Martyrdom of Saint Ursula about 1602

Oil on canvas, 79 × 115 cm
Museo di Palazzo Ducale, Mantua (142)

Ursula, the daughter of an English (or
Breton) king, was distinguished for her
virtue, wisdom and beauty. Accounts of her
life became popular despite a marked lack of
information. Her story, as told in Voragine's
Golden Legend, draws on many apocryphal
sources popular in northern Europe.[1]
Betrothed unwillingly to a pagan prince,
she managed to put off the marriage for three
years to remain a virgin. She spent this time
sailing with 11,000 other virgins until winds

drove them into the mouth of the Rhine,
where they encountered the barbarous Huns.
Their leader offered to marry Ursula, but she
refused to renounce her faith. She, her
companions and the pope were martyred
outside Cologne.

This painting was apparently commissioned
for the Ursuline convent in Mantua, established
in 1603 for the education of young women –
probably by Margherita Gonzaga, widow of
Ercole II d'Este and sister of Duke Vincenzo,
who retired there. Rubens returned to the
subject, possibly for the same foundation, in a
sketch for another painting, now in Brussels.

In 1615–16 Ludovico Carracci won that
commission (this work is now only known
from a drawing at Windsor); the convent was
suppressed in 1786.

This severely abraded painting of smudges
and fog only reveals its secrets when the
gossamer of damaged paint is patiently
unteased. On the far left a woman, whose
foot projects out, twists back. It is hard to
make out whether she is grasped by the
executioner or is having her hair pulled from
behind.[2] Below her two women lunge and
collapse into our space. On the left a kneeling
woman is seen in severe foreshortening

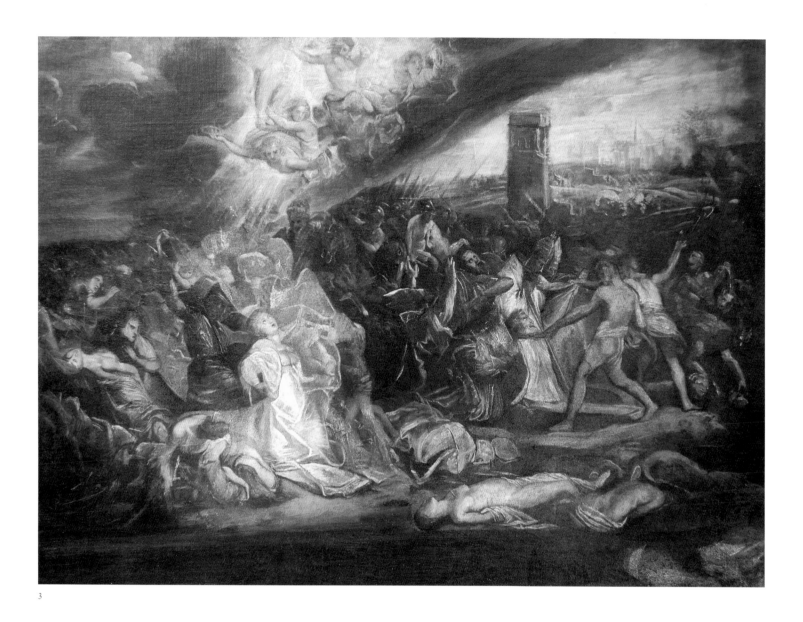

3

turning to the right to see Saint Ursula; her pose recalls the angel on the right of Rubens's *Martyrdom of Saint Sebastian* (Corsini Gallery, Rome). Above, angels sent by a Zeus-like god try to intervene, while the saint herself appears in a cascade of divinely illuminated veils (although this effect is in fact due to the re-emergence of the ruff of the portrait of a woman below the present composition).[3]

Ursula is attacked by a turbaned ruler on a rearing horse, presumably the Hun leader. Below the horses' hoofs a bishop kneels with his arms stretched out in the orant (both arms raised) gesture of prayer – his mitre and cope

are picked out in a few flashy strokes of white. In front of him a swordsman grasps the cope of the pope, while his companion pulls a bishop's beard. Both executioners are surprisingly stick-figure like, recalling the tormentor in the Grasse *Tormenting of Christ* (fig. 3). There are some beautiful rose touches in the landscape, which recall the background of the 1602–3 *Self Portrait with Friends* (fig. 1).[4]

The female martyrs in the foreground seem to be a direct migration from the *Battle of the Amazons* (cat. 1), where their nudity makes more narrative sense.

1 Voragine (1993), II, pp. 256–60.
2 Hair pulling is introduced in the Raphael workshop *Battle of Ostia*, 1515.
3 An X-ray of this portrait is reproduced in Padua-Rome-Milan, no. 4, pp. 250–1. There identified as Margherita Gonzaga.
4 See Cologne 1977, I, no. 82.

ESSENTIAL BIBLIOGRAPHY
Vlieghe 1973, no. 158, pp. 171–2; Cologne 1977, I, no. 17a, pp. 167–8; Padua-Rome-Milan 1990, no. 4, pp. 250–1

Fig. 32 Willem Panneels after Peter Paul Rubens
The Rape of the Sabines 1628–30
Black chalk, pen and brown ink, 21 × 26.9 cm
Statens Museum vor Kunst, Copenhagen (KKSGB 7270)

Fig. 32

4 (detail)

4. The Battle of the Amazons about 1603–5

Oil on canvas, 89 × 135.5 cm
Private collection

This recently discovered and previously unpublished painting is composed in patches of light and dark. There is an enchanting passage of yellows and pinks just above the injured horse on the bottom left – the animal's twin spurts of blood recall the Raphael workshop *Battle of Constantine* (fig. 31). The palette gives the scene a dreamy quality – despite the gruesome severed heads and impaled bodies. We can almost hear the screams from the open mouths and the noise of the trumpet blasts as horses and riders are impaled on the descending phalanx of lances.

Below this, in the centre of the painting, there is an Amazon who has been slain by a lance. Her now almost invisible grey horse has curved its head down towards Hercules. Among the most beautifully preserved

passages are the rearing horse on the far right with its lightly dappled rump and leopardskin saddle cloth, and the trail of soldiers that snake behind – almost consumed by the dust they raise (the dust cloud becomes sunlit to a brighter white in the *Duke of Lerma*, see detail of fig. 5, p. 50). Rubens painted a battle scene at full stretch, and the consummate skill of the execution suggests a date of around 1603–5. The pair of horses galloping towards us on the right are vestiges of the earlier Potsdam version (cat. 1). A warrior with a pose similar to that of Michelangelo's *Night* in the Medici Chapel, Florence, slumps beside the dying Amazons in the foreground.

The fulcrum of the composition is a massive, bucking, pink-tailed horse that ducks under the biting teeth of a rearing black stallion. The black stallion has been abraded but his front legs are just visible on the back of the horse attacking him. A naked Amazon,

perhaps unhorsed, clings to its rump. The inspiration for the pink-tailed animal may again be the *Battle of Constantine*, where a similar (if reversed) oversized horse dominates the foreground (fig. 31).[1] However, Adam Elsheimer (1578–1610) also used the motif in his *Conversion of Saint Paul*, which Rubens knew, so the debt may be indirect.[2]

To the right two dismounted Amazons writhe in Hercules' grip, shedding their clothes in the struggle. The *cantoor* (or studio copies, the majority by Rubens's pupil Willem Panneels) records two further moments in Rubens's juggling of this acrobatic pose (fig. 32). Another woman, slightly to the right of Hercules, is being bear-hugged, bent over. She, seemingly self-consciously, assumes a pose from Michelangelo's *Lapiths and Centaurs* (see cat. 31; a figure just to the right of the centre in Rubens's small *Last Judgement*, Alte Pinokothek, Munich, explores the same

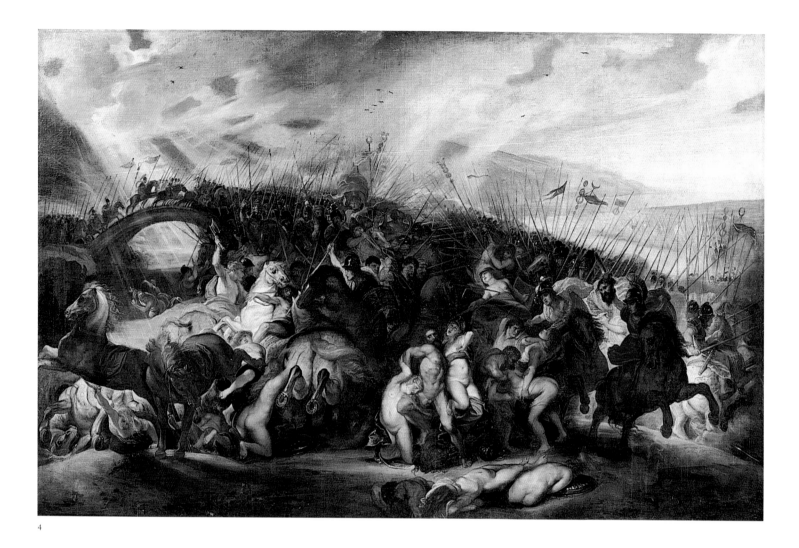

4

invention). The complexity of this group is
heightened by the dying companion who
grasps her waist. Other spent Amazons are
strewn on the ground below.

Rubens has now dispensed with the
feathered hats that were an early example of his
taste for giving Greek myths a contemporary
flavour and – perhaps – significance (see cat. 1).[3]
However, the central Amazon's dress sense,
apart from her cast-off helmet, will still do
little for the Italian fashion industry. Some
of the women are equipped with Roman
'Amazon' shields. These follow the conven-
tions set by female warriors on Roman
sarcophagi and are also described by Virgil.[4]

Rubens has used colour, for instance the
blue banner behind the Amazon on the right
who raises a severed head, as well as light,
to provide accents. There are passages which
do not immediately connect with his other
work, like the two figures under the bridge,

although it is possible that this pair is echoed
in the background figures in the *Massacre of the
Innocents* (cat. 82). Brueghel's *Battle of Issus*
(Louvre, Paris) of 1602, which quotes
Leonardo's biting horses and twisting archers
(possibly via Rubens) shows that historical
battlescenes were a current Antwerp genre.

Rubens continued to paint battles
throughout his career. The basic structure of
the compositions and the constituent groups
always builds on foundations laid in these
early Amazon paintings. It is hard to point to
definite influences, apart from Leonardo, but
Rubens's disputed drawing after Christoph
Schwartz's *Death of Sennacherib* (cat. 87), as
well as Brueghel's coloured copy, suggest
that it, or the copy, had a canonical status in
Antwerp.[5] Certainly the splayed naked
woman reaching for her helmet on the left-
hand side of Schwartz's painting seems to be
echoed in Rubens's *Amazon* pictures, as does

the unhorsed woman grasping a bridle.
Other battlescenes provided more general
influences. Giambologna's *Rape of the Sabines*
(1581–2, Loggia dei Lanzi, Florence), which
inspired the woman being lifted by Hercules,
fed Rubens's general taste for images of
male/female struggle and is an example of
his willingness to use sculpture as a source.

1 See Jaffé 1977, figs 52 and 159.
2 See Jaffé 1977, fig. 159.
3 See McGrath's interpretation of the National
 Gallery *Rape of the Sabines* as a humorous
 commentary on Ovidian and modern dating.
 McGrath 1997, II, no. 40, pp. 185–91.
4 Virgil, *Aeneid*, I, 490: 'Amazons with crested
 shields'.
5 On Schwartz see Jaffé 1977, fig. 234. Also Evers
 1943, pp. 259–60. It has been proposed that a
 copy of the Schwartz was in the Borgia
 Collection; see Velletri and Naples 2001, pp. 77–8.

Fig. 5 (detail during restoration)

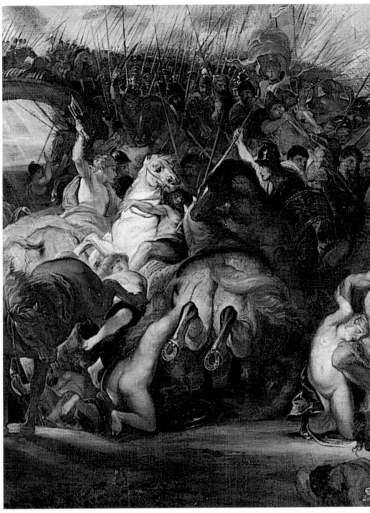

4 (detail)

5. Attributed to Rubens **The Battle of the Amazons** (*verso* of *The Drowning of Leander*, cat. 16) 1597, or after 1602

Pen and brown ink, 20.4 × 30.6 cm
The National Gallery of Scotland,
Edinburgh (D4936 *verso*)

In this drawing the commotion of the battle-scene on the left-hand side is captured in two colliding diagonals. The links in these chains of equine energy are the riders and unhorsed fighters, which are refined into an X-shaped composition.[1] On the left shadows *contre-jour* are established with fast hatching on the horses and figures, while most of the right of the sheet is dedicated to smaller trial figures. Rubens's search for new ideas and variations is exemplified by the Hercules in the bottom-right corner, which has morphed into Samson – or possibly Hercules and his pillars – while the pose recalls both the *Farnese Atlas* and the *Laocoön*.[2] There is a sense of watching ideas migrating from one subject to another.

The notes on the drawing discuss lighting, which was a major concern to Rubens in his early compositions.[3] The varying effects of light shining through dust mirror Leonardo's notes on battles so closely that it is generally agreed that Rubens must have seen parts of Leonardo's notebooks (his *Libro della pittura*), which the the Italian sculptor Pompeo Leoni (1533–1608) had in Spain during Rubens's 1603 visit.[4]

The relationship between this drawing and the newly discovered version of the *Battle of the Amazons* (cat. 4) is intriguing. It is possible (see p. 33) that this sheet precedes the painting, revising an earlier version of the subject in preparation for it. If this sequence is valid, the sketchy appearance and some shaky lines can be explained as steps towards the solution.[5] Indeed, the figure of Samson on the right suggests that the sheet may have begun

as an auxiliary drawing for a *Battle of the Amazons* composition before becoming a repository of more general ideas. While drawing and painting are clearly connected, however, it is feasible that the sequence might be reversed: that this sheet was made as a *ricordo* of a part of the painting rather than in preparation for it.

In addition, if the complex composition of the *Battle of the Amazons* drawing in the British Museum (cat. 2) is compared to this sheet, it becomes more difficult to accept the present work as by Rubens. The fine hatching of the drawing in the British Museum not only reminds us of the many prints Rubens copied as a young artist, but it is also accurately used to convey shadows and depth. The draughtsman here has a different hatching style, and the hatching in the foreground does not help us to understand

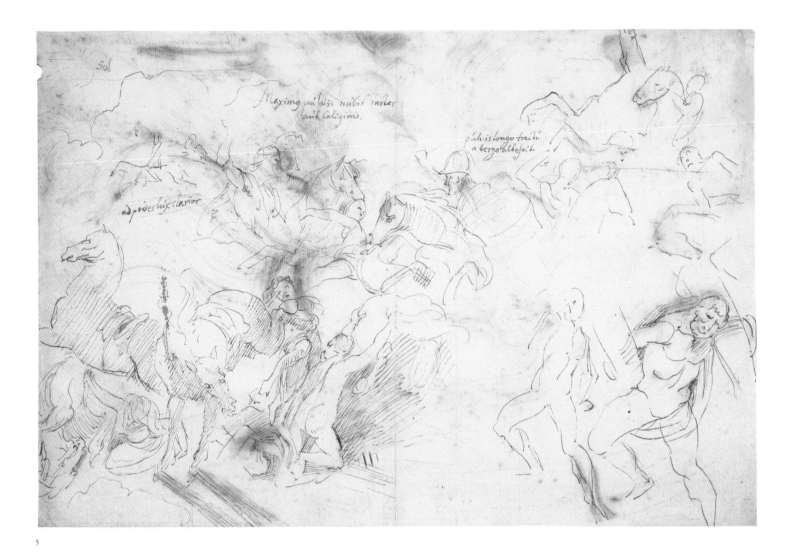

5

the movement of the horse, but rather eliminates the kicking hoofs of the animal.

It is impossible to state definitively whether this is a Rubens original or a copy of one. It is the work of a capable, though perhaps young, draughtsman, possibly the young Rubens himself. The inscriptions allude to Rubens's knowledge of Leonardo, and the fact that they are in Latin suggests that Rubens might have made them.[6] If, however, the drawing was made after Rubens's first trip to Spain in 1602 (where he would have first seen Leonardo's notebooks) it is hard to accept that the child-like handwriting belongs to a twenty-five-year-old artist. And since the drawing and the inscriptions were made by the same pen and ink, this would mean taking the drawing away from Rubens altogether.

Another possibility is that this is a copy of a Rubens original.[7] Given the incongruencies

in the style and inscriptions in the sheet, and the fact that very few original Rubens inventions that date from before 1600 are known, the issue becomes very complex. The linear figurative shorthand in the drawing has parallels with the dust swirling around the troops between the legs of the horse in the *Duke of Lerma* (see detail of fig. 5, opposite).[8] These figures also resemble those in cat. 4. VK

1 Certain figures vary between the painting and the drawing, such as the woman under the horse on the extreme left, and the man clinging to the rear of the horse in the centre, who is replaced by a kneeling woman. A similar figure to the latter is found in a drawing in the Louvre, published in Evers 1943, fig. 264, as the *Daughters of Leucippus*, and Logan 1977, fig. 3, p. 429.

2 The Johnson pocketbook (see fig. 14) is relevant for the drawing of the *Farnese Atlas*.

3 See for example the Liechtenstein *Conversion of Saint Paul* (cat. 67).

4 New York 2005, p. 85; Sparti 2003, pp. 143–88, shows that a readable version of Leonardo's notebook was in Milan in the 1620s, and perhaps earlier, but we have no proof that Rubens saw this version. Rubens's desire to show groups in strongly lit relief developed early during his Italian journey, or even before. See Healy 1997.

5 Comparable handwriting by Rubens is only found on his early copies after Holbein's *Dance of the Death*, which have generally been dated several years before Rubens left Antwerp for Italy. See Elizabeth McGrath's essay pp. 29–37 and there, n. 30. Jeremy Wood has suggested (in private correspondence) that the handwriting could be by a writer trying to copy an inscription meticulously, with a very careful and tidy hand.

6 For a good account of Rubens's inscription see the introduction of Held 1959 (1986), pp. 38–41.

7 Müller Hofstede in Cologne 1977, no. 8, pp. 147–9, argues that the sheet is a copy by a pupil of Rubens.

8 First suggested in McGrath 1997, II, no. 58, p. 326.

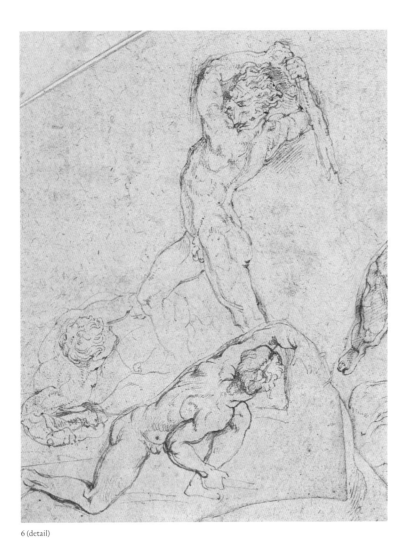

6 (detail) Fig. 34 (detail)

6. After engravings by Barthel Beham **Battle of nude men** about 1599–1600

Pen and brown ink over black chalk,
14.1 × 25.2 cm
National Gallery of Art, Washington, DC
Julius S. Held Collection, Ailsa Mellon Bruce
Fund (1984.3.57)

There was a strong demand for printed images among artists of the late Renaissance; copying engravings was recommended as an exercise for aspiring assistants. Rubens's decision later to engrave his own images (in 1609–11) reflects an awareness of this.

In the present drawing, Rubens selected figures – swivelling, lunging and in difficult foreshortenings – from two engraved friezes (figs 33–4) of fighters by the German Renaissance artist Barthel Beham (1502–1540).[1] Rubens long had a taste for German imagery and what one sees here may be the remains of a childhood interest dating back to his early years in Cologne. It could be, however, that at

this date he found German interpretations of Italian inventions easier to absorb than the source material. The Hermitage *Susanna* (cat. 20) may also be inspired by a Beham engraving, and the slumped Venus in the pocketbook seems rather close.[2]

The poses chosen suggest that he was already collecting recruits to staff his battle-scenes, and these figures would become important additions to his large repertoire of fighting men. These included Mantegna's famous engraving of the *Battle of the Sea Gods* (of about 1480) and the ill-fated battlescenes Leonardo and Michelangelo began painting on the walls of the Palazzo Vecchio in Florence in about 1503 (see fig. 29). Rubens was clearly keen to try his hand at battle painting at an early stage – and he recorded images of bellicose characters throughout his career. The chunky forms of the figures have encouraged scholars to date this sheet to 1599–1600,

when Rubens's avid study of engravings was increasing his figurative vocabulary.

The most interesting aspect of the relationship between source and drawing is the subjects Rubens selected. Victims are drawn with protagonists unrelated to them in the print as Rubens settles on poses that interest him; figures are even stuck on from other sheets. He picks out the most foreshortened and violently swivelling figures (see detail), selecting poses that would not be found in his own paintings until around 1601–2. What he chose to copy gives us an early insight into Rubens's vision of what he wanted his paintings to achieve.

1 Hollstein 1954–, II, p. 191.
2 Hollstein 1954–, II, p. 203.

ESSENTIAL BIBLIOGRAPHY
Held 1959 (1986), no. 3, pp. 64–5

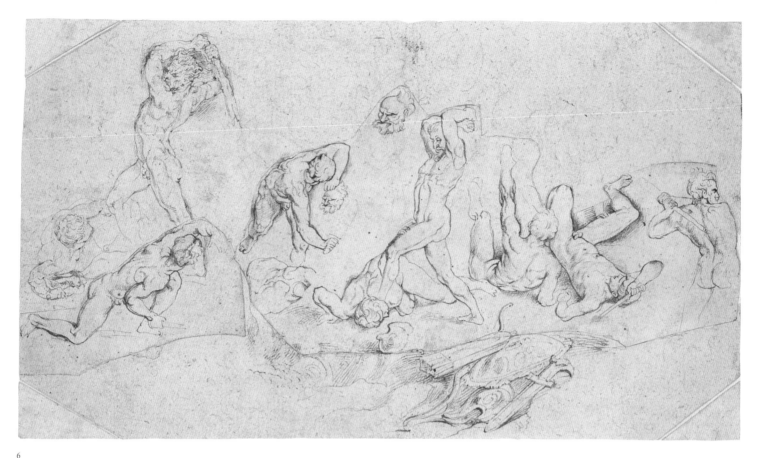

6

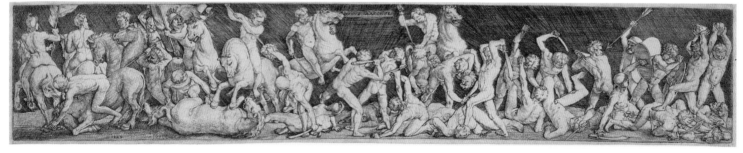

Fig. 33

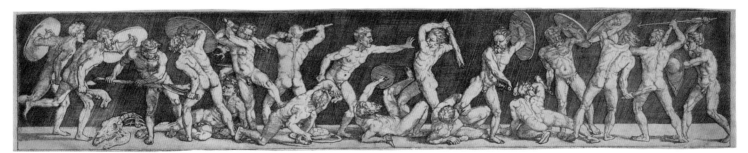

Fig. 34

Fig. 33 Barthel Beham (1502–1540)
Battle of Titus Gracchus, about 1528
Engraving, 5.5 × 29.5 cm
The British Museum, London (P&D 1874.8.8.172)

Fig. 34 Barthel Beham (1502–1540)
Battle of eighteen nude men, about 1528
Engraving, 5.6 × 29.5 cm
The British Museum, London (P&D 1874.8.8.171)

Fig. 35

Fig. 35 **Emperor Sevius Sulpicius Galba**, before 1600
Oil on panel, 67 × 52.5 cm
Private collection

7. Study of a Distressed Man 1602–3

Pen and brown wash, 32 × 19.7 cm
The British Museum, London (P&D 00.9.24)

This drawing may be a first idea for the
weeping Heraclitus (cat. 18) in the painting
Rubens made in Valladolid for the Duke of
Lerma. If so, he completely changed his mind
about how to represent the philosopher,
who weeps at the state of the world as his
companion Democritus laughs at it.

At the end of the seventeenth century it
would have been called a *tête d'expression*; the
term rightly characterises its use of the face

as a stage on which emotion is dramatised.
Rubens has focused on the exaggerated arch
of the eyebrows, the lopsided mouth and the
furrows in the forehead – distortions which
give the face a peculiar surface quality also
found in his early drawings after the antique.
Similar distortions can be seen in other early
drawings such as the man descending the
ladder in the St Petersburg *Deposition* (cat. 55).
The strong crosshatching is a little more
rhythmical than in Rubens's first Italian
drawings; a 1602–3 date is possible.

As in the *Last Supper* drawings (fig. 24),

the challenge was theatrical – he was building
a cast of characters. By the time his work-
shop was established in Antwerp Rubens
had assembled a repertoire of oil-sketches of
character heads that were to become essential
elements in his picture making. Rubens had
already begun exploring 'stock' emotions in
his heads of emperors, for example in the
drooling mouth of his Emperor Galba
(fig. 35), before he left Antwerp.

ESSENTIAL BIBLIOGRAPHY
London 1977, no. 15, pp. 28–9

Rubens

7

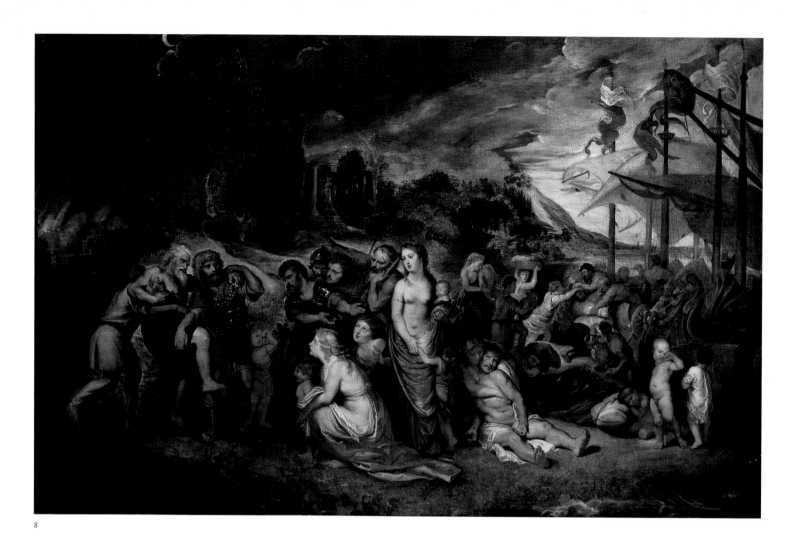

8

8. **Aeneas preparing to lead the Trojans into Exile** about 1602–4

Oil on canvas, 146 × 227 cm
Musée Nationale du Château de
Fontainebleau, on deposit from the
Musée du Louvre, Paris (2007)

In his *Aeneid*, Virgil describes how after the sack of Troy by the Greeks, Aeneas, the Trojan warrior second only to Hector, finally persuaded his aged father Anchises to flee the burning city. He told his family and servants to meet at the mound of the Temple of Ceres, next to an old cypress tree (which Rubens has included here in the background).[1] Rubens shows Aeneas lowering Anchises, whom he has been carrying, to the ground; he grasps the household gods in his right arm. Two women looking for guidance kneel before Aeneas; their expressions recall the pleading faces in the *Amazons* (cat. 1) and illustrate Rubens's growing, although still uneven, ability as a painter of expression.

Rubens has only just begun to master the skills that will later allow him to show how bodies twist, lunge or fall. He introduces bold foreshortening in both the jug carrier and the slumped pietà-like figure at the centre of the picture, who takes up a pose very like that of the man under the kicking horse on the left of the British Museum *Amazons* drawing (cat. 2). Anchises' pose will be reversed in the *Daughters of Leucippus* (Alte Pinakothek, Munich) and in various *Rapes of the Sabines*.

Aeneas' little son Ascanius looks tired and footsore, but in general the figures stand like rows of skittles, without any of the swivelling and twisting found in later pictures. It may be that Rubens wanted to keep a connection with the planar arrangement of figures in antique reliefs while at the same time exploring the nuclear arrangement of the British Museum *Amazons*. The effect is to pull the focus of the narrative off-centre.

The two wind-blown figures approaching the Temple of Ceres in the distance are painted in a broadly impressionistic,

Tintorettoesque style, which suggests a date of around 1602; Rubens first saw Tintoretto's work in Venice in 1600.

Aeneas' wife did not make the rendezvous, and the distraught women Rubens shows at the setting-off point to the right never reached Rome. This threat to the Trojan line was eventually 'remedied' by the rape of the Sabines. Rubens may have considered this work, along with the *Death of Dido* (recorded only in drawings)[2] and cat. 12, as part of a unrealised cycle. Once oval, the picture was extended, probably in the seventeenth century, into a rectangle.

1 Virgil, *Aeneid*, II, 710. See McGrath in London
 1981–2, pp. 214–15 and 227–9, no. 244.
2 Brunswick, Maine 1985. Held 1959 (1986), no. 24,
 pp. 75–6, identified there as 'Death of Thisbe'.
 See also Brunswick 2004, no. 68.

ESSENTIAL BIBLIOGRAPHY
London 1981–2, pp. 214–15 and 227–9; Mantua 2002,
p. 222ff; Brunswick 2004, under no. 81, pp. 304–6

8 (detail)

9 (detail)

9 (detail)

9. The Judgement of Paris about 1597-9

Oil on oak, 133.9 × 174.5 cm
The National Gallery, London (NG 6379)

Paris was the son of Priam, King of Troy, but
at his birth it was prophesied that he would
bring ruin to the city and he was left in a forest
to die. He was rescued and raised by shepherds
and, as a man, was asked to decide who was the
most beautiful of three goddesses: Venus, Juno
and Minerva. Venus promised him the love of
the most beautiful woman in the world, Helen,
Queen of Sparta, if he chose her.[1] He did, and
his choice led to the Trojan War. Paris' dog, in
the foreground, refers to his role as a shepherd,
while his Hercules-like cloak reminds us that,
though abandoned, he was a prince of Troy.
Aeneas wears a similar cloak in cat. 8.

The subject appeared in many variations
in Renaissance art. In Rubens's painting Paris
has had the goddesses undress (as usual)
so that he can better judge their attractions,
and is swinging around to award the prize,
the golden apple, to Venus. She wears a pearl
necklace and earring, and has a red rose in her
hair. Venus' son Cupid points to her *mons
veneris* and pulls her already revealing drapery
still further back (see detail). A putto is already
rewarding her by delivering a wreath of red
and white roses – Venus' flowers and thus,
perhaps, an indication that the competition
was a foregone conclusion. Venus has, of
course, already bribed Paris. The putto and
his companions, who lean out from a bank of
clouds anchored to a tree, hold palms for

victory; a matrimonial ribbon flutters around
Venus' doves. In Rubens's courtly world
flirtation went with marriage.

The river god and his companion, on the
right, emphasise the still-embryonic state
of Rubens's style – even the nymph's breast
seems uncertainly placed. Ancient river gods
did not normally have female companions,
but Rubens clearly thought such support was
needed.[2] The goddesses assume standard
Mannerist poses: Juno is identified by her
crown and a regal gold cloak, embroidered
with green (she wears it again in the *Council
of the Gods*, cat. 12). Her hands are painted
in a difficult foreshortening, a pose that
has been read as anger.[3] Minerva stands with
her back towards us, her armour at her feet.

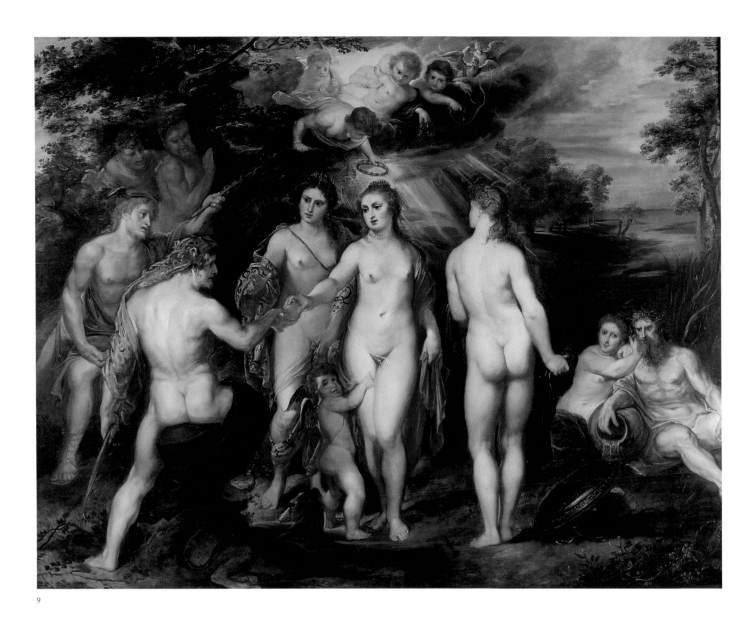

9

Her pose has been connected with a Rosso print of *Juno*.[4]

There has been much discussion as to whether the work was painted in Antwerp or Italy. Evidence for Italy includes the heavy use of Italianate sources, but these, like the engraving of Raphael's *Judgement of Paris*, were readily available in Antwerp through copies and prints. Healy has noted that this is the only time Rubens chooses to show the awarding of the prize in the beauty contest, rather than the competition, and draws attention to the fact that Rubens has emphasised Juno's anger at the result. The lighting has been reckoned to have something of Tintoretto about it, but Brueghel and others, including Elsheimer, had codified

this kind of dramatic spotlighting in small transportable paintings on copper. The fact that it is executed on Baltic oak does not exclude Italy, but such material was more readily available in Flanders. Rubens's 1602 panels (now in Grasse Cathedral) for the St Helena chapel in Santa Croce in Gerusalemme, Rome, were painted on a walnut support.

The picture shows a predilection for tightly muscular physiques, notably in Paris and Mercury, but the figures are still static, as is their grouping. Such schemes were already found in the art of Floris and Goltzius. Healy has compared the figures to analytical drawings of antique statues, like those of the *Farnese Hercules* (cats 27–8) in Rubens's pocketbook, which may have been made

before he went to Italy. They do seem to have a similar geometric basis, down to the 'cubic' buttocks. It seems most likely the painting was made in Antwerp.[5]

1 The most elaborate account can be found in Lucian's *Dialogi Deorum* (XX).
2 Burckhardt (1950), p. 102: 'every water-god must have his mate beside him.'
3 Healy 1997, p. 149.
4 Jaffé 1977, figs 204 and 208.
5 The large rubbery hands resemble those in the *Portrait of a Man* (Metropolitan Museum of Art), which is dated to 1597.

ESSENTIAL BIBLIOGRAPHY
Jaffé 1977, pp. 63–4; Martin 1986, pp. 213–15; Healy 1997, pp. 49–60

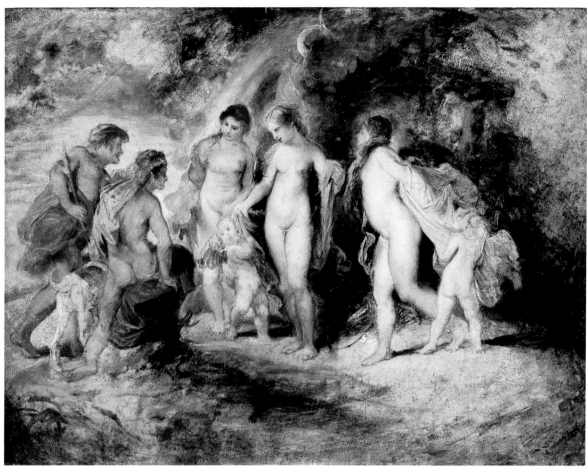

10

10. The Judgement of Paris about 1601

Oil on copper, 34 × 45 cm
Gemäldegalerie der Akadamie der bildenden
Künste, Vienna (644)

This painting is somewhat abraded and its
slightly granulated orange-peel surface
suggests a rough life. The decision to paint
on copper, and so on a small scale, is a little
surprising as Rubens inclined towards larger
projects. However, both Flemish artists and
the Carracci used the support, and it is not
hard to imagine Rubens's German friend and
inspiration Elsheimer playing some role in the
choice; he usually worked on copper which
normally gives a smooth, reflective surface.
Curiously, Nicolas-Claude Fabri de Peiresc
(1580–1637) – Rubens's French antiquarian
friend living in Aix, who was not otherwise
especially interested in painting – collected

recipes for painting on copper from Elsheimer;
presumably they came via Rubens.

Rubens has developed the painting into
a procession of Cupids, forever moving
around their goddesses. The putto on the
left is taken from a famous ancient statue,
the *Boy with a Goose*. Around 1628, one of his
assistants, perhaps Willem Panneels, copied a
drawing by Rubens showing three views of
this statue. Rubens's original drawing may
well have been made in Italy.[1] The putto's
pose also appears in the *Gonzaga Family adoring
the Trinity* (1605, Ducal Palace, Mantua) to the
left of God and Jesus.

The rainbow, an attribute of Juno, seems
to be here more for visual effect than icono-
graphic clarity. It is an early example of
Rubens's pursuit of spectacular natural
phenomena – the lightning in *Hero and Leander*

(cat. 17) is another – culminating in the
Rainbow Landscape (about 1636–7, Wallace
Collection, London). The Cologne *Juno
and Argus* of 1611 also has a rainbow (to
accompany Iris) as does *Marie de'Medici's
Union with Henri IV* of 1622 (Louvre, Paris).

Optics and prisms were a current topic
in scientific circles. Rubens in fact wrote a
treatise (now lost) on optics, and illustrated
a book for his Jesuit friend Aquilonius on
the topic. He is credited with being the first
painter to show the colours of the rainbow
in the correct order.[2]

1 Garff and Pedersen 1988, II, fig. 112.
2 Jaffé 1971, pp. 365.

ESSENTIAL BIBLIOGRAPHY
Jaffé 1977; Garff and Pedersen 1988, fig. 99, pp. 63–4;
Healy 1997, pp. 63–70; Vienna 2004, no. 6, pp. 48–9

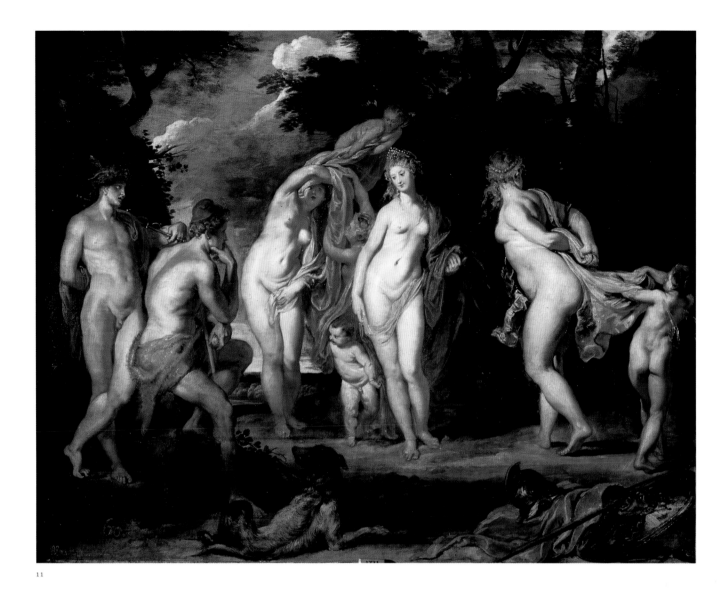

11

11. The Judgement of Paris 1606–8

Oil on panel, 91 × 114 cm
Museo Nacional del Prado, Madrid (P1731)

The painting is a Mannerist reworking of the
Vienna copper (cat. 10). All the figures have
increased torsion – the twisting Cupid on the
right disrobing Minerva is a rotation of the
Cupid in Bronzino's *Allegory with Venus and
Cupid* (The National Gallery, London) – only
his bow is missing.[1] There is a rotundity to the
forms, but also an elegance to the poses. The
drapery is quickly painted with many small,
angled strokes, and the hair is painted broadly,
more softly than is usual for Rubens, in an
almost buttery way.

The angels in the Vienna *Circumcision* (cat.
46) have a swivelling athleticism similar to
that of Cupid here. By contrast, the goddesses
are smoothly bulky, rather like the figures in

Hero and Leander (cat. 17). Paris and Mercury
both hold generic antique poses.[2]

The back of Minerva's Cupid is beautifully
articulated. Rubens gave much thought to the
depiction of putti and young children and
connected Horace's phrase 'self-contained in
their smooth rotundity' with children.[3]

The effect of a coat of unattractive yellow
varnish must be discounted before one can fully
appreciate this picture's considerable merits.
The painterly execution of Medusa's head on
Minerva's discarded shield at the bottom right
is startlingly fresh. Its sophistication recalls
oil-sketches like the *Raising of the Cross* (fig. 50),
where the eyebrows of the standing man
pushing the cross up on the left are sculpted in a
similar way, yet the elongated Mannerist figures
and their sophisticated counterbalancing – a
ballet of disrobing – makes a dating of 1606–8

seem possible.[4] Minerva's scruffy owl is entirely
typical of Rubens's splashy way with plumage.

1 See Primaticcio's *Venus and Cupid* in Paris 2004–5,
 no. 257, pp. 461–2. See also cat. 24 and p. 2 for the
 Cupid on the far right.
2 See Padrón 1996, II, pp. 1024–5, for a proposition
 for Mercury's pose. Mantegna's house in Mantua
 had a replica of this antique Mercury on its façade,
 and there were full-scale Renaissance bronze casts.
 Paris' pose resembles a Hercules in the pocket-
 book (J.ms. fol.44).
3 See Van der Meulen 1994, II, no. 5, p. 251.
4 An engraving of *Diana and Actaeon* of 1593 by
 Jacob de Bray has figures exhibiting a similar
 delight in undressing.

ESSENTIAL BIBLIOGRAPHY
Díaz Padrón 1995, II, pp. 1024–5; Healy 1997,
pp. 73–9; Sylvie Deswarte-Rosa in Winner 1998
pp. 389–410, esp. fig. 20, p. 407

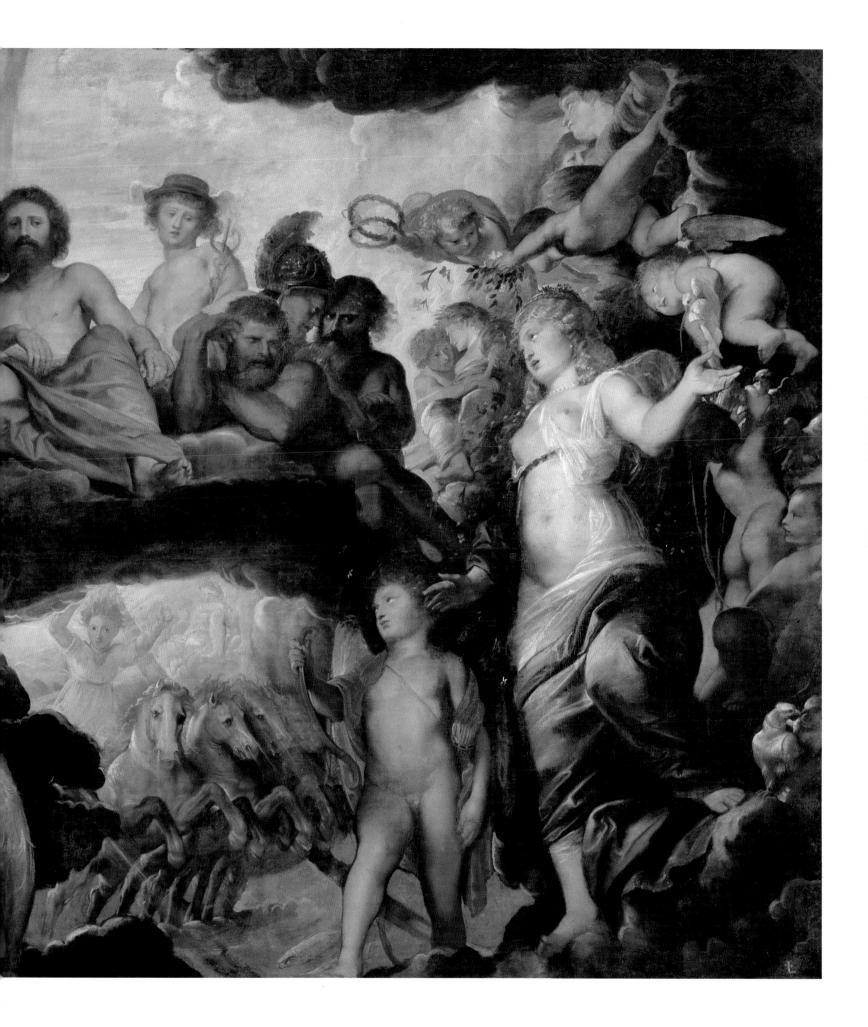

12 (detail)

12. The Council of the Gods 1601–2

Oil on canvas, 204.5 × 379 cm
Prague Castle Art Collections,
Czech Republic (HS 111)

The suggestion by Elizabeth McGrath that this picture depicts Juno and Venus pleading with Zeus over the fate of Aeneas (an episode from Book X of Virgil's *Aeneid*) has been generally adopted and expanded.[1] Heinen has identified the woman in blue as Styx, the only female among the river gods, who presided over the river of the Underworld. The iconographic tradition is limited, but Rubens's figure is an unexpectedly beautiful personification of the river of death. The low viewpoint, and the hanging feet of unseen Olympians which are a consequence of it, is unusual. Mantua was famous for two dramatic 'perspective rooms', one by Mantegna, the other by Giulio Romano. As Rubens worked there he must have known them well: a simple desire to compete with them in his own way may explain this feature. Another proposal is that this is a design for a stage curtain or backdrop.

Rubens has adopted daring colorific devices, such as the red shadows on Juno's green and gold embroidered gown (worn again in the National Gallery *Judgement of Paris*, cat. 9) and the pink sky – a dawn that it is hard not to read as the promise of a golden future for Rome, which Aeneas will found. The city of Mantua is alluded to more

specifically by the swan cradled by a river god in the foreground: Virgil, the city's most famous son, was called the Mantuan Swan. Given the imagery of judgement, the wall of a council hall cannot be excluded as the painting's intended destination – it is possible that it was designed to replace one of the frescoes in the main conference hall of the Palazzo Ducale in Mantua, and that the *Death of Dido* (recorded only in drawings), and *Aeneas preparing to lead the Trojans into Exile* (cat. 8),

were part of a decorative scheme which included this picture.

Venus' scanty drapery shows that Rubens has already become a sensuous painter, but his tremendous gusto is not quite enough to carry the picture. Its scale seems to have tested his developing powers of composition. It is one of his most ambitious early works – perhaps dating from 1601-2. The boldly foreshortened Apollo, with his prophetic hand on the Sphinx, recalls Correggio's view of the *Entombment of Christ*

(Museo Diocesano, Mantua), a work that would later inform Rubens's Borghese *Entombment*.

1 London 1981-2, pp. 214-5; Heinen in Brunswick 2004, no. 81, p. 304.

ESSENTIAL BIBLIOGRAPHY
London 1981-2, pp. 214-5; Ost in Heinen and Thielemann 2001, pp. 110-35; Brunswick 2004, no. 81, pp. 304-6

13 (detail)

13. **The Last Judgement** about 1600

Black and red chalk on paper, 47 × 72 cm
The State Hermitage Museum,
St Petersburg (OP 5235)

This large and important early sheet is similar
to the red-and-black chalk drawings Rubens
made around the same time of the Sibyls from
the Sistine Chapel (now Musée du Louvre,
Paris).[1] The laboured hatching of the group

has caused some scholars to doubt their
authenticity, and it is possible that they are
copies. However, in his graphic work Rubens
used a wide range of styles and one can, in
their defence, point to their early date, to
Rubens's deep admiration for Michelangelo
and to the characteristic fading-out of
the accompanying figures. Drawing with
two colours of chalk was popular in Italy,

and Rubens maintained a taste for the
medium throughout his career.

Weaknesses arise from his early predilec-
tion for caricature – or, as he may have seen
it, from his desire to get all he can out of
facial expressions; here the challenge was
to demonstrate personality. These devils,
which are taken from the bottom right
corner of Michelangelo's *Last Judgement*,

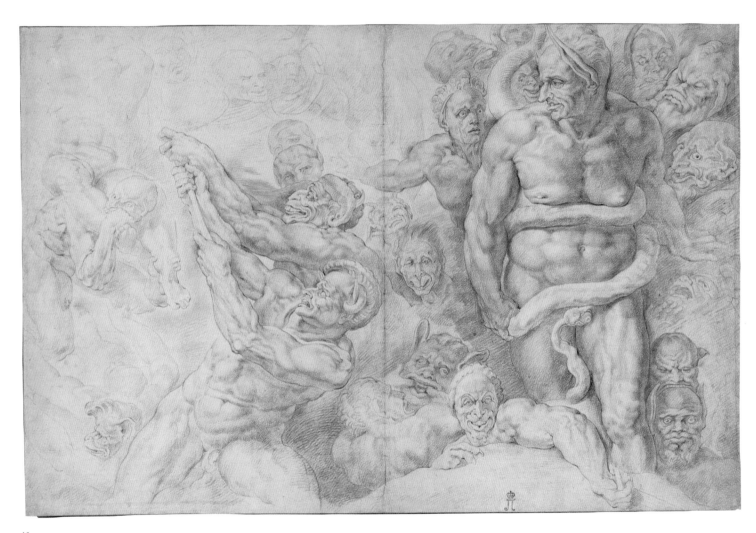

13

offered a whole range of extreme expressions. The fact that the drawing shows the section most visible from the ground, and one that would have suited Rubens's taste, is perhaps circumstantial evidence for his authorship of the drawing.

Links to other works are noticeable: the wide-eyed look of the centre-right devil is similar to that on Dawn's face in the *Council of the Gods* (cat. 12). The emphatic eyebrows appear in the *Laocoön* drawings (cats 23–6), although they are lacking in the original sculpture; the entwined serpent also reappears there.[2] The devilish figures who pull away on a rope represent the beginnings of the great, twisting, heavily muscled nude figures that became Rubens's mainstay (see cat. 52).

Although Rubens does quote from Michelangelo in his early years, it was not until his return to Antwerp that he properly absorbed the lessons he learnt from the Renaissance giant.

1 See New York 2005, no. 4, pp. 69–71.
2 See Van der Meulen 1994, III, fig. 163.

ESSENTIAL BIBLIOGRAPHY
Jaffé 1977, pp. 19–20

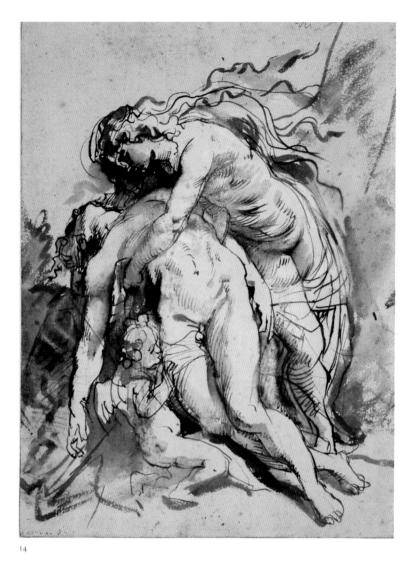

14

15

14, 15. Venus and Adonis

14. **Venus cradling the dying Adonis**, 1603–5
Pen and brush and brown ink, 21.7 × 15.3 cm
The British Museum, London
(P&D 1895.9.15.1064)

15. **Venus lamenting Adonis**, about 1606–7
Pen and brown ink, 30.6 × 19.8 cm
National Gallery of Art, Washington, DC
Ailsa Mellon Bruce Fund 1968 (1968.20.1)

These drawings depict the result of the fate-
ful encounter between the beautiful youth
Adonis and the goddess Venus. Ovid describes
in his *Metamorphoses* how the dying groans
of Adonis, fatally wounded by a wild boar
while out hunting, drew his lover Venus back
to earth. She bends over his lifeless body
and vows that her grief will endure forever.

The composition for which these drawings
were intended, often thought to have been
intended as a pendant to *Hercules and Omphale*
(fig. 36),[1] can be traced back to an antique
statue (*Menelaus and the dying Patroclus*, Palazzo
Pitti, Florence).[2] Giulio Romano also seems to
have been fascinated by the poses, which he
probably found in a bas relief in Mantua and
included in a fresco in the Palazzo Ducale, the
palace of Rubens's employer, Duke Vincenzo
Gonzaga. In Spain (1603–4), Rubens must have
seen the potential of the back-bending figures,
popularised by Giambologna's *Samson and a
Philistine* (now in the Victoria and Albert Mus-
eum, London, but from 1601 in the Duke of
Lerma's collection in Valladolid). They were
explored by Lodovico Cigoli (1599–1613), and
others.[3] Venus' pose is taken from Tintoretto's

Deliverance of Arsinoe (then in Mantua, now
Gemäldegalerie, Dresden).

Rubens loved complicated poses, and his
portrayal of Venus' lament over her dead lover
is no exception. Even a goddess could hardly
have held Adonis' dead weight in the pose that
we see in the British Museum sheet. Perhaps
this is why, in the later drawing in Washington,
Rubens inserts something to prop him up and
rearranges Venus' arm so that she leans on it.
Rubens often tried out spare arms and legs, as
he does here for Adonis. With only a few
touches of the pen he delineates the line of
muscle in Adonis' stomach as he leans into a
backbend. This is a drawing in which we can
see Rubens thinking and rethinking.

These two sheets show how Rubens
develops the relationship between the griev-

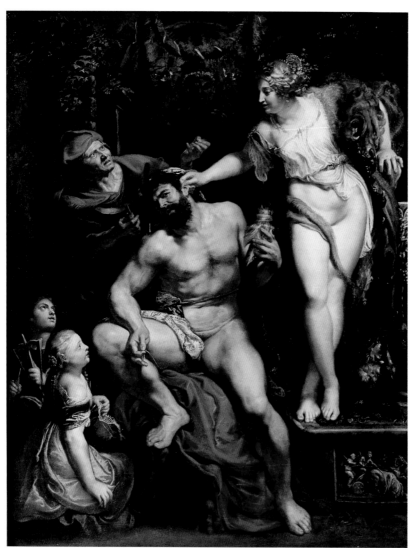

Fig. 36 **Hercules and Omphale**, about 1606
Oil on canvas, 278 × 216 cm
Musée du Louvre, Paris (854)

Fig. 36

ing Venus and dying Adonis by altering the relationship of one head to the other – he used similar means to finetune Caravaggio's *Entombment* (see cat. 57). The wonderfully fluid pen drawing and evocative use of wash in cat. 14 is typical of his energy and inventiveness.

In the Washington sheet Rubens retained the pose of Adonis, perhaps by tracing, but rethought the rest of the composition – in particular the distance between the heads. It is as though, in the reworked figures in the top right corner, Venus does what the Latin inscription indicates: catches the dying man's breath in a kiss (see p. 35). The Washington sheet, despite being an auxiliary compositional drawing, feels much more fluid than the primary study. It is a step towards reconstructing the final painting, which is now

effectively lost because of its poor physical state. The angels Rubens introduces in cat. 15 are retained in the final painting, where they become forest nymphs pulling their hair and exposing their breasts, as specified by Ovid (*Metamorphoses*, X, 720–3).

Strong hatching, liquid pen drawing and animating wash make the British Museum drawing more sensual, while the later Washington sheet reveals more about Rubens's ideas for the development of the composition. The drawings represent a transition from the plunging horse and flying mane dramas of Rubens's battle paintings, to a more profound focus on emotion. This transition suggests a date of 1606–7. A date of 1606 for the *Hercules and Omphale* (fig. 36) seems possible, which would support this.

There is a third drawing of this composition in Antwerp in the Stedelijk Prentenkabinett.[4]

1 Jaffé 1977, fig. 215.
2 Jaffé 1977, p. 65; White 1987, p. 39, fig. 56, but see also Jaffé 1977, fig. 120, a Giulio Bonasone print after Perino del Vaga, in which this group is adapted to a shipwreck.
3 See Pope-Hennessy 1964, III, plates 483–4.
4 Jaffé 1977, fig. 213. This seems to be the first in the series.

ESSENTIAL BIBLIOGRAPHY
Evers 1943, pp. 121–36, fig. 37; Jaffé 1977, p. 65; Rowlands 1977, nos 60–1, p. 64; Held 1959 (1986), pp. 102–3; White 1987, p. 39, fig. 56; Mantua 1989, p. 230; Wellesley-Cleveland 1993–4, no. 41, pp. 183–4

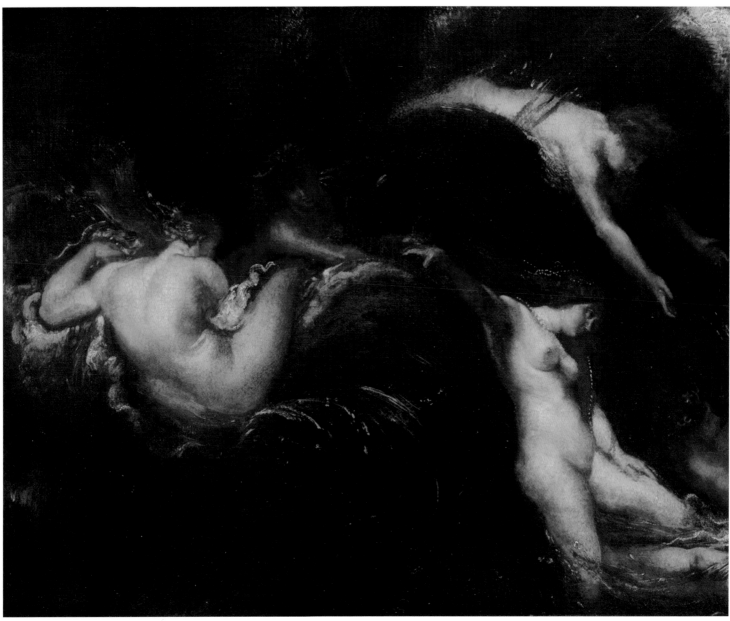

17 (detail)

16. Attributed to Rubens **The Drowning of Leander** (*recto* of the *Battle of the Amazons*, cat. 5) 1597, or after 1602

Pen and brown ink, 20.4 × 30.6 cm
The National Gallery of Scotland,
Edinburgh (D4936)

Hero and Leander were lovers separated by
convention (she was a priestess at Sestos)
and the straits of the Hellespont (now the
Bosphorus). Each night Leander would cross
the dangerous waters to his beloved, guided
by a torch she lit for him. One night a storm
blew the torch out and Leander drowned.
Upon seeing his body washed ashore, Hero
threw herself into the sea.

This drawing is clearly related to the
painting of *Hero and Leander*, made in about
1604–6 (cat. 17), but if it is an original (see
p. 34) it is much earlier, dating from Rubens's
years in Antwerp. At first glance it seems to
be a generic shipwreck; the woman clinging
to the spar on the left is a common motif
in such scenes. Only the central – possibly
male – figure, floating on his back, and the
fact that the others caught up in the wave
are all women, suggest that the subject may
be Hero and Leander. The Latin inscription
'Leander natans Cupidine praevio' ('Leander

swimming as Cupid leads the way', see p. 34),
along with the development of the composition
in the New Haven painting (cat. 17) seems to
indicate not an identification of an existing
subject, but more a potential one.

Rubens treats water as a plastic material; it
cradles the top central female in a hammock –
she recalls *Leda* (cat. 30); to her right another
swimmer scrambles to the lip of a wave. On
the upper right a woman cuts another crest
as she slumps forward, so that her thigh and
her leg trail into the spiral of water. This
meeting of wave and thigh almost reads

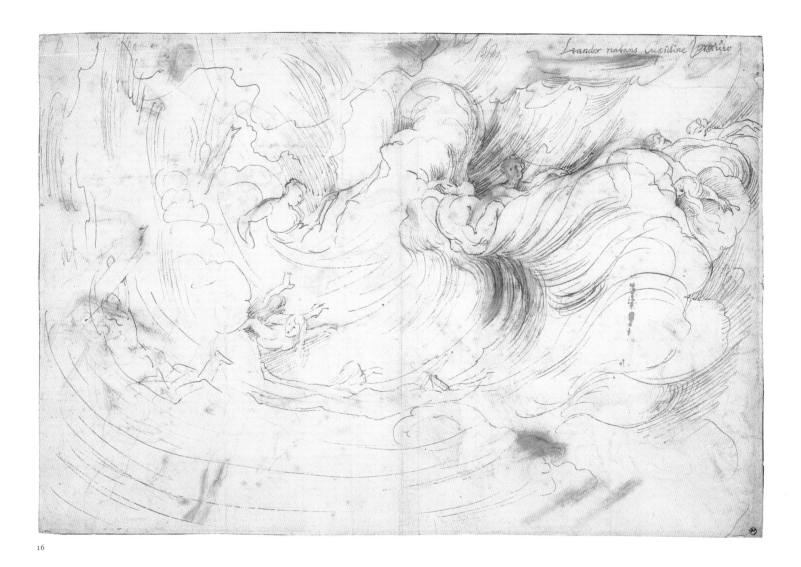

16

like a *pentimento* (a redrafting).[1]

Rubens emphasises the sculptural quality of the swirling water with strong hatching. It recalls similar shading in the British Museum *Amazons* drawing (cat. 2), which may have been made around the same time.

In the related painting (cat. 17), the water has lost its sculptural solidity (the emphasis is on the stormy light and the flash of lightning) but water still underpins the composition, supplying a support for the tumbling figures.

It has been supposed that Rubens would have been inspired by Leonardo's deluge drawings, but he is unlikely to have known them at this early date – although he would have seen them before making the later painting.

Even if the drawing is a faithful copy of a lost Rubens drawing it preserves an extraordinary invention. Its spirals of energy help us to reconstruct the missing modelling in the dark water of the *Hero and Leander*, which is now only visible in the durable lead white highlights.

1 The Greek poet Musaios mentions the 'straits of Abydos which still lament Leander's fate', lines 26–7, but otherwise the mourning nereids have no textual basis. See above p. 34.

ESSENTIAL BIBLIOGRAPHY
Jaffé 1977, fig. 229; London 1977, no. 11, pp. 26–7; Logan 1977, p. 422; New York 2005, no. 10, p. 83

65

17. Hero and Leander about 1604–6

Oil on canvas, 95.9 × 127.9 cm
Yale University Art Gallery, New Haven, CT
Gift of Susan Morse Hilles (1962.25)

The swirls, eddies, waves and storm clouds of *Hero and Leander* seem to translate the vortices of Leonardo's deluge drawings into paint. We are trapped in the eye of a storm that, by extinguishing his guiding beacon, drowns Leander and will cause his lover Hero to jump to her death – an event we see at the far right of the painting. Sea-nymphs, or nereids, struggle to sustain the already green and vomiting body, while distressed putti fly helplessly through lightning bolts and spray.[1]

In the story it is morning when Hero falls in despair from her tower, having seen the corpse of Leander washed up on the shore. Rubens imagined that Hero, alerted by lamentations that rose above the noise of sea and wind, has seen the nereid-borne corpse in the darkness of the night. The mourning nymphs have been eloquently described as 'garlanding Leander',[2] and the nereid procession from front to back seems to anticipate the wreaths of angels in the *Circumcision* (see cat. 46).

Dating the picture is difficult. The figures are on a gigantic scale – you feel that they need the support of the sea and would find life on land difficult. This kind of weighty flesh is apparent in *Aeneas preparing to lead the Trojans into Exile* (cat. 8) and on this basis a date of 1605–7 is possible, but the problem is compounded by cat. 16, where Rubens possibly explored a similar composition (with even more emphasis on the drama of the whirl of water), in about 1597. This would lead to the conclusion that Rubens started planning a *Hero and Leander*, or at least a shipwreck, and then put it aside for some years, or that he returned to a theme he had explored at least five years earlier.

The comparative absence of twisting motion in any of the figures, except the flying putti, suggests a date of about 1604–6.[3] If this painting was made as a companion piece to the less abraded Washington *Fall of Phaeton* (cat. 65), that would also support a date no later than this time.

The painting found immediate fame when it, with Rubens's lost *Judith and Holofernes* (now known only from Galle's print), were mentioned by the Italian poet Marino in a collection of sonnets about paintings.[4] Marino must have known the painting when he was

court poet to Rubens's patron Vincenzo Gonzaga from 1606–8. He read the event as a tragic consequence of 'impious' lust, but Rubens sees the story as pure tragedy, and perhaps, if it was a pendant to the *Fall of Phaeton* (cat. 65), wanted to portray the unfortunate consequences of misdirected, or misguided, love. Phaeton and Leander being stories of air and water, it is possible two other elemental myths were planned. Later, in 1619, Rubens referred to the painting as a *favola* – a mythical tale – that might be engraved, but the project never materialised.

1 See Goedde 1989. This is a relatively early attempt to paint lightning. The shafts of light are developed further in Rubens's *Transfiguration*, today in Nancy (fig. 6). See also the new *Amazons* painting, cat. 4.
2 Jaffé 1958, pp. 415–21.
3 Rubens experimented with foaming ocean again in the *Saint Walburga* predella (See Brunswick 2004, no. 39).
4 Marino 1620 (1979), pp. 209–11. See also Golahny 1990, pp. 20–37.

ESSENTIAL BIBLIOGRAPHY
Cologne 1977, no. 8, pp. 147–9; Belkin in Bauman and Liedtke 1992, pp. 172–4; Wheelock 2005, pp. 146–53

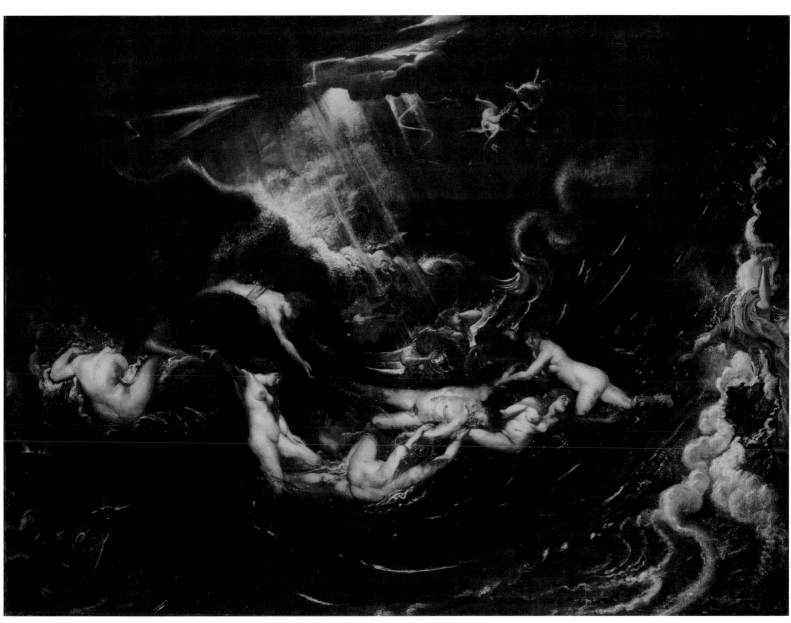

17

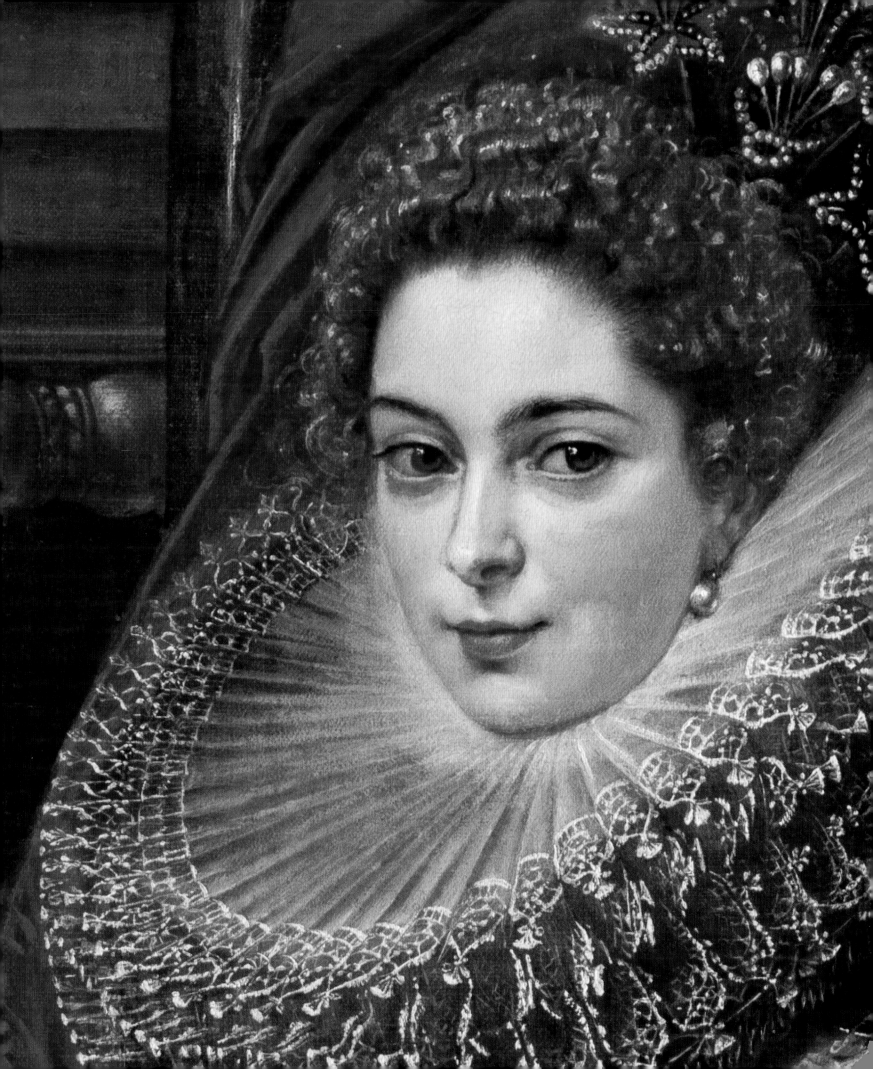

2. Rubens on the Move

Many Northern painters were overwhelmed by their encounter with Italian art, but Rubens responded with confidence, energy, and an insatiable appetite for more. Having left Antwerp in May 1600 he arrived in Venice about a month later and was introduced to the Duke of Mantua who happened to be looking for court painters. Rubens was employed, and returned with the duke to the small duchy of Mantua in north-east Italy, long established as an artistic centre. Given Rubens's ambitious nature it was fortunate that his employer was a busy man who left him relatively free.

Rubens spent much of his time travelling. In his first five years in Italy we know that he spent six months in Rome (July 1601–January 1602) and made numerous trips around northern Italy: to Florence (1600), Verona (1601), and probably to Parma, Treviso and Padua as well as Bologna. He was also sent on a diplomatic mission to Spain where he stayed ten months (March 1603–January 1604), during which time he painted *Democritus and Heraclitus* (cat. 18), as well as the first great masterpiece of his career, the magnificent equestrian portrait of the *Duke of Lerma* (fig. 5). What is astonishing – as this portrait demonstrates – is that by 1603, Rubens had skilfully absorbed the lessons he had learned from artists such as Tintoretto and Titian, about light and about how to apply paint to a canvas, with confidence and a lightness of touch.

On his return to Mantua Rubens passed through Genoa where he met the Marchese Pallavicini, a member of the Genoese aristocracy. His connections won him commissions and in 1606, he painted a series of portraits of the city's nobility, such as that of *Marchesa Brigida Spinola Doria* (cat. 22), who sat for him in the year following her marriage. Like Rubens's portrait of the Duke of Lerma, *Brigida Spinola Doria* is a *tour de force*. The beautiful face of this twenty-two-year-old, which is painted in a much more highly finished manner than her costume, is dazzling. Rubens uses dry paint to create the stiffness of her lace ruff and the glittering hair pieces which hover above her head. He paints her with reddish hair and amber eyes. The seams of her dress are decorated with brooches featuring a table-cut central diamond flanked by two hog-backed stones. The lower facets are tinted black to improve their sparkle.

Perhaps the culmination of the new painterly style which Rubens developed in these years is *Saint George* (cat. 21). In it, a bravura explosion of brushwork translates into a turbulent swirl of action. Saint George, astride his horse, bears down on the dragon – and the viewer – with palpable energy. Rubens's genius for handling paint has been unleashed by his contact with Venetian art. We are caught in a vortex that sends the horse's tail and mane and the saint's cloak swirling. Rubens kept this painting with him all his life and seems to have been justifiably proud of this youthful masterpiece.

18 (detail)

18. Democritus and Heraclitus 1603

Oil on panel, 95.4 × 124.5 cm
Museo Nacional de Escultura, Valladolid, Spain

Three years after his arrival in Italy, Rubens was sent to Spain as part of a deputation from the court of Mantua to the court of king Philip III. He took a number of valuable gifts for the king and his powerful minister, the Duke of Lerma, including a collection of Italian paintings. Having reached Alicante Rubens continued inland to Valladolid, the site of the Spanish court, where he arrived on 13 May 1603. The bad weather during the journey (Rubens writes of 'daily rains and violent winds')[1] meant that some of the paintings for the duke were damaged and Rubens decided (possibly opportunistically) to add a work of his own. This was *Democritus and Heraclitus*, which he painted in Valladolid, between 14 June and 6 July.[2]

The two early Greek philosophers were often paired, by writers and artists, because of their contrasting temperaments. Democritus was known as the laughing philosopher since he found amusement in the folly of mankind, while Heraclitus, due to his melancholic reputation, was called the crying philosopher. The names of both appear in (slightly faulty) Greek lettering along the edges of their capes. Rubens based Heraclitus on a bust of the Roman Emperor Galba, which he studied in Antwerp,[3] while the bearded and open-mouthed Democritus may be an adaptation of the *Laocoön* (fig. 30).

The pair confront the spectator, while leaning over a large globe on which red dots mark (roughly) the area of Northern Europe. A compass is shown, and the meridian line indicated. It has been noted that Democritus'

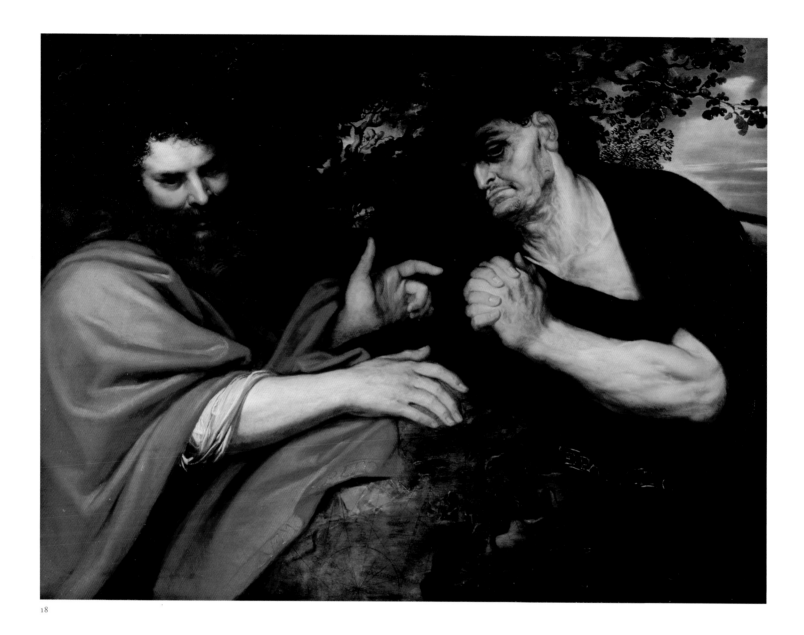

18

cloak covers the part of the globe that would represent the still-undiscovered New World, while the unhappy Heraclitus seems to wring his hands over the area of North-western Europe, perhaps alluding to the warring Netherlands.[4] Behind them grows an ever-green oak tree, native to Southern Europe, on which can be seen red leaf-galls, which are a source of natural dye.

What is remarkable about this work is the extraordinary looseness of the brushwork – no doubt in part due to the speed with which it was painted – and the way Rubens uses paint

to express the two very different personalities. Democritus' cheeks are ruddy and his lush, curly beard and hair (which is highlighted at the front with flecks of blue paint) is luxuriant, as befits the hair of a man in the prime of life. Heraclitus, by contrast, seems to have been eaten away by the ravages of time and worry. His red-rimmed eyes have dark circles underneath, and Rubens uses blue paint again, this time to indicate his stubble. Veins bulge in his vast straining neck and forearm. It is a brilliant painterly evocation of an intellectual idea, and must have pleased the

Duke of Lerma, as it led directly to further commissions. MME

1 Magurn 1955, letter 7, p. 31.
2 Vergara 1999, pp. 16–17.
3 Rubens also used this bust to make his *Portrait of Galba* (fig. 35), which was one of a series of portraits of emperors that he made before he left Antwerp. See McGrath 1991, pp. 699–703.
4 McGrath 1997, II, p. 55.

ESSENTIAL BIBLIOGRAPHY
Jaffé 1977, p. 68; Padua-Rome-Milan 1990, no. 11, pp. 56–7; McGrath 1997, I, fig. 36, II, no. 8; Vergara 1999, pp. 16–17

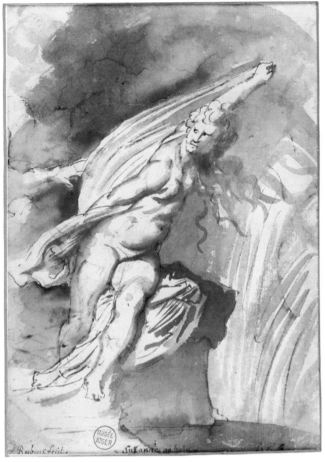

Fig. 37

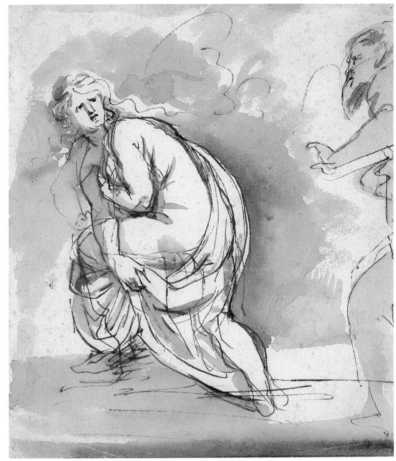

Fig. 38

19, 20. Susanna and the Elders

19. **Susanna and the Elders**, about 1606
Oil on canvas, 94 × 67 cm
Galleria Borghese, Rome (277)

20. Attributed to Rubens
Susanna and the Elders, about 1609
Oil on panel, 123 × 108 cm
The State Hermitage Museum,
St Petersburg (7080)

While bathing, the chaste Susanna was surprised by two Elders who tried to blackmail her into sleeping with them. Rubens made four early paintings and two drawings of this well-known subject from the Apocrypha.[1]

The Borghese painting shows the Elders warning Susanna, conspiratorially, to be silent – but biting a finger was also a Renaissance gesture of anger. Her face clearly conveys the distress she feels. The pose recalls the ancient Roman bronze of the *Spinario*, which Rubens,

following Raphael in the *Parnassus* (Stanza della Segnatura, Vatican) had already tried adapting by turning the boy's head around.[2] On the left is a flute-playing putto fountain figure, while the arcade of moonlit poplars leads to a stormy sky. Susanna's right arm is half lifted in a gesture of shock, as is that of the princess in the Louvre *Saint George* drawing (fig. 41). With her other arm she tries to draw a white cloth – freely painted, as is her flaxen hair – over herself. There are other explorations of women's bathing poses in the pocketbook (see p. 24), which could have been drawn from life.[3]

The New York drawing (fig. 38, if it really is by Rubens – it is almost too pretty and the wash is a little superfluous) appears to show an intermediate step between cats 19 and 20. Susanna's right arm starts in the Borghese position (cat. 19), before going on to create (or follow) the backward arm thrust of the Hermitage version (cat. 20).

The Montpellier drawing (fig. 37) is more directly linked to this painting; both show the stretched arm and sweep of cloth as Susanna leans forward and attempts to cover herself. This somewhat overlooked picture now hangs high in the Hermitage, but it does appear to be very close to the later, autograph *Susanna* in Madrid (fig. 40). Some details of cat. 20 seem strange, especially the broad highlights on the forehead of one of the Elders (which are actually reminiscent of a similar detail in the Madrid version), but in general the energy and vigorous brushwork seem consistent with Rubens's own hand. There is a comparable use of bold highlighting without articulated modelling in the figure of Joseph in the *Holy Family* (cat. 47).[4] The flesh of Susanna's body in cat. 20 is smoother than one might expect from Rubens, but her face is manifestly autograph. Her powerfully raised leg recalls a Beham print of *Three*

Fig. 39

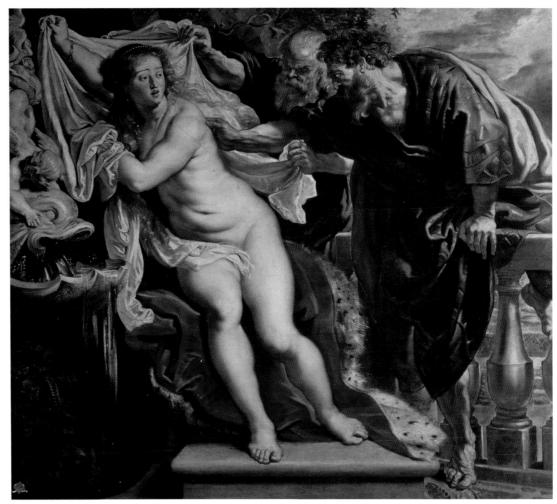

Fig. 40

Fig. 37 **Susanna**, about 1610–12
Pen and brush, brown ink and wash,
21.9 × 15.9 cm
Musée Atger, Montpellier (MA 245)

Fig. 38 **Susanna**, 1607–11
Pen and brown ink, 17.5 × 15.2 cm
The Metropolitan Museum of Art,
New York
Purchase, Anonymous Gift, in memory
of Frits Markus, 1998 (1998.74)

Fig. 39 Sebald Beham (1500–1550)
after Barthel Beham (1502–1540)
Three Women in the Bath House, 1548
Engraving, 8.3 × 5.7 cm
The British Museum, London
(P&D 1853-709-78)

Fig. 40 **Susanna**, about 1610
Oil on panel, 190 × 223 cm
Museo de la Real Academia de Bellas
Artes de San Fernando, Madrid

Women in the Bath House (fig. 39), and may be a
deliberate evocation of that image, even if the
pose is now masked by the red cloak.

Rubens had this subject engraved, and its
titillating appeal was well known.[5] Dudley
Carleton, one of Rubens's patrons, wrote to
him that he hoped the Susanna would even
enamour older men.[6]

However, only in the Madrid painting
do the Elders' become more active. As in the
Annibale Carracci version (1604, Galleria
Doria Pamphilj, Rome) they hurdle the
balustrade to catch the fleeing subject. Here
the paint handling has much in common
with the National Gallery *Samson and Delilah*
(cat. 77), confirming it as the latest of the three
paintings. There are broad, white brushed
highlight contours on the dolphin fountain,
and splashy hair curl highlights.[7] The thick
white drapery now feels as if it is made from
plaster, while by contrast cats 19 and 20 seem

to be closer in conception. In all three paint-
ings Susanna's big body and small breasts
suggest a physical canon not far from that of
Rubens's *Hero and Leander* (cat. 17).

The 1614 *Susanna and the Elders* (National-
museum, Stockholm) is a later experiment that
harks back to the Borghese solution. There is a
Susanna in the pocketbook.[8]

1 Paintings: Museo Galleria di Villa Borghese, Rome
 (cat. 19), Museo de la Real Academia de Bellas
 Artes de San Fernando, Madrid (fig. 40), The State
 Hermitage Museum, St Petersburg (cat. 20), and
 Nationalmuseum, Stockholm. Drawings: The
 Metropolitan Museum of Art, New York (fig. 38),
 and Collection Atger, Bibliothèque Universitaire
 de medecine, Montpellier (fig. 37).
2 Cologne 1977, no. 5, pp. 140–1. Van der Meulen
 1994 (I, pp. 44 and 80) does not mention Susanna.
3 Jaffé 1966, fols 56r, 58r, 58v.
4 The Elder is similar to Rubens's drawing, possibly
 of *Socrates*, in Chicago. See New York 2005,
 no. 19, p. 107.

5 His first engraving of the subject was dedicated to
 the poet Anna Roemers Visscher, whom Rubens
 referred to as an exemplar of chastity because she
 renounced marriage to look after her ill father. See
 D'Hulst and Vendenven 1989, III, p. 209.
6 McGrath 1997, I, p. 52.
7 Similar use of white is found in the sculptured
 cartouches below the saints in the *Raising of the
 Cross* (fig. 50).
8 Jaffé 1966, fol.53r. The left-hand Elder's gesture
 of a raised finger is repeated in the Borghese
 painting and her pose is very similar to the figure
 on the bottom right of 58r. It is possible that 58r
 is in fact a trial for the painting.

ESSENTIAL BIBLIOGRAPHY
Cologne 1977, no. 5, pp. 140–1, no.25, pp. 118–20;
Held 1959 (1986), no. 52, p. 90; D'Hulst and
Vandenven 1989, nos 58–60; Padua-Rome-Milan
1990, no. 25, pp. 88–9; Vienna 2004a, no. 22, pp.
190–1; New York 2005, no. 29, pp. 127–9

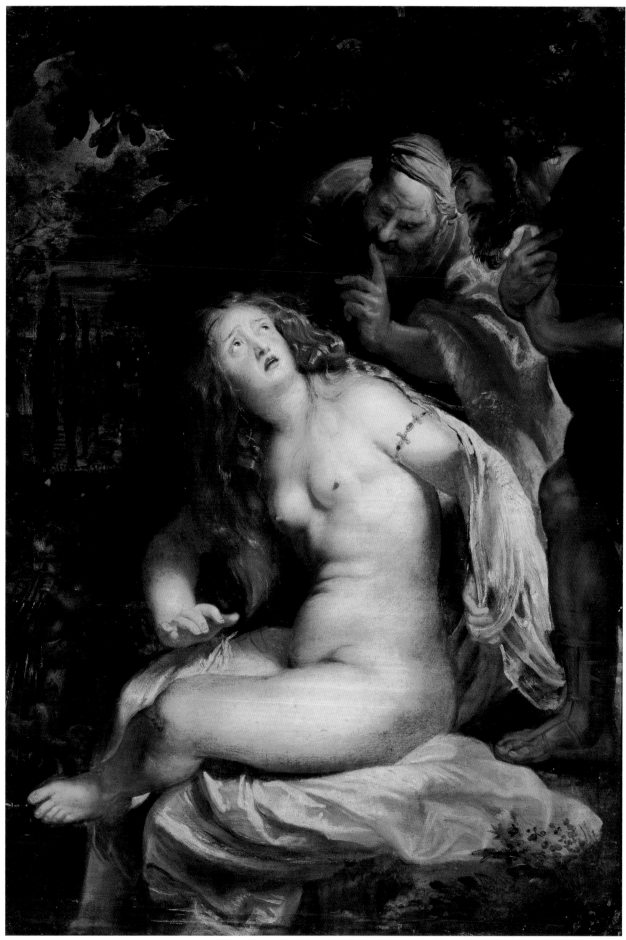

19

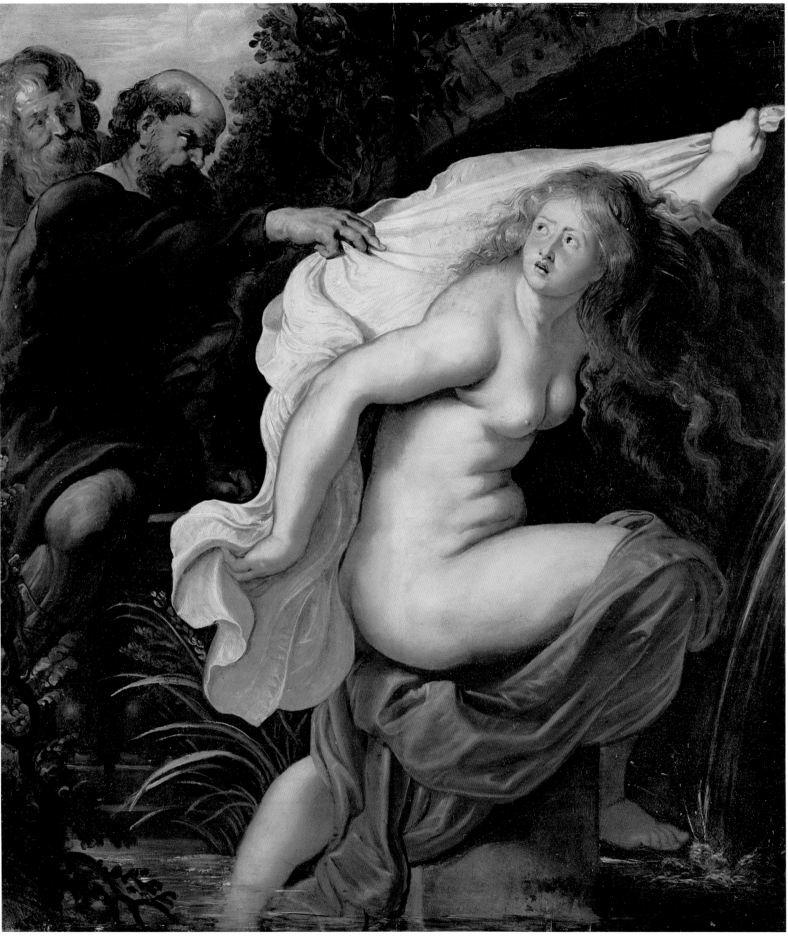

21. Saint George 1605-7

Oil on canvas, 304 × 256 cm
Museo Nacional del Prado, Madrid (P1644)

In the preparatory pen and wash study in the Louvre (fig. 41) Rubens has visualised the whole of the painting's composition. His only uncertainty is recorded in ambiguous lines that explore a second position for the princess and adjust her gesture and head. Her face is half-lit in the manner of Veronese, while in the painting the horse twists its neck less; the imbalance in the pose is masked by the open-mouthed dragon. Dried blood in the monster's mouth and on its tongue are gruesomely described – a dental nightmare. Between drawing and painting Rubens adjusted the balance of the horse, making it leap forward from its hind legs rather than squat back, thus intensifying the excitement of its swirling movement. Rubens's love of horses is given full rein: the flaming mane, executed with great verve, outshines the tumbling plumage of the helmet.

The power of the horse is emphasised by the nightingale bit in his bridle; this gave greater leverage and helped a rider control a strong animal. The saint's seat on his mount is surprisingly like that shown in Peiresc's Barberini ivory version of the subject (now in the Louvre),[1] but the basic pose must have been inspired by the *Dioscuri* ('Horse Tamers', fig. 53) on Montecavallo, Rome.[2] Rubens has taken a viewpoint very similar to that chosen by the Dutch engraver Hendrik Goltzius (he may even have found inspiration for his design in Goltzius's print of the sculpture). It is thus a self-consciously *all'antica* exercise, in which Rubens has agitated the classical formula by adding flaming hair; the Italian sculptor Pietro Tacca (1577-1640) animated Giambologna's equestrian models by adding flying tails and manes in much the same way.

Horses were a seventeenth-century obsession. In 1603 one of the gifts Rubens delivered to the King of Spain (see cat. 18), on behalf of his employer the Duke of Mantua, was bloodstock. The duke's grandfather had his audience room, in the Palazzo del Te, Mantua, decorated with paintings of his favourite steeds. Horses offered a challenge to any great Renaissance or Baroque painter. Here, as in his equestrian portrait of the *Duke of Lerma* (fig. 5), Rubens stakes his claim to mastery.[3]

The leopard- or cheetah-skin saddle cloth, which appears later in the *Conversion of Saint Paul* (about 1614, cat. 70) and the Munich *Sennacherib* (cat. 88) was a stock studio prop. Saint George, despite his incongruous modern armour, pays lip service to his third-century origins: he has no stirrups and wears the correct ancient boots. The horse's mane however is a baroque flourish, not clipped in the correct ancient manner. While Rubens liked to show off archaeologically accurate details in his paintings of olden times he never aimed to produce systematic reconstructions.

There are some astonishing painterly details. Bright curling strands in the right-hand part of the mane are scratched into the dark background with the sharp end of the brush. The surface of the forehead of the horse is enlivened with what almost seems like Post-Impressionist dappling. Saint George's cloak originally came down lower, it shows pink through the blue sky behind his drooping helmet plume, and its reflection has been left on the armour. A bigger cloak is indicated in the Louvre sketch (fig. 41); it was the decision to go for a larger plume that caused him to cut it down.

The variety of experimental brushwork – dots and hatching in particular – which animates the dragon's claws is evidence of Rubens's constant search for effective ways to enliven the picture surface. The dynamic pose of Saint George is used again in the Munich *Lion Hunt* (Alte Pinakothek, Munich, see further cat. 71). This dazzling starburst of energised equine force was too great an achievement not to be repeated. Never before had paintings of quivering, snorting horses achieved such an overwhelming presence.

The precise dating remains difficult, but the range 1605-7 seems safe. The saint wears a shell-like fluted breastplate that appears to be a studio prop, as it appeared in the *Adoration of the Magi* (fig. 57) before Rubens repainted it. The picture may have been first intended for the church of Sant'Ambrogio in Genoa, which was dedicated to Saint George, who was patron saint of the city.[4]

Rubens's pocketbook is rich in comparisons between human and animal expressions, but in this work the emphasis is on the overbearing assault of horse and man on the wide-eyed dragon.

1 Canberra 1988, pl. XV, p. 43.
2 See Bober-Rubinstein 1987, pp. 159-61 for the various identifications then current and McGrath 1997, p. 125, for other uses by Rubens.
3 Guido Reni's *Fall of Phaeton* (Palazzo Rosso, Bologna, about 1596-8) includes the same archetypal rearing horse.
4 There is a variant of this painting in the Museo Nazionale di Capodimonte, Naples. Rubens may be recalling Martin de Vos's Saint George from his influential 1590 *Risen Christ* triptych in Antwerp Cathedral. See Baudouin 1993, p. 197.

ESSENTIAL BIBLIOGRAPHY
Müller Hofstede 1965, pp. 69-112; Vlieghe 1973, II, no. 105; Cologne 1977, no. 17, pp. 164-6; Díaz Padrón 1995, II, pp. 878-81; Vienna 2004a, no. 21, pp. 187-9.

21 (detail)

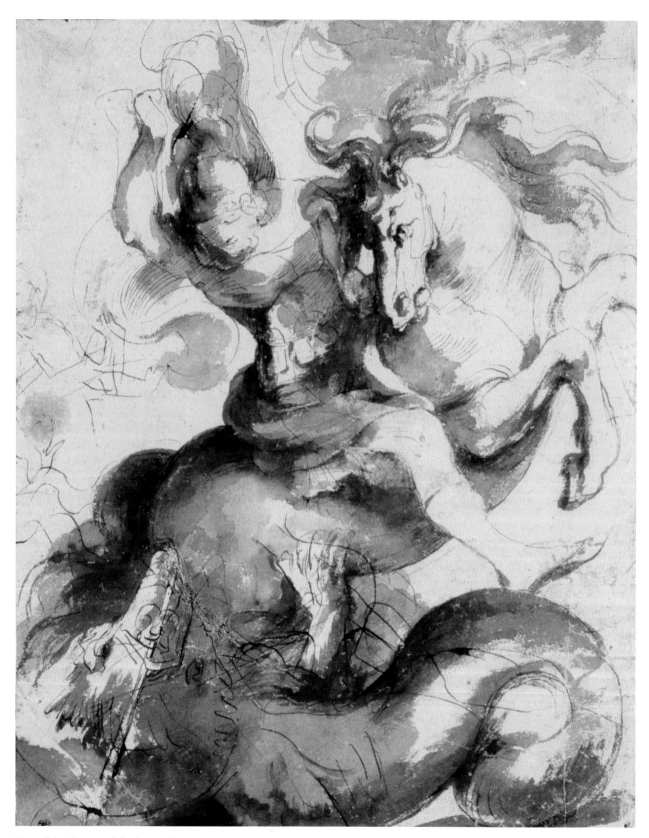

Fig. 41 **Saint George and the dragon**, 1605–7
Brown ink, 33.7 × 26.6 cm
Musée du Louvre, Paris (21.964)

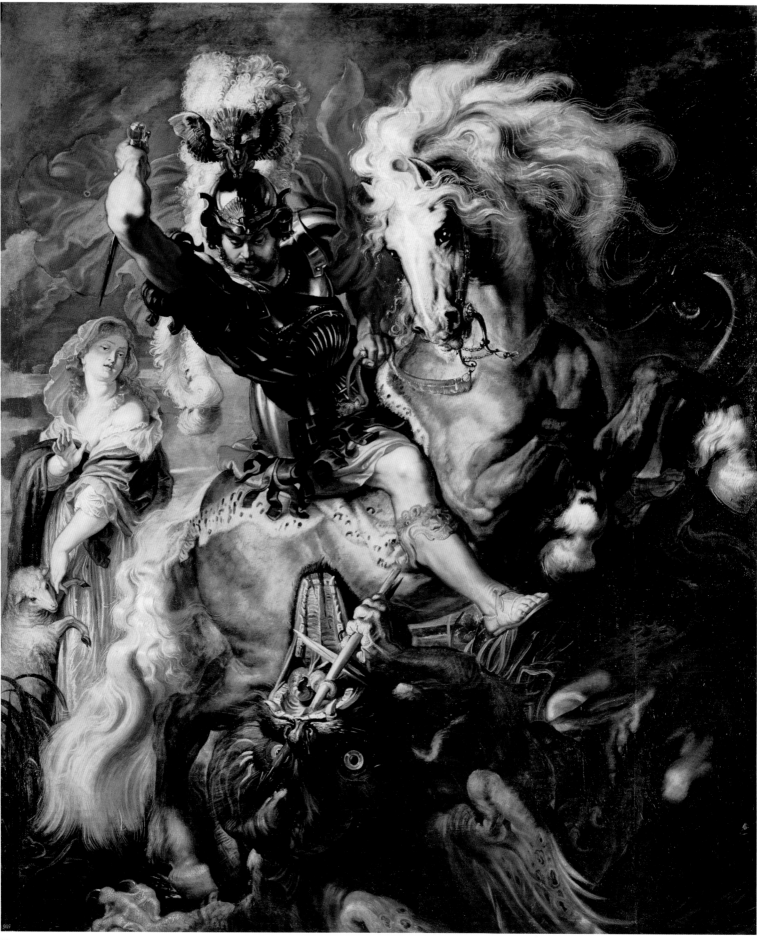

22 (detail)

22. **Marchesa Brigida Spinola Doria** about 1605–6

Oil on canvas, 152.5 × 99 cm
National Gallery of Art, Washington, DC
Samuel H. Kress Collection (1961.9.60)

Rubens was a skilled portraitist but, unwilling to be characterised as just another Flemish face painter, was generally reluctant to do them (although see cat. 91). Nevertheless, in Genoa his ability to paint reflecting silks and lace surrounding beautiful, if somewhat doll-like, faces resulted in some of the most eye-catching seventeenth-century portraits. The Genoese, no doubt already familiar with Flemish painting through their trading connections, seem to have taken quickly to Rubens and his career soared in the city. In fact, the demand for his portraits was so great that one wonders if a costume specialist's services were used to repeat the formula. The present portrait, however, can be separated from other, less inspired, portraits by the vigour of the brushwork.

Rubens attacks the highlights with dry, white strokes to give energy to the dress and enforce its contrast with the porcelain-smooth face. Costume in portraits was a display of wealth, but Rubens instils such luminosity into the dress here that the impression is of a radiant material more precious than fabric. Moroni, a sixteenth-century painter from Lombardy, had already evoked the sheen of cloth, but in Rubens's work its brilliant glow becomes an emblem of status. How far the use of massed drapery to enforce the sitters' stature was inspired by ancient statues remains to be clarified, but Rubens took the device further than anyone before him.[1]

Brigida Spinola (about 1583–1648) married her cousin Marchese Giacomo Massimilano Doria (1571–1613) on 9 July 1605, and Rubens probably painted this portrait some six months later. Here she is placed before the façade of a grand Genoese palace. As Genoese palaces sit tight to narrow streets it may be a rear façade or country villa – if the setting is real. A drawing (Pierpont Morgan Library, New York), possibly made after the painting and not by Rubens, indicates that the canvas has been cropped on the left and at the bottom, and that at one time the background included a balustrade and trees.[2]

The red curtain is, of course, a splendid visual foil. Such curtains were hung over doorways in palaces as draught stoppers, but Rubens used them to carry the family coat of arms and to animate his portraits. In this case the curtain is direct evidence of moving air implied by the fan; it is easy to imagine the pearl sprays trembling and the rustle of dress and ruff.

1 For more see Genoa 2004, no. 29, p. 208.
2 For the drawing see Held 1959 (1986), no. 29, pl. 32.

ESSENTIAL BIBLIOGRAPHY
Huemer 1977, I, no. 41, pp. 169–70, fig. 119; Cologne 1977, no. 91, pp. 324–5; Padua-Rome-Milan 1990, no. 23, pp. 84–5; Farina 2002, pp. 55–6; Genoa 2004, no. 29, p. 208; Wheelock 2005, pp. 154–9

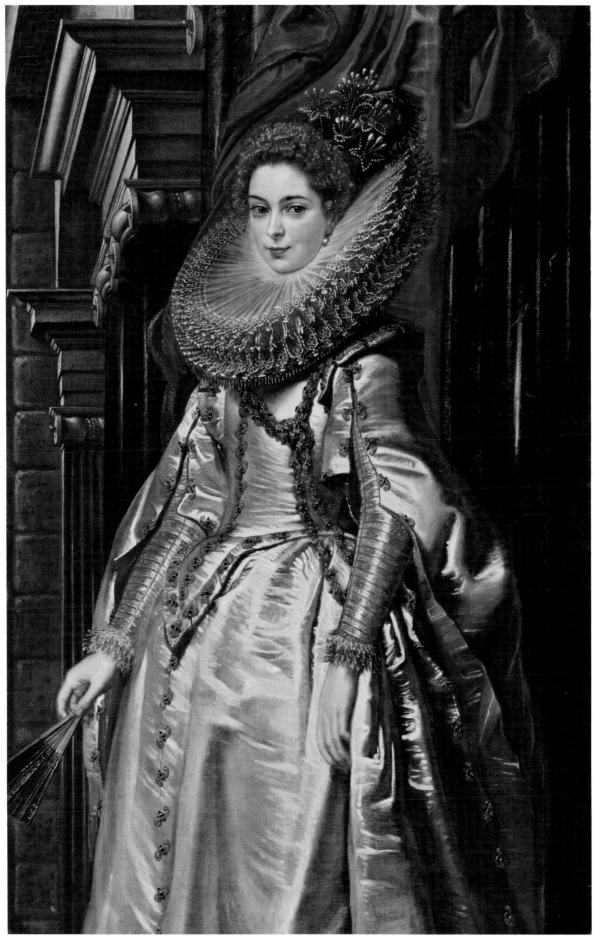

22

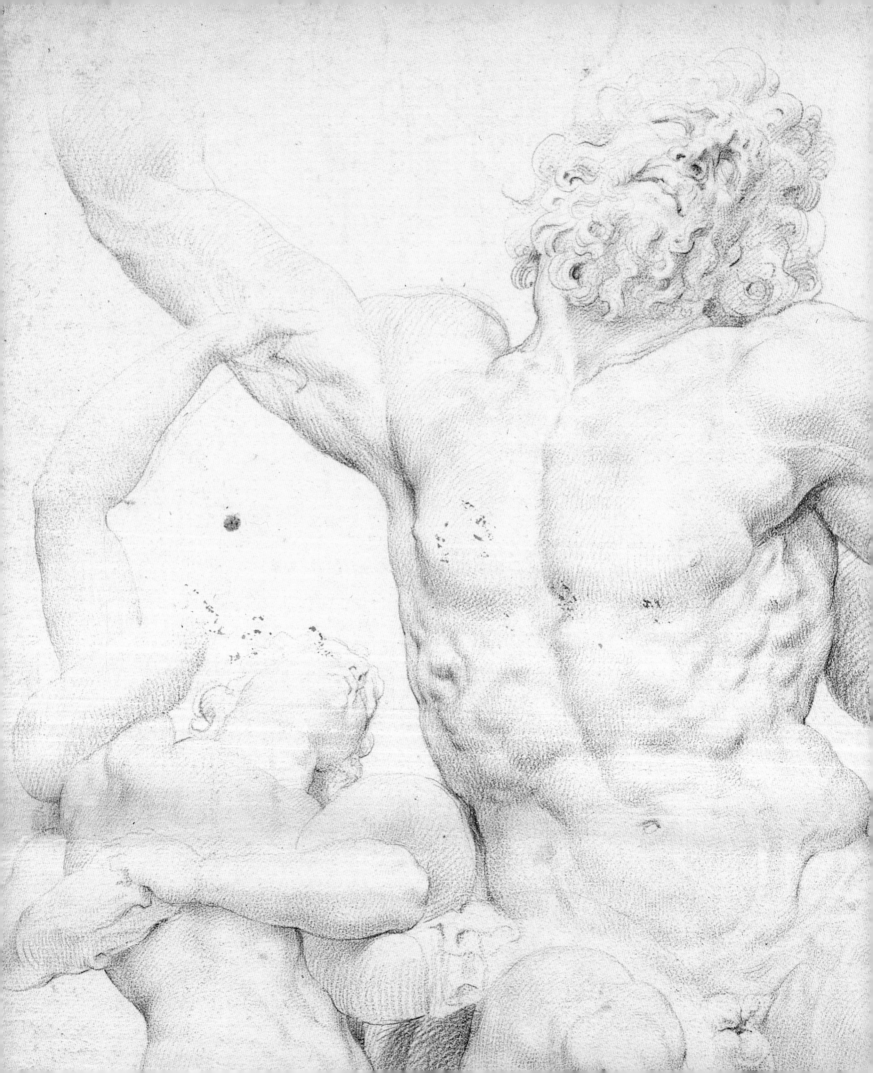

3. The Reworking of Rome

As a boy in Antwerp, Rubens attended the prestigious Latin school of Rombout Verdonck, where he became well acquainted with classical texts such as Virgil's *Aeneid* and Ovid's *Metamorphoses*. He could read and write Latin and used quotations from classical sources on his drawings to inform his portrayal of a subject (see cat. 15). As an adult his infatuation with the ancient world extended beyond simply drawing antique sculpture; he also pioneered the use of Roman art to explain classical texts. In the book on Roman customs his brother Philip wrote during their time together in Rome in 1605 (*Electorum Libri*, published in 1608 by the Plantin Press in Antwerp), there are five engravings after Rubens drawings of Roman sculpture, including one showing how senators wore their togas, selected to illustrate various points in the text.

In Italy Rubens kept a pocketbook (see pp. 21–37) in which he made drawings and notes about what he saw. From surviving copies (the original was burnt in 1720), it seems that the pages were annotated and images were grouped by topic: women bathing, massacres, figures being dragged, and so on. The picture we have of Rubens during these years is of a young artist with an inexhaustible appetite for visual sources amassing a 'visual museum' into which he could delve for ideas. He drew from life and copied from *écorché* (flayed) sculptures to refine his figurative skills, but, given his education and interests, it is not surprising that during his two protracted stays in Rome (1601–1602 and 1605–1608), he immersed himself in the works of antiquity.

The *Laocoön*, excavated in Rome in 1506, was one of Rubens's favourite antique sculptures (fig. 30). He had copied plaster casts of the *Laocoön* in Antwerp, but on seeing the original his approach altered (see cat. 1, detail, p. 42, and cat. 26). The sheer size and energy of the group, which was on display in the Vatican's sculpture courtyard, the Belvedere, as well as the subtlety with which the anatomy of the figures was carved, must have impressed him. The central figure of the priest Laocoön, whose every vein and muscle is visible, particularly attracted Rubens. He drew the *Laocoön* repeatedly, and from all angles (see cats 23–6), some rather unusual (figs 42–3).

More broadly, Rubens's paintings changed as a result of his studies. His figures take on the Herculean physique of antique sculpture and there is a marked increase in his knowledge of anatomy. The giants that populate his later paintings – the soldiers in the *Massacre of the Innocents* (cat. 82) and Samson in *Samson and Delilah* (cat. 77) – derive from this study. His art would never be the same again. Images of the *Laocoön* and the *Farnese Hercules* (fig. 44) and others, became part of his repertoire of pictorial ideas for the next twenty years.

26 (detail)

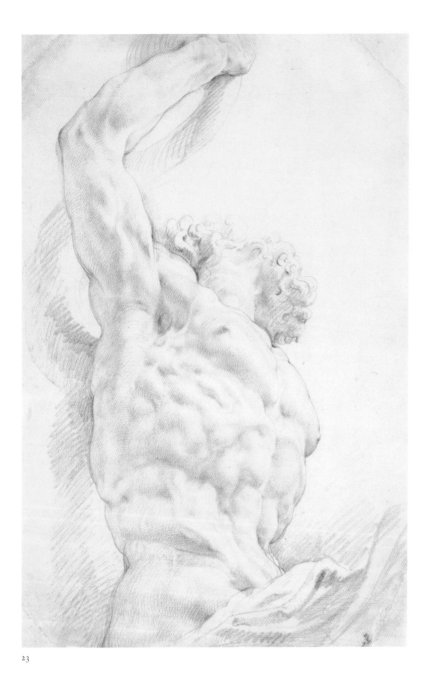

23

24

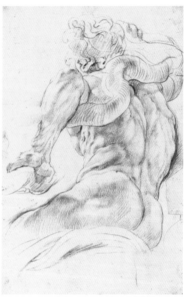

25

23-26. Laocoön and his Sons

23. The Priest Laocoön, about 1601-2
Black chalk with white traces, 45.7 × 29.7 cm
Kupferstichkabinett, Staatliche
Kunstsammlungen, Dresden (C1874-22a)

24. The Younger Son of Laocoön, about 1601-2
Black chalk with white traces, 44.4 × 26.5 cm
Biblioteca Ambrosiana, Milan (F249 INF 5, P. 11)

25. The Priest Laocoön, about 1601-02
Black chalk with white traces, 44 × 28.3 cm
Biblioteca Ambrosiana, Milan (F249 INF 5, P. 11)

26. Laocoön and his Sons, about 1601-2
Black chalk, 48.2 × 37.5 cm
Wallraf-Richartz-Museum, Cologne
(CFN 1025/WRM/Z 5889)

Rubens must have known the *Laocoön* (fig. 30)
many years before he saw the original in Rome,
as his early *Battle of the Amazons* (cat. 1) shows.[1]
The group, the only sculpture described by
Pliny in his *Historia Naturalis*, shows the Trojan
priest Laocoön, who warned his people of the
dangers of the Trojan horse, being silenced,
along with his sons, by sea-monsters sent by

the god Neptune who supported the Greeks.
 Casts of the sculpture occur in many
paintings of artists' studios and collectors'
cabinets. Leone Leoni (1509-1560) had a full-
scale plaster cast, later acquired by Cardinal
Federico Borromeo for his Milanese school of
artists and now in the Biblioteca Ambrosiana.
There were also dozens of prints available.
 This set of black chalk drawings (cats 23-6)
may not have been made from the sculpture
itself, although it is impossible to be certain.
The original was set into a niche that made it
hard to get a good rear view of the central

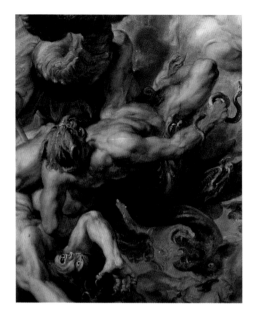

Fig. 42

Fig. 43

Fig. 42 **Saint Michael striking down Rebellious Angels**, 1621–2 (detail)
Oil on canvas, 438 × 291.5 cm
Alte Pinakothek, Bayerische
Staatsgemäldesammlungen, Munich (306)

Fig. 43 Cast of the **Laocoön** (fig. 30), from above
Plaster, height 219 cm
Museum of Classical Archaeology,
University of Cambridge (386)

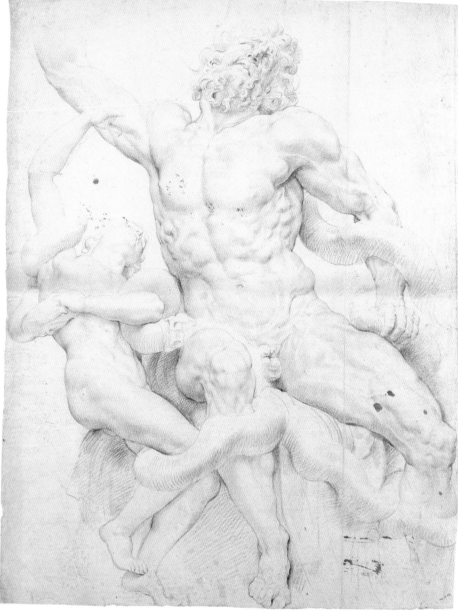

26

figure. Rubens draws the left-hand son in detail from behind – but as that figure is twisted backwards and outwards, he could have been working from the original.[2]

However, two drawings by the late-sixteenth-century Milanese painter Ambrogio Figino (about 1551–1608) at Windsor are so close to Rubens's that one wonders if the Ambrosiana drawings were not made when they worked side-by-side, from Borromeo's cast in Milan. Rubens also made dramatic drawings of the statue from close up and low down, and drew individual back views of the

figures. Dating the Ambrosiana drawings is difficult: the white highlights fit well with drawings associated with 1609 projects, while the interest in the surface of the sculpture would encourage a date of 1601–2.

What seems to have caught Rubens's imagination is the expressions of faces and bodies. He exaggerates their contortions, veins and musculature. There is a sense that he is scanning the surface for protrusions and indentations. The drawings are both a homage to the antique, and the basis of a formula that enlivened his own (and his pupils') anatomies.

1 Rubens apparently drew the figure first from a reversed print – judging by Chatsworth fol.56v – where one of the sons is illustrated in reverse: see p. 25, fig. 16.
2 Nesselrath and Liveroni 1994, no. 36, pp. 57–8. See also Settis 1999.

ESSENTIAL BIBLIOGRAPHY
Fubini and Held 1964; Winner 1974; Cologne 1977, no. 54, p. 250; Haskell and Penny 1981; Held 1959 (1986), nos 34–5; Tokyo 1994, no. 36, pp. 57–8; Van der Meulen 1994, II, nos 81 and 92; Westfehling 2001, pp. 171–222, fig. 1; Brunswick 2004, no. 75, pp. 291–2; Coccolini and Rigacci 2004, pp. 53–68

Fig. 44 Roman, probably third century AD
The Farnese Hercules
Marble, height 317 cm
Museo Archeologico Nazionale, Naples

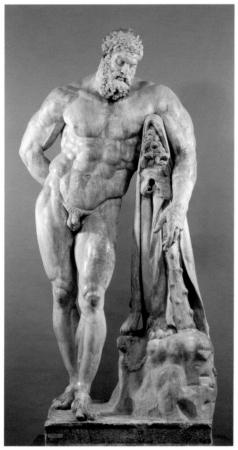

Fig. 44

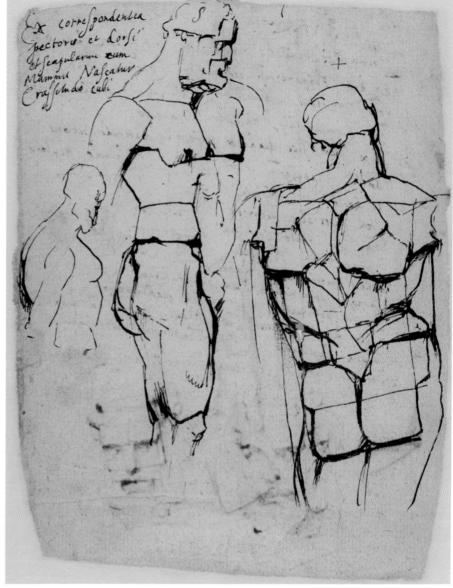

27 verso

27, 28. The Farnese Hercules

27. Study of the Farnese Hercules, about 1602
Pen and ink on paper, 19.6 × 15.3 cm
(D.1978.PG.427, *recto*, and D.1978.PG.427.V, *verso*)

28. Head of Farnese Hercules, about 1602
Black and white chalk on paper, 36.3 × 24.5 cm
(D.1978.PG.53, *recto*, and D.1978.PG.53.V, *verso*)

The Samuel Courtauld Trust, Courtauld
Institute of Art Gallery, London
Bequeathed by Count Antoine Seilern as part of
the Princes Gate Collection, 1978

The *Farnese Hercules* (fig. 44) is a marble
colossus of overwhelming physical power.
Standing over three metres high, it is thought
to recall a lost bronze by Lysippus of about
300 BC. Rubens would have seen it in the
courtyard of Alessandro Farnese's palace in
Rome; it was an ideal archetype for the artist.

 The Courtauld drawings of the sculpture
have a fascinating cubic structure reminiscent
of the studies of figures and heads reduced
to an arrangement of blocks made by Luca
Cambiaso (1527–1585). Like Leonardo before
him, Rubens seems to be testing Vitruvius'
claim in *De Architectura* that the ancients

worked to a fixed canon of proportion.

 Rubens analysed the statue closely, drew it
and made free variations of it. There is an
almost literal translation in an oil-sketch
Hercules overcoming Discord (Rotterdam
Museum), but one of his most successful
derivations is his painting of *Saint Christopher*
which formed the left panel of the exterior
wing of the *Descent from the Cross* (cats 54–6) in
Antwerp Cathedral. The design is flipped but
the character and personality are faithfully
evoked.[1] Mentally reversing sculptures is far
from straightforward (although Tetrode had
already made a reversed bronze from this very

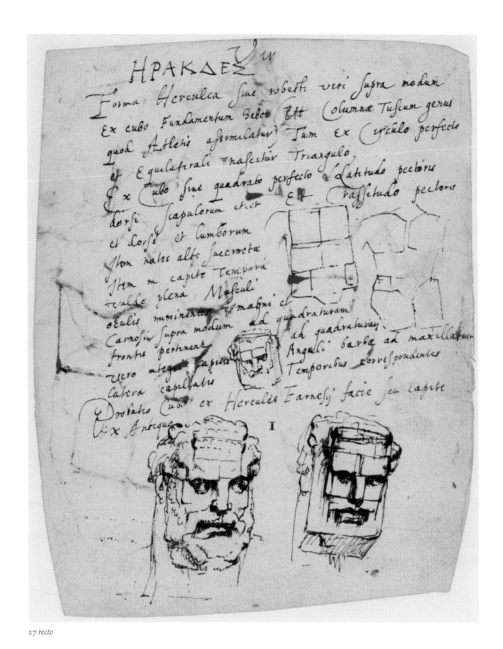

27 recto

28 recto

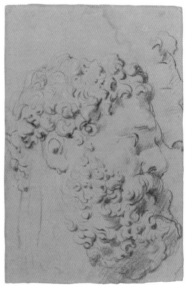

28 verso

figure) and may have involved tracing or counter proofing.

The statue is so tall that one has to speculate as to whether Rubens used a ladder or worked from a cast for these studies. Coins and gems would have supplied supporting material for the vast bull-like neck and the blocky profile, but Rubens does seem to be trying to capture the essence and personality of this sculptural hero. Interestingly, a drawing after the Hercules in the same album as cats 24–5 is smaller and looser than cats 27–8. Was his first impression of the *Farnese Hercules* such that it overwhelmed even this

confident draughtsman, or was he working from a lesser reproduction? It is possible that the Albertina *écorché* (cat. 35) refers to the leg positions of this statue.

Here the musculature is reminiscent of the imposing print of the back view of Hercules that the Dutch artist Goltzius engraved in 1592. Interestingly, Goltzius also tried to capture the awe inspired by this larger-than-life marble. He anticipated Rubens in his studies of statues and modern bronzes (especially by Tetrode), which he turned to when seeking inspiration for his prints. Rubens was thus working in a Northern

tradition when he made his survey of sculptural sources. He had a cast of the *Farnese Hercules* built into his Antwerp house.[2]

1 The Johnson version (see p. 21) of the pocketbook (J.ms. fol.65r) notes the story of Saint Christopher above two drawings, one of *Hercules carrying the Boar*, the other of *Saint Christopher*.
2 See Muller 2004.

ESSENTIAL BIBLIOGRAPHY
Van der Meulen 1994, II, nos 14–24, figs 31–52; Balis in Heinen and Thielemann 2001, pp. 11–40

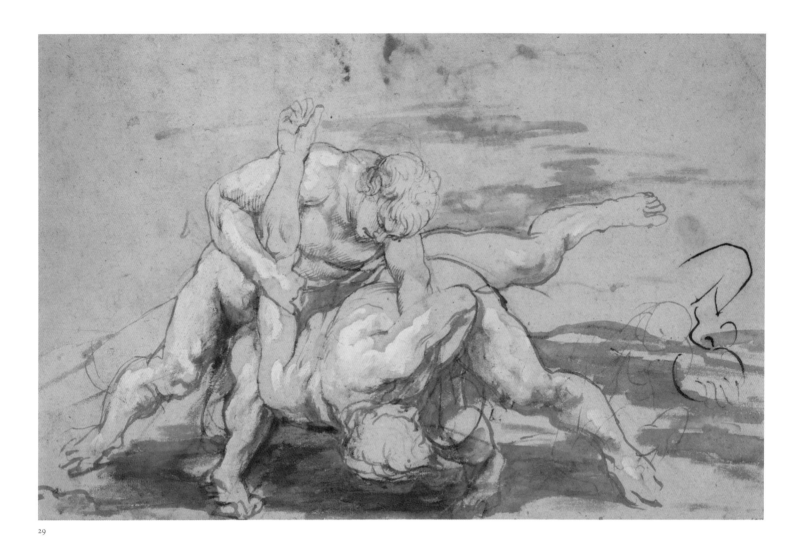

29

29. Two Men Wrestling 1605–8

Charcoal, pen and ink, heightened with white and yellow on buff paper, 23.5 × 36.6 cm
Fitzwilliam Museum, Cambridge (PD 2181)

The antique marble group that inspired this drawing was discovered in 1583. It is now in the Uffizi, Florence (fig. 47), but Rubens saw it in the Villa Medici, Rome. He used it as a starting point for a free exploration of the theme: he tries out a foreshortened right leg on the lower figure and changes the position of the left leg of the upper one, so that it is beside, rather than entwined around, his opponent.

He adapted the ancient model more literally in a drawing for *Saint Gregory of Nazianzus* (Gesù, Antwerp), and for the figure bending down on the camel in the 1609 *Adoration of the Magi* (fig. 57). He also quotes the same viewpoint of the statue in a lost

drawing known from the *cantoor* copy of the pocketbook.[1] If the copies are accurate they show that Rubens chose to separate the two wrestlers. In fact the artist generally avoided intertwined figures. For example, despite his admiration for the sculptor, Michelangelo's intensely bound *Samson and the Philistines* – which was developed in models but never executed – was not absorbed into Rubens's vocabulary.

Rubens found straining backs, like the wrestlers', irresistible. He used them to great effect, perhaps nowhere more dramatically than in the London *Samson and Delilah* (cat. 77). Rubens may have taken the figure on the far right of the Cologne *Miraculous Draught of Fishes* (cat. 64) from a side view of the same sculpture.

The composition is developed in the Lugt

drawing (fig. 45) where a figure turned into a bearded Hercules, is beginning to stand up.[2] Hercules' stance is here close to a drawing by Daniele da Volterra in the British Museum, which suggests Rubens may have had access to a Volterra sketchbook, as he copies another fighting group by the artist.[3] There are two pairs of wrestlers, almost certainly *Hercules and Antaeus* in the Hercules section of the pocketbook (fig. 46), which could be seen as further explorations of this theme.

1 Martin 1968, p. 141–2, fig. 133.
2 London-Paris-Bern-Brussels 1972, no. 78, pl. 49.
3 Barolsky 1979, pl. 96. See J.ms. fol.35r.

ESSENTIAL BIBLIOGRAPHY
Van der Meulen 1994, II, p. 110, nos 100–1, figs 177–8; Balis in Heinen and Thielemann, 2001, pp. 11–40

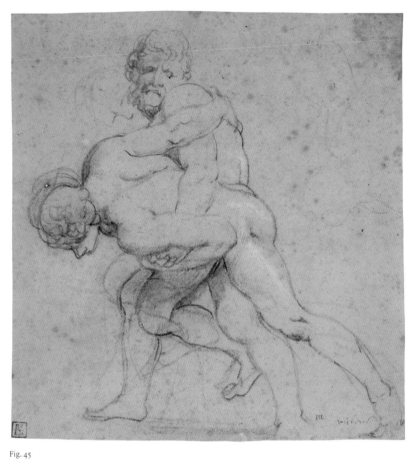

Fig. 45

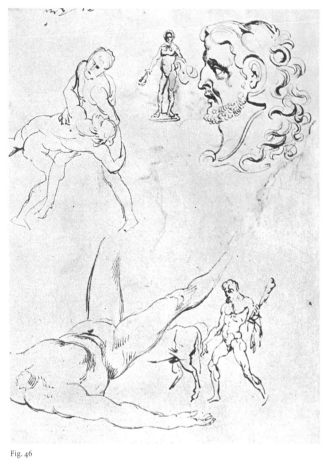

Fig. 46

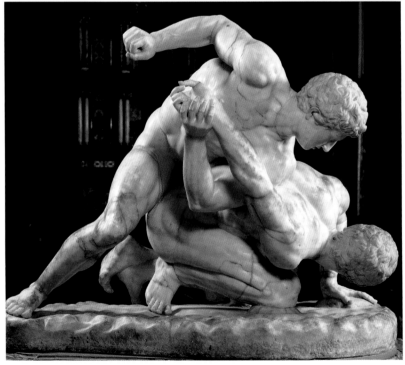

Fig. 47

Fig. 45 **Two Men Wrestling**, 1605–8
Black chalk, heightened with white, 25.2 × 23.5 cm
Collection Frits Lugt, Institut Néerlandais, Paris (5251)

Fig. 46. Copy after Rubens
(attributed to Anthony Van Dyck)
C.ms. fol.41r
Devonshire Collection, Chatsworth

Fig. 47 Roman, third century AD?
The Wrestlers
Marble, height 89 cm
Galleria degli Uffizi, Florence

Fig. 48 After Michelangelo
Leda and the Swan, after 1530
Oil on canvas, 105.4 × 141 cm
The National Gallery, London (NG 1868)

Fig. 49 **Leda and the Swan**, 1602
Oil on panel, 122 × 182 cm
Gemäldegalerie Alte Meister, Staatliche
Kunstsammlungen Dresden (AM-71-PS01)

30. Leda and the Swan about 1600

Oil on panel, 66 × 81 cm
Private collection, on loan to the Fogg Art
Museum, Harvard University Art Museums,
Cambridge, MA (59.2001)

According to Greek myth, the god Zeus dis-
guised himself as a swan in order to make love
to Leda, wife of the King of Sparta. Rubens
made two paintings of the subject, cat. 30 and
a work in Dresden (fig. 49). It is likely that the
present version was first, as the handling is less
confident and the iconography less sophis-
ticated.[1] However, the relationship between
the two remains problematic and controversial.

Both are based on a celebrated composition
by Michelangelo, made in 1529-30 for Alfonso
d'Este, Duke of Ferrara. Michelangelo's com-
mission was never delivered to the duke
but taken instead to France by his assistant,
Antonio Mini, in the hope of selling it to
Francis I at Fontainebleau.[2] Although
destroyed in the late seventeenth century,
this painting and its cartoon (which Mini also
took) acquired instant fame and are known
from contemporary copies (fig. 48), as well
as mid sixteenth-century engravings.

The loose handling of paint, and the speed
with which cat. 30 appears to have been
executed, is suggestive of an oil-sketch, and it is
also small enough to have been sold as a cabinet
painting. However, it is perhaps most likely
that the work was made for Rubens's own use,
as a record of Michelangelo's famous design.

Leda sits on a piece of drapery, as in the
sixteenth-century copies, but Rubens
introduces an element of narrative by showing
her leaning against a tree stump in a wood.
Behind, an orangey sun glows, illuminating
a woodland landscape and a patch of water,
from which a swan might have just emerged.
The glint in the swan's eye is made decidedly
human, a reminder that this is really Zeus.
These adjustments are entirely in keeping
with Rubens's habit of animating the sources
he copied from, and were a natural way of
avoiding being a mere copyist.

The oak panel (a northern support) on
which cat. 30 is painted has led some to date
the work prior to Rubens's departure for Italy
in 1600.[3] In this case the young artist would
have had to copy, and reverse, the composition
from one of the engravings made after
Michelangelo. However, there are icono-
graphical differences between Rubens's
painting and the engravings, and a crucial
compositional divergence: Leda's left arm is
raised higher in the Rubens paintings.

Rubens's work is closer to the copies that
derive not from Michelangelo's painting but
from the full-size cartoon. For example, one
wing of the swan is darker than the other, as in
the copy in the National Gallery (fig. 48). It is
possible that Rubens took oak panels with him
on his journey south,[4] stopped at the Château
de Fontainebleau (hailed by Vasari as 'una nuova
Roma')[5] and there seen Michelangelo's work.[6]

Leda and the Swan was an instantly recog-
nisable subject in Rubens's day, its antique
connotations and Renaissance updating by
Michelangelo were well known.[7] Rubens was
thus making a painting that was simultaneously
antique and modern, and annoucing his
awareness of an erudite double tradition.
The figure of Leda is echoed in later paintings,
such as in the nereid on the left side of *Hero
and Leander* (cat. 17), and in the women being
lifted in the *Rape of the Daughters of Leucippus*
(Alte Pinakothek, Munich).[8] MME

1 See Jaffé 1968, pp. 180-3. Jaffé considers the
 Dresden painting 'a natural sequel'.
2 See Cox Rearick, 1996, pp. 237-41.
3 Canberra-Melbourne 1992, no. 32, pp. 114-16.
4 X-radiographs have revealed an oval frame painted
 underneath this *Leda*. Similar frames appear in the
 series of portraits of emperors painted by Rubens
 (and others artists) before 1600. See Edinburgh-
 Nottingham 2002, no. 8, p. 43.
5 Vasari (1966), VI, p. 144.
6 Fontainebleau was open to visiting artists. See
 Grivel in Paris 2004-5, p. 45.
7 For more on the antique cameo of *Leda and the
 Swan*, see Florence 2002, no. 20.
8 The importance of this image for Rubens is con-
 firmed by the fact that he made a version, reputedly
 for himself, on his return to Antwerp. See
 Correspondance de Rubens 1887-90, II, p. 137.

ESSENTIAL BIBLIOGRAPHY
Jaffé 1968, pp. 180-3; Jaffé 1977, pp. 64-5;
Canberra-Melbourne 1992, no. 32, pp. 114-16;
Edinburgh-Nottingham 2002, no. 8, pp. 42-3;
Vienna 2004a, no. 3

30

31 (detail)

31. After Michelangelo The Battle of Lapiths and Centaurs about 1600

Black chalk and black-grey wash, 25.3 × 33.9 cm
Collection Frits Lugt,
Institut Néerlandais, Paris (5422)

Rubens's enthusiasm for Michelangelo's work extended to early pieces like the marble relief of a battle between Centaurs and Lapiths copied on this sheet. The work was carved right at the beginning of Michelangelo's career and may have been, in part at least, a critique of ancient sculpture. Certainly Michelangelo's figures weave more deeply into the surface than ancient convention, which lined them up close to it, would have allowed.

Rubens's interest, however, was not so much in sculptural form as in the way the fall of light can give significance to one figure or another. There are two *Lapiths and Centaurs* drawings, the present sheet and one in Rotterdam, which show the relief lit from opposite sides. Both use the same strong, engraving-like hatching.

From the outset of his career Rubens was interested in exploring ways in which light can emphasise relief. That he noted the varying effect of light on Michelangelo's sculpture fits with the idea that he was looking for ways to give figures a pronounced three-dimensional presence. The impact of the *Lapiths and Centaurs* studies can be seen in the knotted figures of the *Massacre of the Innocents* (cat. 82) and in the turning poses and contorted musculature which were to become a feature of his painting. The twisting female figure that he uses unchanged in the *Amazons* (cat. 4) is explored further in a drawing

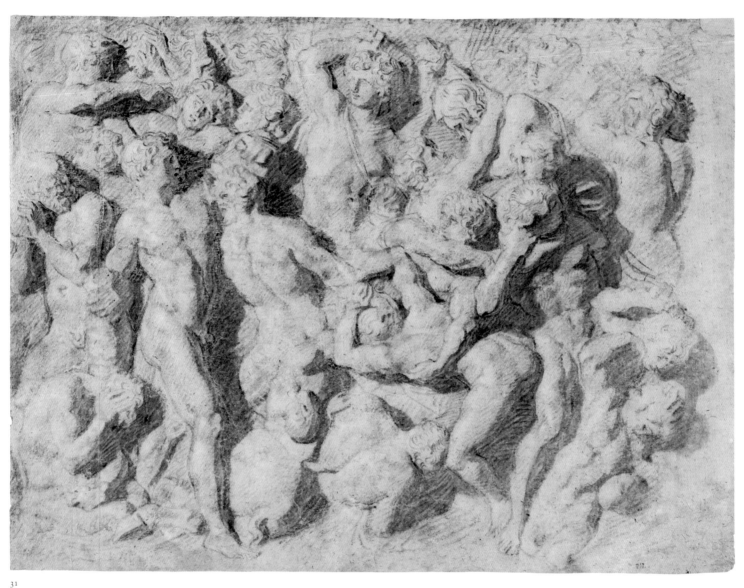

31

connected with the smaller *Last Judgement* (Alte Pinakothek, Munich). He tried other variations on it when he transferred it to his pocketbook (C.ms. fol.56r, fig. 13). As poses were also borrowed from the *Lapiths and Centaurs* for cat. 4, it is tempting to conclude that Rubens saw the relief on his first trip to Florence, to attend the marriage by proxy of Maria de Medici to Henri IV in 1600, and that the painting was made shortly after. One can imagine Rubens, the young representative of the Mantuan court, seeking out Michelangelo

Buonarotti's heir and setting up an evening of drawing by candlelight. In general, Rubens was more interested in sculpture in the round and when he did study reliefs tended to turn to glyptic art (that is, engraved gem stones) rather than sarcophagi. The hatching in the background may refer to the marks of the claw chisel Michelangelo used to start on the forms. The atypically thick lines throughout the drawing could be a sympathetic response to his chisel strokes. There is a series of disputed drawings of heads from Trajan's column

that are similar in technique and it is just possible that they are early Rubens drawings. The attribution of this drawing to Rubens is debated, but there is enough circumstantial evidence to justify its review here.[1]

1 See Logan 1977.

ESSENTIAL BIBLIOGRAPHY
Cologne 1977, no. 65, p. 270; Jaffé 1977, fig. 16, p. 20; Rotterdam 2001, pp. 73–5; Brunswick 2004, no. 61, pp. 268–9

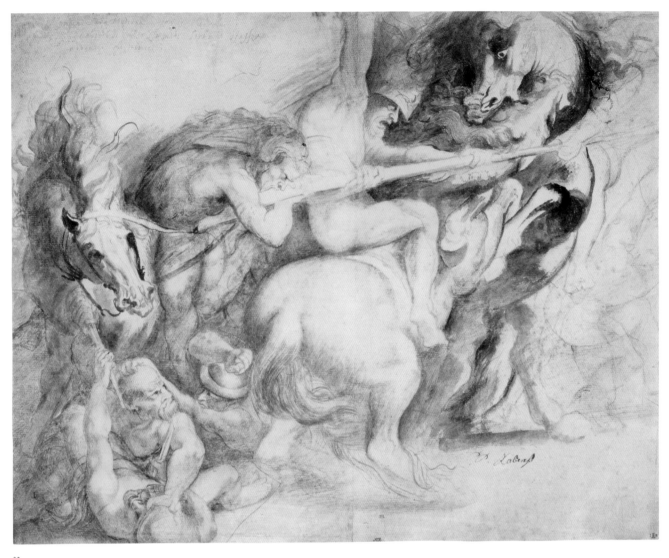

32

32. The Battle for the Standard 1605–10

Black chalk and brown wash, with traces
of red chalk, 41.5 × 52.2 cm
The British Museum, London
(P&D 1895.9.15.1044)

At the beginning of the sixteenth century,
Leonardo da Vinci and Michelangelo
Buonarroti were commissioned, in competition
with one another, to paint vast battlescenes
side by side on the wall of the Council Hall of
the Palazzo Vecchio in Florence. Leonardo
depicted *The Battle of the Anghiari* a scene from
the fifteenth-century wars between Florence
and Milan, Michelangelo showed *The Battle of
Cascina*. It was one of the most intriguing and
tantalising commissions of the Renaissance –
not least because the two celebrated frescoes
were obliterated when Vasari redecorated the

Council Hall in 1557. They are known today,
as they were to Rubens, solely through
descriptions, copies and a handful of sketches.

It is not known if Rubens worked from an
engraving or another copy of the fresco. In
this free version of the *Battle for the Standard*,
the central scene in Leonardo's lost work,
Rubens explores the motif of biting, scratch-
ing men and frenzied horses. The way he
has employed wash is unusual. It is normally
associated with fast compositional inventions,
but here he seems to be using it to achieve
painterly local colour in manes and tails, to
resolve lighting and to emphasise the rumps
of the horses (particularly the one on the right
which rears up into an almost human, bipedal
pose). Lighting also emphasises the energy of
the charging horse breaking out into the

viewers space on the left-hand edge of the
sheet. It is the horses and riders, rather than
the fighting men (some fallen, some trying
to pull others down or scramble up) that drive
the composition.

The three male figures fighting on the
ground at the bottom left are on a piece of
paper added by Rubens (possibly from an
earlier sheet), indicating a rethinking or a
reworking of the group. One is gouging at his
prostrate opponent's eye while trying to stab
him with a dagger. The twisting elbow of the
eye-gouging arm is particularly disturbing.
The knee of this man fills the far left corner as
he tries to force his arm down, and his victim's
legs are splayed to an unbelievable degree.
The knife wielder is, in turn, attacked by an
adversary who scratches his skull and tries to

32 (detail)

punch him. This knot of interlinked foot soldiers is echoed in the cavalry above.

One must look closely to see that the horse in the centre of the composition is lunging backwards into the drawing to bite the neck of the horse ahead of it, which in turn rears in alarm, nostrils flared. This horse's foreleg makes a link with its attacker, and we can just make out the rider's calf and foot. We cannot see his torso – which is only suggested on the far right, but it is possible to make out his left leg and an arm that grabs hold of the lance. Below him another man seems to be trying to drag him from his mount. Rubens has tried out several leg positions for him.

It is the horses that are the heroes of the composition. Their forms, emphasised by wash, emerge from shadow and faint chalk

lines as sculpted relief forms, just as the sea-monster emerges from the water in the *Death of Hippolytus* (cat. 66).

On the left, the rider holding the lance, which he bites into, has pulled his reins over his mount's head as he twists. He must be about to topple off his horse given that his centre of gravity is far over his left knee. The shouting man grasping the lance and raising his arm seems to have had his face lightly sketched again behind his head; his cry echoes the screaming fighters in the Leonardo composition (see fig. 29). Rubens developed the plunging horse on the left into a standard motif in his cavalry compositions.

Rubens's source for the Leonardo may have been an engraving, as the corresponding passage is reversed in his Louvre drawing

(fig. 29), which is considered to be the canonical version of the lost painting. The Italian inscription at the top left corner of this drawing (there is a little pen sketch for a man with an open mouth next to it) suggests it was made in Italy but composed some time after his arrival – one would not expect Rubens to be able to write Italian much before 1602.[1]

1 The instructions inscribed in the top left corner are incorporated into the composition of cat. 71 – note the stirrup. This suggests a later date, closer to the sketch, than has previously been supposed.

ESSENTIAL BIBLIOGRAPHY
Cologne 1977, no. 28. p. 194; Jaffé 1977, pp. 29–30; Edinburgh-Nottingham 2002, cat. no 5; Vienna 2004a, no. 11

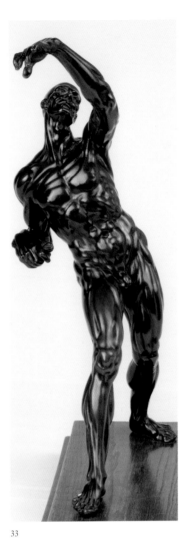

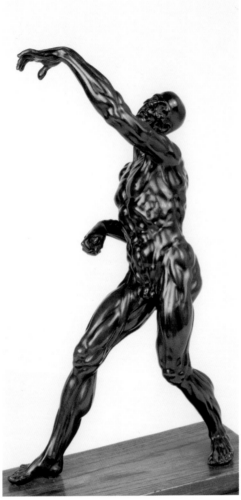

33

34

35

33-44. Ecorché Figures and Anatomical Studies

33. Willem van Tetrode (about 1525–1580)
The Horse Trainer, 1562–7
Bronze, height 43 cm
The Hearn Family Trust, New York

34. Willem van Tetrode (about 1525–1580)
Ecorché, 1562–7
Bronze, height 43 cm
Abbott/Guggenheim Collection

35. **Anatomical study of legs**, 1606–8
Black chalk, pen and ink, 27.5 × 17.9 cm
Albertina, Vienna (8309)

36. **Anatomical study of the arm of a recumbent man shielding his head** (*recto*) and **A left arm in three positions** (*verso*), 1606–8
Black chalk, 26.4 × 19.6 cm
Private collection

37. **Study of three *écorché* nudes**, 1606–8
Pen and ink, 29.1 × 19.7 cm
Private collection

38. **Study of an *écorché* nude reaching up to the left**, 1606–8
Pen and ink, 29.8 × 17.2 cm
Private collection

39. **Study of an *écorché* nude striding to the right**, 1606–8
Black chalk, pen and brown ink, 28.8 × 18.8 cm
Private collection

40. **Anatomical study of a man moving to the right**, 1606–8
Red chalk, 27.3 × 19.2 cm
Jan Krugier and Marie-Anne Krugier Poniatowski Collection, Geneva (JK 4351)

41. **Study of an *écorché* nude reaching up to the left, seen from the back**, 1606–8
Pen and brown ink, 28.6 × 19 cm
Private collection

36 recto

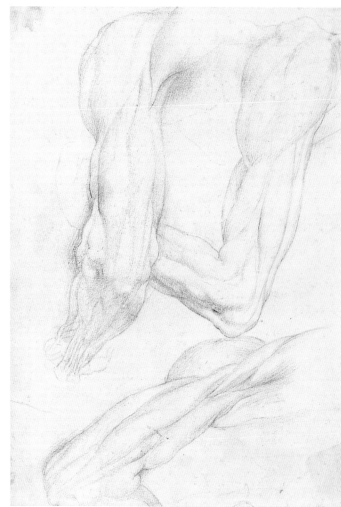

36 verso

42. **Study of an *écorché* nude lunging
to the left**, 1606–8
Pen and brown ink with
black chalk, 27.6 × 18.5 cm
Private collection

43. **Anatomical studies**, 1606–8
Pen and brown ink, 27.9 × 18.7 cm
The J. Paul Getty Museum, Los Angeles,
California (88.GA.86)

44. **Study of three *écorché* nudes
in combat**, 1606–8
Black chalk, 29.1 × 20 cm
Private collection

It can be taken for granted that Rubens's
so-called 'anatomical studies' were originally
part of a sketchbook or notebook. Anne-Marie
Logan confirmed this supposition when she
showed that two of these sheets had originally
been opposite pages in a book. Rubens's pupil
Willem Panneels wrote beside one figure
on his copy after some of the sheets that he
had 'drawn this figure after the anatomy-book
of Rubens'.

Since the early sixteenth century printed
collections of studies after the nude had
helped artists to master human anatomy,
proportion and difficult poses, and to instruct
their pupils. Rubens must have made the
studies in his anatomy book not only for

himself and his pupils, but also with the
intention of publishing them as part of an
engraved pattern book for other artists.

Accordingly, Rubens sought to combine
the bodies or isolated extremities on some
of the pages into a new interwoven style,
used by Giacomo Franco in his drawing book
published in 1611.[1] Rubens elaborated most of
his studies with great diligence, using curved
'fishnet' hatchings and little dots to indicate
the anatomical structure of muscles, gristle,
sinews, ligaments and bones with smooth
midtones and sculptural bulges. He never used
these hatchings and dots in other drawings,
but must have taken note of how this manner
was typical of prints – for example Sisto

33 and 34 (detail)

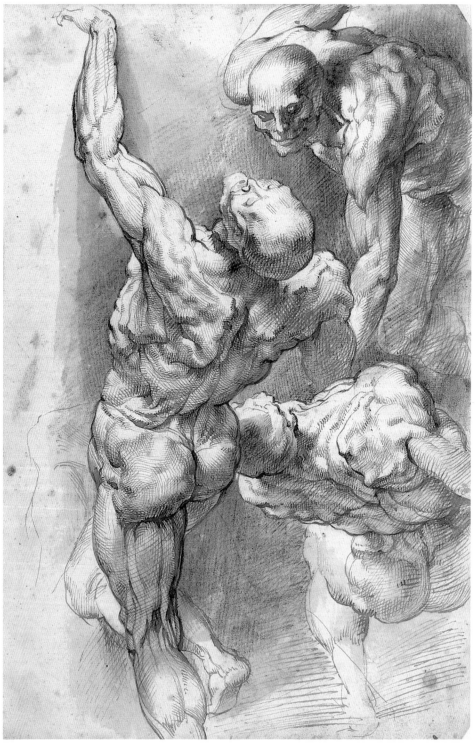

34 (detail)

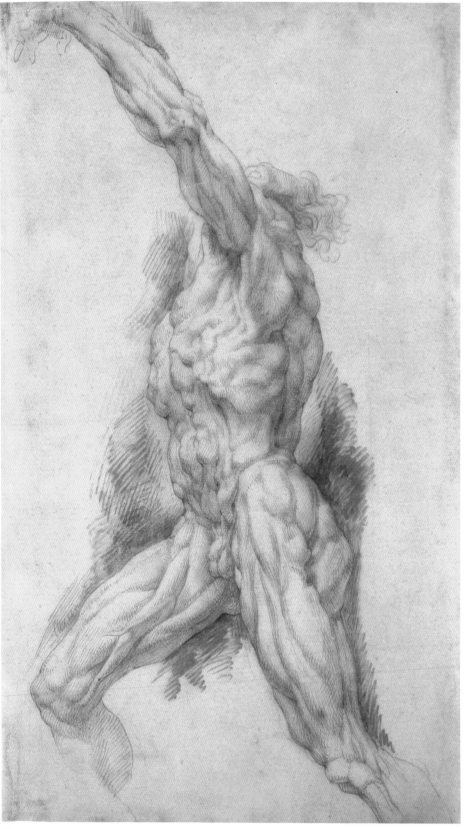

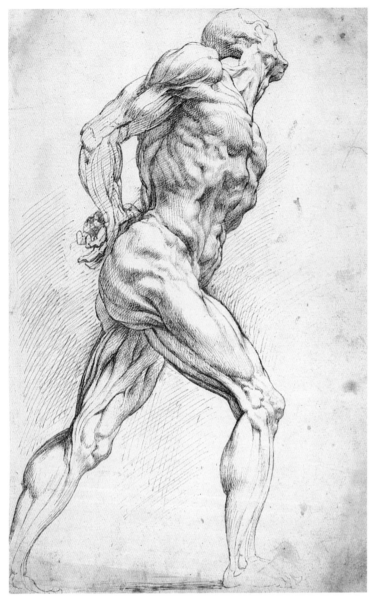

39

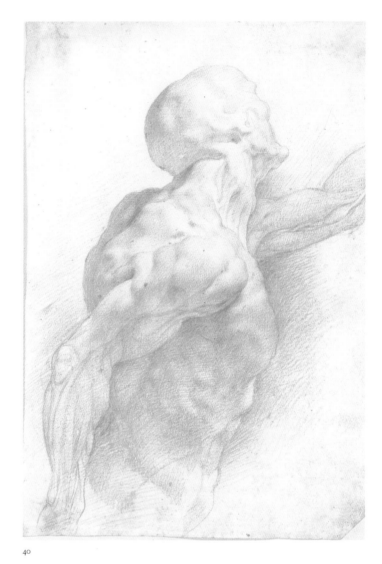

40

Badalocchio's etching after Rubens's drawing of the *Laocoön* group, or many of the skilful engravings of Hendrick Goltzius (1558–1617), the leading Netherlandish engraver, whose virtuoso *Federkunststücke* of about 1590 Rubens could have seen in about 1612.[2]

The twelve or – if one accepts the Vienna study of legs (cat. 35) – thirteen studies after a flayed male, drawn in black or red chalk, or pen and wash, are carefully modelled demonstrations of this drawing style. Rubens obviously tried to compete with Hendrick Goltzius, whose celebrated study of a hand was copied by other Dutch artists such as Jan Muller (1571–1628) who, in around 1615, was one of the first artists to make engravings after Rubens's paintings.

Rubens's interest in anatomy began to develop as soon as he reached Italy. Roger de Piles reports that he studied the anatomical drawings of Leonardo da Vinci, and he could have seen the elaborate anatomical drawings of the Paduan anatomist Fabricius ab Aquapendente – Rubens's brother Philip reports in 1602 that the Paduan medical faculty was impressive.[3]

But Rubens's *écorchés* only imitate the precision of anatomical drawings: they were not drawn after dissections. Instead, he followed Willem van Tetrode's backward-leaning flayed figure (cats 33–4), an expressive sculpture, with mannerist distortions and anatomical defects.[4] This impressive statuette is preserved in casts, which combine different combinations of pairs of arms and legs with a uniform torso. In some of Rubens's drawings the arms are cut away, or shown with incorrect anatomy, indicating that Rubens probably had an example of the sculpture with exchangeable extremities. By combining the two pairs of arms and legs documented in the preserved versions of the statuette, one can reconstruct all of the positions in Rubens's drawings. The only change is that in some sheets he animated his source by adding hair and eyes.

This jointed doll could play different roles, depending on the angle it was drawn from, and variations of it were used to show power or despair, aggression or defence, joyful dancing and lamentation. Rubens never sought to hide his source, indeed he

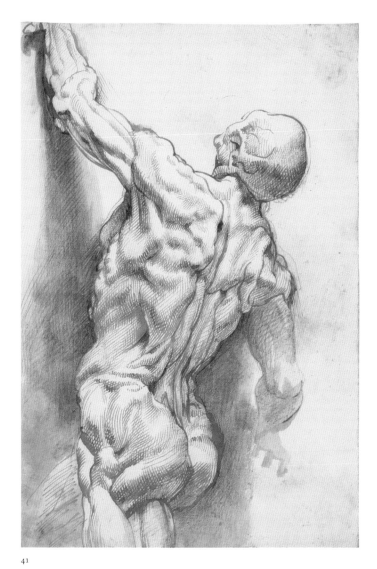

41

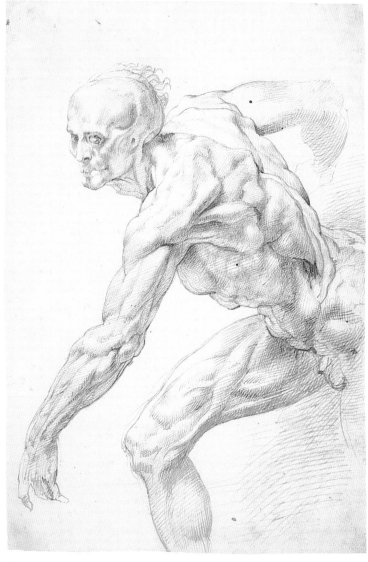

42

was proud of it: the figure of Tetrode's *écorché*, complete with bald head, is given a prominent position in his Antwerp *Raising of the Cross* (1610–11, fig. 7).

His intense engagement with Tetrode's adjustable statuette helped Rubens solve artistic problems that one can identify in earlier compositions. In his *Raising of the Cross*, the impressive bald-headed giant is substituted for the anatomically impossible, twisted cross-bearer of his modello (central figure, fig. 50), and the figure is used again, from different angles, in the strip added to his *Saint Michael striking down Rebellious Angels* (fig. 42). He drew no other sculpture, antique or modern, as often as that of Tetrode, and no other sculpture reappears so many times in his

final compositions.[5] The interchangeable extremities may also have stimulated Rubens to invent alternative positions for the figures in some of his drawings.

In view of his earlier errors in anatomy and given that there is no trace of the figure in Rubens's oeuvre before 1609–10,[6] it is likely that Rubens did not know Tetrode's statuette much before then, despite what has been assumed until now. It may seem strange that the well-learned Rubens, returning to Antwerp with first-hand knowledge of antique sculpture, should copy a statuette by a Netherlandish Mannerist. But there is a strong resemblance between the modelling of this figure and that which Rubens so much appreciated in Michelangelo, and with

publication of the drawings as engravings in mind, it seems possible that Rubens made his studies after Tetrode about 1608. UH

Examining Rubens's *écorché* studies transforms the way we read his painted figures: these 'anatomical drawings' were vital to the development of his Michelangelesque style of about 1610. The formidable agility and rippling musculature that give his figures their almost superhuman qualities take their authority from these studies (see, for example, the figures in cat. 82, who are clearly manifestations of this subcutaneous study). Earlier artists had explored the cult of the Michelangelo superman, but Rubens took the process further, giving his figures greater conviction.

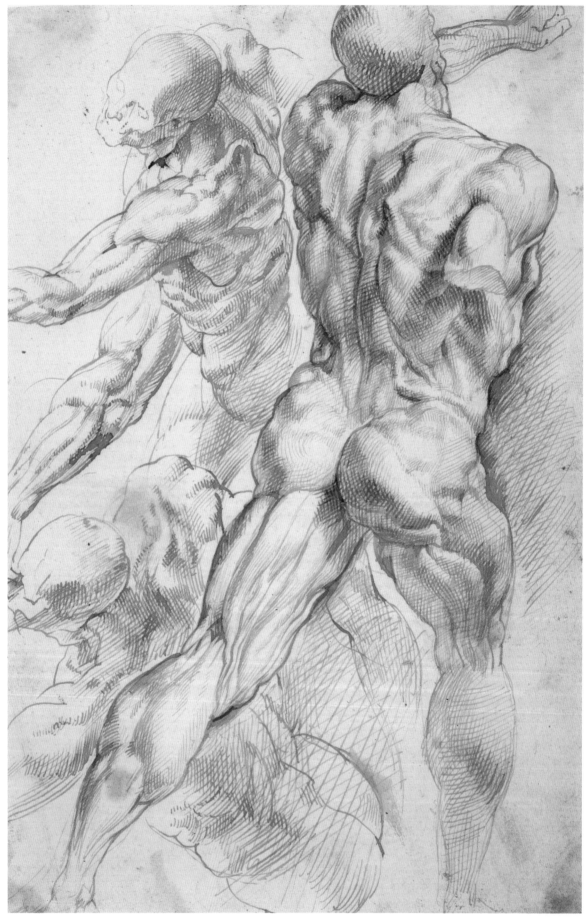

43

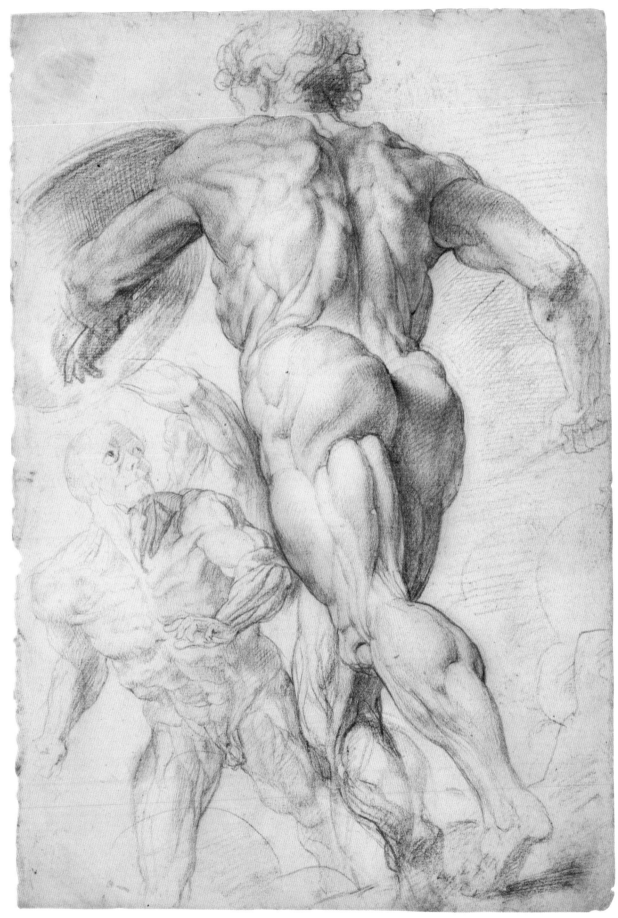

44

Tracing muscle groups and exploring difficult poses in drawings of tilted bronzes expanded his anatomical repertoire and suggested new ways of linking figures. The *écorché* drawings show him inventing and exploring at the same time as learning. Muscle structure is followed around contours, the shoulders, for example, are picked out to create a geography of hills and valleys. In some studies the potential of a figure to act in a group is tested when two or three figures are crowded onto one sheet.

Anatomists could find errors in the bodies Rubens shows, but the overall effect of rippling surfaces conveying tension and movement is highly effective. Leg muscles curve like strained springs, bent arms coil tensely to protect the head. The drawings of single arms (cat. 36, *verso* and *recto*) focus on fists in which robot-like index fingers and thumbs move inwards as they clench. Rubens evidently had a fascination for the way arms could be intertwined, and used them to link individuals together, often rotating or counter-balancing the same appendage to create a *pas de deux* or *trois*.

These drawings, assembled from sculptural sources, are a valuable way into Rubens's more complex compositional inventions. In the paintings there is often a strong three-dimensional choreography of interacting figures – men and men, horses and men, men and women, women and horses, and so on. The Prado *Judgement of Paris* (cat. 11) is a self-conscious series of *pas de deux* between three women and their disrobing putti. In the *Samson* oil-sketches (cats 72–3) a similar sense of reciprocated movement establishes the relationship between Samson and Delilah. In two of the sketches, the captor on the right of Samson counterbalances his more bulky but now ineffectual opponent.

The intertwined arms of the *écorché* studies expose the bones of Rubens's spatial thinking. Copies of his pocketbook suggest that the anatomy drawings were primary sources for the process of composition we see developing there.

1 Franco 1611; See Bolten 1985, figs 93b, 242b, 244a.
2 47.5 × about 35.4 cm, Biblioteca Ambrosiana, Milan. The etching is in Westfehling 2001, pp. 171–222, p. 198, 210, fig. 38; the connection between Rubens's drawing and Badalocchio's etching first noted in Heinen 1989.
3 Heinen in Heinen and Thielemann 2001, pp. 70–109.
4 For the identification of Tetrode's *Flayed Man* as Rubens's source see Price Amerson Jr 1975, pp. 312–33, no. 37 and Heinen 1996, p. 192, n. 94, p. 136, 138–9, 332, n. 375–7; pp. 335–7, n. 411–28.

Muller had identified the drawings as free and imaginative combinations of antique sources based on another *écorché* (Muller in Antwerp 1993, pp. 78–106 and pp. 78–106, no. 23A). This sculpture was ascribed to Tetrode in Heinen 1996, pp. 136–8, 332–5, n. 375–410.
5 Heinen 1996, pp. 139–40, 337–9, n. 436.
6 The earliest trace of Tetrode's statuette in Rubens's oeuvre is the figure of the executioner in *The Beheading of Saint John* (cat. 80). Illustrated in Jaffé 1989, no. 115, p. 170.

ESSENTIAL BIBLIOGRAPHY (CATS 33–4)
Price Amerson Jr 1975, pp. 312–33, nos 36, 37; Boeckl in Werner Hofmann 1987, 3.4–12.7, pp. 299, nos VI–41; Heinen 1996, pp. 136–8, 332–5, ns 375–410; Scholten in Amsterdam-New York-Toledo (Ohio) 2003, p. 125 ff, no. 31; Heinen in Brunswick 2004, pp. 271–6

ESSENTIAL BIBLIOGRAPHY (CATS 35–44)
Rooses 1886–92, V, no. 1229, p. 24; Jaffé 1966, I, pp. 43, 102, n. 70–1, pl. XLVIII; Price Amerson Jr 1975, no. 37, p. 312–3; Vienna 1977, no. 2, p. 4; Jaffé 1987, pp. 58–83; Garff and Pedersen 1988, pp. 78–83; Logan in Wellesley-Cleveland 1993, no. 37, p. 49, pp. 177–8; Muller in Antwerp 1993, pp. 78–106 and no. 23A, pp. 78–106; Heinen 1996, p. 192, n. 94, pp. 136, 138–9, 332, n. 375–7; pp. 335–7, n. 411–28; Höper 1997, pp. 73–82, on pp. 81 ff; Heinen in Heinen and Thielemann 2001, pp. 70–109, pp. 84–6 ff; Jaffé and Bradley 2003, pp. 3–12, p. 7 ff; Cohen 2003, pp. 490–522, 490 ff, 507

45. Female(?) nude – Psyche about 1609

Black chalk heightened with white on buff paper, 58.1 × 41.2 cm
The Royal Collection (RL 6412 W&C 434)

In the early years of Rubens's career there are few life drawings of women and little information about how and why they were made (although we have more information about his later practice: the fragment of a 1625 letter sent ahead of his arrival in Paris enquiring about the availability of three black-haired sisters is usually related to the famous sirens in the *Arrival of Maria de Medici*, Louvre, Paris, but this may be fanciful).

This large study, one of his most accomplished sheets, dates from about 1609. In all of his life drawings of men from this period a delicate use of white body colour or chalk carries highlights across the forms. That this drawing was indeed made from life

is supported by the cloth spread modestly between the model's legs. Even so, nature may have been adapted to fit Rubens's taste. The women in his paintings and drawings at this time are small-breasted and it is possible that already the young model's body is being adapted to a type that owes something to Rubens's study of ancient sculpture. The width of the figure's torso and the musculature of the stomach give a certain masculinity to the form – so it might be thought that Rubens was using and modifying the body of a male model. A comparison with the studies of men for the *Raising of the Cross* (cats 51–2) puts paid to such an idea. In this drawing the curves are rounder and the forms softer, the relief less sharply defined and muscles less clearly articulated. Rubens's search for her physicality rather than her sexual identity explains her appearance.

The drawing is a preparatory study for *Cupid and Psyche*.[1] Its existence raises the interesting question of whether similar nude studies might have been made for the various *Susannas* (cats 19–20) and even for Delilah (cats 72–7). It is possible that life drawings of individual figures were more integral to his way of working than present survivals indicate. Certainly the series of lion studies for the *Daniel in the Lion's Den* (National Gallery of Art, Washington) and *The Garden of Love* (Prado, Madrid) drawings at the end of his career encourage the idea.[2]

1 Sale catalogue, Sotheby's New York, 24 January 2002, lot. 236, fig. 1. The painting was dated about 1611–12.
2 Vienna 2004a, nos 44–6 and 111–14.

ESSENTIAL BIBLIOGRAPHY
London 2002, no. 359; Vienna 2004a, no. 35; New York 2005, no. 36, pp. 147–8

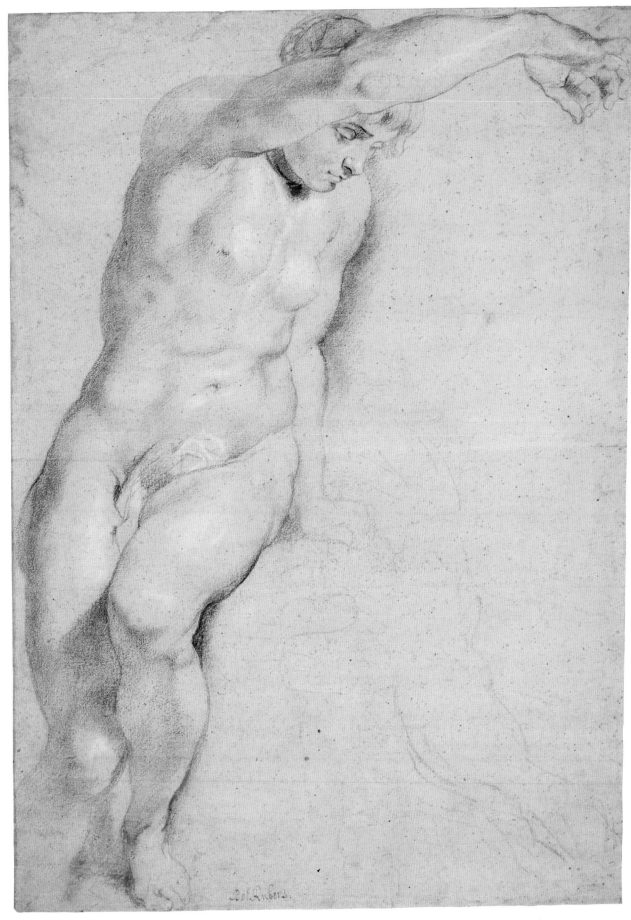

45

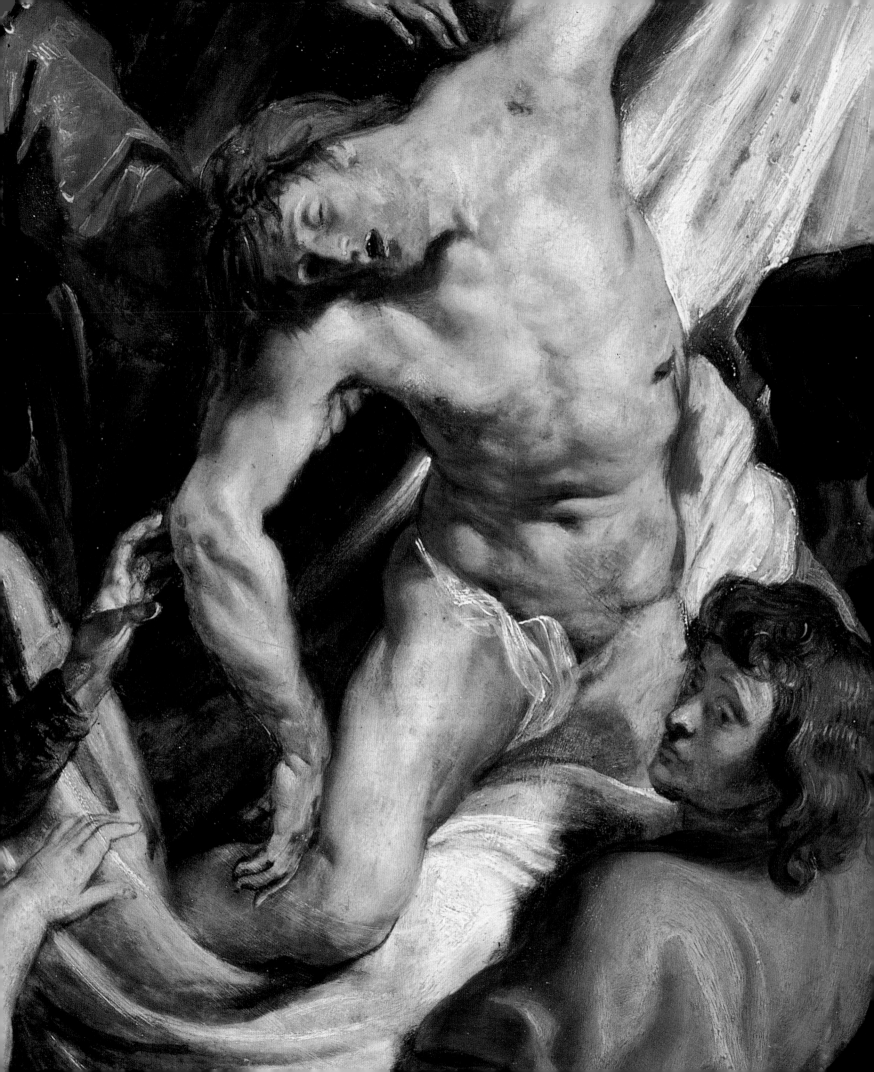

4. Rubens, the Religious Painter

Rubens would have been aware, from his earliest years in Antwerp, of the demand for religious painters. Catholicism had only been restored to the city in 1585 and Otto van Veen's workshop was busy supplying churches with altarpieces that met the demands for clearly presented religious subjects, as recommended after the reforms of the Church at the Council of Trent. In travelling to papal Rome, the heart of the Catholic world, one of Rubens's most burning ambitions must have been to succeed as a religious painter.

He undertook four important public religious commissions during his time in Italy. The first, the 1602 decoration of the crypt chapel of St Helena in Santa Croce in Gerusalemme, Rome, and second, the three canvases painted for the Gonzaga family in Mantua in 1605 (see p. 15), are too large to travel to this exhibition. They reveal Rubens as a bold and ambitious painter willing to lock horns with the great artists of the High Renaissance. His quotations from Raphael, Michelangelo and Correggio are, at this stage, still obvious.

On 1 January 1606, his *Circumcision* (see cat. 46) for the high altar of the Jesuit Church of Sant'Ambrogio, Genoa, was unveiled. It is perhaps the first indication we have of the power and monumentality which would be the trademark of Rubens's religious works. It was in part achieved, as was so much else in his art, through his study of the antique (see cats 23–8).

Confirmation of Rubens's success as a religious artist – in Italian eyes – came in the autumn of 1606, when he won the commission to decorate the area around the high altar of the church of Santa Maria in Vallicella, better known as the Chiesa Nuova. The church had been rebuilt by the reformer Philip Neri as the centre of his lay Congregation of the Oratorians. Hanging in the same church was Caravaggio's great *Entombment* (see cat. 57), a work that was to haunt Rubens and to which he would return on more than one occasion when he was back in Antwerp (cats 58–9). The commission for the Chiesa Nuova was, however, not without its problems. The Oratorians were not happy with Rubens's first attempt, and he had to submit a second. Such rigour on the part of the patron would at least have provided Rubens with valuable first-hand exposure to the demands Counter-Reformation taste could make of an artist.

Upon his return to Antwerp in 1608, Rubens's reputation preceded him and he was inundated with commissions. In the two great altarpieces he painted soon after his return, the *Raising of the Cross* (1610, see cats 50–3) and the *Descent from the Cross* (1611–14, see cat. 56), the heroic figures he learned to paint in Italy are coupled with a highly charged emotional style that embodied the spirit of contemporary Catholicism. These works established him as the leading painter of the Counter-Reformation, a position he maintained for the rest of his career.

46 (detail)

46. The Circumcision 1605

Oil on canvas, 105 × 74 cm
Gemäldegalerie der Akademie der bildenden
Künste, Vienna (897)

This oil-sketch was made in preparation
for the *Circumcision* for the high altar of the
Jesuit Church in Genoa. Rubens installed his
painting in December 1605, ready for the
Feast of the Circumcision of 1 January 1606.

The giant figures are engrossed in the
ceremony of circumcision – the cutting of
Christ's foreskin. The Virgin's raised arm
recalls the gesture of an antique Vestal Virgin.[1]
The eucharistic implications of this first
spilling of Christ's blood are advertised by
the brilliant red of the glass of wine. In the
Jewish ritual wine is sipped before the bleed-
ing wound is sucked; connections with the
Catholic mass are obvious. No knife is shown.

Rubens relied on massed drapery and over-
life-size figures to establish a sense of

monumentality in the finished picture,
complementing the vast cathedral-like interior
of the Jesuit church. The handling of paint
and perspective is fluent, from the wispy
strokes of the hair which blow around the old
man (possibly Joseph) on the far right, to the
ambitious foreshortening of the angels frolick-
ing in the beams of heavenly light. Thick,
precisely placed daubs of paint describe the
light which catches the feathers of the centre-
right angel's wing before it descends to the
man's open book. He looks up in awe at the
source of illumination, the divine light from
the inscribed name of Jesus above (which
Rubens did not add to this sketch) stresses the
fact that he is reading God's word. Above
Mary's head is the frog-jumping angel also
found in the Hermitage *Coronation* (cat. 62),
possibly inspired by a bird's-eye view of
Giambologna's *Hercules and Antaeus*. The left-
hand angel reappears as the soldier showing

his armpit in the *Conversion of Saint Paul*
of about 1598 (cat. 67); the inspiration here
seems to be the prints Rubens copied in the
1590s, but there is a similar pose in Titian's
ceiling for the Church of Salute, Venice.

The oil-sketch was already a powerful
visual tool for Rubens. In this case it
convinced the Fathers that he was fit to
undertake a major project.[2]

1 See Van der Meulen 1994, II, no. 61; III, figs
114-17, for the Mattei *Pudicitia* or Priestess of
Ceres. See also Uncini in Winner 1998, pp.
339-44. There is a similar pose in Giulio
Romano's Sala degli Stucci.
2 See New York 2005, no. 17, pp. 102-3 for a
drawing in the Walker Gallery, Liverpool, that may
be preparatory.

ESSENTIAL BIBLIOGRAPHY
Jaffé 1977, pp. 73 and 87; Jaffé 1988, pp. 525-7,
fig.39; Vienna 2004, no. 4, pp. 42-5; New York
2005, no. 17

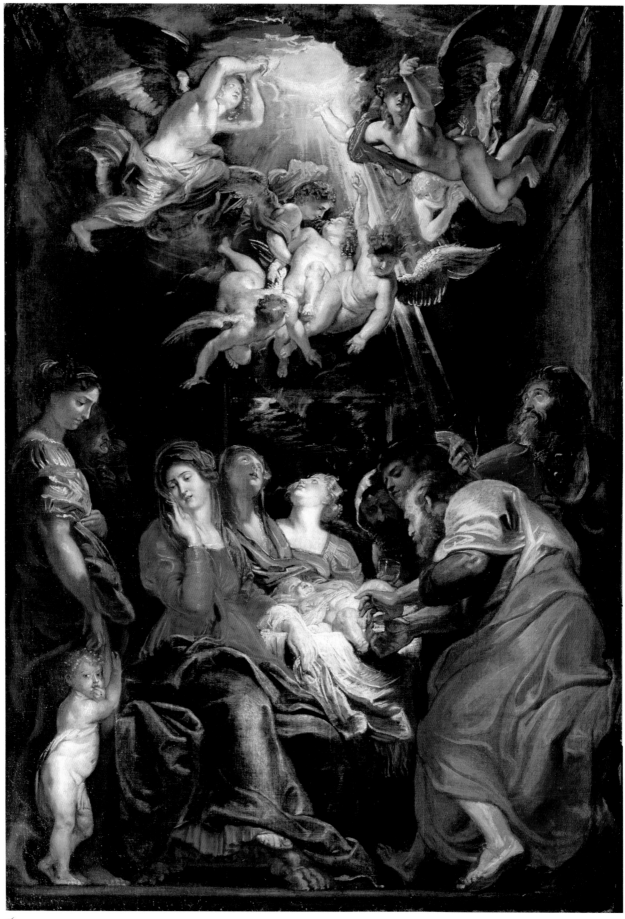

47 (detail)

47. The Holy Family with Saint Elizabeth, Saint John the Baptist and a Dove 1608

Oil on panel, 66 × 51.4 cm
The Metropolitan Museum of Art, New York
Bequest of Ada Small Moore, 1955 (55.135.1)

There is a long tradition of showing the infant Jesus with a goldfinch; the bird was supposed to have acquired its red throat by flying under the Crucified Christ. While a dove in this context would not normally be read as a prefiguration of the Crucifixion, it would have been interpreted as a symbol for the Holy Ghost – and therefore suggests some kind of violence will befall the children. Perhaps the treatment being meted out to the bird shows that Christ accepts his fate. Iconographic dove-plucking occurs suddenly in Italy in around 1611–12.[1]

The attribution of this painting has recently been challenged, partly because the large replica in LA County Museum has been joined by two new pretenders, however the visual evidence confirms its autograph status.

It is a key painting that resonates with works of around 1608. The Madonna has the flat, almond-shaped face of the servant beside

Salome in the *Beheading of Saint John the Baptist* (cat. 80). Joseph recalls *Democritus* in the Valladolid painting (cat. 18). The liberal use of an off-white ground, which Rubens has allowed to show as a half tone against the white around the dove, has strong similarities with the National Gallery *Samson and Delilah* (cat. 77), where the ground is particularly broadly used on Delilah's sleeve.

The ruffled feathers are typical of Rubens's unpreened birds.[2] The loose curls on John and Jesus are the least convincing passages, but the same failure of hair to sit around the skull is found in sections of the Prado *Adoration* (fig. 57) painted in 1609. The impasto paint surface of the dove's beak and the carpet recall the Cincinnati *Samson and Delilah* oil-sketch and passages in the London version (fig. 56 and cat. 77).

Rubens has given Saint John the pose of the climbing boy in Raphael's *Fortitude* in the Stanza della Segnatura, Vatican, but its ultimate source is probably the antique putti on the columns of the old St Peter's. Rubens introduced a similar vigorously leaping angel

in his drawing for the Vallicella Altarpiece.[3]

Joseph's face and hands have unexpected broad yellow highlights. Close up they seem crude, like those on the Elder in *Susanna and the Elders* (cat. 20), but they function well at a distance from below.[4] The painting may have hung high or been illuminated by candles, and details such as the red dots around the eyes would have been invisible.

1 See Liedtke 1984, pp. 209–13.
2 In general Rubens's birds have ruffled feathers, and the smooth, streamlined forms of the dove in the first version of the Vallicella Altarpiece (now in Grenoble) is exceptional. This applies also angel's wings – those on side panels of the *Raising of the Cross* are more typically dishevelled. Snyders, in contrast, paints a more ordered plumage, see cat. 90.
3 See Vienna 2004a, no. 17.
4 Rubens uses very similar yellow touches on Saint Jerome's neck in the *Disputation over the Holy Sacrament* in St Paul's church, Antwerp.

ESSENTIAL BIBLIOGRAPHY
Liedtke 1984, I, pp. 209–13, II, plates 79 and 80;
Liedtke in Bauman and Liedtke 1992, pp. 181–3

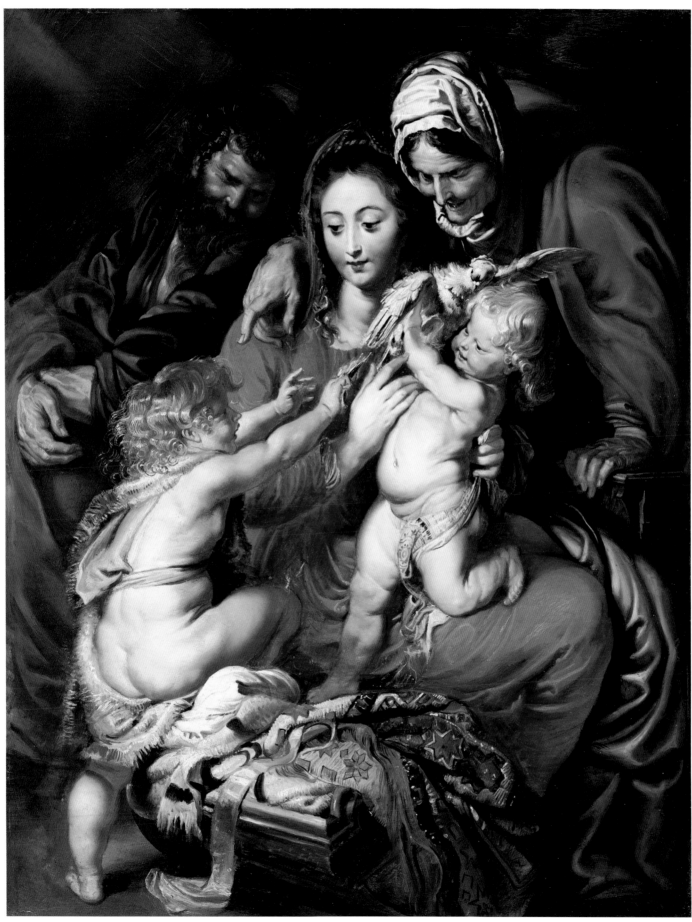

47

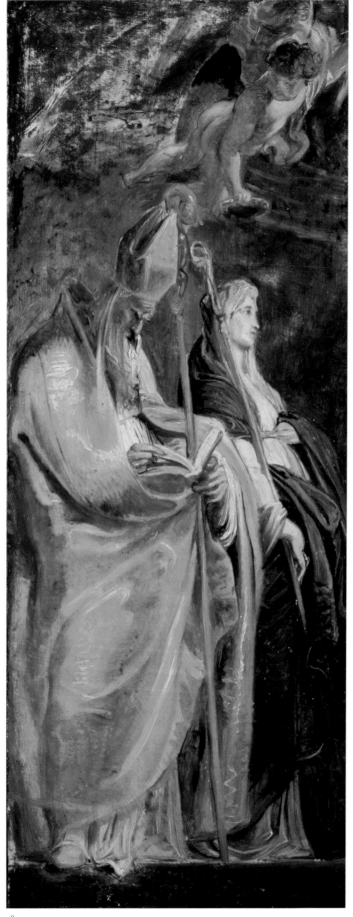

48

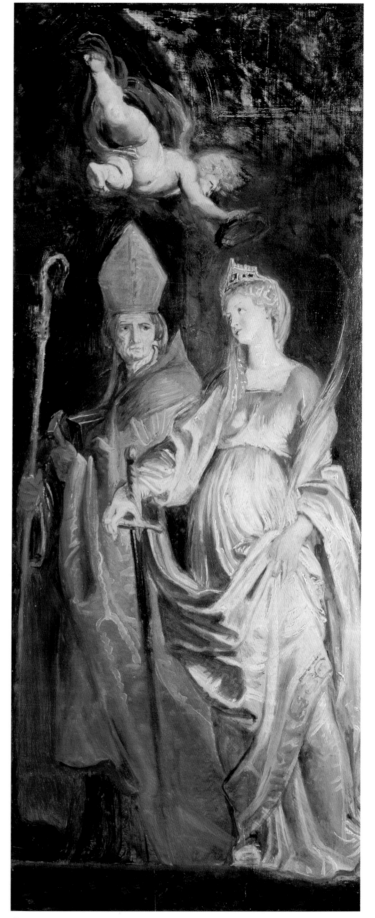

49

49 (detail)

48, 49. **Saints Amandus and Walburga** and **Saints Catherina and Eligius** (for the *Raising of the Cross* altarpiece) about 1610

Oil on panel, 66.3 × 25.6 cm and 65.6 × 24.4 cm
Dulwich Picture Gallery, London
(DPG40A/1811 and DPG40B/1811)

Rubens's *Raising of the Cross* in Antwerp
Cathedral (fig. 7) is flanked by two wings
(or shutters). On the left is a *Mourning Virgin
and Saint John*; on the right a Roman officer
supervises the nailing of one of the thieves to a
cross. On the reverse of these wings, intended
to be visible when they were closed, are two
pairs of saints: Amandus and Walburga, and
Eligius and Catherina. Catherina holds the
palm of martyrdom and the sword that
executed her (rather than the wheel which
failed to do the job). The Dulwich oil-sketches
emphasise the statuesque, larger-than-life

presence of the saints.[1] By this time Rubens
had already begun to paint large, bulkily draped
figures – for example the page in the *Gonzaga
Family worshipping the Holy Trinity* and *Saint
Gregory* in the altarpiece for Santa Maria in
Vallicella (see p. 15). His pocketbook included a
section labelled *habitius* or 'dress' (C.ms. fol.52r),
in which Raphael's pioneering, heavily draped
Saint Cecila is recorded. In the present sketches
the figures have a weight that suggests statues
or columns. In the sketches the bishops' mitres
are on their heads, not held above them by
flying putti. This made them more imposing,
but broke the colonnade-like recession of the
figure groups and was rejected in the final
painting. Saints arranged in rows were already
an established formula in Italian altarpieces

where they often supported a central,
enthroned Virgin. Showing attendant saints as
statues was popular in Antwerp altarpieces.[2]

The incised quadrants above the Dulwich
wings suggest that the altarpiece was to have a
semicircular top, as is indicated in the Louvre
sketch for the *Raising of the Cross* (fig. 50). The
final rectangular shape was adopted later.

1 Princes Gate Collection, Courtauld Institute of
 Art Gallery. See Judson 2000, fig. 86.
2 See Martin de Vos, *Risen Christ* (1590, then in
 Antwerp Cathedral), which even features a stone
 mason.

ESSENTIAL BIBLIOGRAPHY
White 1987, pp. 86–95; Judson 2000, nos 20–8 (on
the triptych), see esp. 21a

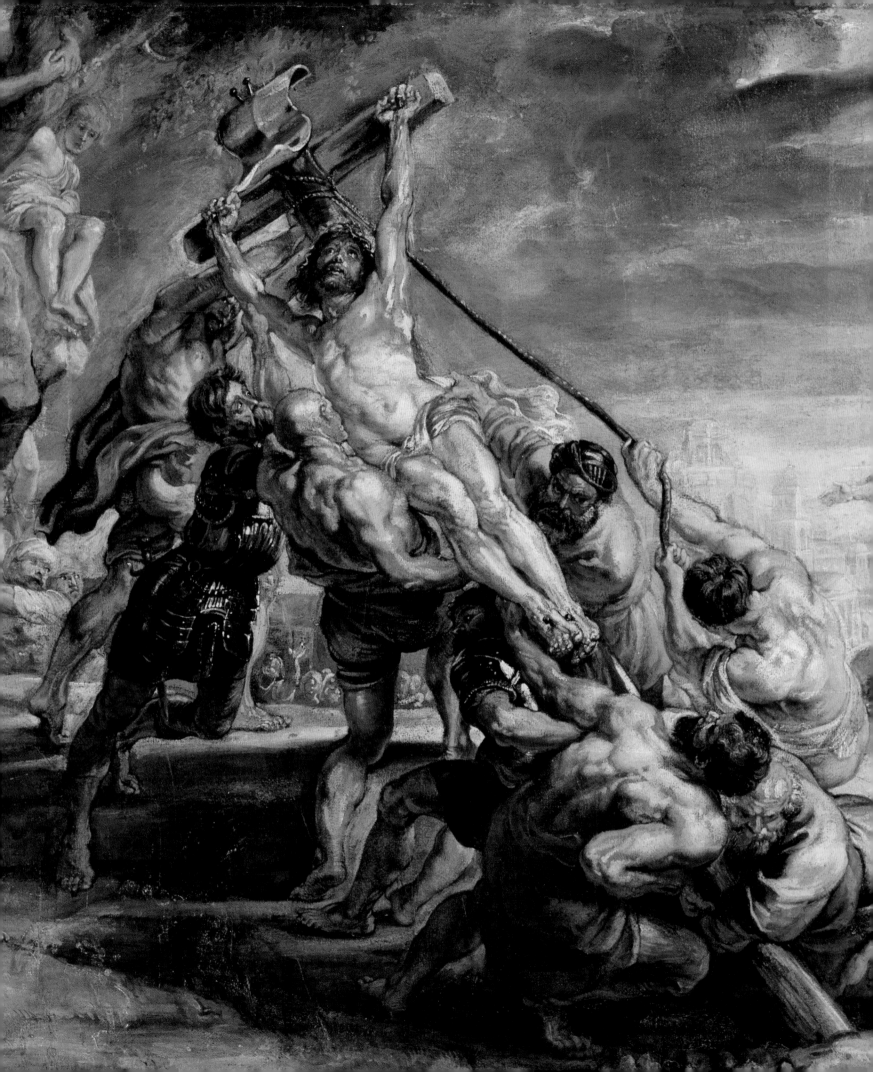

51

50-53. Studies and a *ricordo* for The Raising of the Cross

50. *Ricordo* for The Raising of the Cross,
about 1637–8
Oil on paper, later mounted on canvas,
72.1 × 132.7 cm
Art Gallery of Ontario, Toronto
Purchased 1928 (906)

51. A nude man partly from behind, about 1610
Black chalk, white heightening, 31.5 × 36.7 cm
The Ashmolean Museum, Oxford
Presented by Chambers Hall, 1855
(P.I. 200, WA 1855.154)

52. Crouching man from the back, about 1610
Black chalk with grey-black wash, 46.5 × 32 cm
Private collection

53. Study with clasped hands; a male head; a
female head, about 1610
Black chalk, white heightening, 38.9 × 26.9 cm
Albertina, Vienna (8306)

Rubens began to paint the triptych of *The
Raising of the Cross* in 1610, after his return to
Antwerp (see p. 19). Commissioned for the

church of St Walburga, which has now been
destroyed, the altarpiece is vast and therefore
cannot travel; the central panel alone is over
4.5 metres high. Several works related to it
are known, including an oil-sketch in the
Louvre (fig. 50) and the preparatory drawings
(cats 51–3, there are others). The final version
of the *Raising* (fig. 7, now in Antwerp
Cathedral) was engraved in 1638, and for that
purpose Rubens, possibly with his assistants,
made a slightly revised smaller version (cat. 50).
Rubens's ability to draw male figures in

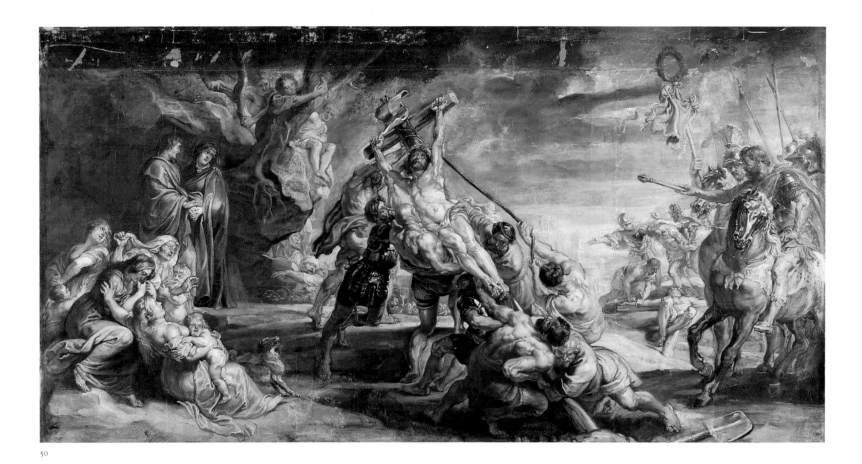

50

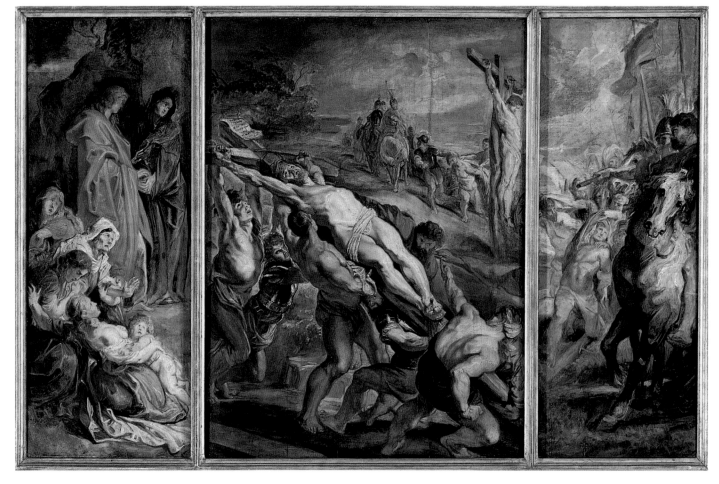

Fig. 50
**The Raising of
the Cross,**
about 1610
Oil on panel,
central panel
68 × 51 cm,
wings
67 × 25 cm each
Musée du Louvre,
Paris (MNR 411)

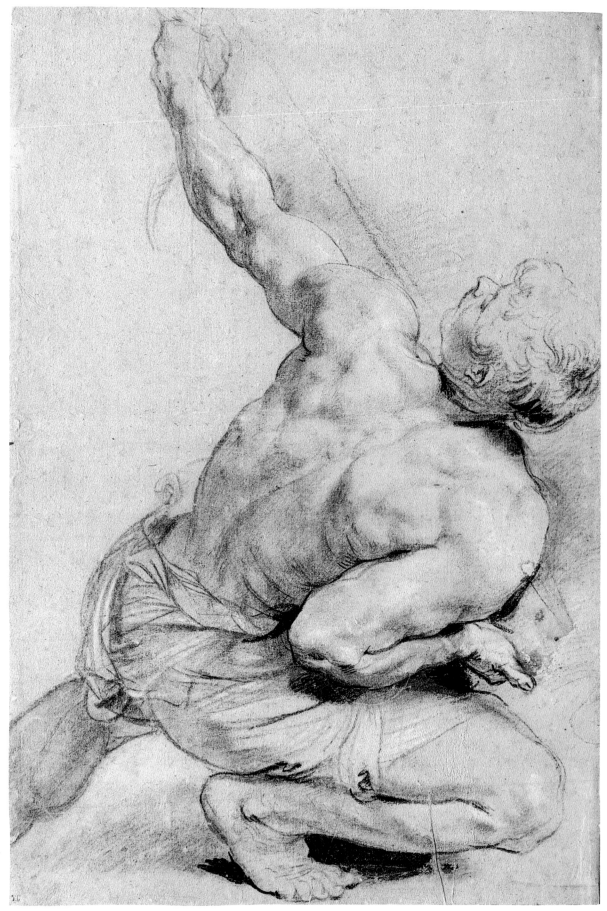

53

action is nowhere better illustrated than in the study for the man who leans back, supporting the cross (cat. 51). Muscle groups are convincingly articulated to give a real sense of effort. Redraftings at the shoulder and thigh show that the coherence of the pose and the effort to show a body under strain were Rubens's primary concerns. He has dramatised the contours of the muscles by introducing heavy black shadows, especially behind the neck and around the shoulder-blades to project the figure backwards into our space, and to accentuate the white highlighting. He repeats these profiles and deep shadows in the finished painting, showing how crucial this kind of drawing was to his picture making.

While shading is used to stress the shoulder-blades and back, the raised arm is barely defined. This study concentrates on the contours of muscle groups on the torso rather than on the whole figure. The indications of hair suggest a specific model, but one is left to wonder if this is not, in fact, a life study 'from the mind'. We know that it was preceded by an oil-sketch, where the figure's right leg is also stepped back (fig. 50), so it is possible that in the group of drawings associated with the *Raising of the Cross* Rubens was searching for poses with greater plausibility without recourse to a model. The drawing has been dated as early as 1602, and connected with the Santa Croce *Raising of the Cross* (see fig. 52) where the backward-leaning man first appears, but the highlighting seems to fit better with the 1610 *Raising* (fig. 50).

Michael Jaffé has plausibly proposed the figure of Hercules, from Tintoretto's *Hercules and Antaeus* (Wadsworth Atheneum, Hartford Connecticut), as the source of this drawing, but the pose is recorded in fig. 11, where the same leg permutations are explored.

The study of a *Crouching man from the back* (cat. 52) is perhaps even more remarkable. In the final painting, this figure, wound up like a spring, gets one leg under the cross as he pushes it up – the model appears to have pulled on a rope to hold the pose. Rubens had already explored a similar pose in his studies after two wrestlers (cat. 29); it is not surprising that he adapted it for the *Raising of the Cross*.

There are very few surviving studies by Rubens of individual hands. The hands in cat. 53 have been associated with the grieving Virgin in the final painting, and, although they are not an exact match, the idea is attractive. An alternative hypothesis, that the drawing was made as a guide for a never realised engraving, would make sense of the emphasis on the hands' expressive gesture.

The white highlight zigzagging along the wrist is typical Rubensian 'hand-writing', and has its brush-drawn equivalent in many of the artist's paintings.[1] At this date, about 1610, Rubens normally prepared for paintings with oil-sketches, so the carefully modelled head studies are surprising. However, his skilful arrangement of the elements on the sheet demonstrates his talent at assembling disparate components for later use.

The Toronto painting (cat. 50), made as a model for the engraver, represents Rubens's later assessment of his invention (assistants may have transferred some of the design). The sun that splatters the legs under the cross has been softened and the dog pulled back to clarify the energy of the central diagonal helix. Chromatic jumps between costumes have been muted to give a more coherent overall effect – although the question of why a coloured modello was needed for a monochrome engraving remains. To some degree, the pace of the composition has dropped. The rope seems slacker, the lifting muffled. The side groups wrap around the composition in a way which gives more depth and coherence and cleverly links the wings to the main picture. The spectators in trees hold the middle ground, in a way that recalls the later *Landscape with Saint George and the Dragon* in the Royal Collection (1630, Windsor).

1 It can be seen on Samson's ankle in *Samson and Delilah* (cat. 77) and the altar in the *Massacre of the Innocents* (cat. 82), as well as in the background of the Prado *Adoration* (fig. 57).

ESSENTIAL BIBLIOGRAPHY
Held 1959 (1986), no. 55, p. 91; Judson 2000, p. 105, under no. 20i (for cat. 52); Vienna 2004a, no. 31 (for cat. 53); Vienna 2004a, no. 41, pp. 248–9 (for cat. 53); New York 2005, no. 38 (for cat. 52), pp. 149–155; New York 2005, no. 40, pp. 149–155 (for cat. 53)

54. Saint Christopher and the Hermit about 1612–13

Oil on panel, 76.9 × 68 cm
Alte Pinakothek, Bayerische
Staatsgemäldesammlungen, Munich (72)

Rubens began his *Descent from the Cross* altarpiece for Antwerp Cathedral in September 1611, and started on the wings in September 1612. He had completed the commission by 1614. This study for the outside of the wings, which would be visible only when the shutters were closed, shows the giant Saint Christopher, who was patron of the guild who paid for the triptych and immensely popular since the fifth century. In the legend of the saint, he carried travellers over a dangerous torrent ('Christopher' means 'Christ bearer'), but found that an unknown child passenger got heavier and heavier.

He discovered that the child was Christ, who carried the sins of the world.

Rubens seems to have no qualms about appropriating an ancient statue, the *Farnese Hercules*, strongman of antiquity (fig. 44), as a source for a Christian saint. He relishes the chance to exaggerate the musculature with strong side lighting, and has the figure lean forward and burst out into our space. The water lapping around his shins is beautifully painted but without any refraction.

The X-ray shows that the Christ Child's left arm originally crossed his head, as it does in the British Museum drawing of *Saint Christopher*,[1] apparently derived from Adam Elsheimer's drawing of the saint (now in the Hermitage, St Petersburg).

The spotlighting provided by the hermit who guides the saint is one of Rubens's most Caravaggesque essays. In the final work the hermit is on the right-hand shutter; the strong sidelight from his lamp shows how Rubens, responding to Caravaggio, brought a new physicality to his painting.

On a page (J.ms. fol.64) in the Johnson copy of the pocketbook Saint Christopher is shown with a Hercules carrying a boar. The saint's suffering under his increasngly heavy burden is noted in the Latin inscription.

1 See Judson 2000, no. 46a.

ESSENTIAL BIBLIOGRAPHY
Held 1980, I, no 359, II, plate 355; Baudouin 1993, pp. 208–10; Judson 2000, nos 46, a–c; Munich 2002, no. 72, pp. 342–3

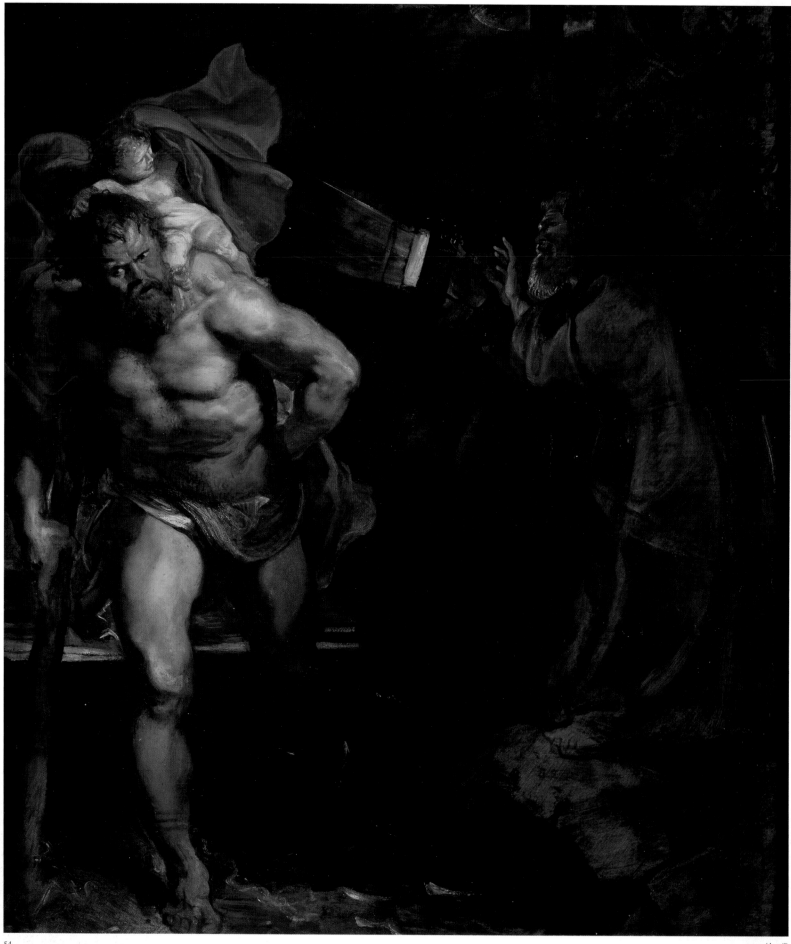

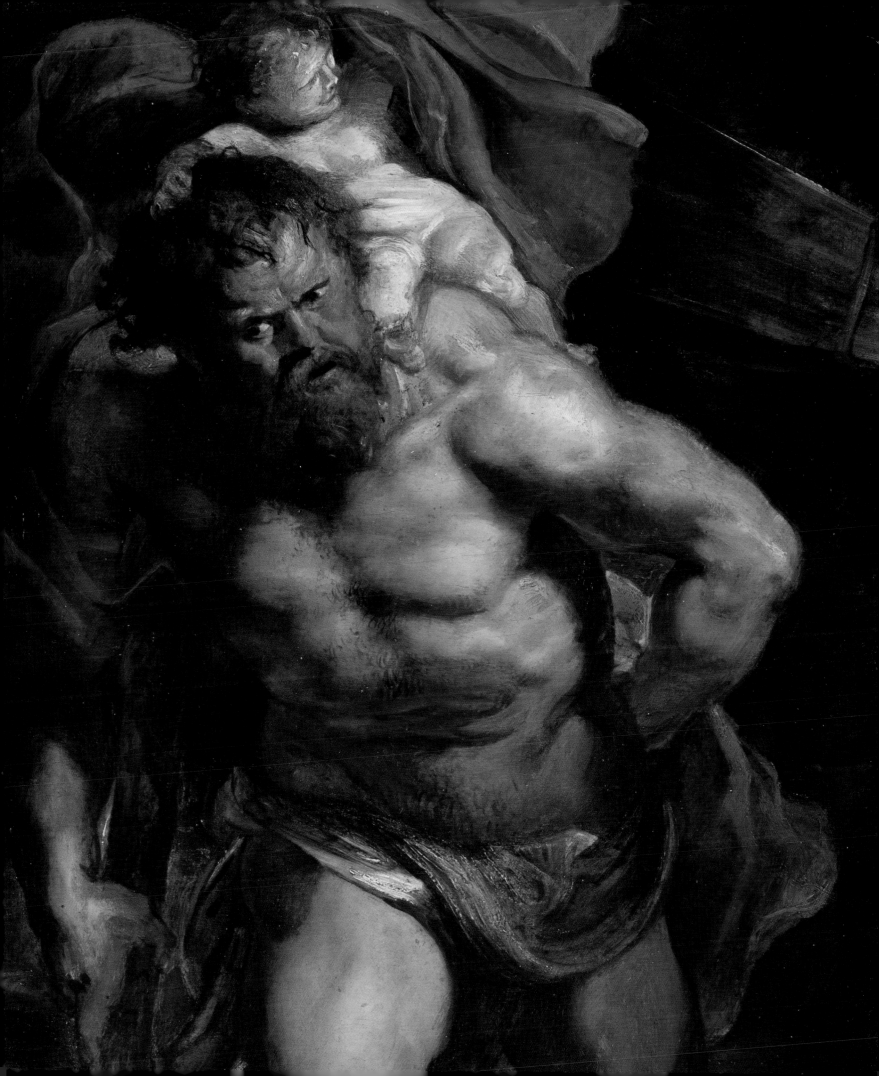

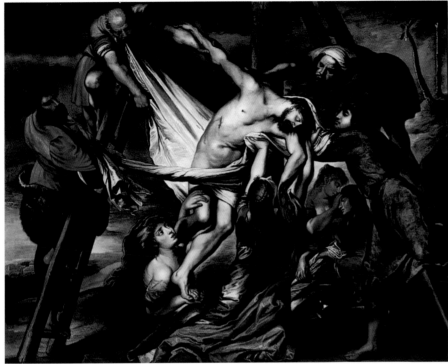

Fig. 51

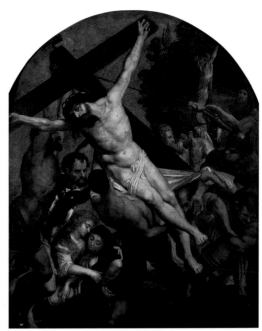

Fig. 52

55. The Descent from the Cross 1601–2

Pen and brush, with brown ink and wash,
over black chalk, 43.5 × 38 cm
The State Hermitage Museum,
St Petersburg (OP 5496)

The stocky, stumpy figures and big hair
suggest a date of around 1600. As this
drawing has much of the sophistication of
Rubens's 1611 style it has been argued that
it dates from then,[1] but the open-armed
gesture of the kneeling Virgin is reminiscent
of a drawing of *Dido* (1602–4, Louvre, Paris)
and there are related poses in the Nancy
Transfiguration of 1604–5 (fig. 6). The woman
with her back to us, evidently Mary
Magdelene, recalls a Rubens drawing
of a nereid in the Lugt collection.[2] (Showing
principal figures from behind was an innova-
tion also found in Caravaggio.) Rubens is here
working out spatial relationships between
figures that will be finally resolved in paint.

The Hermitage *Descent from the Cross*
drawing is a key document in the history of
Rubens's exploration of the passion of Christ
between 1600 and 1612. He appears to have
first painted the subject around 1601–3 for the
Duchess of Mantua's chapel. A copy of that
lost work (fig. 51) shows many of the ideas
developed in the drawing, for instance the

back view of the Magdalen and the male
assistant holding the cloth in his teeth.[3]
The latter was an idea of Lorenzo Lotto's
transmitted to Rubens through a Battista
Franco engraving.[4] The trees and jug also
appear in both cat. 55 and fig. 51. The style
of fig. 51 is heavily influenced by Tintoretto
(although his technique is not yet fully
understood), which suggests a date of
1601–3.[5] Other details, like the slumped
Virgin, recall Rubens's 1602 *Raising of the
Cross*, painted for the Chapel of St Helena, in
Santa Croce, Gerusalemme, Rome (copy in
Grasse, see fig. 52).

In the copy of the duchess's painting
(fig. 51) Christ is in a traditional straight leg
pose rather than the *all'antica* hooked pose
adopted in the drawing.[6] There are similarities
with the 1602 *Raising of the Cross* (fig. 52),
which also has a similar group of mourners
around the fainting Mary. The rope-like
drapery, which has been twisted into a cord in
order to haul the body horizontally, is
different from the drawing, but the drawing
has a vestigial chalk line running across from
Christ's hand, suggesting that the line of the
shroud has been altered.[7] Saint John's pose
could be seen as a further exploration of the
Hercules/Atlas type we have met in the

pocketbook (fig. 11), and relates to the figure
in the *Raising of the Cross* (fig. 52). Above him
there is a black chalk indication of a nailed
hand being grasped by the wrist, a
permutation resolved in the inscription. The
passing of the body and the row of mourning
women are the focus of the composition.
Rubens clearly felt that the standing woman
supporting Mary in the drawing (but not in
fig. 51), was an improvement. In the 1611
painting it is Mary herself who is standing; her
arms which are spread in the drawing now
reach forward to touch her son, as prescribed
following the Council of Trent.[8]

Rubens takes up much of the vocabulary
of the Hermitage drawing in the *Raising of
the Cross* of 1610 (see cats 50–3), and its
counterpart the *Descent from the Cross* of
1611–12 (fig. 23). The pose of Christ is
turned into a flourish, but most of the cast
in the drawing recur. Only the horizontal
rope-like cloth is suppressed to allow a more
vertical descent.

In this sequence we see Rubens conceive a
complicated composition, refine it and
develop it. Typically, having resolved it, he
explored very different variants.

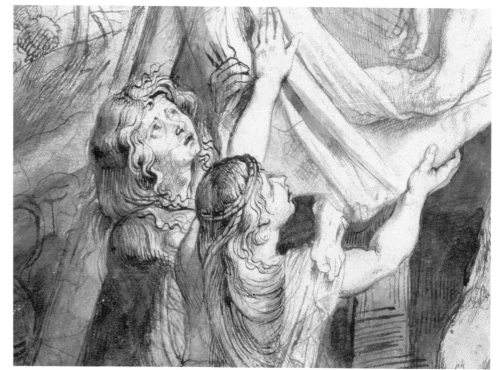

Fig. 51 After Peter Paul Rubens
The Descent from the Cross, 1601–3
Oil on canvas, 200 × 255 cm
Private collection

Fig. 52 After Peter Paul Rubens
The Raising of the Cross, after 1602
Oil on canvas, 224 × 180 cm
Grasse Cathedral
Conseil général des Alpes-Maritimes, Nice

55 (detail)

56. The Descent from the Cross 1611

Oil on panel, 115.2 × 76.2 cm
The Courtauld Institute of Art Gallery, London
(P.1947.LF.359)

Rubens was commissioned to paint the *Descent from the Cross* for Antwerp Cathedral on 7 September 1611. The centre panel, made in his studio, was installed before 17 September 1612. The wings (see cat. 54) were delivered in the spring of 1614. For the composition he turned to a drawing he had begun some ten years before (cat. 55) – perhaps with this prestigious space already in mind. The present work is a much smaller version of the central panel of the great altarpiece, but it is taken to a high degree of finish and may have been the *modello* Rubens presented to the Arquebusier's Guild to secure the commission.

Christ's body is caught by John the Evangelist who acts as foil, much as the man who holds the cross in the *Raising* (cat. 51) does. Rubens, like Tintoretto, was fascinated by figures that lean into our space and although Federico Barocci's Senigallia *Entombment* gives a supporting figure a role similar to that of Saint John, Rubens was quite capable of inventing the pose himself. The unusual hooked position of Christ's legs has a direct source in sculptures showing Pentheus being torn apart

by maenads: the subject appears on a carved sarcophagus at Pisa, but more topical was a relief found in Rome that was already being discussed by 1600.[1] The X-ray shows Christ was originally more cradled by the shroud – as he is in the St Petersburg drawing (cat. 55).

Rubens has already begun to contain the energy of the paintings he made on his first return to Antwerp, and to focus more on expressive details. The Virgin Mary leans forward with spread fingers to touch her son. The two Maries (Mary Magdalene and Mary Cleophas) who grasp Christ's feet offer a respite from the effort of the straining men. They remind one of their less grief-stricken counterparts in the *Assumption of the Virgin* (cat. 62) painted at just this time. Altogether Rubens's compostion has become more measured and classical.

1 See Jaffé 1994, fig. 5, pp. 301–22. Bruni stated in a letter from Rome (27 October 1601) that the relief was in Altoviti's house. It is now in Turin Archeological Museum, see *Lexicon Iconographicum Mythologiae Classicae*, VII, I, no. 32, p. 310. Other sources have also been suggested, see Judson 2000, pp. 167–8.

ESSENTIAL BIBLIOGRAPHY
Held 1980, I, no. 355, pp. 488–91 and II, fig. 351; Judson 2000, no. 43b; London 2003–4, pp. 54–61

1 For example London 2003–4, p. 55; Held 1980, I, p. 490.
2 Jaffé 1977, fig. 230.
3 See Bernaerts, Antwerp, *Oude & Romantische Meesters Kunst* 23–5 November 2001, lot 124. Thanks to George Gordon and Ben Benhaven for this notice.
4 See Rotterdam 2001, no. 8, p. 78.
5 Berzaghi 1984, pp. 85–107.
6 A possible Pentheus and maenads source is proposed in the Courtauld *Descent from the Cross* entry (cat. 56), esp. n. 1. See also, for the general use of fragments, Mendelsohn 2001, pp. 107–8.
7 The use of a shroud to support (rather than wrap) Christ's body was inspired by Titian's *Deposition* (Louvre), which was then in Mantua. This painting was also displayed in the Duchess of Mantua's chapel.
8 There is a *pentimento* with her arm further back.

ESSENTIAL BIBLIOGRAPHY
Held 1980, I, no. 355, pp. 488–91 and II, fig 351; Judson 2000, no. 43a; London 2003–4, pp. 54–61

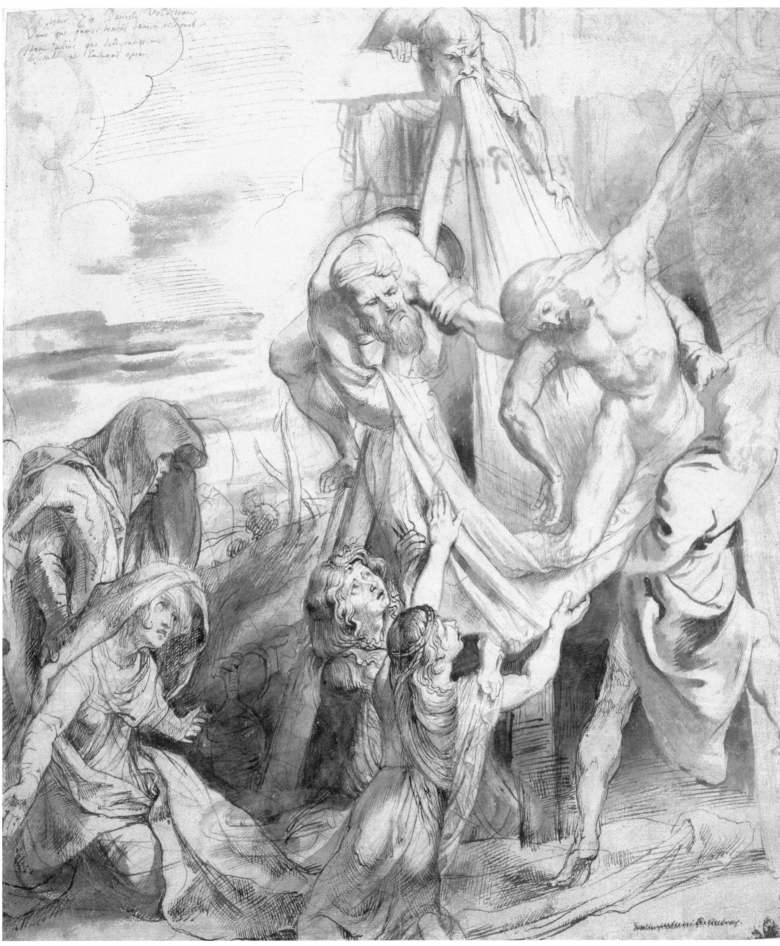

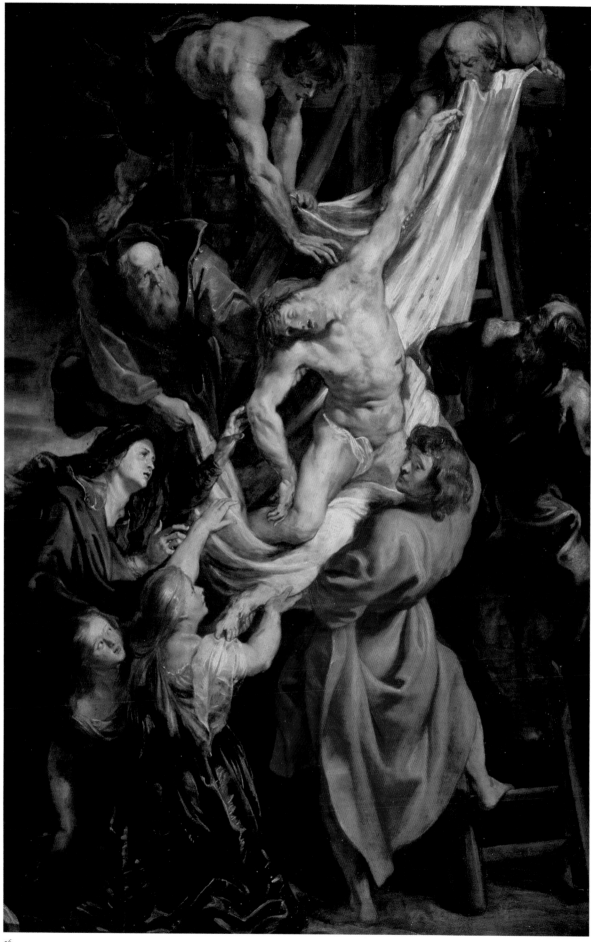

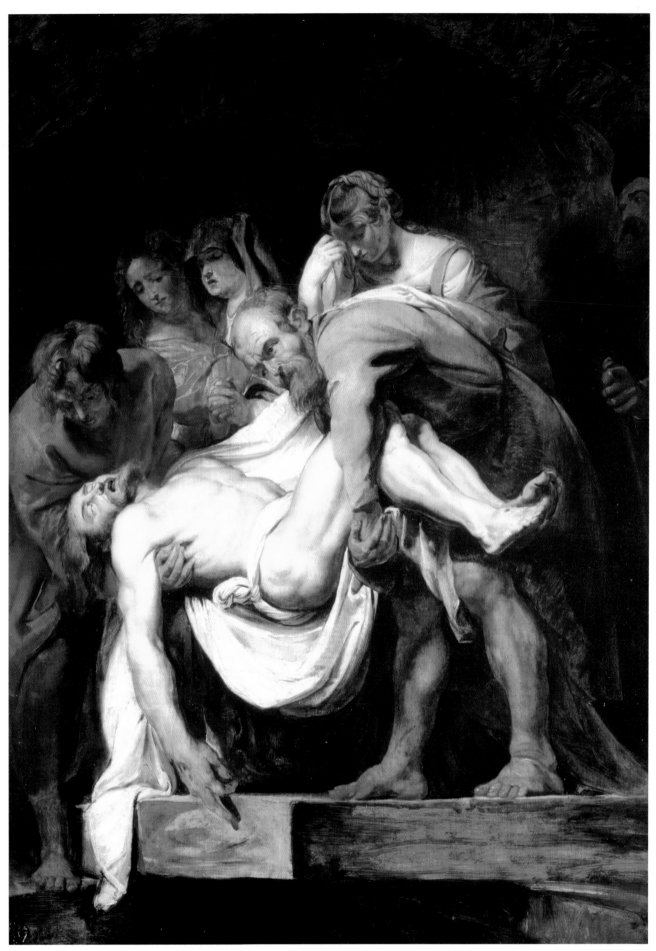

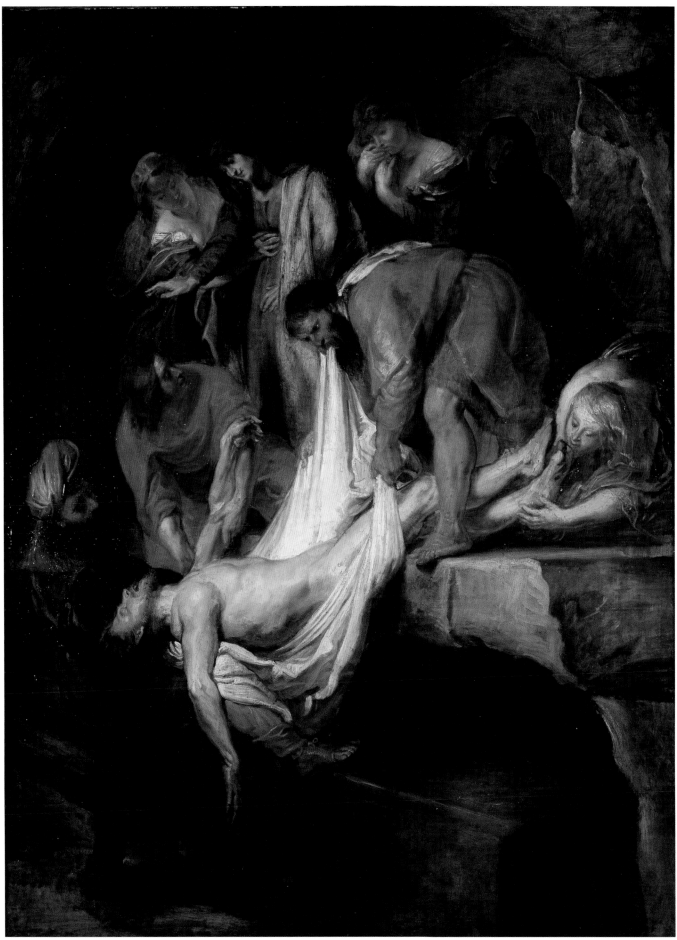

57. Rubens after Caravaggio The Entombment 1612–14

Oil on panel, 88.3 × 66.5 cm
National Gallery of Canada,
Ottawa, Ontario (6431)

Caravaggio's *Entombment* of around 1603 decorated the second chapel on the right in Santa Maria in Vallicella. This great new church of the Oratorians was a show place for leading artists then in Rome. Rubens contributed a high altarpiece (see p. 17) and worked on it there for a considerable time in 1607–8.

The inventory made after Rubens's death lists a number of painted copies, many after Titian (Rubens's pupil, Van Dyck, had a roomful of those) and several after other painters, including Leonardo and Mantegna (see the National Gallery's *Triumph of Caesar*, made after a Mantegna now at Hampton Court). Nor is there anything strange in finding a copy after Caravaggio – Rubens admired his work and tried to promote it. He recommended the purchase of Caravaggio's *Death of the Virgin*

(now in the Louvre) to the Duke Vincenzo Gonzaga and later, in 1620, led a public appeal to purchase Caravaggio's *Madonna of the Rosary* for St Paul's church in Antwerp (today in the Kunsthistorisches Museum, Vienna).

Extreme side-lighting, and the play of light and dark that it creates, was an innovation Rubens absorbed from Caravaggio. Both artists were interested in suggesting the mental state of their subjects, both chose to represent individual faces rather than ideal types, and both introduced white cloth as a foil to enhance flesh tones – perhaps the effect it created was the 'glow' which Dutch painters at the time said was being introduced by their Italian contemporaries.[1] What is difficult is working out when the copy was made.

Although Caravaggio's picture was in Santa Maria in Vallicella in Rome while Rubens was working there, it is not likely that he would have used an oak support for a painting when in Italy, which has led to the

suggestion that it must have been painted on his return to Antwerp, perhaps from a drawing. That view is supported by the modifications he made to Caravaggio's design. He deleted the woman who reaches upwards at the back and changed the appearance of other subsidiary figures. The composition intrigued him, but he challenges its relief-like planar arrangement.

The Deposition, the taking down of Christ from the Cross, and the Entombment, the carrying of his body to be anointed and buried, are related moments in the final drama of Christ's passion. It was essential to Catholic doctrine that Christ was made man and died for the remission of our sins. Rubens, in his art, took up the challenge of how to represent the humanity and the divinity of Christ.

1 Taylor 1992, pp. 210–232.

ESSENTIAL BIBLIOGRAPHY
Jaffé, 1977, pp. 57–8; Judson 2000, no 75, pp. 243–5

58. The Entombment 1615–16

Oil on panel, 83.1 × 65.1 cm
The Samuel Courtauld Trust, Courtauld Institute of Art Gallery, London
Bequeathed by Count Antoine Seilern as part of the Princes Gate Collection, 1978
(P.1978.PG.365)

Rubens must have felt Caravaggio's solution (which he copied in cat. 57) was too planar; in this later attempt at the subject he builds a much more complex setting. The Maries, fanned out in a curve, stand on an angled ledge. The precariousness of the figures, despite being muted in reproductions, is reinforced by the way the sarcophagus juts out below them. Rubens must have been engaged by the tension Caravaggio created in his *Saint Matthew and the Angel* (Santa Luigi dei Francesci, Rome), where the saint's stool almost topples into our space.[1]

The stage Rubens creates allows him to retain the arrangement of the figures while introducing tilts and slides that energise the composition. The jack-knifed man holding the shroud in his mouth is the fulcrum for the group.[2] His saffron tunic contrasts with the red reflections it receives from John's cloak. The Virgin's gesture, reaching across towards Jesus, is spatially ambivalent but doctrinally relevant as she became our intercessor.

There is a remarkable resonance between cat. 58 and the *Descent from the Cross* (cat. 56). Indeed, the present painting can be best read as a revision of cat. 56 built around the matrix of Caravaggio's *Entombment* (see cat. 57).

Many of the same ingredients are used, but transformed. The straddled pose of the red-cloaked Saint John in the *Descent from the Cross* (cat. 56) has been adopted by the green-cloaked, turbaned Joseph of Armathea in the *Entombment*. The play of Christ's dead flesh against white cloth is repeated, but the pose is inverted. In both pictures the weight of the shroud is countered by a straining, biting figure (the only figure to show emphatic physical force). It is as if Rubens, having assembled his cast in 1611, is working through the choreographic possibilities five years later. In both the *Descent* and the *Entombment* Christ's dead arm becomes an eloquent plumb line which expresses the downward force of the weight of his body.

The emotional centres of the painting are the faces of Christ, his teeth bared in the agony of his death, and of the Virgin, who reaches out, open-mouthed in her grief, to touch him. The figures are surrounded by drapery which swirls in agitated curves.

The figure attending to Christ's feet,

almost certainly Mary Magdalene, leans forward in a way that recalls a 1548 Enea Vico print after Raphael's *Pietà*. There is a copy of this engraving in the pocketbook, and a large painted copy has recently been attributed to the young Rubens, rather than to his teacher Van Veen.[3] There are similarities to Rubens's style of around 1600 – the angular fold patterns of the drapery and the dawn light chilling the landscape – that encourage the idea of Rubens authorship.[4] All the women in the Courtauld *Entombment* have some décolletage but the Magdalen would appear to be wearing a backless dress – risqué even by the generous standards of Antwerp in 1610.

1 Although at this date Rubens even stacked books precariously, see the *Saint Jerome*, Schloss Sanssouci, Potsdam.
2 The inspiration may have been one of the Apostles in Raphael's cartoon for the *Draught of Fishes*, now in the Victoria and Albert Museum, London.
3 For the pocketbook copy see C.ms. fol.10v. For the painting see Jaffé 1989, no. 6.
4 Another candidate for Rubens attribution, *Adam and Eve* (also dated around 1599, Rubenshuis, Antwerp) has its source engraving copied in the pocketbook: fol.62v; Jaffé 1989, no. 8.

ESSENTIAL BIBLIOGRAPHY
Judson 2000, no. 77, pp. 246–7; London 2003–4, p. 112

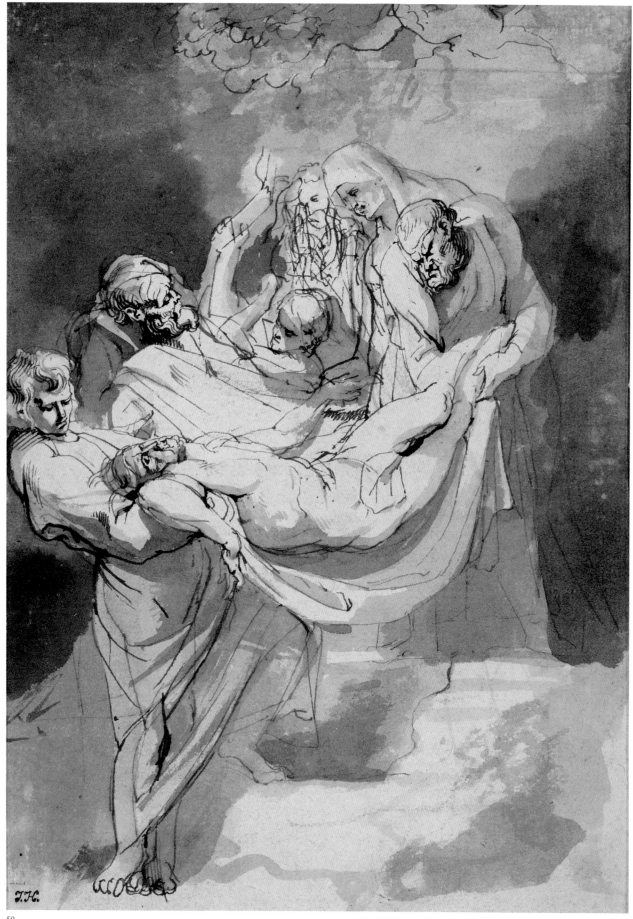

59. Study for an Entombment about 1615

Pen and brown ink and wash, 23.3 × 15.3 cm
Rijksmuseum, Amsterdam (RP-T-1899-A-4301)

In this exploratory study of another scene from Christ's Passion (see cats 55–8), Saint John the Evangelist again leans back to hold a much more floppy Christ. A redrafting increases the straddle of John's right leg. Christ's pose may have been inspired by Titian's Louvre *Deposition*, which Rubens copied when it was in Mantua.[1] The simplified, almost wedge-like face of the man holding the feet (Joseph of Arimathea) recalls the Louvre oil-sketch for the *Raising of the Cross* (fig. 50), and it may hark back to his early Antwerp explorations of that composition. He holds the shroud with Nicodemus who stands just above John. The triangular tension increases the sense that Christ could tumble out into our space. The torch-bearer unwraps himself from the shroud, while his light shows the grieving Mary behind him and casts a deep shadow onto Christ's hand. Two heads beside the Virgin's face may be the other Maries or simply experiments in positioning. Rubens has used wash to solidify and support the forms.

1 Jaffé 1989, no. 129. Giulio Romano explored the angled orienatation of Christ's body in a series of drawings (probably inspired by Titian's *Deposition* (now in the Louvre).

ESSENTIAL BIBLIOGRAPHY
Judson 2000, no 76, pp. 245–7

60-62. The Assumption and Coronation of the Virgin

60. Upper body of a man leaning forward,
about 1611–12
Black chalk and red chalk, heightened with white, 40.2 × 24.6 cm
Albertina, Vienna (8300 *recto*)

61. The Assumption of the Virgin, 1613–4
Oil on panel, 102 × 66 cm
The Royal Collection (RCIN 405335)

62. The Coronation of the Virgin, 1611
Oil on panel, applied to canvas, 106 × 78 cm
The State Hermitage Museum,
St Petersburg (GE 1703)

The *Coronation of the Virgin* in the Hermitage and the *Assumption of the Virgin* sketch in the Royal Collection were part of Rubens's 1611 attempt to seize Otto van Veen's commission for the high altar of Antwerp Cathedral. Rubens's audacious offer of impressive alternatives worked, but the painting was not put in place in the Cathedral until 1625. It may be that he did not want to offend his former teacher. The dating of both the London and the Hermitage paintings is complicated by their physical condition and by the fact that Rubens also worked on a whole series of other versions of the subject in the 1610s.

Although his *Assumption* drawings are softer than those for the *Raising of the Cross* (cats 51–3) and seem to show a move towards his later, more classical phase, the study for the man rolling back the stone (cat. 60), clearly the most stressed figure in the painting, has some of the straining muscularity and strong relief of the earlier drawings (cats 51–3). Rubens emphasises the effort involved in supporting the tomb lid by introducing red chalk over the black to convey the flush in the man's face.[1]

Rubens uses the rolling back of the stone to break the symmetry of the gathering. The three Maries gathering the flowers the departing Virgin left behind are one of his most sensuous and beautiful female groups. The banks of musicians in the upper corners and frolicking putti give the painting a joyous mood; only the emphatic gestures of the apostles suggest that anyone below is focused on the coronation above. The Royal Collection picture integrates the tomb and the men lifting the lid with the group at the centre of the design. It is a more robust and mature version of the subject, and an explanation will have to be found if this really is one of Rubens's 1611 submissions. Unlike the Russian painting, which is muted by a skin of old vanish, it is sparklingly clean. A strongly Raphaelesque kneeling figure closes the composition on the right-hand side.[2] Later, in the final work he was to revive a Taddeo Zuccaro invention of the back view of a standing man leaning on the tomb and looking back to close off the right-hand side. The intermediate steps between these first sketches and the final painting are complex, but the Kunsthistoriches Museum, Vienna, painting is a reasonably accurate translation of sections from both oil-sketches. A drawing in the Albertina of the *Assumption* curiously shows a child on its back that recalls the Christ Child in *The Circumcision* (cat. 46), and the baby being held by the scratching woman in the *Massacre* (cat. 82). Certain gestures such as Saint John's raised arm covered by a cloth which casts a very Veronese-like shadow over the face appealed to him in both versions.

The Virgin was the protector of the city of Antwerp and the patron of the Cathedral. Confirming her position with an altarpiece (and installing her statue onto the façade of the town hall) was a political as well as a religious statement.

1 There is a drawing of a distorted head in the pocketbook (C.ms. fol.17v), labelled 'Facis Rubcinda' ('red faced').
2 Titian's *Pentecost*, in the Church of Salute, Venice, has a similar kneeling figure – which may have been Rubens's direct source.

ESSENTIAL BIBLIOGRAPHY
Freedberg 1984, nos 35 and 46, pp. 138–143;
London 2003–4, pp. 62–5; 136; Vienna 2004, no. 16, pp. 80–5; Vienna 2004a, pp. 238–47

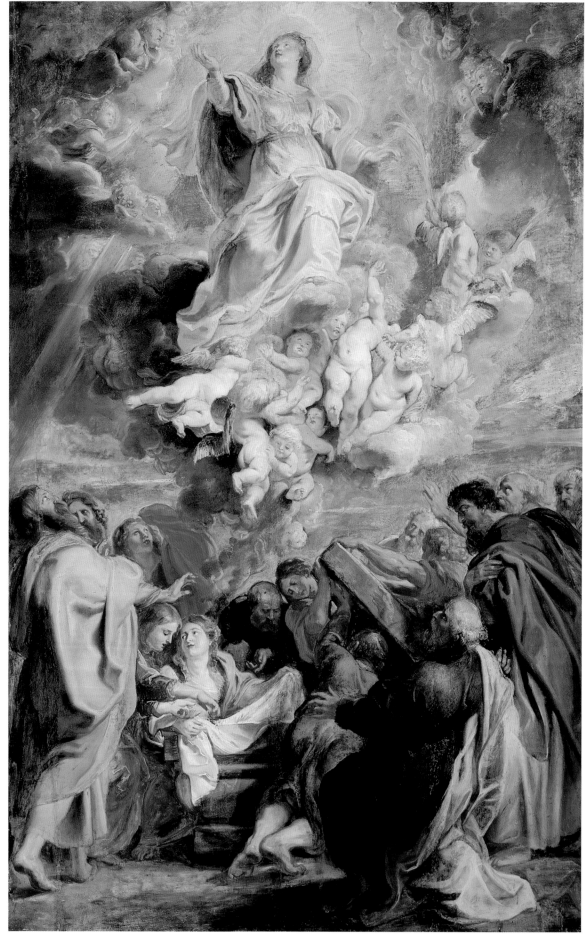

61

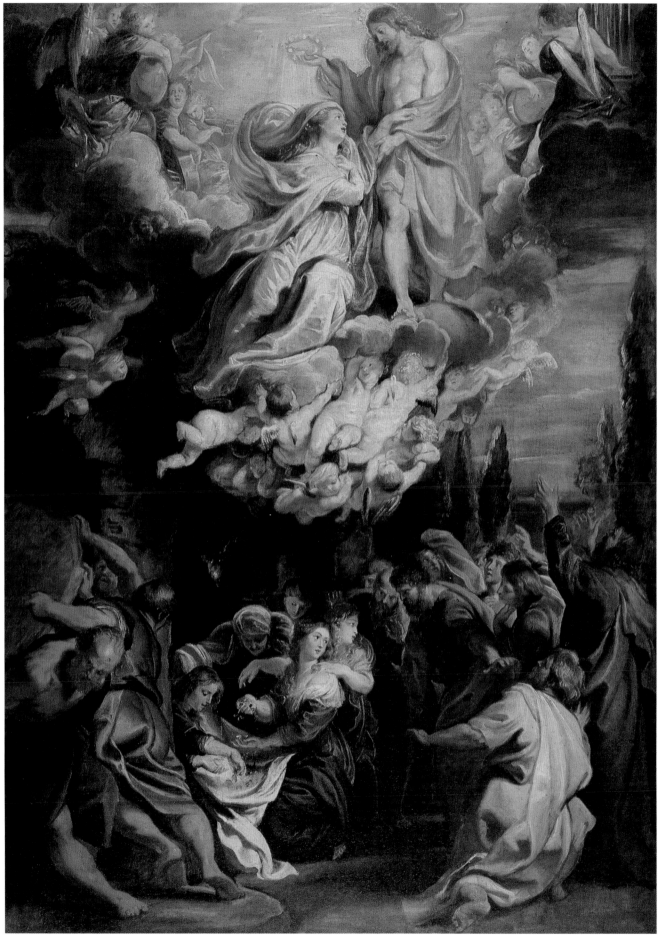

63

63. Saint Bavo about to receive the Monastic Habit 1611–12

Oil on oak, 106 × 164 cm
The National Gallery, London (NG 57.1–3)

Saint Bavo was a soldier who defied an edict of Emperor Mauritius by renouncing the Roman army and joining the Church. In the centre we see him on the steps of St Peter's, Ghent, handing in his sword and being received by Saints Amand and Floribet into the Benedictine order. The imperial herald is arguing with Kings Clothar and Dagobert on the right.

The composition of the central scene starts with a trickle of Benedictine monks by the background portico and flows down to the magnificently poised receiving bishops before streaming across the right shutter.

On the left shutter Bavo's sister, who stands on the ledge, again shows how big drapery can be used to emphasise the main protagonists. A nucleus of the poor is embraced by these two masses of figures.

The *Saint Bavo* altarpiece has recently been associated with the *modello* ('*disegno colorito*') that Rubens refers to in a 1614 memo to the Archduke Albert in which he asks the archduke to intercede for him in his efforts to obtain the St Bavo Cathedral, Ghent, commission.[1] The painting's strongly Venetian mode is at odds with most of Rubens's paintings from this period. The centre right figures do match some of those in the early oil-sketches, but as there are also parallels with the figures and handling found in the 1616–19 Jesuit altarpiece oil-sketches for Saint Xavier and Saint Ignatius now in the Kunsthistoriches Vienna, it is just possible this oil-sketch is connected with Rubens's second attempt (around 1614) to win the St Bavo commission. He finally got it in 1622. There is evidence of Rubens's interest in historical costume; his costume book has many drawings made after late medieval and early Renaissance dresses and headdresses. The horse in the right wing was recycled in the Prado *Adoration* of 1629 (fig. 57), as the wings were eventually redundant in the reduced St Bavo scene (which was just the central panel).[2]

The sketch has many beautiful passages: the sleeping babies in the foreground, the child gathering his smock to catch the handout, the diaphanous sails of the women's headdresses on the left, and the interplay of the flashing eyes of horses and men on the right. It is not in very good condition, so it is now hard to see why Rubens called it the most beautiful thing he had made until then – but the complex composition is handled with great assurance.

1 Submitted during the bishopric of Maes – 1610 to 21 May 1612.
2 Held has speculated that the *verso* of a Berlin drawing of Bathsheba may be related to this painting. Held 1959 (1986), no. 83, p. 102.

ESSENTIAL BIBLIOGRAPHY
Held 1980, I, no. 400, pp. 547–50; Martin 1986, no. 57, pp. 126–8; London 2003–4, p. 9

63 (detail)

5. Sequences: Building a Composition

Throughout his career Rubens used drawings to develop ideas. In addition, around 1606, he began to make use of another device, the oil-sketch, to work out compositions. He may have begun using them to satisfy Italian clients, as these *disegni coloriti* (as the sketches were known) were an effective way to present ideas to patrons. They quickly came to replace wash drawings as his chosen medium for the fast explorations of ideas, and more precise worked-up oil-sketches were used as templates for assistants and engravers to work from.

One can follow Rubens in the process of designing a composition in sequences, such as those associated with the *Conversion of Saint Paul* and the *Samson and Delilah* (cats 67–70 and 72–7). In both cases he captures the essence of the image on paper (cats 68 and 74) before rehearsing its impact in an oil-sketch (cats 69 and 72–3). Although over time Rubens was to develop increasing mastery of the oil-sketch medium, at no other point in his career do the effects in his oil-sketches so closely resemble those in his finished paintings as in works from the early 1610s. It is hard to read the rough, striated brushwork of the child in the right-hand bottom corner in the *Massacre of the Innocents* (cat. 82) as anything but a sketch wrought large, and there is a real question as to whether the Courtauld Gallery *Brazen Serpent* (cat. 81) is unfinished or an experimental large-scale exercise.

What also emerges when sequences of works are grouped together is the way in which Rubens selected and used a limited number of motifs. For his great images of the fury and fear of horses under stress, his primary inspiration was Leonardo's *Battle of the Anghiari* (fig. 29) and the famous Quirinal 'Horse Tamers' (fig. 53) the group known as the *Dioscuri*. The group was so famous that Rubens could have worked from bronze statuettes or engravings (possibly Tempesta's book of *Horses From Different Lands*, Rome 1590) as well as studying the original marble group. Some of Rubens's compositions seem to take the prints rather than the originals as their starting point.

In time, he derived his own stock repertoire of horse motifs from these sources: the bucking horse, the rearing horse and the plunging horse. His imaginative use of them links works such as the *Conversion of Saint Paul* (cats 67–70) and *Death of Hippolytus* (cat. 66), the *Battle of the Amazons* (cats 1–5) and the *Fall of Phaeton* (cat. 65). Sometimes he rotates the horses, sometimes he just modifies the angle of a neck or head, but from what is actually a relatively restricted number of equine poses, he creates numerous exciting compositions. In this early stage of his career, it was horses that preoccupied him far more than semi-clad women.

Fig. 53 Roman, second century AD?
The Dioscuri (the 'Horse Tamers'),
Piazza del Quirinale, Rome

Fig. 53

65 (detail)

64 (detail)

Fig. 50 (detail)

64. The Miraculous Draught of Fishes (Netting a Sea-Monster) about 1610

Oil on panel, 48 × 39 cm
Wallraf-Richartz-Museum, Cologne
(WRM DEP. 317)

'After he had preached from Peter and Andrew's boat, Jesus asked Peter to let down his fishing net into deep water. Peter protested saying "Master, we have toiled all night and caught nothing, nevertheless at Your word I will let down the net." ... And when they had done this, they caught a great number of fish, and their net was breaking. Astonished, Peter fell to his knees. Jesus said to him, "Do not be afraid. From now on you will catch men".' (Luke 5: 1–10).

Rubens's version of the *Miraculous Draught of Fishes* seems to be more an artistic exercise – a rehearsal of dramatic poses – than a serious attempt at telling the story of how fishermen had to deal suddenly with miraculously over-filled nets. Rubens includes just one fish in the net, and it is more like an antique sea-serpent. He may have been exploring an astrological cycle frescoed by Giulio Romano in the Palazzo Te, Mantua.[1] Rubens was later to paint and engrave a much more conventional version of the *Miraculous Draught* (that picture is now in the National Gallery, London, NG 680). It is possible that the present painting was a *bozzetto* (preparatory oil-sketch) for a larger work unknown today.

The degree to which he was besotted with the look of strong men in action can seem indecorous to modern eyes, but here, as in the *Massacre of the Innocents* (cat. 82), he probably saw his figures as homage to classical sources,

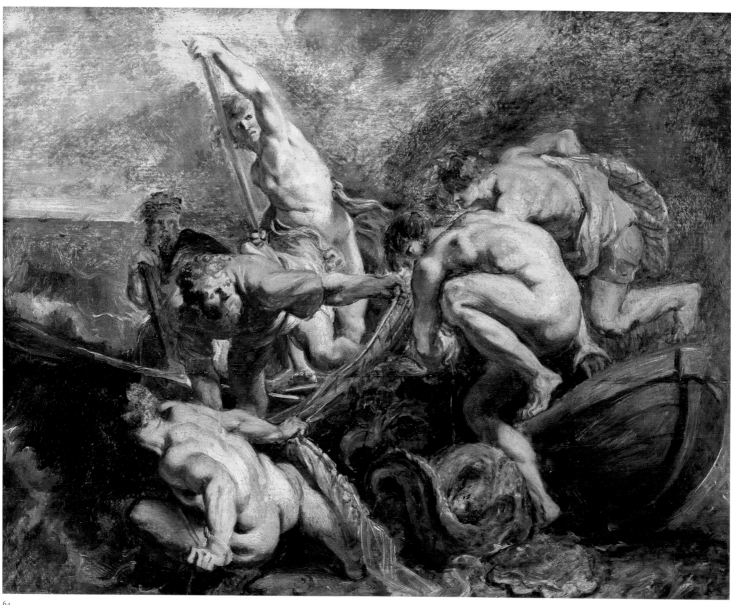

64

as well as to Raphael and Michelangelo. Rubens seems delightfully unconcerned about the credibility gap as artistic display displaces narrative.

Athletic figures lunge forward, twist and are violently foreshortened. The man in red, who first appears in the Hermitage *Descent* drawing (cat. 55), was, as the Courtauld oil-sketch shows, also tried out and then rejected for a part in the *Conversion of Saint Paul* (cats 67–70). By now Rubens was perfectly capable of inventing his own poses but he seems to be

deliberately quoting ancient authorities; the effect is of a tableau set up in a Roman sculpture garden. A male version of the crouching Venus (or Atlas), already seen in the Prado *Adoration* (fig. 57) from a slightly different angle, recalls both the *Torso Belvedere* and the *Wrestlers* (fig. 47) in the Uffizi. The *Wrestlers* also seems to be the source for the bent back and raised elbow of his companion. The foreground figure leaning back in the lower left-hand corner is a reversed version of the bottom-right rope puller in the Louvre oil-

sketch for the 1610 *Raising of the Cross* (fig.50, detail opposite) – the same invention, toned down a little, appears in the the *Resurrection* triptych (fig. 4). Rubens was always alert to sources for deeply lunging figures like these, as his early copies of prints (see cat. 6) demonstrate.

1 See Hartt 1958, fig. 210. Engraved by Ghisi (Bartsch 1986, 31 (15–4), no. 106, p. 222).

ESSENTIAL BIBLIOGRAPHY
Jaffé 1989, no. 30, p. 173

65 (detail)

65. The Fall of Phaeton about 1604–6

Oil on canvas, 98.4 × 131.2 cm
National Gallery of Art, Washington, DC
Patrons' Permanent Fund (1990.1.1)

Apollo, the sun god, motivated by affection, fatally granted his son any wish he chose. Phaeton resolved to drive Apollo's sun chariot across the sky for a day, but he failed to control it. Zeus, to put an end to its destructive path, destroyed him with a lightning bolt.

This painting shows Rubens at his boldest.[1] Although versions of the subject on ancient sarcophagi were known to Renaissance artists (and enshrined in Michelangelo's famous drawing of the subject), Rubens's solution was original. Like the *Death of Hippolytus* (cat. 66) and the *Battle of the Amazons* (cat. 1), this was another great excuse to show twisting horses in flight. Leonardo's *Battle of the Anghiari* was again the touchstone, even if statues such as the *Horse Tamers* (fig. 53) had a role to play.[2]

Rubens shows the horses rearing and plunging as Zeus' thunderbolt strikes. Ovid describes Phaeton's golden locks, but Rubens

has focused on his flaming cloak and the burning earth below. Although the legend had it that Phaeton eventually crashed near Mantua, Rubens concentrates entirely on the tumbling horses, taking great delight in their anatomy and the potential of flying manes and tails.[3] The plunging horse on the left is found in the British Museum drawing of the *Battle for the Standard* (cat. 32), and becomes a fixture in Rubens's equine compositions, for example in his *Defeat of Sennacherib* (cat. 88).

The female figures – either cringing in alarm or struggling to restrain the horses – are the horae, guides to the hours of the day. The near-nude girls on the left are inspired by the *Naked Venus* (fig. 61), although Rubens has adapted the pose to express distress and fear. The central horae, with their billowing drapery, have an almost Pre-Raphaelite air, and seem less disturbed by the panic around them than those to the sides.[4]

The light streaming in from the top right must be Zeus' bolt, but no light comes from the charioteer. Rubens's emphasis on the

horses (including his late introduction of a superfluous fifth horse behind the rearing stallion on the right) reminds us of the fury of the encounter. The artist's display of this range of horse poses is much more important to him than pedantic reconstructions of chariot teams and narrative.

1 For its probable pendant, see cat. 17.
2 The *Horse Tamers* (fig. 53) had already been quoted in Rubens's early *Rape of the Sabines*, now only known from a copy, see Garff and Pedersen 1988, II, pl. 243, p. 240; McGrath 1997, II, no. 38.
3 Curiously, given Rubens's tendency to link the beauty of women and horses (see fig. 9 and p. 22), the central white horse's tail is braided in the same way as the hair of some of the horae.
4 There is a precedent for showing the horae with the Zodiac (which would explain the circular light effect in the top-left corner) in Giulio Bonasone's *Rising of the Sun* (Bartsch 1985, 28 (15–1), fig. 99).

ESSENTIAL BIBLIOGRAPHY
Cologne 1977, no. 7, pp. 145–6; Jaffé 1977, p. 71; Wheelock 2005, pp. 146–53

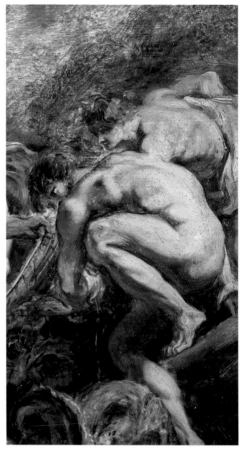

64 (detail)

66 (detail)

66. The Death of Hippolytus 1612–14

Oil on copper, 50.2 × 70.8 cm
Accepted by the H.M. Government in lieu of
Inheritance Tax and allocated to the
Fitzwilliam Museum, Cambridge (PD.8-1979)

This oil painting on copper is one of Rubens's most breathtaking accounts of startled horses. The four animals, terrified by Poseidon's sea-monster (called by Theseus to destroy his son), do not escape from the broken chariot but buck, rear and apparently topple under the monster's fearsome onslaught. Its bull-like head rears out of the huge wave that will engulf the hapless Hippolytus. In the story the horses are frightened by the monster and drag Hippolytus to his death, but here the horses and monster seem to collide. The rearing horse swivels precariously on its haunches as if off-balance. A beautifully picked out cabinet collection of rare shells, coral, a lizard, a turtle and a crab lie in the path of the wave's advance (detail on p. 6).

The Bayonne drawing (fig. 54) shows a more explosive first idea for the subject, in which an overwhelming tsunami is about to

sweep the precariously balanced horses and scattered humans away. The wash both creates the water and models the figures.

Rubens has based the figure of Hippolytus on a celebrated drawing by Michelangelo of *Tityus* (now in the Royal Library, Windsor Castle). He first tried out Hippolytus' pose for a *Prometheus* (Philadelphia Museum of Art), and it occurs again in the early drawing and oil-sketch for the *Conversion of Saint Paul* (cats 68–9). Michelangelo's solution is so dominant here that it is easy to forget that the original inspiration, and perhaps Rubens's direct source for the figure of Hippolytus, was a high view of the *Laocoön* (see fig. 43).

The sea-monster that startles Hippolytus is depicted as a rearing flipper-finned bull that mirrors the rearing horse.[1] His pink, scaly skin glistens as water foams across his neck and through his thrashing tail. Below him, a sea-triton, his elbow and palm enlivened with deft red strokes, blows his conch shell. The focus is the quivering horses, whose flying manes resemble the crashing surf, entangled in the

red reins to which Hippolytus still clings. Even the nails on their shoes and the froth on the mouth of the horse on the right glisten.[2] The wild glances of monster, horses and charioteer criss-cross the composition. Rubens's rearing horses are by now a well-tried formula – see those horses on the right of *Phaeton* (cat. 65), but here he has fine-tuned the flickering manes. In both pictures fallen men appear puny beside the unleashed power of their teams.

1 One is reminded that Rubens often compared emperors with bulls (as well as women with horses) in his pocketbook, see p. 22.
2 There is a horse with a foaming mouth in Rubens's portrait of *Giovan Carlo Doria* (1606, Galleria Nazionale della Liguria a Palazzo Spinola, Genoa), which he may have developed with Pliny in mind. Rubens also seems to have used the motif, perhaps in an embryonic form, in the *Fall of Phaeton* (cat. 65). Animals foaming at the mouth are mentioned in Pliny's *Historia Naturalis* (xxxv:xxxvi, 93–4), see McGrath 1978, p. 249; also Koslow 1996, p. 295.

ESSENTIAL BIBLIOGRAPHY
Jaffé 1989, no. 144, p. 175

65

66

Fig. 54 **The Death of Hippolytus,**
about 1612–14
Ink and wash, 22 × 32.1 cm
Musée Bonnat, Bayonne (NI 1419)

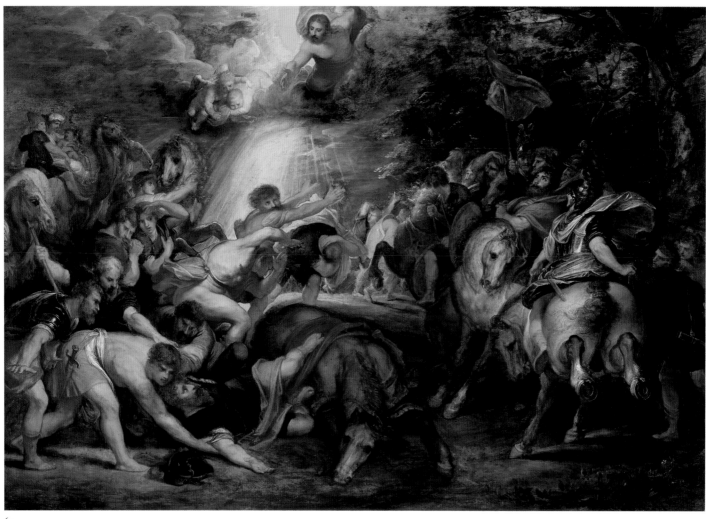

67

67. The Conversion of Saint Paul 1598–9

Oil on panel, 72 × 103 cm
Sammlungen des Fürsten von und zu
Liechtenstein, Vaduz, Wien (GE 40)

Rubens tackled the *Conversion of Saint Paul* several times. This painting may have been completed as early as 1598–9, although a later date, 1602, has also been proposed. Another version executed around 1620 was unfortunately destroyed in Berlin in 1945 and only a preparatory oil-sketch for it survives (Ashmolean Museum, Oxford). Although the present painting is a vivacious composition, it seems to lack confidence and does not fully express Rubens's imagination or his technical mastery. The influence of the German painter Adam Elsheimer can be seen here. The later version (cat. 70) offers instead motifs assimilated from Italian Renaissance masters – Raphael and Michelangelo in particular.

This painting has the same shafts of light and blue-green sky filled with flying putti as the National Gallery *Judgement of Paris* (cat. 9). The *Conversion*, however, has a firmer, if still imperfect, sense of light and shade. The shadow cast by the bending man on the left, to take one example, secures him to the ground but has no realistic light source.

There are effective passages of painterly abbreviation – extreme examples are the profile head on the far left, the man whose forehead is a single crimson stroke and the right-foreground horse, its tail and mane enlivened with bursts of white. The bucking horse on the right, magnificent if not convincing anatomically, appears rotated in later works. There are attempts at expressing the fear and anxiety of the soldiers.

Perhaps the least expected motif is the near-naked figure behind Paul. He is, in embryo, the prototype for the muscle men who will fill Rubens's later designs.[1] The closest graphic source is the sailor in Holbein's *Dance of Death*, 1538, who holds his hands above his head in the same way and was copied by Rubens.[2] Paul's collapsed horse would seem to be from a print.[3]

1 He used the pose much later in *Hercules over Discord* (Banqueting House, Whitehall, London). Given the strange gesture of the arms one wonders if he was inspired by a Flemish wood statue.
2 Transcribed on the Berlin pocketbook sheet, fig. 18. See Belkin 1989, figs 57a and b, p. 249. Titian's *Cain and Abel* (Church of Salute, Venice), is another possible inspiration. The pose occurs again in the Munich *Defeat of Sennacherib* (cat. 88).
3 Ulrich Heinen informs me that there is a Flemish panel of this composition in Leipzig. For comparison see Mario Cartaro's 1567 *Conversion* (Bartsch 1986, 31 (15–4), no. 17).

ESSENTIAL BIBLIOGRAPHY
Freedberg 1984, no. 29; Vienna 2004, no. 1, pp. 34–5

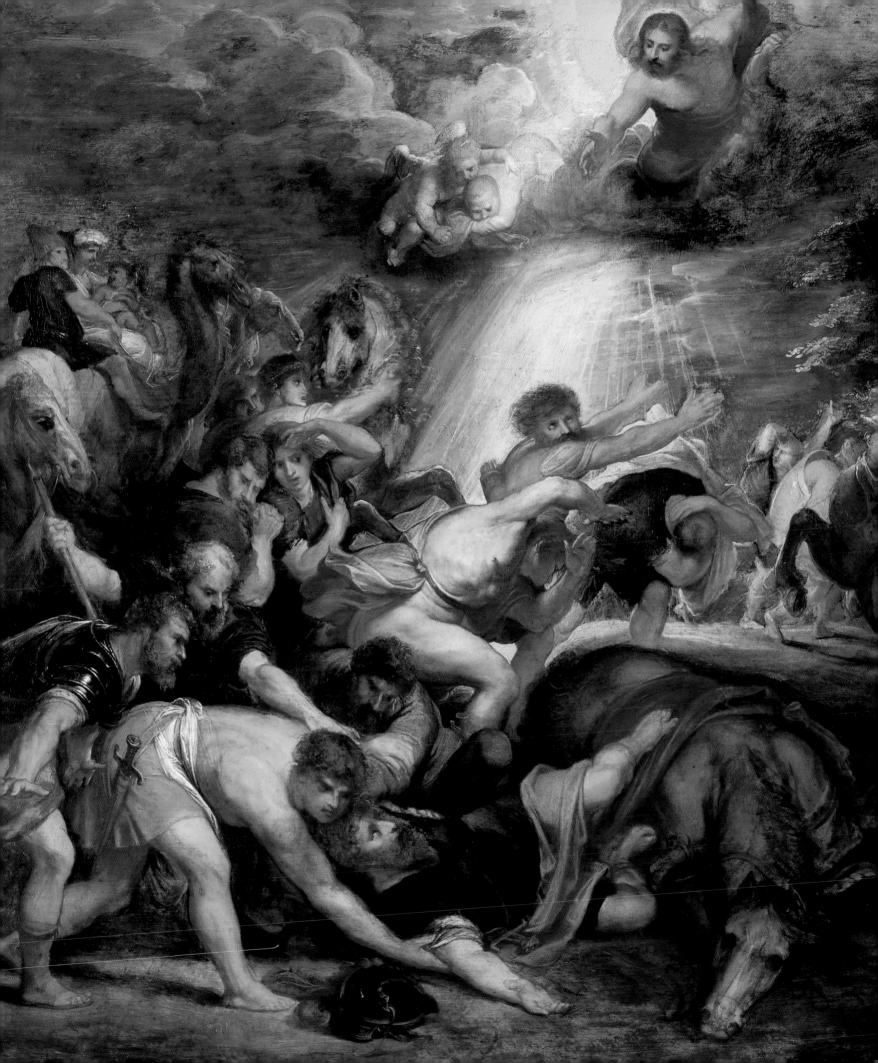

68

68-70. The Conversion of Saint Paul

68. **The Conversion of Saint Paul**,
about 1610-12
Pen, brown ink and brown wash with white
body colour on paper, 22.2 × 32.9 cm
(D.1978.PG.57)

69. **The Conversion of Saint Paul**, about 1614
Oil on panel, 57.4 × 80.2 cm
(P.1978.PG.356)

70. **The Conversion of Saint Paul**, about 1614
Oil on panel, 95.2 × 120.7 cm
(P.1978.PG.357)

The Samuel Courtauld Trust, Courtauld
Institute of Art Gallery, London
Bequeathed by Count Antoine Seilern as part of
the Princes Gate Collection, 1978

Paul began his life as Saul of Tarsus, a
fierce enemy of the Christian Church and
a persecutor of its believers. The story of his
conversion is told in the Acts of the Apostles.
While on the road to Damascus to hunt for
Christians, a bright light, stronger than the
sun, dazzled Saul 'And he fell to the earth, and
heard a voice saying unto him, "Saul, Saul,
why persecutest thou me?" And he said, "Who
art thou, Lord?" And the Lord said, I am Jesus
who thou persecutest".'[1]

The iconographic tradition added various
elements to the Bible story. The Bible makes
no reference to Christ himself, only to his
voice, but artists often showed him appearing
from behind clouds. The Bible also does not
say that the episode took place at night; that
convention probably arose to increase the
dramatic effect of the light from heaven.

Another convention without biblical
authority – to have Paul fall from his horse on
the ground – may relate to medieval
representations of pride as a fallen horseman.

Rubens's versions of the *Conversion*, which
culminate in the Courtauld oil painting (cat. 70),
are reminiscent of those by other artists as
diverse as Michelangelo, Tintoretto, Raphael,
Parmigianino and Salviati. Among the first
things the eye is drawn to is the horse kicking
Paul. Its feline energy seems to owe something
to Leonardo. The second centre of attention is
Saint Paul himself, lying on the ground, joined
to Christ by the light which streams down
from above onto his face. Michelangelo may
have provided Rubens's inspiration for the
figure of Christ, as well as for the night setting
and for the way the beam of light shines
down. However, unlike Michelangelo – but

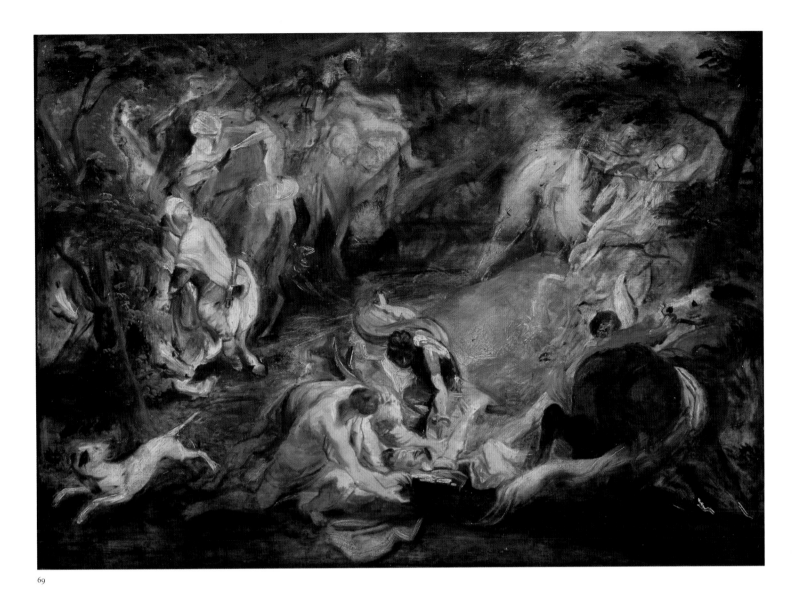

69

like Raphael (*Conversion of Saint Paul*, tapestry, Vatican) and Caravaggio (*Conversion of Saint Paul*, Santa Maria del Popolo, Rome) – Rubens follows the Bible story in showing Paul as a relatively young man. He makes him a robust, muscular figure. Parmigianino chose to simplify the crowd.[2]

It is fascinating to trace the development of the composition between drawing, sketch and painting. The oil-sketch (cat. 69) includes a favourite foreshortened figure above the stricken Paul – one used in the *Descent from the Cross* (cat. 56) and in the *Miraculous Draught of Fishes* (cat. 64, see detail p. 144), but eliminated from the later *Conversion* (cat. 70). Above him two horsemen can just be made out, emerging from strokes of lead white. On the right another animal balks at a rearing horse.

In the drawing (cat. 68) the right-hand side

has been reworked on an additional sheet of paper placed over the bottom right-hand corner. The left side of the oil-sketch (cat. 69) follows the group of camel riders in the drawing (cat. 68) – even down to the two children, one bound to his mother's back.

Pairs of cowering men in the foreground of the drawing, which recall wrestlers, have been abandoned later in the sequence.

In Rubens's most considered view of the subject (cat. 70) the saddle cloth wrapped around Saint Paul's leg is almost hidden on the far side of the horse, and the groom holds not the reins, but the bridle. The rearing grey horse further back in the picture, with its leopard-skin saddle cloth, is grasped by a groom who recalls a figure in the British Museum *Amazons* drawing (cat. 2).

The red mane of the charging white horse

behind Paul was a favourite colour accent. The lunging horse on the right recalls the left-foreground bucking horse in the British Museum Leonardo exercises (see cats 2 and 32); its rider struggles with his spiralling golden cloak. Arrows falling from his quiver recall Giulio Romano's *Hylas* drawing.[3] The pose of Paul himself seems to have pleased Rubens as he reused it in the *Battle of Milvian Bridge* and the *Death of Maxentius* (1620, Wallace Collection, London).

There is much debate about whether the drawing or the oil-sketch came first. That the drawing is on two sheets of paper, later glued together, suggests that Rubens made it on facing pages of a sketchbook.[4] As the drawing is closer to the painting, some have suggested that the sketch came first and that the sequence was oil-sketch – drawing – painting.

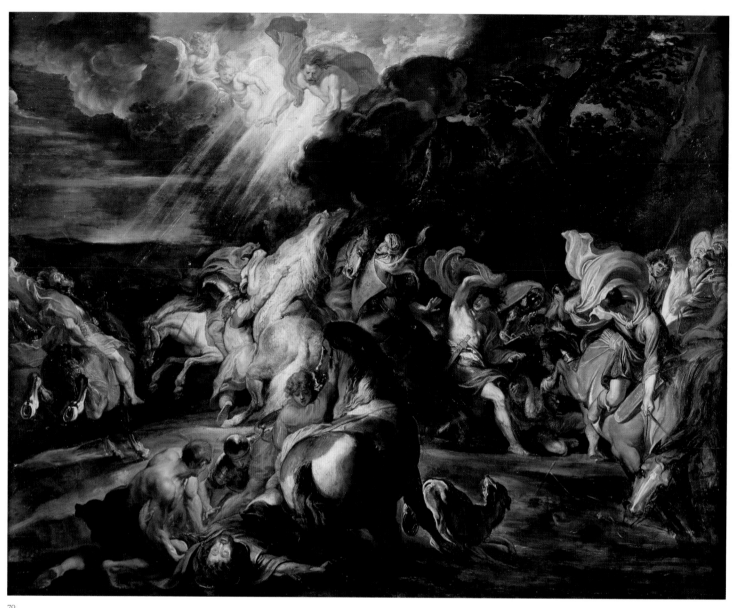

70

Another school of thought, which has the sequence run drawing – oil-sketch – painting, takes the line that Rubens studied the composition from the standpoint of Saint Paul, gradually bringing him forward until he occupies the extreme foreground. In this respect the painting is more dramatic than the studies, which makes it possible that the drawing gives Rubens's first ideas for the *Conversion* and pre-dates the oil-sketch in which he challenges his own first thoughts, develops ideas about the source of light, and explores sources for the energy and dynamism he wants to give to the composition. The final version is a controlled explosion of power radiating outwards from the centre: note that the horse bucking on the left is reflected on the right.

As a counterpoint to the horses, Rubens introduces a running man leaning back – he is at the bottom right in the drawing and above Paul's dog in the painting. This figure has echoes of the Carracci and Primaticcio and reappears in the *Massacre of the Innocents* (cat. 82) and Rubens's *Flagellation* (1616, St Paul's Church, Antwerp). Tetrode's *écorché* (cats 33–4) may be the source for him. The entanglement of hair, cloth and limbs is a recurring motif throughout Rubens's explorations of horses and riders.

The culmination of Rubens's engagement with horses that kick and rear is reached in pictures such as the *Defeat of Sennacherib* (cat. 88). *Sennacherib* hung for many centuries as a pendant to the *Conversion*, although no conclusive evidence for the connection has come forth. Divine intervention causing havoc among cavalry at night is perhaps not enough to link the two as pendants. DJ/DB

1 Acts 9: 1–9.
2 Parmigianino's horse is based on the *Horse Tamers* (fig. 53), which Rubens also drew on for his *Saint George* (cat. 21).
3 See London-Paris-Bern-Brussels 1972, no. 72, pl. 35, p. 92.
4 The two sheets used to belong to different owners and were only reunited in 1953 when Count Antoine Seilern added them to his collection, which already included the oil-sketch and the painting.

ESSENTIAL BIBLIOGRAPHY
Held 1980, I, no. 421; Freedberg 1984, nos 30, 30a and 30b; Rotterdam 2001, no. 14, p. 98; London 2003–4, pp. 66–73

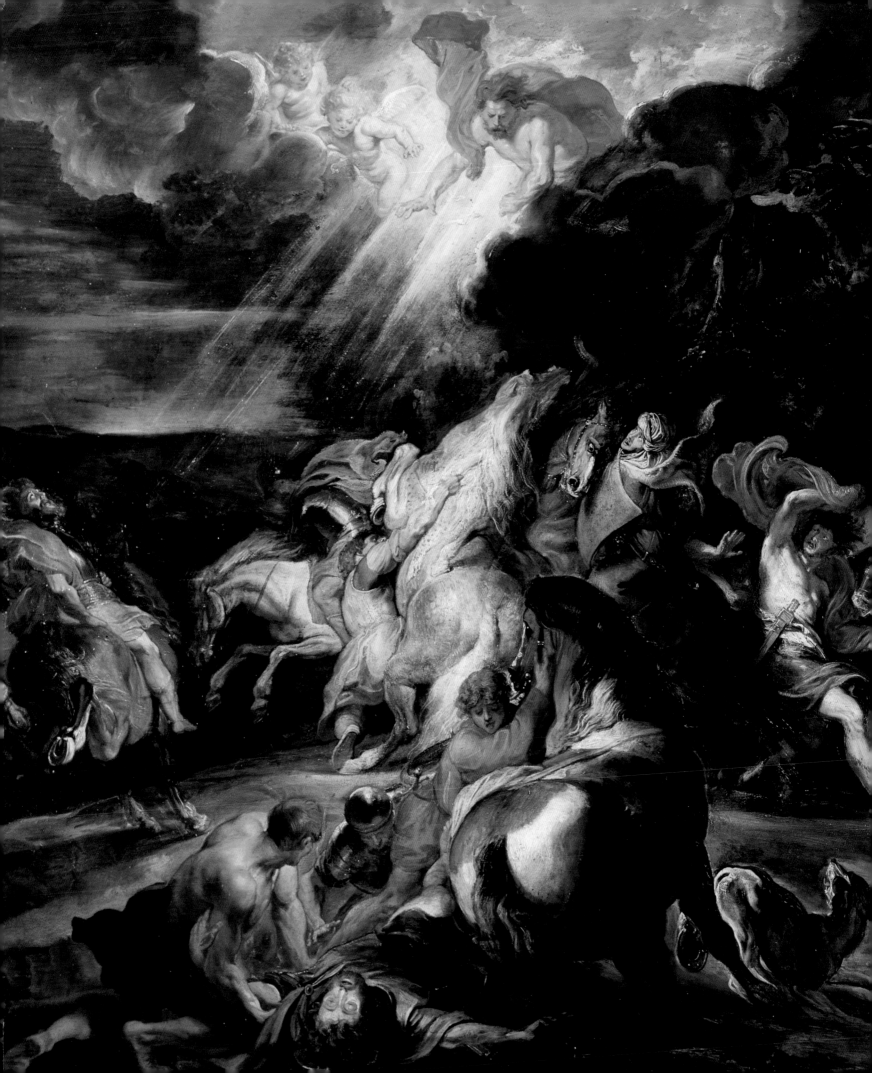

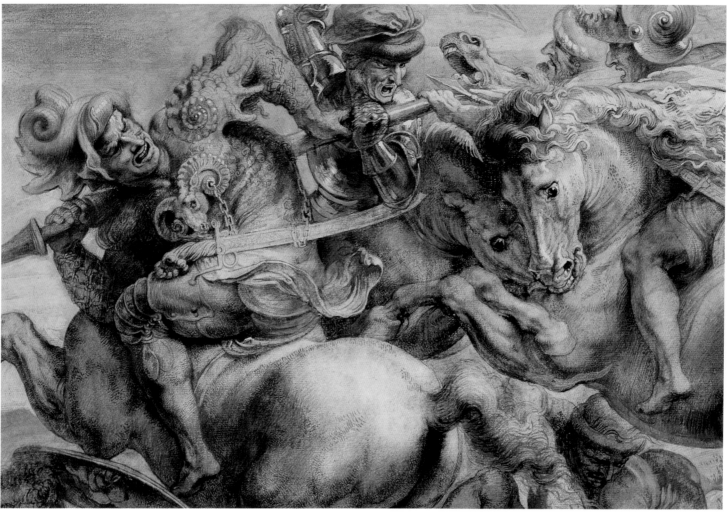

Fig. 29 (detail)

71. **A Lion Hunt** about 1614–5

Oil on panel, 73.6 × 105.4 cm
The National Gallery, London (NG 853.1)

This oil-sketch may be preparatory for a
composition of Africans or Arabs struggling
with a lion, one of a set of four hunting scenes
made for Maximilian, Duke of Bavaria, in
about 1616. That painting seems, however,
to be the disappointing work in Dresden
executed largely by Rubens's assistants. The
National Gallery's *Lion Hunt*, by contrast, is a
splendid homage to Leonardo's *Battle of the
Anghiari* (see fig. 29). Here he reworks it on his
own terms.[1]

 In a crucial adjustment to the original
formula, Rubens gives the rider on the left
a stirrup so that he can stand up and gain
greater purchase on his lance. He specified
this alteration in a reminder he wrote himself
on the top left of the *Battle for the Standard*

drawing (cat. 32). The huntsman is indeed
now able to push on the lance with more force
than Leonardo's horseman could muster.

 The earlier drawing's inscription (see
above, p. 31) is the key to reading this
composition.[2] It draws our attention to the
twisting energy initiated by the left-hand
rider's foot. His pressure on the stirrup
anchors the whole composition, which
culminates in the lion toppling the attacked
rider. He in turn tries to steady himself by
putting his left arm on the horse's rump. We
have already seen this gesture in the large
Courtauld *Conversion of Saint Paul* (cat. 70).[3]
The toppling rider's right arm once held the
butt of his spear, which was apparently
threaded behind him, missing the lion's flank,
an idea that is also taken from Leonardo.[4]

 The shaft of this spear has been painted
out, but the same pose occurs in the Dresden

painting. The change, if it was made by
Rubens, would mean that at some point he
jettisoned the spear and instead had the rider
gain purchase by grabbing the band around
the horse's chest. In the Dresden copy the lion
places one paw on the victim's forehead, as it
does here, but the lances have been banished
entirely. There is no reason why these
alterations could not be revisions directly from
this sketch, which would date it about 1614–15,
just before the painting made for Maximilian.

 The pose of the biting lion is taken directly
from a Ghisi print (fig. 55), itself inspired by
an antique marble of a lion attacking a horse.
Springing lions are, of course, difficult to
draw, so Rubens used an imaginatively rotated
engraving as reference.

 In his *Lion Hunt* Rubens started to redraw
the attacking lion so that we see more of its
back (its original profile becomes its spine).

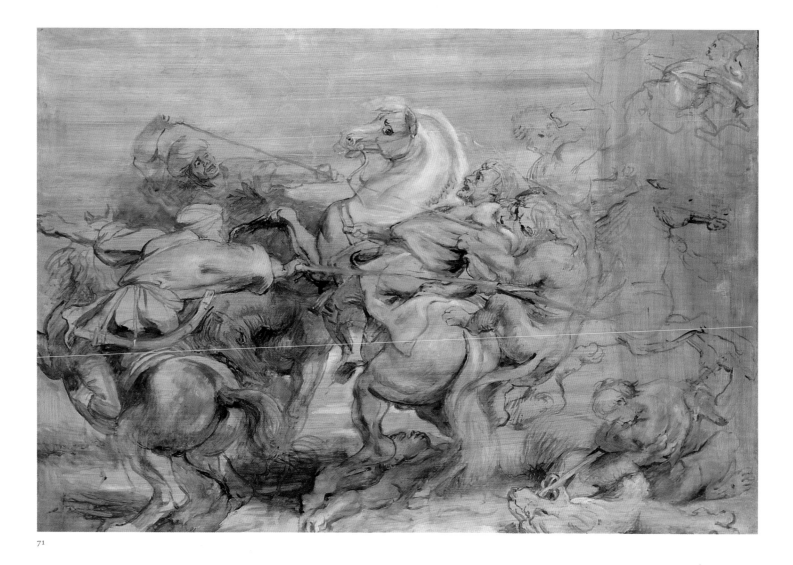

71

This required adjusting the position of the lion's front-right leg so that it could still grasp the rider's forehead. Rubens resolved this small adjustment in the top-right corner of the sketch by turning the lion's head into a more profile view and realigning the right paw higher on the victim's head.

Rubens appears to have begun by drafting in the composition in a light brown colour, before picking out the forms in black. He then clarified certain elements with thick, opaque whites, yellow accents and thin reds.

This oil-sketch lays bare the whole graphic process of Rubens's picture-making. The transparent view it gives of his creative thinking makes it one of our closest encounters with the artist at work. The design is taking shape before our eyes in a few quick strokes. The liquid first version of the left-hand horse's hind leg, and the half-defined victim's torso on

the ground are reminders of just how fast his ideas flowed. Details such as hand of the shouting red-caped rider, and the touch of white around his pupil demonstrate Rubens's brilliance.

1 Balis 1986, no. 8 and fig. 63. pp. 149–53.
2 See above, p. 31, for discussion of the inscription.
3 See Rotterdam 2001, no. 14, p. 99, for a drawing which A.-M. Logan regards as a copy.
4 Rubens tries out another view of this backward jab in his St Petersburg *Lion Hunt* sketch. See Held 1980, I, no. 299 and II, fig. 299.

ESSENTIAL BIBLIOGRAPHY
Held 1980, I, no. 298, pp. 406–8; Balis 1986, pp. 107–10; Martin 1986, p. 182–7; White 1987, pp. 119–21

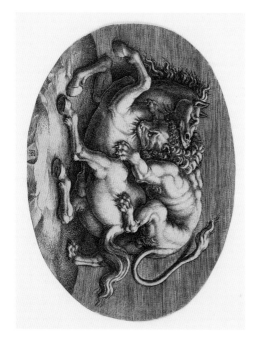

Fig. 55 Adamo Ghisi (1530–1587)
A Lion attacking a Horse (rotated), mid-sixteenth century
Engraving, 12.9 × 17.6 cm
The British Museum, London (P&D 1856-712-1064)

72

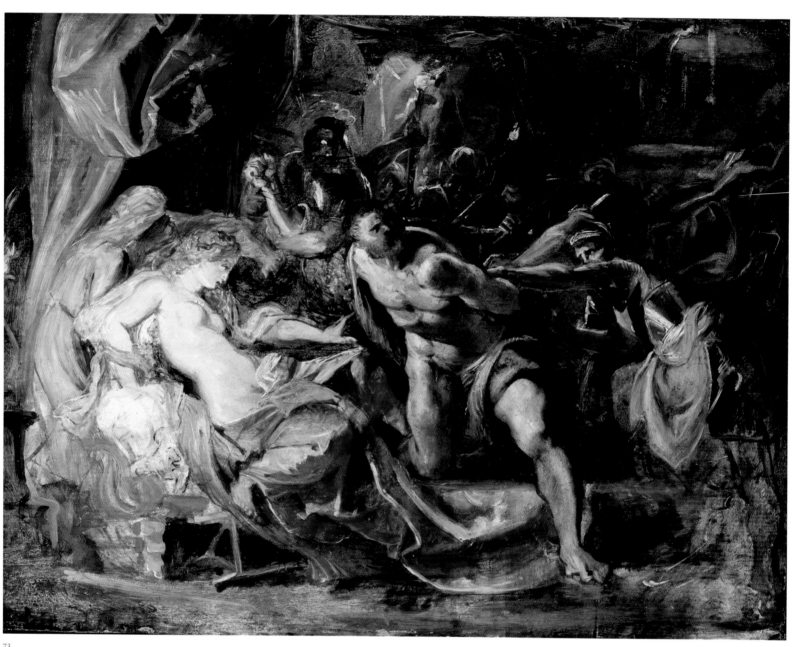

73

72 (detail)

73 (detail)

72–76. Studies for, and versions of, Samson and Delilah

72. The Blinding of Samson, 1609–10
Oil on panel, 37.5 × 58.5 cm
Museo Thyssen-Bornemisza, Madrid
(351 1978.47)

73. The Capture of Samson, about 1610
Oil on panel, 50.4 × 66.4 cm
The Art Institute of Chicago, IL
Robert A. Waller Memorial Fund (1923.551)

74. Samson and Delilah, about 1609–10
Pen and brush and brown ink, 16.4 × 16.2 cm
Private collection

75. The Capture of Samson, about 1614–20
Oil on canvas, 118 × 132 cm
Alte Pinakothek, Bayerische
Staatsgemäldesammlungen, Munich (348)

76. Jacob Matham (1571–1631)
Print after Samson and Delilah, probably 1611
Engraving, 37.5 × 44.1 cm
The Hearn Family Trust, New York (186.1)

After the cutting of his hair had rendered Samson impotent, he was bound and blinded. Rubens explores this, the most violent episode in the story, in an oil-sketch (cat. 72). Samson's severe backward bend makes one think of other defeated foes – those in Giambologna's *Samson and the Philistine*, and in his *all'antica* centaur fighting.[1] Other precedents are the captive being bound in Raphael's *Battle of Ostia*, and the Vatican Stanza del Incendio. Rubens copied Raphael's captive in his pocketbook (C.ms. fol.13r), and used the pose, unaltered, for the prisoner being prepared for nailing on the right wing of the *Raising of the Cross* in the Louvre (fig. 50): it is probably the immediate source here.

By contrast, the Chicago painting (cat. 73) shows Samson leaning forward and puts more emphasis on the torsion of his stomach. It is probably fair to assume that this, too, is a free exploration of Raphael's captive. The soldier who lunges into the picture and tries to bind Samson's left arm appears in both sketches. Although he is smaller, Rubens uses him as a counterpoint to the stricken hero (a gentler version of this figure was borrowed from Correggio for the first trials of the Vallicella altarpiece). In cat. 73 the lunging soldier is echoed by the old woman entering from the left – and Rubens retained her framing role in

the National Gallery *Samson* (cat. 77), which was made to hang over a fireplace in his friend Nicolaas Rockox's house. In both sketches (cats 72–3), a soldier restrains Samson's right arm, which places Samson in a position that recalls the *Laocoön* (fig. 30), one of Rubens's favourite models for struggling groups. The overturned furniture has a history in sixteenth-century engravings. Many of Rubens's favourite motifs are rehearsed in these oil-sketches, for example Delilah's twisted, backward-turning pose in cat. 72 that counter balances Samson's move in the opposite direction (it might, one feels, suit a male figure better). The centrifugal composition of the sketches, focusing on the flashing blade about to blind the disabled hero, is very ambitious.

The drawing (cat. 74) may well be Rubens's first trial for the *Samson and Delilah* now in the National Gallery (cat. 77). Delilah's uncrossed legs, the absence of a band over her breasts, and the rather ungainly barber all suggest an early stage. The barber's stance is unstable, but Rubens has already decided that the focus will be the lifting and cutting of the hair, and that the old woman should echo the barber's action.[2] She still seems to be entering the

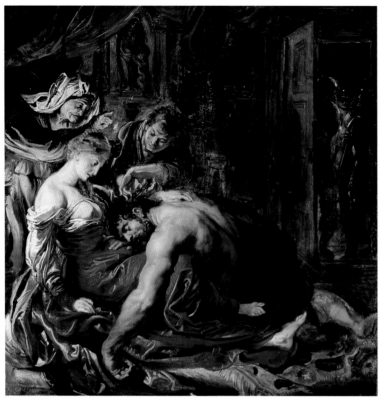

Fig. 56

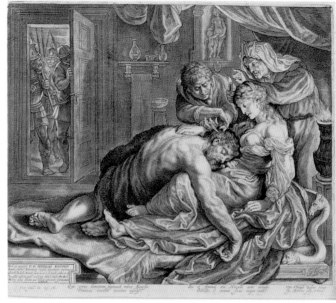

76

Fig. 56 **Samson Asleep in Delilah's Lap**, about 1609
Oil on panel, 52.1 × 50.5 cm
Cincinnati Art Museum, OH
Mr and Mrs Harry S. Leyman Endowment 1972 (1972.459)

scene, as in the sketches, and is not yet holding up a candle as she will in the Cincinnati oil-sketch (fig. 56) and in the final, London, version. In cat. 74 the central figures of Samson and Delilah are moving towards their eventual positions, folded down across each other, but their anatomy is still uncertain. Delilah's arm is segmented and brittle, while Samson's back is seal-like, and the transition to his legs unsatisfactory.

The peeping soldiers recall the tiny heads snatching a glimpse of the *Raising of the Cross* (fig. 7). Antonio Campi introduced servants coming through a door in a *Beheading of Saint John the Baptist* – another night scene, and one that may have influenced Rubens.[3]

Rubens is already experimenting with a left-side light source that causes the barber and Samson's legs to cast shadows in the drawing. As the natural light came over Rockox's fireplace from this direction (see cat. 77), it could be argued that this drawing was made back in Antwerp. The naiveté of the handling would thus be explained by the speed of execution rather than immaturity. The folded back flap below Delilah's breast recalls similar costume details in Rubens's

early copies of Michelangelo's Sibyls in the Sistine Chapel.

In the more static reworking of the Chicago sketch in Munich (cat. 75) Delilah holds the scissors, implying she was the barber. Details like the slipper, dog, and antique bed are probably Rubens's own inventions, and her pose could be from his repertoire. However, there is real doubt as to who executed this painting, and its worn condition makes judgement difficult.

It can be read as a translation of the Chicago oil-sketch (cat. 73) but there is no clear indication as to when it was painted. However, the form of Delilah's breasts and the way the blue underpainting of the flesh is applied may allow an earlier date than the 1617 usually assigned to it.

When Rubens returned to Antwerp he fulfilled a promise by dedicating an engraving of his lost *Judith* to Jan Woverius, an Antwerp friend whom he had met in Padua. He then tried out several other engravers including the great Goltzius's son-in-law, Jacob Matham, who was briefly in Antwerp. Matham's engraving of the *Samson* (cat. 76) seems to be drawn from the Cincinnati oil-sketch rather

than the finished painting, which was in Rockox's house.

It is not clear whether Rubens supervised the engraving of the print or even when it was made. A date of 1611, as inscribed on a proof for it in the British Museum, seems plausible.

Rubens had many of the compositions he painted on his return to Antwerp engraved. He finally settled on Lucas Vorsterman as his in-house engraver, who worked for him until 1622–3 when he was replaced by Paul Pontius. It was clearly a deliberate policy to publicise his achievements with prints.

1 Which Rubens would have seen in the Duke of Lerma's collection. It is now in the Victoria and Albert Museum, London.
2 The Louvre has a Genoese painting with the hair-dresser – painted perhaps ten years later – but it may indicate an earlier tradition.
3 See Sgarbi in Mantua 2004–5, no. 120, p. 334 (C.ms. fol.61v–62r).

ESSENTIAL BIBLIOGRAPHY
Held 1980, I, no. 314 and II, fig. 311 (cat. 72); Held 1959 (1986), no 51; Connecticut-Cincinnati-California 2004–5, pp. 94–7 (cat. 72); Connecticut-Cincinnati-California 2004–5, pp. 92 (cat. 73); New York 2005, no. 28 (cat. 74)

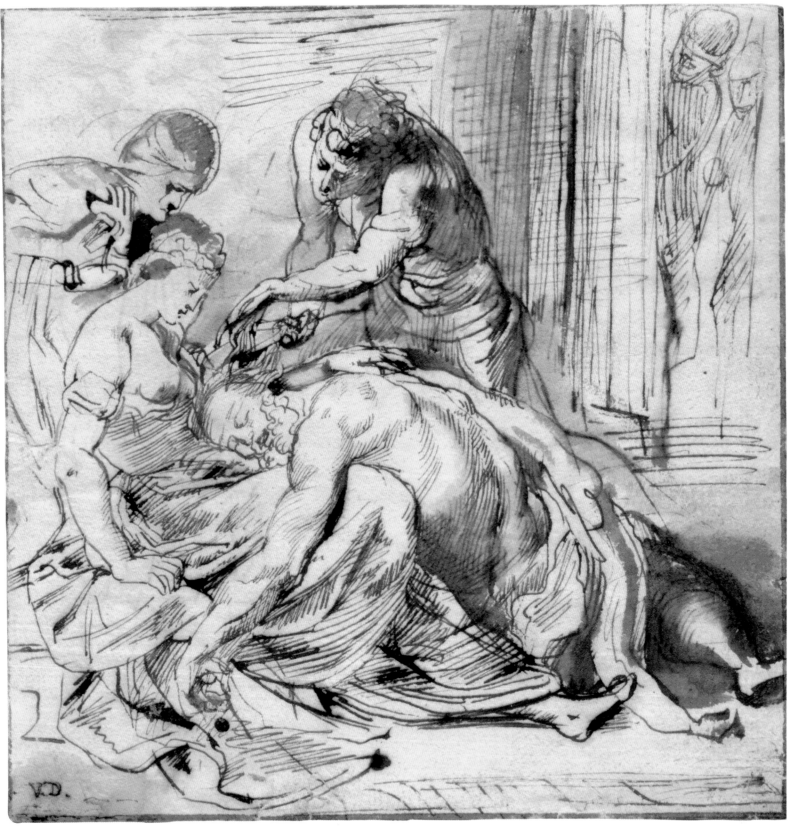

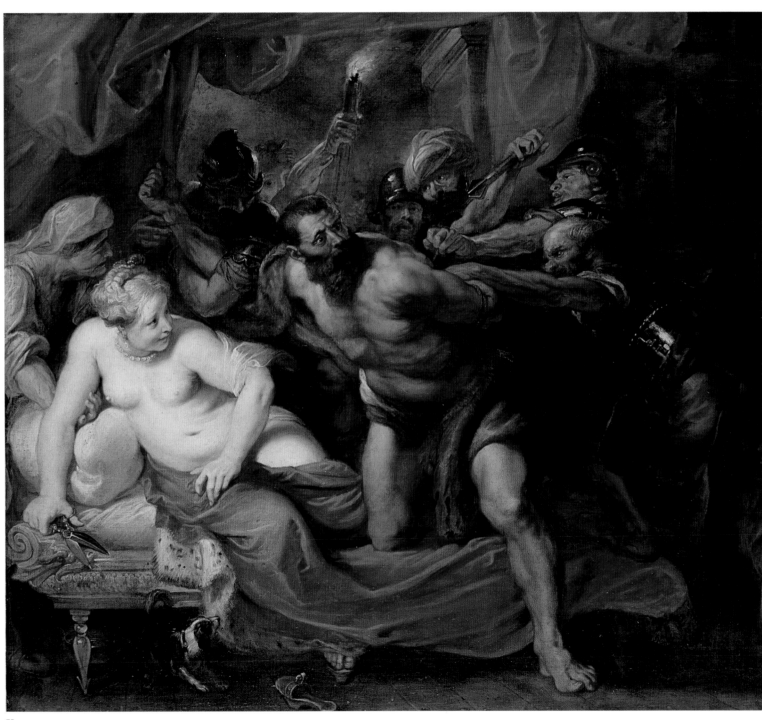

75

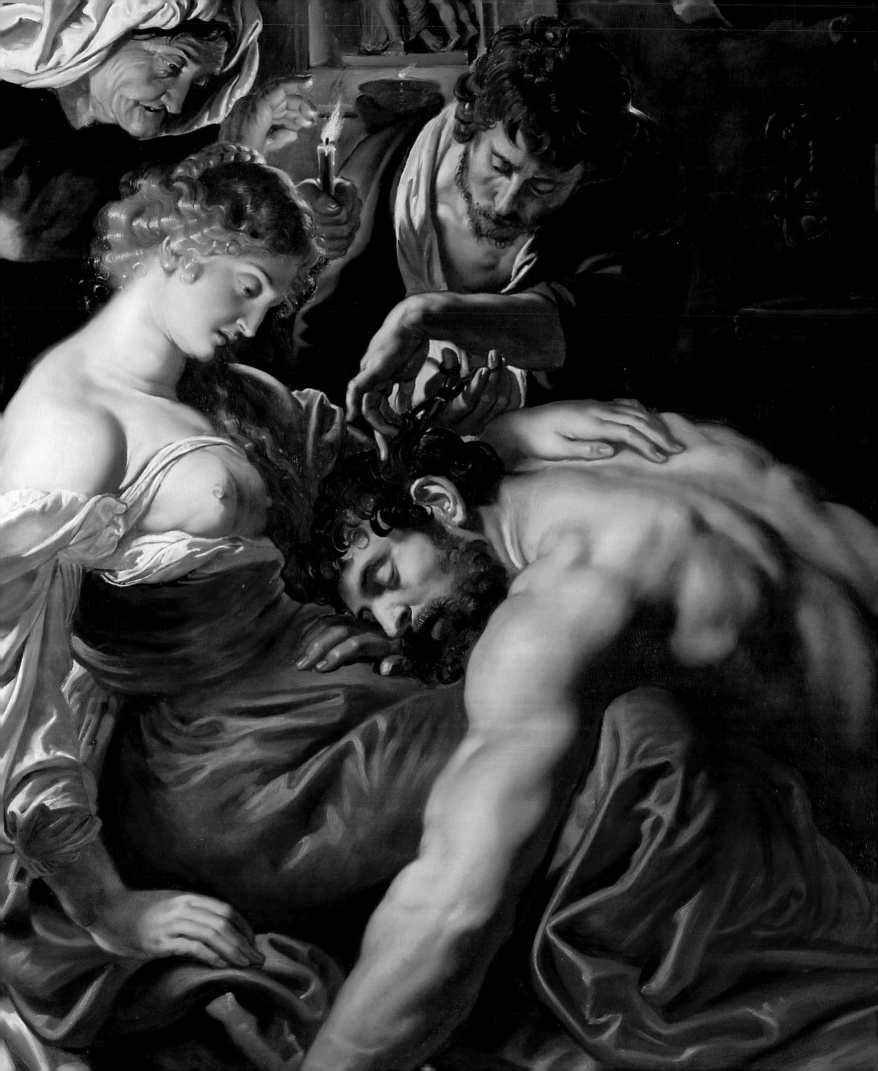

6. Back to Antwerp

Rubens's return to Antwerp in December 1608 required him to integrate what he had learned from his time in Italy with local artistic traditions. His teacher, Otto van Veen, still had considerable status in the city and there were other painters who, like Rubens, had spent time in Italy. Abraham Janssens, who had recently returned from Rome, must have been his immediate competitor. His *Allegory of the River Scheldt and the City of Antwerp* (today Koninklijk Museum voor Schone Kunsten, Antwerp), was painted for the same room in the Antwerp town hall as Rubens's *Adoration of the Magi* (1609–10, fig. 57), but Janssens's figures lack the powerful physical presence that was a decisive factor in Rubens's rise to dominance in the city. Certainly, he did not lack commissions and in 1609 was made court painter to Archduke Albert and the Infanta Isabella, govenors of the Spanish Netherlands. The paintings he made between 1609 and 1614 are a synthesis of what he learned in Italy and his own ebullient mastery.

Rubens's *Adoration of the Magi* (fig. 57) was a flagship for his eclectic painting process. In it he fuses such devices as a life drawing (now in the Museum Boijmans van Beuningen, Rotterdam, v52) and an unremarkable Marcantonio Raimondi engraving into the first display of his new-found mastery after his return to Antwerp.

The greatest masterpieces from Rubens's first post-Italy years in Antwerp are his two giant altarpieces – the *Raising of the Cross* for the church of St Walburga (fig. 7) and the *Descent from the Cross* for Antwerp Cathedral (fig. 23). In both he uses larger-than-life versions of ordinary people to witness divine events. The men who raise the cross (see cats 51–2) and the mother clutching her child in the left wing (detail p. 18) lean out into our space to engage us, and this blurs the distinction between picture and viewer's space. We become witnesses to the religious drama, not least because we empathise with the protagonists.

Both altarpieces were in part financed by two wealthy collectors – the merchant Cornelis van der Geest and the burgomaster Nicolaas Rockox. Rockox, in particular, was a friend of Rubens's – it was he who commissioned *Samson and Delilah* (cat. 77) to hang over his fireplace. Paintings such as *Samson and Delilah* and the *Massacre of the Innocents* were directed towards informed connoisseurs, men like Rockox and Van der Geest, who would have understood Rubens's pictorial allusions to antique sculpture and ancient texts. On another level, Rubens had become an epic painter. He understood the power of the stories he told, and his paintings still have the power to stop us in our tracks.

Rubens saw his career as international, and it quickly became so. Paintings like *Ecce Homo* (cat. 84) and *Samson and Delilah* (cat. 77) were all quickly engraved, further increasing his fame and disseminating his style. In his private life, following the death of his mother in 1608 which precipitated his return to Antwerp, Rubens married Isabella Brant in 1609. His portait of Clara Serena Rubens (cat. 91), aged about five, is as tender and enchanting an image as he ever made. In every way a different type of work from the large panels he was executing about the same time, this tiny painting demonstrates the versatility that was one of Rubens's great strengths as an artist.

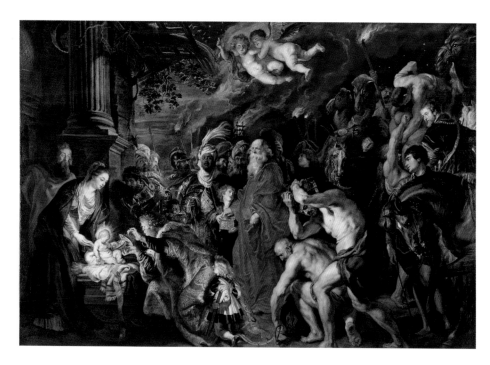

Fig. 57 **The Adoration of the Magi**, 1609–10
(enlarged about 1628–9)
Oil on canvas, 346 × 438 cm
Museo Nacional del Prado, Madrid (1638)

77. Samson and Delilah about 1610

Oil on panel, 185 × 205 cm
The National Gallery, London (NG 6461)

Visually, *Samson and Delilah* can be seen as a pendant to *Roman Charity (Cimon and Pero)* (cat. 78). The poses are almost identical, down to the reassuring hand which rests on a man's back in both pictures. The very different meanings of this gesture are reinforced by the contrast between Pero, who is matronly and veiled, and Delilah whose ready availability is suggested by her bared shoulders.

The story of Delilah's discovery that long hair was the secret of Samson's strength, and her betrayal of her lover, is well known. Rubens shows the moment when Samson's power is taken from him. In oil-sketches (cats 72–3) he explored more violent, irreversible and conclusive episodes – the blinding and capture – but in the final painting he returned to the moment when scissors severed Samson's strength and sealed his fate. Made for his friend Nicolaas Rockox's home in Antwerp, the painting hung above a fireplace, and so had to be painted with strong contrasts to overcome the distraction of the real flames which would have flickered beneath it.

The painting shows light from different sources – the unseen fire, the candle held by the old woman – rippling across the surfaces of flesh and clothing. The draught from the left that disturbs the candle flame creates a sense of light that not only illuminates, but also burnishes the forms.[1] The light becomes the electricity that energises the composition as it streaks across an otherwise still scene. The windows of Rockox's room were on the left of the painting and so real light and breeze came from the direction indicated in Rubens's painting.

The contouring emphasis of Delilah's raised girdle contrasts with the modest chemise closing-band across Pero's chest. Samson's massive back is the focus of the picture, reminiscent of the antique *Belvedere Torso*. Rubens could enhance the musculature of his antique inspirations but he could also build new poses to suit his needs. The *écorché* studies (cats 35–44) gave him the basis for a plausible anatomy. Rubens enlivens both paintings by adding a twisting movement to the male arm.

Rubens's drawings after the *Belvedere Torso* (such as that in the Metropolitan Museum of Art, New York), with their exaggerated island-like protrusions, as well as those after Tetrode's bronze statuettes (both figures and *écorchés*, cats 33–44), give an idea of where this landscape of flesh and drapery came from. The awkward positioning of Samson's leg is surprising. Rubens delights in the way light shapes the bulging muscles and picks out the metallic glisten of strands of hair and the saffron robe. The gleaming glassware is reminiscent of Caravaggio's response to the play of light on such materials.

The monumental massing in the foreground of the composition is dramatic. Rubens's purple curtain may acknowledge Homer's description of purple- or red-covered ivory wedding beds.[2] There is a sense of timelapse between this *Samson* and a *Jupiter and Callisto* (Staatliche Kunstsammlungen, Gemäldegalerie Alte Meister, Kassel)[3] seduction painting which repeats Delilah's pose while depicting the seducer in an earlier frame of the story – another reminder of how often Rubens explores a sequence of poses before picking his moment. There are also links with British Museum drawings by Michiel Coxie for the *Loves of the Gods* engravings.[4]

Samson and Delilah feature in a series of prints of powerful women, but it is not clear why Rockox settled on this subject for his house, although there is long Northern tradition of depicting men with exaggerated muscles which derived from Michelangelo – Heemskerk, Floris and Tetrode all acknowledged his influence.[5]

The development of Rubens's ideas can be traced from the preparatory drawing (cat. 74), in which Samson's torso is almost fish-slippery, to the oil-sketch (fig. 56, although it is possible that this was a simplified *ricordo* of the painting for the engraver) and the painting. The drawing, in which the bodies are weak when compared with those in the over-robust final solution, may have been started earlier – perhaps even in Italy – and only developed into a commission when Rubens was back in Antwerp. In the drawing the barber has a more upright stance, the old woman holds a 'lamp' (possibly the shadow of her hand) behind Delilah, and Delilah's legs are still uncrossed; crossed legs could carry an erotic message.

In the drawing (cat. 74) wash establishes strong shadows, a contrast maintained in all the stages of the design. The oil-sketch (fig. 56) includes a cast shadow (probably the barber's) on the door, which is reversed in the finished painting, as if it is a shadow from one of the soldiers. The doorway on the right in the painting and the drawing appears behind the barber in the earlier oil-sketch (cat. 73). In the painting a statue (of Venus and Cupid, in a niche) fills that space. Cupid's blindfold, or gag, may be a comment on Samson's betrayal. Rubens plays with the idea of including such a door in his 1611 *Visitation* drawing in Bayonne which suggests that he liked the motif.

The splattering of over-emphatic paintwork in the flesh and carpet resonate with the Metropolitan *Holy Family with Dove* (cat. 47) and the *Self Portrait with Four Philosophers* (Palazzo Pitti, Florence); in all of these, Rubens indulges in over agitated, tactile surfaces.

The dating of the painting is problematic. If the Chicago sketch (cat. 73) is seen as preliminary to it, then the radiographic evidence of an *Adoration of the Magi* below it would suggest Rubens was reusing a panel from 1609. The question of just how soon after remains, but a date of 1610–11 is plausible.

1 Titian used windblown light in his *Martyrdom of Saint Lawrence* (there are versions in the Escorial and Gesuiti, Venice), which was engraved.
2 See *Odyssey*, XXIII, 205–46. Catullus's famous poem on the marriage of Peleus and Thetis ('Carmina' LXIV. 47–9) features a purple bedcover.
3 See Jaffé 1989, no. 196.
4 For Michiel Coxcie's *Loves of the Gods*, see Brussels-Rome 1995, nos 77–8, p. 172–3.
5 Note Fiona Healy on Delilah's ambivalence in Brunswick 2004, p. 39.

ESSENTIAL BIBLIOGRAPHY
Brown 1983; D'Hulst and Vandenven 1989, III, no. 31; Jaffé 2000; Jaffé and Bradley 2003, p. 13; New York 2005, no. 28, pp. 124–7

77 (detail)

78 (detail)

78. Roman Charity (Cimon and Pero) 1611–13

Oil on canvas (transferred from panel in 1846),
140.5 × 180.3 cm
The State Hermitage Museum, St Petersburg
(GE-470)

The story of how a devoted daughter gave her breast to her starving, imprisoned father intrigued many artists, perhaps because, like the subject of Lot and his Daughters, it broke taboos. It was told by ancient writers and admired by Renaissance Humanists.[1] Both were explicit about the story's moral theme. An inscription on the base of a print which appeared a few years after the present picture was painted reads: 'Now you see what real love is…'[2] Pero's devotion to her father was such that the authorities were persuaded to release Cimon from imprisonment.

In fact Cimon looks surprisingly well-nourished despite having been chained in a cobweb-covered cell – the muscles in his upper arm are particularly strongly defined.[3] Cimon's dejected pose revives one Rubens first tried in *Aeneas preparing to lead the Trojans into Exile* (cat. 8), but he must also have recognised its *Pietà* associations. Although crossed legs in seventeenth-century paintings often suggest lustful intentions, the pose was also used to signify imprisonment. The way loose hair caresses flesh has sensuous overtones but Pero's gesture is affectionate, not amorous. Her veiled head is a reminder of her married status, in contrast to Delilah's loose coiffure.

In Pero, Rubens achieved one of his most beautiful classical profiles – the inspiration may well have been a Roman gem like the Gonzaga cameo he wistfully recalled handling some fifteen years later.

Rubens explored a similarly posed encounter in his 1613 *Jupiter and Callisto* (Staatliche Kunstsammlungen, Gemälde-galerie Alte Meister, Kassel), where the amorous couple are further apart. The *Samson amd Delilah* (cat. 77) is, of course, a further investigation into the way the arrangement of a couple can express emotion. To explore the many possible variations of feeling in what is essentially the same arrangement of figures is typical of Rubens.

1 For example in Pliny, *Historia Naturalis*, VII.36 and most notably in Valerius Maximus, *Dicta et facta memorabilia*, V.4, where it is described as the subject of a painting.
2 For the print, by Cornelis van Caukercken, see McGrath 1997, I, fig. 70 and II, p. 100.
3 There is a Vorsterman engraving (see Madrid 2004–5, fig. 37) after a Rubens *Adoration of the Magi* that includes a broken cobweb, without the guarding spider.

ESSENTIAL BIBLIOGRAPHY
Varshavskaya 1989, pp. 39–41; McGrath 1997, II, no. 18, pp. 97–103; Lille 2004, no. 44, pp. 90–1

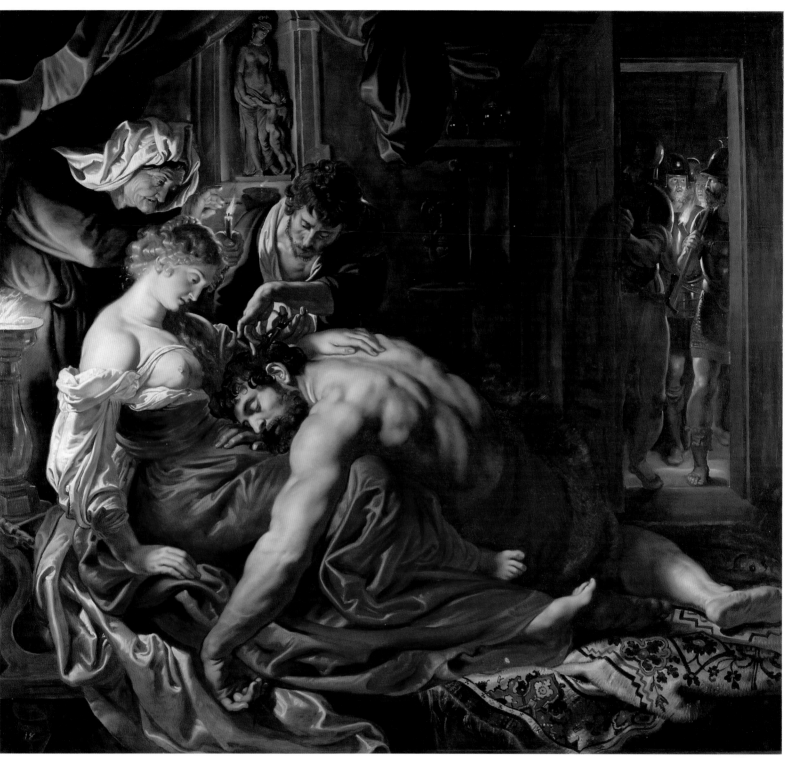

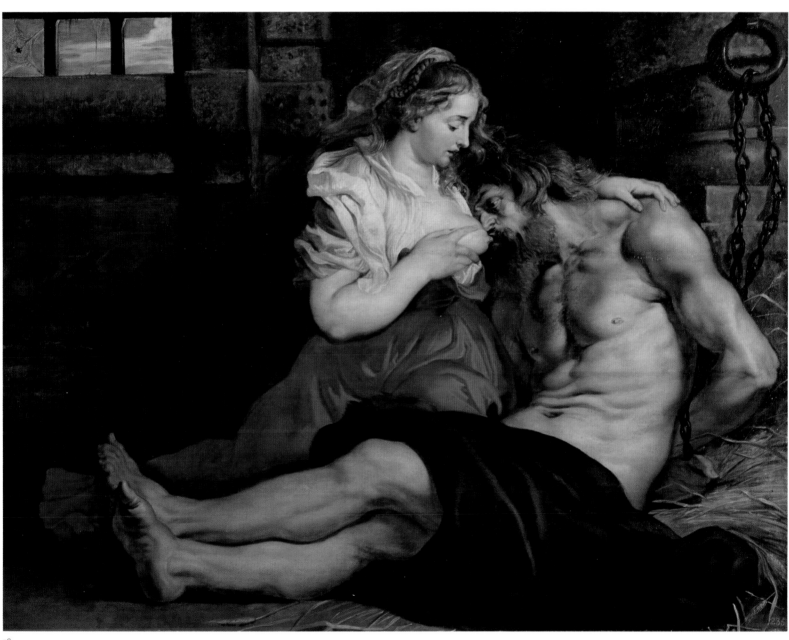

78

79

79. Cain Slaying Abel about 1608

Oil on panel, 131.2 × 94.2 cm
The Samuel Courtauld Trust, Courtauld
Institute of Art Gallery, London
Bequeathed by Count Antoine Seilern as part
of the Princes Gate Collection, 1978
(P.1978.PG.353)

The unlikely Old Testament story of how one brother murdered another while they made a sacrifice to God became popular as an artistic subject when, in the early seventeenth century, the expression of violence began to figure more prominantly as a challenging subject. In Rubens's picture, the violence of the action is stressed both by Abel's agonised expression – worthy of the written descriptions of the last moments of many of Aeneas' foes – and by the tendons, criss-crossed by blood vessels in the arms and the suggestion of sinews around the elbow. Muscles, in contrast, lack anatomical clarity and look more like bubblewrap than credible bodies under stress. The somewhat tentative handling, the lack of plausible definition and the choppy paint surface of the flesh fits well with a date of around 1608.

Possible visual sources are Giambologna's *Samson and the Philistine* (Victoria and Albert Museum, London), which the Duke of Lerma had acquired in 1601, and Michelangelo's treatment of the subject, which was well-known as a bronze statuette. Rubens could have seen the Giambologna marble during his visit to Spain in 1603–4.[1] The straining heads of the Philistine and Abel are very similar. For Rubens the challenge was to find a design that gave a sense of more than one viewpoint and of sculptural relief.

This composition, like Rubens's other violent images from around 1610, such as the lost *Judith and Holofernes* (known only from Galle's engravings) were popular. *Cain and Abel* was engraved by Willem Pietersz Buyteweck around 1612–13. DJ/AB

1 See Vergara 1999, p. 15.

ESSENTIAL BIBLIOGRAPHY
Held 1957, pp. 125–35; Jaffé 1989, no. 86, p. 164–5; D'Hulst and Vandenven 1989, no. 4, pp. 38–40; Jaffé and Bradley 2003, pp. 14–15

80. The Beheading of Saint John the Baptist 1608–9

Oil on panel, 94 × 102 cm
Private collection on loan to the
The National Gallery, London (L960)

The story is told in the Gospels of how Salome's dancing so enthralled Herod, her stepfather, that he promised her anything she wanted. John the Baptist had verbally attacked her mother, Herodias, for living with Herod who was her brother-in-law. Herodias urged her daughter to demand John's head. Herod kept his promise and the head was duly brought to Salome on a charger.

There is a drawing of Salome's servant pulling John's tongue, while his head is on a platter, which suggests that Rubens first planned a half-length painting.[1] The full-length composition allowed him to include John's decapitated body. The blueish colour of the hands is a convention of his own for limbs emptied of blood. It may have been informed by the experiments on valves in veins which were being conducted in the University of Padua's famed medical schools around 1602 by the great Fabricius of Aquapendente. One of his students at this time was the Englishman William Harvey, who later wrote the groundbreaking *On the Circulation of the Blood* (1628). Rubens was to return to the image of John's tongue being prodded (again by Herodias) in the late Edinburgh painting of the *Feast of Herod*. The device makes us feel the violence as well as see it; *Judith and Holofernes* and the *Massacre of the Innocents* (cat. 82) exploit similarly gruesome subject matter. This marvellously ghoulish motif reminds us how Baroque artists used extreme brutality both to move us and to make us physically uncomfortable.

The man in red with a hat pays homage to Rubens's close friend Adam Elsheimer, and a work like his *Saint Lawrence* (National Gallery, London). Rubens is already using stock costume props: the tight red dress and yellow shawl will appear again in the *Massacre* (cat. 82) and the *Samson* (cat. 77), where it has more difficulty containing the wearer.

As in the Prado *Adoration* (fig. 57), a black slave boy has engaged Rubens's attention. Here he holds the platter, but his bright eyes are directed at Salome. She hardly reacts to the scene. Her aloofness is stressed by the way the outdoor platform shoes which protrude from under her dress keep her delicate slippers free from the blood that drips across John's hands and soaks his animal-skin cloak. The executioner ironically sheaths his sword in the fasces, symbol of civic Concordia and civil justice. His anonymous back and the way he steps on John's body, as if the corpse were a pedestal, suggest disengagement. There is some free brushwork creating opalescent passages around his ankle. Even the chain is slack as the saint's life ebbs away.

The old woman is a stock character derived from sources such as Caravaggio's *Judith* (Palazzo Barberini). Her large headdress reminds one of similar headgear in cat. 89. They may both date from 1608–9 (there is a 1609 copy, by Hieronymus Franken, in Dresden). The figure of the executioner may be derived (in reverse) from the executioner in Raphael's *Judgement of Solomon* in the Stanza della Segnatura in the Vatican (copied on the *verso* of the Berlin pocketbook sheet, fig. 18).

1 For the drawing, which is in Amsterdam's Historich Museum, see New York 2005, no. 26r.

ESSENTIAL BIBLIOGRAPHY
Jaffé 1989, no. 115, p. 170; Jaffé and Bradley 2003, pp. 13–14; New York 2005, no. 26

80

80 (detail)

81 (detail)

81. The Brazen Serpent 1609–10

Oil on panel, 161.2 × 146.1 cm
The Samuel Courtauld Trust, Courtauld
Institute of Art Gallery, London
Bequeathed by Count Antoine Seilern as part of
the Princes Gate Collection, 1978
(P.1978.PG.355)

The Old Testament (Numbers, 11: 4–9)
records that those who saw the bronze serpent
on Moses's staff were saved from a plague of
venomous snakes. For an artist, the subject of
the curative power of sight must have had
special significance. It also let Rubens take on
Michelangelo, whose Sistine Ceiling treatment
of the story he knew well, from a retouched
and repaired drawing he owned.

The male figure on the left who charges
out towards us is the most finished part of
the picture. Rubens had already shown a
predilection for singling out similar figures
in his selective copy after the Beham print
(cat. 6) *The Brazen Serpent*, like cats 77 and 82,
is a study of tight, rippling surfaces. Rubens's
brief submersion in the heroic *all' antica* style
of over-emphatic musculature resulted in

many successes, but the problems he has here
in getting the highlights in the children's
hair right, and in welding the composition
together, is a reminder that the challenge
of creating complex, dramatically lit
compositions in this style was sometimes
beyond him.

Individual elements, however – like the
mother who, desperate that her child should
see the snake, raises it above her head – are
successful both as dramatic inventions and as
pure painting.[1] The curved planes of the body
of the dying child show Rubens's continuing
fascination with rounded forms. They can be
found in the elder boy assisting the disrobing
in the Prado *Judgement of Paris* (cat. 11, see also
frontispiece) and in the dead baby with his
back towards us on the right-hand side of
cat. 82. He also develops his handling of curved
surfaces like these in his drawing of the sons of
the *Laocoön* (cat. 24). It is possible that the
skeletal tension of energised flesh in his later
paintings of women's backs evolved from his
studies of well-muscled youths. It may surprise
us today that Rubens's female canon evolved

from these early, violent visions of young men
– but in the seventeenth century one would
expect male models to be used for all studies
from life. Although we know of one Rubens
request for female models, it is probable that
they were rarely employed in artists' studios
(Rembrandt's studio was exceptional).

The subject shows how closely Rubens
allied himself to Michelangelo after his
return to Antwerp. There is a sense that
Michelangelo's inventions are being revived,
and then transformed by painterly handling
and Flemish realism. Paintings such as *The
Brazen Serpent* give Rubens a claim to be
Michelangelo's last pupil.

The original arched top of the painting
can still be seen cutting into its present
rectangular shape. The sense of the figures
projecting into the viewer's space is enhanced
by seeing the painting from below.

1 For rehearsals of the subject in the pocketbook
 see C.ms. fol.14v.

ESSENTIAL BIBLIOGRAPHY
Jaffé 1989, no. 110, p. 169; D'Hulst and Vandenven
1989, no. 23; Jaffé and Bradley 2003, pp. 15–16

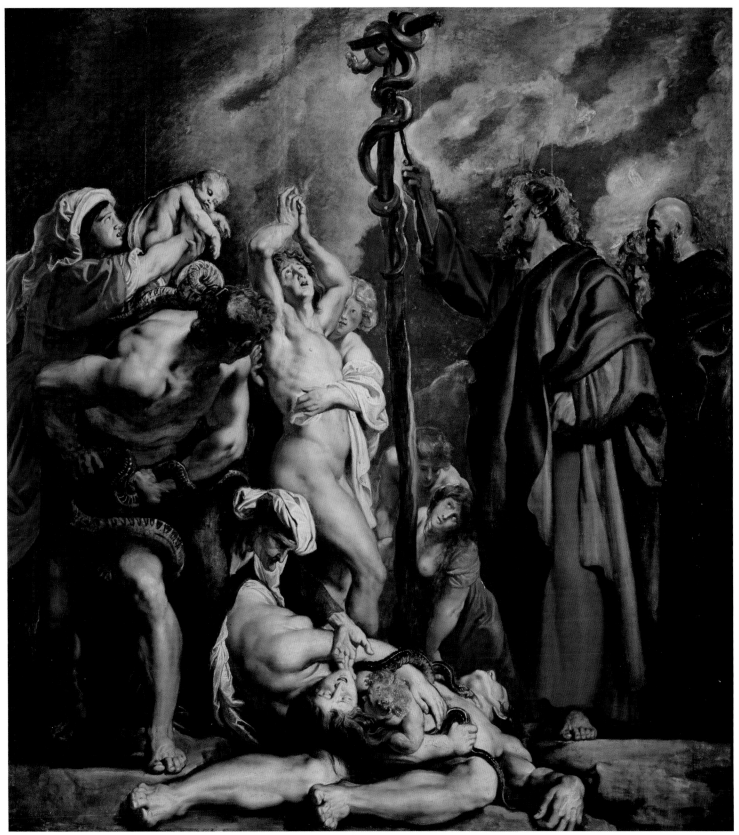

81

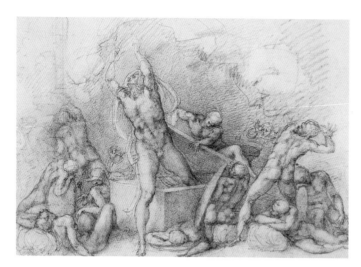

Fig. 58 Marcantonio Raimondi (about 1480–about 1487) after Raphael
The Massacre of the Innocents, after 1509
Engraving, 28.3 × 43.4 cm
The British Museum, London (P&D 1985.0915.103)

Fig. 59 Michelangelo (1475–1564)
The Resurrection of Christ, 1530
Black chalk, 28.3 × 43.4 cm
The Royal Collection (RL 12767 P&W 427)

82. The Massacre of the Innocents about 1611–12

Oil on panel, 142 × 182 cm
Private collection, on loan to
The National Gallery, London (L949)

The Massacre of the Innocents can be read as
the summation of all Rubens learned on
his travels in Italy. It is a bravura display of
classical and artistic learning, designed to
astonish his Flemish patrons and contem-
poraries through imagery as well as explosive
brushwork. The painting is much more than
a plethora of sources, for while a list of them
can make it seem like a sculpture garden
morphed into a graphic encyclopaedia,
unravelling Rubens's quotations makes
us realise that imitation was an intellectual
as well as a visual part of Rubens's picture-
making.[1]

The composition is built from 'chains'
of struggling figures, an idea that seems to
have its basis in the *Laocoön* (fig. 30), but the
technique is now deployed infinitely more
elegantly than when Rubens inserted ideas
from that sculpture into his Potsdam *Battle
of the Amazons* (see cats 1 and 4, and the detail
on p. 40).

An analysis of the composition helps one
understand the complexity of the figural
relationships. The main group of fighting
men and women is made up of two parallel
formations which rise from lower left to
upper right. One chain, which we see from
behind, comprises the lunging, helmeted

soldier grasping the hair both of the crouching
woman on the left and the dark-haired mother
behind the central executioner. The woman
in the red dress scratching the face of her
assailant forms another chain with her baby
and her attacker (left, detail). In the first
group, the crouching woman leans forward to
balance the backward-leaning central figure,
but in the second Rubens makes no attempt to
balance the forces within the chain. The
central woman topples over us, pushed by the
old woman who falls onto her. The composition
collapses over us, just as the mothers' worlds
are collapsed by the soldiers' athletic brutality.

Despite the strong diagonal arrangement
of these chains of figures, the image can also
be read as an energetic sphere, where the
centrifugal energy is contained in part by the
drapery that flows down from the tangle of
figures, fixing them to the ground.

This taut sequence of thrust and counter-
balance has much in common with Rubens's
early battlescenes, but his years in Italy have
utterly transformed him as an artist.

The arrangement and lighting of the figures
evoke the horror of the events described in the
biblical narrative (Mathew 2: 16–18). We feel
as well as see the effect of nails scratching, of
steel cutting and of teeth biting. Waves of pain
are conveyed in outstretched limbs and
twisted expressions.

Rubens surpasses the prototypes he
sought to emulate.[2] Marcantonio Raimondi's

print (after a design by Raphael) of the same
subject (fig. 58) was perhaps the most famous –
or at least the most widely disseminated –
precedent, but Rubens has abandoned
Raphael's graceful, stylised approach in favour
of something more vigorous and, as a
consequence, more horrific. He has translated
Raphael's idea into paint, showing how brush
marks on canvas could be more powerful than
lines engraved in copper. Perhaps that is why
he chose not to engrave his version of the
Massacre, although prints were made of other
paintings he executed at this time.

Michelangelo was another important
source. His lifelong obsession with the
portrayal of the male figure, particularly in
action, appealed deeply to Rubens, and his
example greatly affected the way Rubens
developed the sculptural potential of the
human body in painting.

From Michelangelo's drawing of the
Resurrection of Christ (fig. 59), Rubens borrowed
the dramatic figure of Christ bursting from his
tomb for the soldier on the right who holds a
baby above his head in the *Massacre of the
Innocents*. But whereas Michelangelo's Christ
pushes upwards, Rubens's soldier directs all
his force in the opposite direction, ready to
smash the baby he holds against the column.
Where Michelangelo's Christ is triumphant
over death, Rubens's soldier purveys it. In the
Massacre, as in the *Resurrection*, the human
body is the vehicle of emotion.

82 (detail)

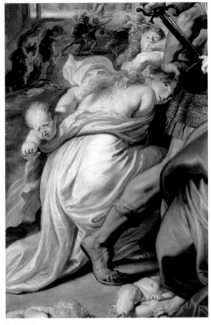

82 (detail)

Fig. 60 Philippe Galle (1537–1612) after Frans Floris (1519/20–1570)
The Massacre of the Innocents, possibly 1570s
Engraving, 33.1 × 41.6 cm
The British Museum, London (P&D H-F-1-69)

Baccio Bandinelli – the scourge of Michelangelo, and therefore perhaps a surprising source for Rubens – had himself designed a print of the *Massacre of the Innocents* in about 1520. Rubens singled it out as a good source for poses in the text of his pocketbook, and a whole sequence of drawings after Bandinelli's prints can be found in various copies of it, although none were transplanted directly into paintings.[3]

Rubens also paid attention to Antwerp precedents. The protagonists in Frans Floris's *Massacre* of 1570, then in the Antwerp city hall, were faithfully echoed but made over into a more modern composition. Floris must have been the giant of the previous generation, and it is sad that we can only judge Rubens's re-imagining against an engraving of a now-lost work (fig. 60).[4]

Rubens probably also copied a *Massacre of the Innocents* (datable to 1604) by Giovanni Battista Paggi when he went to Genoa in 1606, as it appears in the Chatsworth copy of his pocketbook. It is tempting to imagine

that he was already gathering material for this picture at that time. Further, in the same copy of the pocketbook there is a folio covered with sketches of women being dragged – which again would be useful material for a projected *Massacre* (fig. 12).

As there are no known drawings that relate specifically to the painting, we must rely on such records to envisage the making process. The running woman in the background and the tug on the baby's swaddling band in the foreground (see the *Descent from the Cross*, cats 55–6), were motifs that excited the young Rubens as we see, once again in the pocketbook copies, where images of figures pulling clothes and drapery are collected together.[5]

A sculpture, the *Naked Venus crouching at her Bath* (fig. 61, owned by the Anglo-Dutch painter Peter Lely in the late seventeenth century) provides the most literal of several quotations from classical works. Rubens would have known it from the Gonzaga collection in Mantua. The free variations on the *Venus* made in Rubens's pocketbook mark

the beginning of a long love affair with the pose – it was a figural type he drew upon throughout his career (most literally in the *Venus Frigida* (fig. 62).[6]

In the distant-left background a woman shields her offspring. Her pose, reminiscent of Niobe's futile attempt to save her children, may have been inspired by the ancient sculpture of the subject in the Uffizi, Florence. Rubens quoted the same figure in an early *Rape of the Sabines* drawing,[7] but in the painting he has ingeniously paired her with a soldier drawn from the print after Raphael's *Massacre of the Innocents* (fig. 58).

The sculpture showing a dish of three sleeping putti in the Galleria Borghese (acquired on 30 June 1607 by Giovan Borghese) may have inspired the form of the slain child in the left foreground.[8] While Michelangelo had tried to surpass the skill of the ancients with his sculpture of a sleeping *amorino*, for which there were various ancient sources available in the Renaissance, Rubens here translates sculptural forms into paint.[9] It is as though he

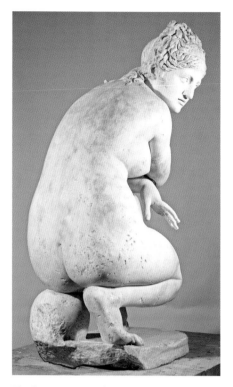

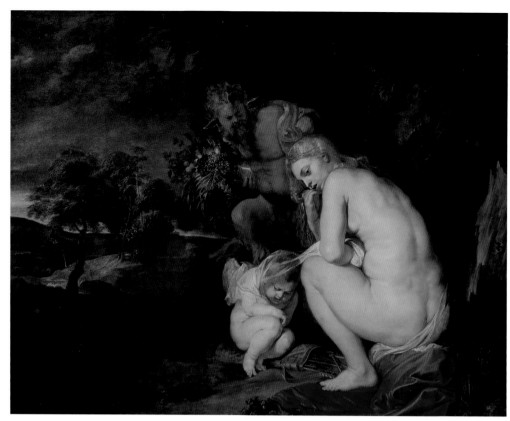

Fig. 61 Roman, second century AD
Naked Venus crouching at her Bath
Marble, height 112 cm
The British Museum, London, on loan from
Her Majesty Queen Elizabeth II (GR 1963.10-29.1)

Fig. 62 **Venus Frigida**, 1614
Oil on panel, 142 × 184 cm
Koninklijk Museum voor Schone Kunsten, Antwerp (709)

was entering both the debate about the relative merits of painting and sculpture and that which set antiquity against modernity.

While these derivations are important, it is the bold, painterly technique that makes the *Massacre of the Innocents* such a compelling image. It must be one of Rubens's first attempts to capture the fire of an oil-sketch in a larger format; to deliberately harness the vibrancy of the brushstrokes to convey the urgency of the narrative. The superb interweaving of active figures makes a date of around 1611 tempting, but there is still a plasticity in the faces – as if they are rubber masks rather than flesh stretched across bone – and a splattery use of white that would suggest a date closer to 1609. Rubens was a consistent reuser of his own inventions, so it is worth noting that he tried out the pose of the scratched man shying backward in his drawing for *Judith and Holofernes* (about 1609, now lost) and again in the *Conversion of Saint Paul* (cat. 70).[10] While a date of about 1611 for the *Massacre of the Innocents* seems to best

match the painting's sophistication and complexity, there are persuasive arguments for other chronologies. The confrontations of this exhibition can only help.

1 Compositions developed as a combination of small units have antecedents in Italian pictures such as Piero di Cosimo's *Fight between the Lapiths and the Centaurs* (1500–15, National Gallery, London) and Daniele da Volterra's *Massacre of the Innocents* (1560s, Uffizi, Florence). The latter we know from his drawings, which began as pairs of struggling figures and rotations of Michelangelo's *Samson and the Philistines*, before being assembled into a complex composition.

2 For more on the *Massacre of the Innocents* and its sources, see Jaffé and Bradley 2003. For Rubens's sources generally see Muller 1982, pp. 229–47.

3 Bandinelli is one of only two Renaissance artists (the other being Daniele da Volterra) Rubens names in the pocketbook.

4 It might help to visualise some details – including the Vitruvian cityscape – by referring to Martin de Vos's *Tribute Money* of 1603–4 (Royal Museum Antwerp), where a similar setting can be consulted in paint.

5 In a pocketbook folio (C.ms. fol.54v, fig. 12)

labelled 'Trahentes' ('those being pulled') Rubens has ingeniously changed images of skeletons pulling monks into men grabbing women's skirts and hair. More occur on folios 55v and 56r (fig. 13). The child's pose is revisited in the Albertina, Vienna, drawing for the *Assumption of the Virgin*.

6 There are looser adaptations in the Dulwich *Adonis* oil-sketch (Held 1980, I, no. 267; II, pl. 239). See also the pocketbook essay, p. 24 and fig. 16.

7 Garff and Pedersen 1988, II, pl. 243.

8 There are later versions of the Borghese *Sleeping Putti* in the Palazzo Pitti, Florence, and at Chatsworth House, Devonshire. See Faldi 1954.

9 McGrath 1997, II, no. 37, fig. 126. Rubens's friend Rockox even owned one. See Hirst and Dunkerton 1994, pp. 24-8.

10 The primary inspiration for this figure is Tetrode's *Ecorché* (cat. 33) – with its legs swapped.

ESSENTIAL BIBLIOGRAPHY
Gordon 2003; Jaffé and Bradley 2003; Genoa 2004, under no. 37, pp. 224-7

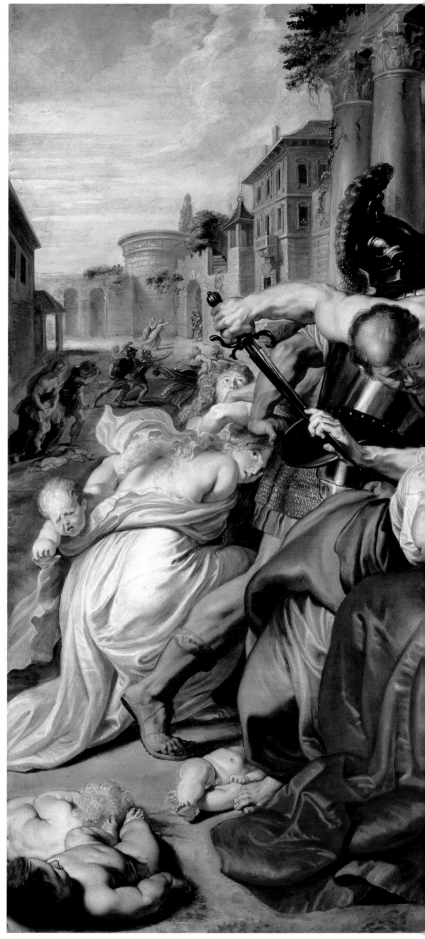

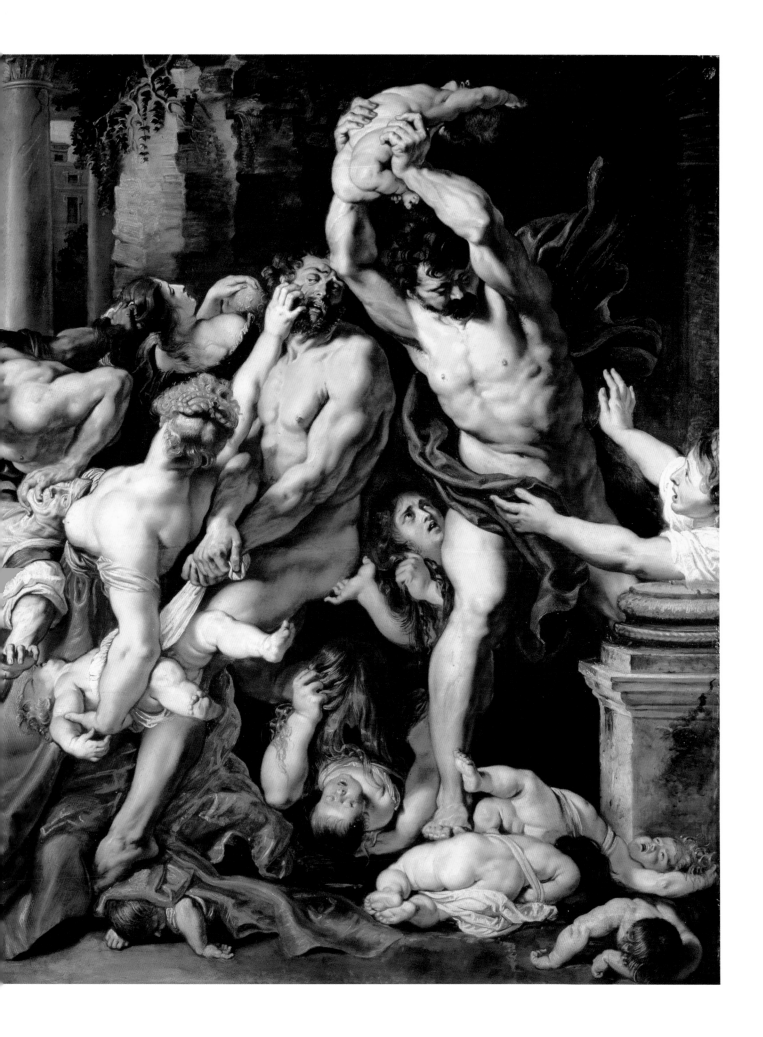

Fig. 63 **Study of male figures and female centaurs** (*verso*), 1628–30
Pen and brown ink on brown paper, 26.2 × 34.8 cm
The Samuel Courtauld Trust, Courtauld Institute of Art Gallery, London
Bequeathed by Count Antoine Seilern as part of the Princes Gate Collection, 1978
(D.1978.PG.61.V)

Fig. 64 Roman after Greek original, second century AD
Centaur with Cupid
Marble, height 147 cm
Musée du Louvre, Paris (MA 562)

Fig. 63

Fig. 64

83. Centaur tamed by Cupid 1605–8

Black chalk, 48.1 × 37.1 cm
Wallraf-Richartz-Museum, Cologne
(WRM/Z 5888)

This, and *Laocoön and his Sons* (cat. 26), are recently discovered drawings by Rubens after famous antique sources (fig. 64). The *Centaur* drawing is notable for the authority with which the surface is mapped in black chalk with fine accurate hatching, and for the care Rubens, by nature a completer of images (as we see in his repairs to torn drawings), takes to record breaks in the statue.

There must have been a real wish to document rather than reconstruct the sculpture. The first record we have of it is Rubens's drawings, which suggests that it was discovered about 1605. It is thought to be a copy of a second century BC bronze. Rubens would have been interested in the way the bands of the quiver belt pull against the Cupid's flesh – he used an equivalent girdle over

Delilah's breast to great effect in the *Samson and Delilah* (cat. 77). The drawing is similar to the *Laocoön* sheets, and was probably made either in 1605 or on his final Roman visit in 1606–8. However, a case for an earlier date can be made due to the surface treatment of the forms, and the element of caricature in the head. This connects them with copies after Michelangelo from around 1600, in which Rubens imposes extreme readings of expressions.

Two other Rubens drawings from this group, after the *Dying Seneca*, have been documented as being made after his 1602 trip to Rome, that is to 1605–8, so perhaps the later date is more probable.[1] As the centaur group appears to have been 'prettified' by later restorers it is hard to be certain about how far Rubens played up the facial types in his drawing. He certainly raised the chest hair, which is only incised in the marble. There are real questions as to whether one can detect the influence of drawings like this and his *écorchés*

in his paintings before 1609.

Rubens clearly admired the statue for he copied the pose directly in his *Ecce Homo* (cat. 84) and he found other uses for the Borghese *Centaur*. In a drawing of centaurs embracing (fig. 63) Rubens animates the sculpture, explores various poses and uses it for a narrative in which a centauress reaches back to embrace her partner.[2] In some of these trials the pose is closely dependent on the antique source. He restores the centaur's right leg (which has now been replaced on the sculpture as well), and replaces any stoney stiffness with erotic animation.

1 New York 2005, cats 22–3, pp. 112–15. Rubens may have been scrutinising such statues for his brother's book *Electa*, Antwerp 1608, which he illustrated.
2 Held 1959 (1986), no. 184, pl. 179.

ESSENTIAL BIBLIOGRAPHY
Haskell and Penny 1981, no. 21, fig. 93, p. 179; Van der Meulen 1994, II, nos 65–9; Westfehling 2001, figs 26, 28, pp 171–222; Brunswick 2004, no. 74, p. 289

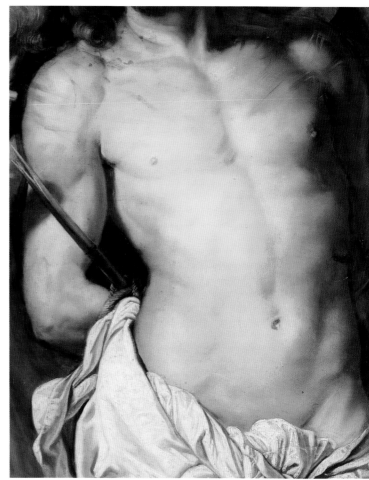

83 (detail)

84 (detail)

84. Ecce Homo about 1610

Oil on panel, 125.7 × 96.5 cm
The State Hermitage Museum,
St Petersburg (GE-3778)

This bravura work, among the most expressive paintings of the 1610–11 group, is unexpectedly a literal quote from the *Centaur tamed by Cupid*.[1] The sculpture was discovered in Rome at the beginning of the seventeenth century and extensively drawn by Rubens (see cat. 83).[2] The painting probably targeted an Antwerp patron well-informed about Roman antiquities, such as Van der Geest or Rockox.[3] Although the pose of the ancient source makes Christ seem triumphant rather than dejected after his flagellation, blue bruises and congealed blood are painful reminders of his suffering. The subject is taken from the gospel of John (19: 4–5), and records the moment when Pilate, or his proxy, who is shown on the left of the painting, presented Christ before the crowd, saying,' "Behold, I am bringing

Him out to you, that you may know that I find no fault in Him." Jesus came out, wearing the crown of thorns and a purple robe and Pilate said to them, "Behold the Man!"'

Christ's frontal position, with his head turned but his gaze directed outwards, is disquieting, for it requires the viewer to participate in his plight. Rubens's painting differs from the usual formula of Christ's hands being tied in front of him; instead they are behind his back, an innovation prompted by the use of the Centaur sculpture as a source.[4]

The billowing red cloak is held up in a gesture also found in Titian's late treatments of the subject (for example, the *Ecce Homo* in St Louis Art Museum, Missouri). The red reflections which bring out the blue welts are Rubens's own invention. An expansive loincloth completes the setting for the body. There is a play of contrasts between Christ's resignation and the vigour of the tormentors

who crowd tightly in on him. The panel is very like the *Massacre* (cat. 82) in its explicitly painterly brushwork and physically overwhelming presence, and like the *Samson* (cat. 77) in the insistent physicality with which it confronts the viewer.

Like the now lost *Judith and Holofernes* this painting was engraved by Cornelis Galle.

1 See Linnik 1981, pp. 30–3.
2 New York 2005, nos. 20–1, pp. 108–11.
3 Mantua 2002, p. 59, suggests that this painting was the *Ecce Homo* in the 1626–7 inventory (19 January) of the Gonzaga Collection.
4 Romanino in the Metropolitan Museum of Art, New York, and Caravaggio, Capodimonte, Naples, use a similar forward pose in their *Flagellations* – so Rubens may be playing on this Lombard tradition as well.

ESSENTIAL BIBLIOGRAPHY
Varshavskaya 1989, nos 10, 11; Judson 2000, no. 13 (where it was rejected as a work by Rubens)

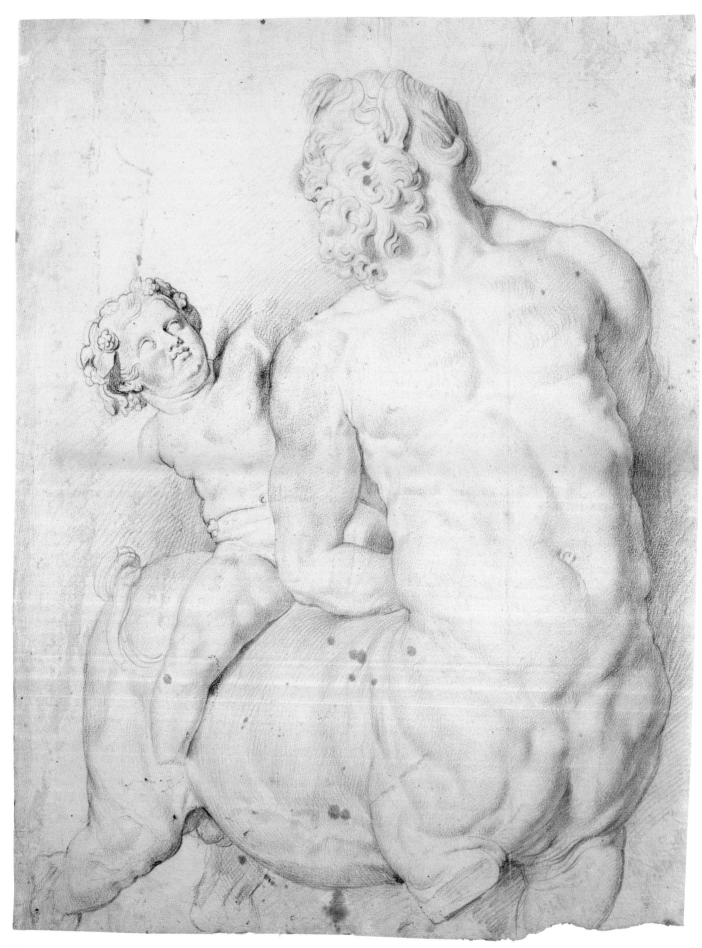

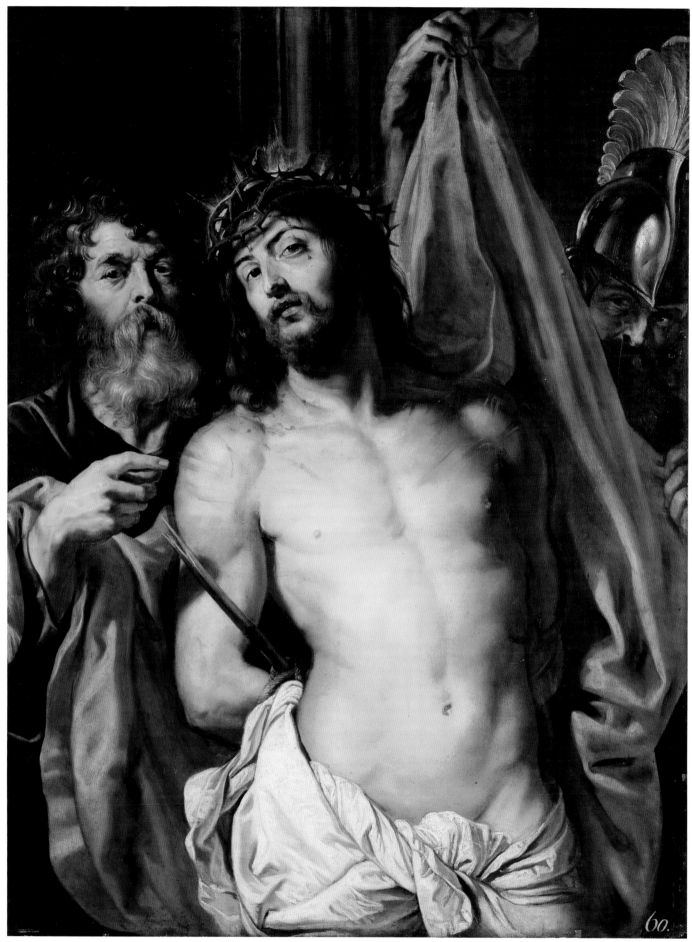

60.

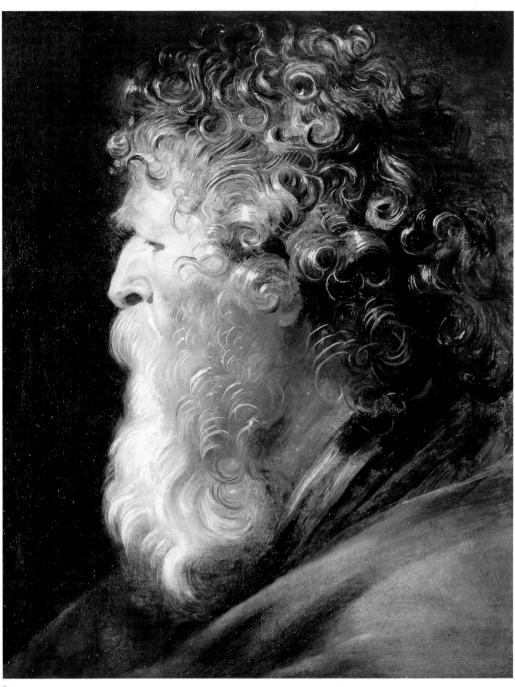

85

85-6. Studies of Old Men

85. Study of a Man's Head, about 1608
Oil on panel, 59 × 52 cm
Galleria Nazionale d'Arte Antica
di Palazzo Corsini, Rome (343)

86. Study of a Man's Head, about 1608
Oil on panel, 63.5 × 50.2 cm
The State Hermitage Museum,
St Petersburg (GE 4745)

These two heads show the same model.
Together with the Glasgow *Old Man*
(Hunterian Art Gallery, University of Glasgow),
the three seem to have been used as character
heads for the *Adoration of the Magi* (fig. 57), and
the *Ecce Homo* (cat. 84).

It is possible that they were made well
before the pictures themselves, but as they do
not seem to infiltrate earlier paintings a date of
around 1608 is probable. The only one that
has a definite claim to have been made in

Rome is the African for the *Adoration* (fig. 57)
which is on Roman paper.[1]

Frans Floris is supposed to have made head
studies, but Rubens used them systematically
to build a library of types. His copies of heads
from Raphael's tapestry cartoons suggest that
he felt a need for a wider facial vocabulary.

The heads display explosive vitality: the
faces jump out of the panel at you. Rubens
reveals his painterly skills in these works
made for his own and his pupils' private

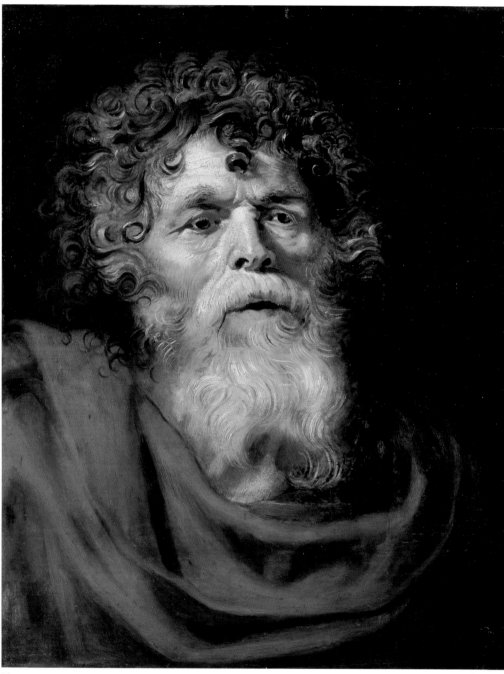

86

consumption. The lightning-like jagged strokes down the nose and cheek of cat. 85 animate the surface – a tactile approach also found in the *Adoration*.[2] Effects of colour, for instance the blue in the beard of the Glasgow head, are explored. We are made acutely conscious of the quality of hair – black wriggling strands that hang across the skull, rather than following its contour. Similar hair is found in the Madrid *Susanna* (fig. 40).

Much later, Rubens instructed an assistant to cover these key preparatory works from prying eyes, which suggests that he saw them as building blocks or templates for his paintings.[3] They are the characters through whom he tells his stories. The Corsini study (cat. 85) was originally paired with another view of the same model;[4] it is possible cat. 86 has also been separated from its pair.

1 See Madrid 2004–5.
2 *The Raising of the Cross* (fig. 50) also incorporates

faces enlivened with hatched brushwork. The closest painterly precedent is Tintoretto.
3 'I have urgent need of ... three heads in life-size, painted by my own hand.... It would be a good plan to cover it ... so it may not suffer on the way, or be seen.' See Rubens to Lucas Fayd'herbe, Magurn 1995, letter 244, pp. 410–11.
4 See Held 1980, I, p. 600.

ESSENTIAL BIBLIOGRAPHY
Held 1980, I, no. 432; II, pl. 421 (for cat. 85); Held 1980, I, no. 435, pl. 422 (for cat. 86); Varshavskaya 1989, no. 3 (for cat. 86); Madrid 2004–5, no. 3, p. 31

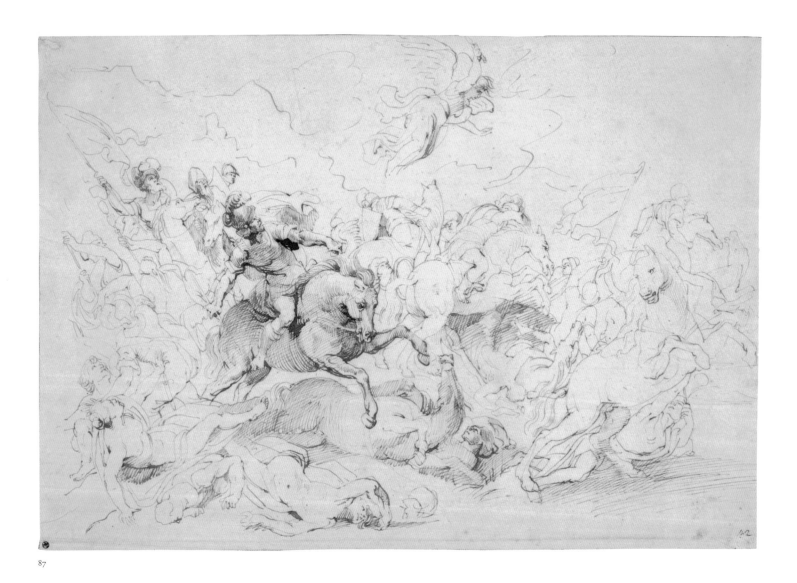

87

87–8. The Defeat of Sennacherib

87. Attributed to Rubens
The Defeat of Sennacherib, about 1600–2
Pen and brown ink, 21.8 × 31.4 cm
Albertina, Vienna (8204)

88. **The Defeat of Sennacherib**, about 1615
Oil on panel, 97.7 × 122.7 cm
Alte Pinakothek, Bayerische
Staatsgemäldesammlungen, Munich (326)

The Old Testament records how King
Sennacherib, leader of the powerful Assyrian
people – one of the great enemies of the
Nation of Israel – was marching to invade
the city of Judah when an angel of the Lord
descended upon his camp at night and
destroyed his army.

In this amazing battlescene one sees how
'the angel of the Lord went out, and smote
in the camp of the Assyrians an hundred four-
score and five thousand: and when they arose

early in the morning, behold, they were
all dead corpses' (2 Kings 19: 35). In this
painting Rubens's early equestrian vocabulary
reaches its culmination. Although making
references to Rubens's early ideas for horse-
men in battle, the brilliance of the amalgam-
ation, rather than the individual inventions,
is now foremost. The shower of falling arrows,
inspired by Giulio Romano's *Death of Hylas* –
met again in the Wallace Collection's *Death of
Maxentius* – emphasises the snapshot-like

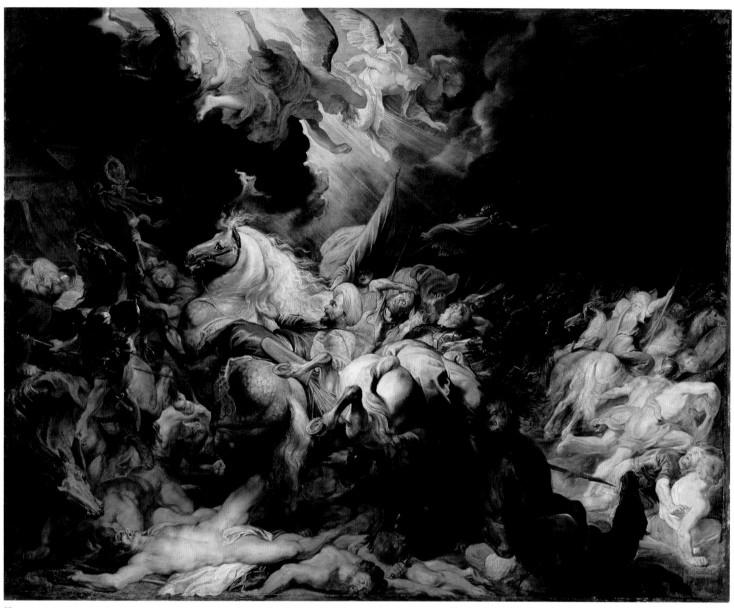

88

instantaneousness of the image. Terror is conveyed here with the same assurance with which violence is represented in the *Massacre* (cat. 82). The painting is a roll-call of models used earlier: the Liechtenstein *Conversion of Saint Paul* (cat. 67), provides the lunging figure on the far right;[1] the twisting seated man below him is a rotation of a foreground figure in the Antwerp Cathedral *Resurrection* (fig. 4) and the plunging horse can be found again on the left of the British Museum *Battle*

for the Standard drawing (cat. 32).

Other Rubens paintings have related motifs. The *Boar Hunt* includes the dappled rearing horse (as well as a similar splayed figure).[2] The dappled rearing horse is another exploration of the horse in the Prado *Saint George* (cat. 21), but here the protagonists are heavenly.[3] The *Dioscuri* (fig. 53) have been metamorphosed into living flesh, the treatment Rubens prescribed for Roman sculpture.

1 Perhaps inspired by Holbein. See fig. 18.
2 For the Calydonian *Boar Hunt* see sales catalogue Jean-Marc Delvaux, 10 Dec 2004, lot 63. See Balis 1986, no. 1 (as untraced).
3 See Jaffé 1989, fig. 251a. The same figure pose occurs in the right corner of a painting by Jan Brueghel of *Aeneas and the Sibyl in the Underworld* (Szépmüvéseti Museum, Budapest). Illustrated in Essen-Vienna-Antwerp 1997-8, no. 38.

ESSENTIAL BIBLIOGRAPHY
Balis 1986, II, pp. 91-5; Munich 2002, no. 326, pp. 288-91

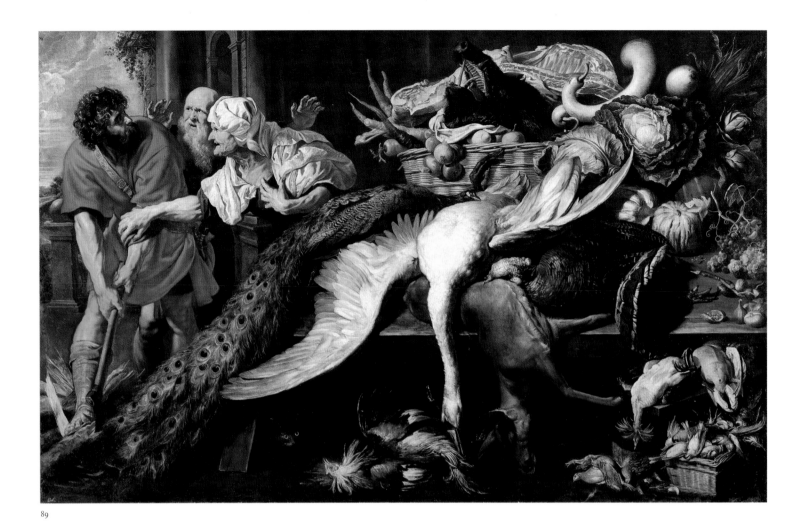

89

89. The Recognition of Philopoemen 1612–13

Oil on canvas, 201 × 311 cm
Museo Nacional del Prado, Madrid (1851)

The life of the impeccably mannered Achean general is told most famously by Plutarch in his *Lives*.[1] He writes of how Philopoemen who, despite his greatness as a general was of plain appearance and simple dress, once visited the city of Megara. A lady of the city, busy preparing a lavish meal for the general, did not recognise him when he arrived. Taking him for a servant she asked him to help in the preparations and the general at once began chopping firewood. When the woman's husband arrived, he exclaimed and the general's identity was revealed. 'What are you doing', he was asked, to which Philopoemen replied, 'What else, but paying the penalty for my ugly looks.'

There is a lively oil-sketch in the Louvre in which Rubens mapped out the composition – including (presumably) the still-life elements,

the cat under the table and the figures.[2] However, when he came to paint the large canvas he assigned this area to Frans Snyders, a specialist still-life painter, who had returned to Antwerp from a year-long trip to Italy in 1609. The oil-sketch is a reminder that Rubens could compose still-lifes even if he preferred to assign their execution to others. The swan, sometimes the preserve of royalty, dominates the centre of the composition.

The sketch differs in several important ways from the finished painting. The raised foot of the axeman, Philopoemen, is lowered in the final version, which gives more energy to the act of splitting the wood, while the old woman – his embarrassed hostess – is given a much bigger headdress that further emphasises the tension caused by the hero's face being in semi-darkness. The drops of blood on the table below the boar's head are similar to the droplets in the *Head of Medusa* (Kunsthistorisches Museum, Vienna), another

painting in which the attribution of parts – in that case the snakes and lizards – is suspended between Rubens and Snyders. It is possible Rubens touched up the swan's feathers and other details here to harmonise the work.

Rubens painted in a looser way on canvas supports, and the painting has a softer feel than, for example, the *Samson* (cat. 77) or the *Massacre* (cat. 82) which are on panel. This might suggest a date of 1612–13. However, the gusto with which Rubens handles the faces ties the painting to the 1609 Prado *Adoration* (fig. 57).[3]

1 Plutarch, *Philopoemen*, II.
2 Held 1980, I, no. 278 (for the Louvre oil-sketch) pp. 374–5.
3 The large headscarf, not found in the oil-sketch for the painting, also occurs in the *Beheading of Saint John the Baptist*, cat. 80.

ESSENTIAL BIBLIOGRAPHY
Held 1980, I, p. 375; Vergara 1999; Madrid 2004–5, p. 68–71

89 (detail)

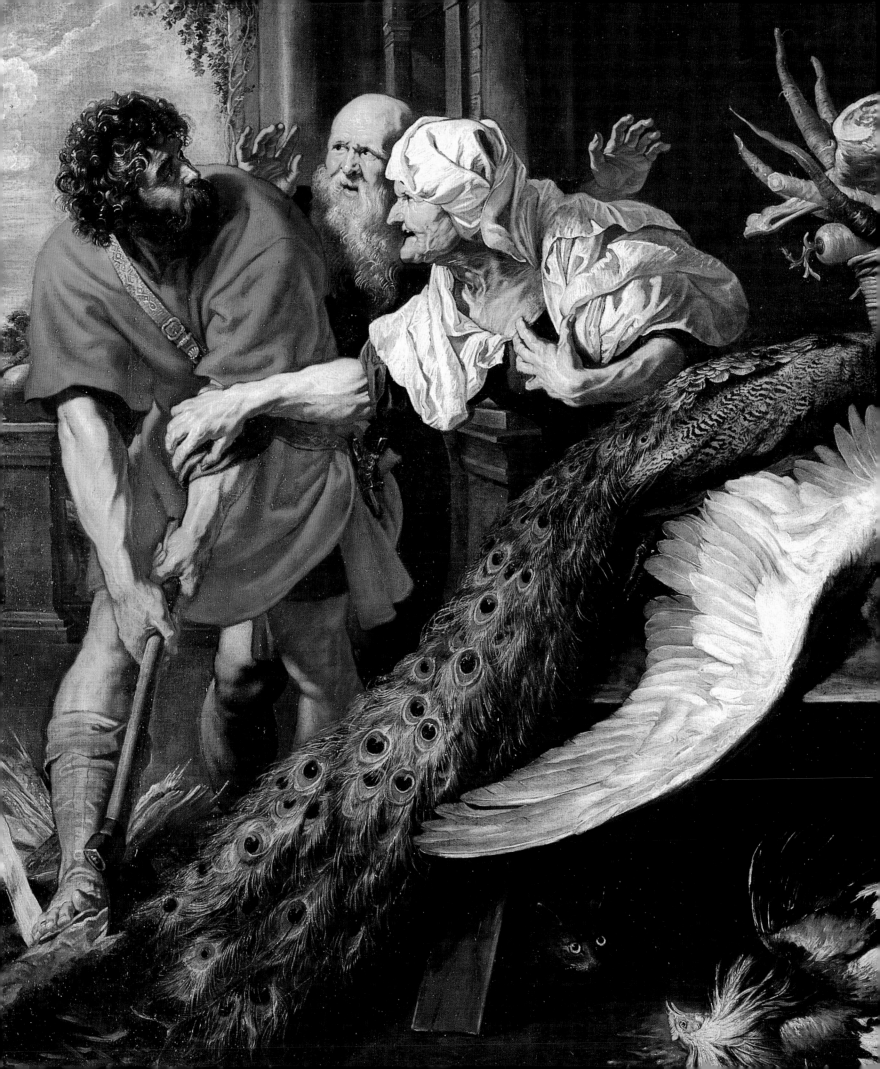

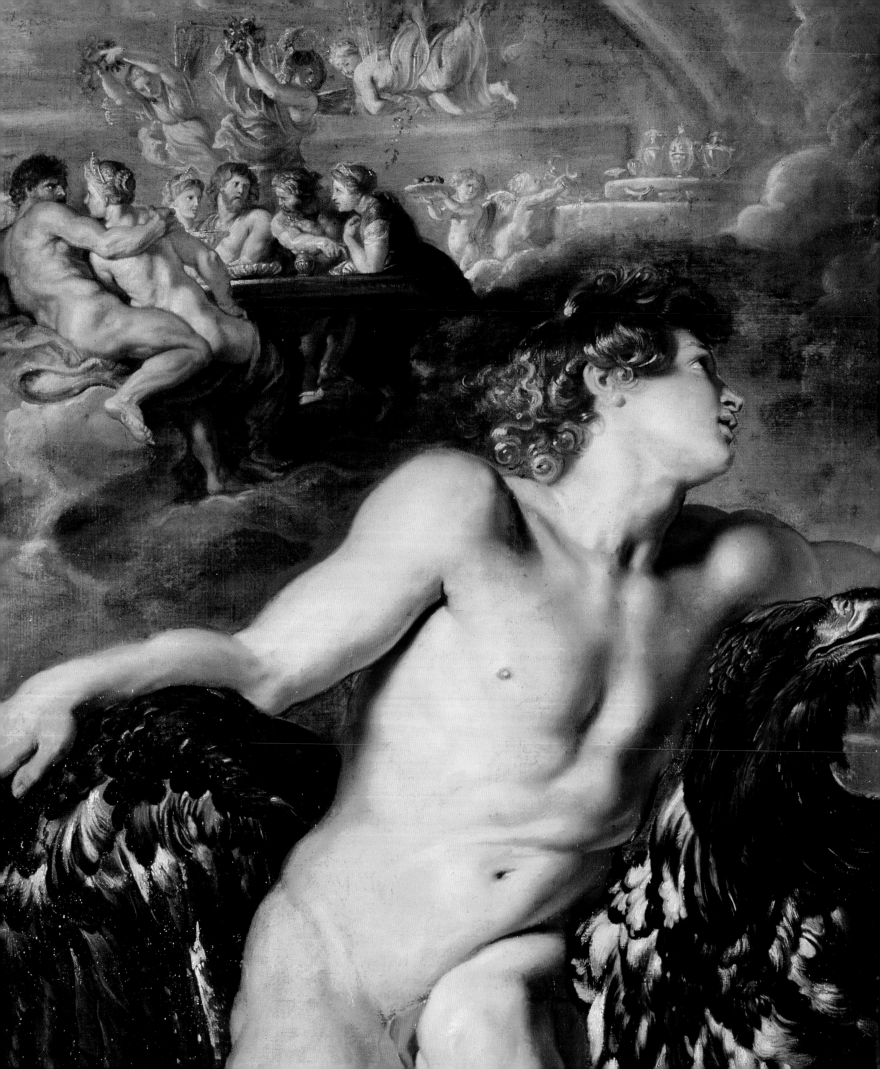

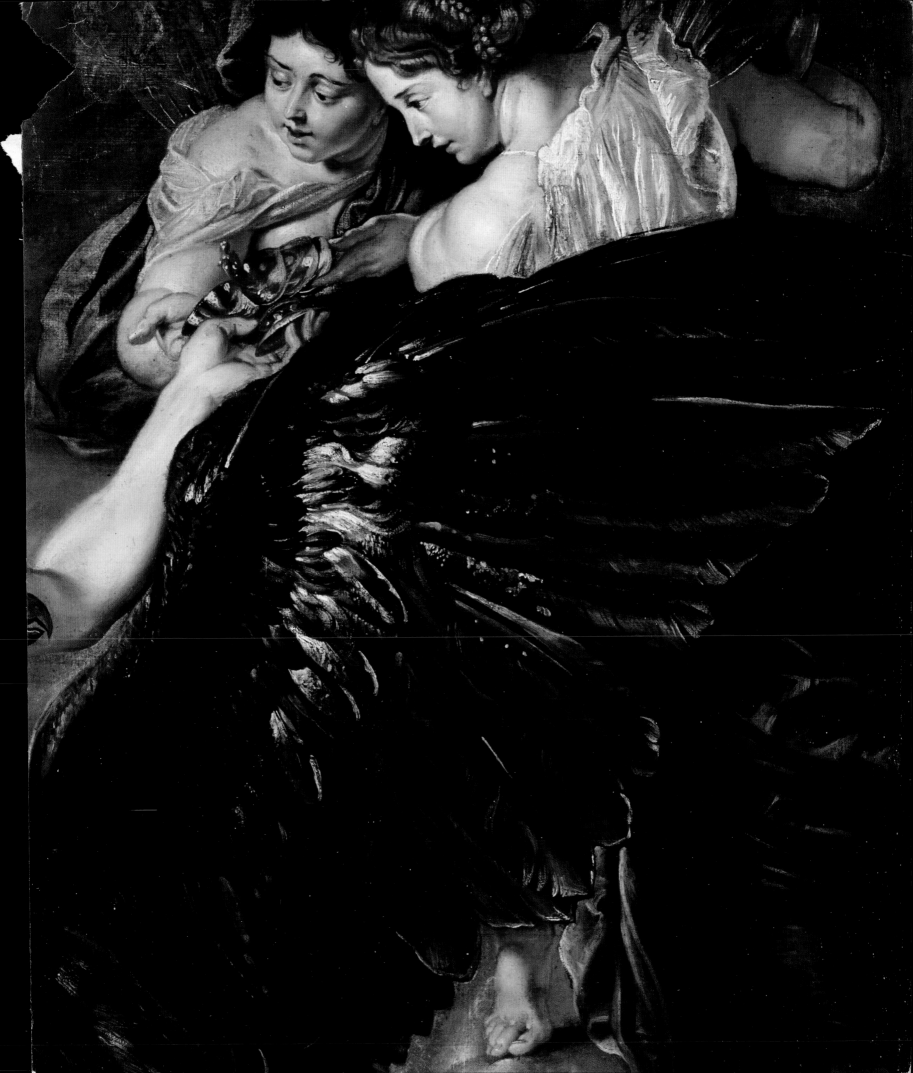

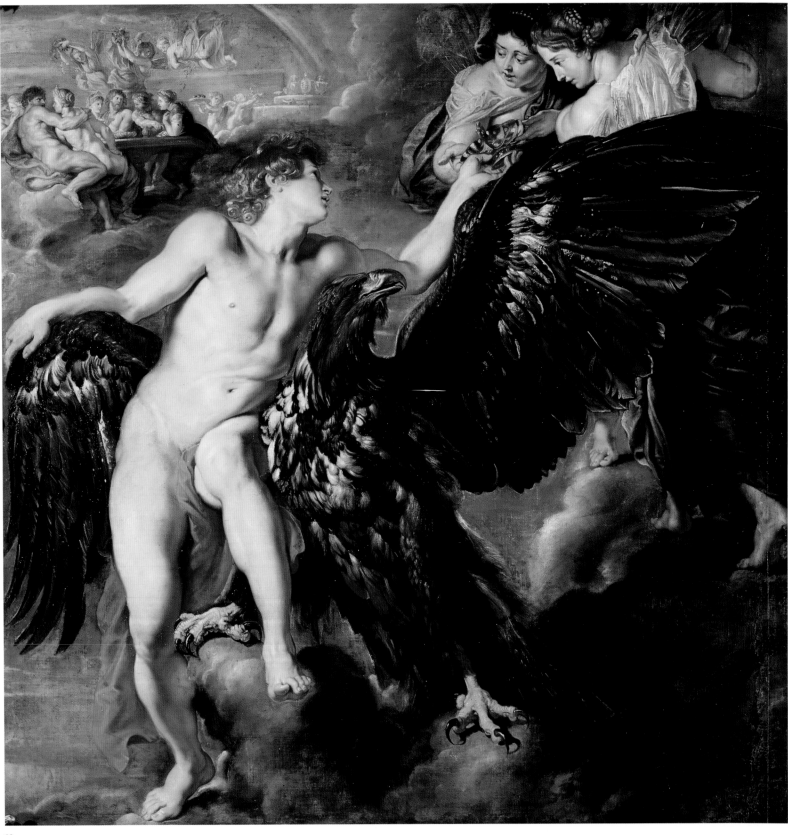

90. Ganymede receives the Cup from Hebe 1611–12

Oil on canvas, 203 × 203 cm
Collection Prinze Karl zu Schwarzenberg,
Vienna, on loan to the Liechtenstein Museum.
The Princely Collections, Vienna (10)

The story of how Zeus, assuming the form
of an eagle, abducted a beautiful youth called
Ganymede, was well known. According to
Ovid, Zeus carried the Phrygian shepherd
boy to Mount Olympus where he made him
his cup-bearer. The subject was popularised
by Michelangelo who made a black-chalk
presentation drawing of Ganymede in 1532
for Tommaso de' Cavalieri. It was later
engraved.[1]

In the painting Zeus has already landed
on a cloud while Ganymede is making the
transition from kidnap victim to cup-bearer.
Rubens has embellished the image with a
feast – gods are being waited on by three
flying putti while younger putti busily fetch
food and drink from the *credenza* (the side
table where Renaissance lords displayed their
silver plate). Ganymede converses with two
beautiful winged women who occupy the top
right of the picture. The one handing him the
cup may be Hebe – but she might be also be
the woman at the feast in the background
embraced by her new husband, Hercules
(identified by his lion-skin). Hebe was the
daughter of Jupiter and Juno and was the
cup-bearer before Ganymede took her job.
The amorous pairings at the table make one
ask what other needs the handsome
Ganymede was expected to satisfy.

The entangled poses are metaphors for
physical union. Raphael's *Farnesina* decoration,
which shows a similar feast of the gods, has
been absorbed into the composition, and

unsurprisingly there was a copy of the
Raphael in Rubens's lost pocketbook.[2] One
of the copies of it includes a summary of
Correggio's solution, but Rubens has chosen
a calmer moment.[3] Ganymede, in some ways
a develop-ment of Apollo in the *Council of the
Gods* (cat. 12) and Christ in the *Descent* (cat. 56)
is carefully modelled.[4] Rubens is no longer
forcing the difficult foreshortening: the
presentation of the boy is assured and
understated and there is pleasing recession
from the boy in the fore-ground to Hebe on
the right and finally the feast on the left. The
swish of the wine-carrier as she strides into
the painting from the right-hand edge is
especially alluring. Her purple dress recalls
the bed cloth in the *Samson* (cat. 77). We feel
the way gravity pulls at the flesh of the boy's
belly, and marvel at the reflected red high-
lights from his cloak that glows in the shadows,
modelling the curves. The eagle is, by contrast,
a little 'cut out' and forced. This was painted
by Frans Snyders, and he has captured all of
the bird's detail, but not the energy, although
some white shimmering highlights make
one suspect that Rubens retouched it. In
Rubens's Antwerp, collaborations like this
were admired, and the resulting works were
thought greater than the sum of their parts.
To a modern eye the figures are spliced
together convincingly, but in fact Snyders's
model, the ancient marble of the *Capitoline
Eagle*, has been considerably enlivened and is
now aerodynamically sound.

The date of the canvas is hard to resolve.
A date of 1611, based on the resemblance
to the *Raising of the Cross* (fig. 7) has been
proposed.[5] This is possible but it may be a
year or two too early. What is indisputable is

the quality of the painting. It is hard to accept
that works such as the *Supper at Emmaus*
(Church of St Eustache, Paris) and *Lot and
His Daughters* (Staatliches Museum, Schwerin)
are autograph when they are put beside this
picture. The latter was painted by 1611, when
the composition was engraved in Holland,
and it may have been produced to please Dutch
taste; but the smoothness of the drapery in the
picture is not reassuring. The highlighting on
the right-hand side of the gold bowl seems to
show a lesser order of skill than the equivalent
passage in the *Ganymede*.

The somewhat abraded painting of *Cupid
asking Zeus for permission to marry Psyche* (now
at Princeton University Art Museum) may be
a pendant, but it is the lesser picture.[6] The
contrast with Rembrandt's later treatment,
which shows Gaymede as a distressed child,
could not be more abrupt.

1 For a full discussion of Michelangelo's *Ganymede*,
 see Joannides in Washington 1996, no. 15, pp.
 72–4. The unsigned engraving is believed to be by
 Nicolas Beatrizet. The subject was treated by
 other Renaissance artists, including Correggio,
 Parmigianino and Giulio Romano. See Ekserdjian
 1997, pp. 282–4.
2 C.ms. fols 60v/61r.
3 De Ganay version of Rubens's pocketbook (see
 p. 21), fol.44.
4 His languid leg is a reminder of another possible
 source – the Sabine woman in Giambologna's
 Rape of the Sabines.
5 Vienna 2004a, no. 34.
6 See Franklin 2004, p. 155.

ESSENTIAL BIBLIOGRAPHY
Vienna 2004, no. 13, pp. 68–71; Vienna 2004a,
no. 34, pp. 222–4

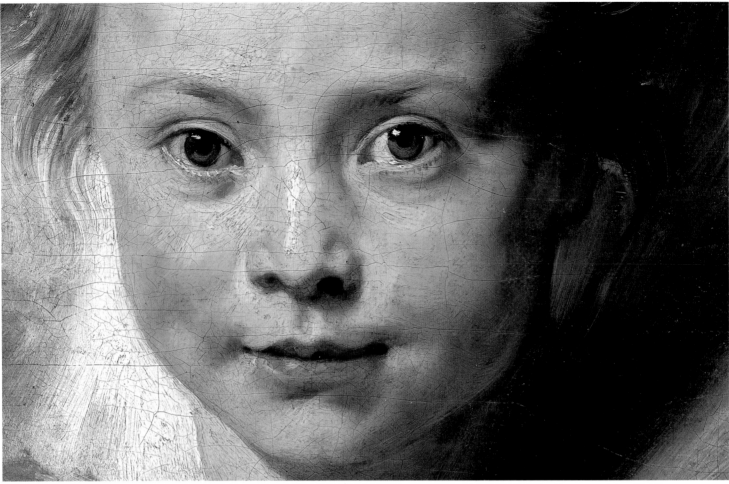

91 (detail)

91. Clara Serena Rubens about 1614

Oil on canvas mounted on panel,
34 × 27 cm
Sammlungen des Fürsten von und zu
Liechtenstein, Vaduz, Wien (GE 105)

In October 1609, soon after his return to Antwerp, Rubens married Isabella Brant. Their eldest daughter Clara Serena was born in 1611, only to die in 1623. Her age here remains speculative. If she is five the painting would have been done in 1616, but 1614 seems equally possible. Rubens's portrait of her is first recorded in the house of his friend and father-in-law Jan Brant in 1639.[1] It has become an exceptional memorial to what must have been his most beautiful creation. Unlike his self-portrait with his wife of about 1609–10, there is no emphasis on social position, no fine jewels and costumes.

It is a completely frank and honest portrayal; Clara is as he knew her, a vital intimate face exchanging her gaze with her adoring father. The sureness of Rubens's brushwork gives the impression that she was evoked in a few minutes. The dabs of blue shadow on her forehead, red touches around her nostril, and the glistening white highlights down her nose convey a freshness that has rarely been matched in Western portraiture. A few lines of black chalk define the edge of her collar (the only concession to her seventeenth-century origins). From the whirl of her hair, possibly pulled back by an Alice band, to her sparkling eyes Rubens has painted both a personal and a universal masterpiece.

We know almost nothing about Clara Serena except that she may have been a lady-in-waiting to Infanta Isabella in Brussels shortly before her premature death in 1623. Rubens's words on the death of his wife, 'she had no capricous moods, and no feminine weakness, but was all goodness and honesty' must surely also indicate something of his feelings for their daughter.[2]

Rubens used a panel of almost the same size for the portrait he made of his gifted young pupil Anthony Van Dyck (1613–15). That painting, which is now in the Rubens House, Antwerp, is similar to this work in its informality. Rubens was a reluctant portraitist, and these images of his eldest child and his favourite pupil have a clear personal significance. Both are mesmerising images condensed from a flurry of brushwork, enchanting displays of the magic of paint.

Clara Serena is a reminder that Antwerp was now home to Rubens. At this time, his family must have been the most important thing in his life. It is fitting that one ends a survey of Rubens's path to mastery with this glimpse of the private man behind the very public art.

1 Denucé 1932, p. 54; See Held 1959 (1986), p. 138.
2 Magurn 1995, p. 136. Rubens letter 15 July 1626 to the Royal Librarian Pierre Dupuy.

ESSENTIAL BIBLIOGRAPHY
Vienna 2004, no. 28; Vienna 2004a, no. 84, pp. 357–9

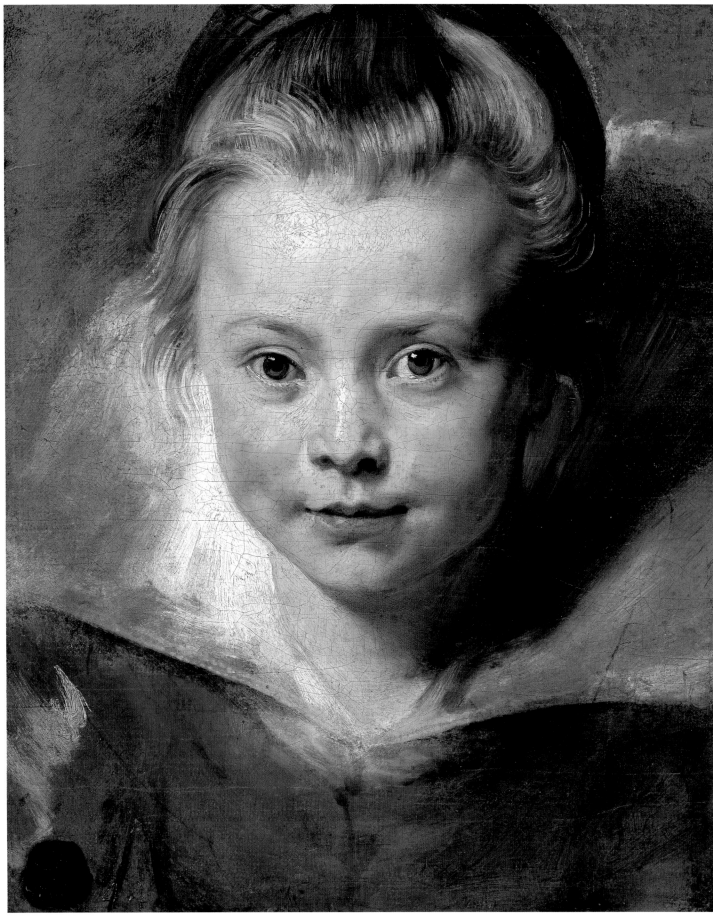

Bibliography

AERTS 1993
The Cathedral of Our Lady in Antwerp, ed. W. Aerts, Antwerp 1993

ALPERS 1971
S. Alpers, *The Decoration of the Torre de la Parada* (Corpus Rubenianum Ludwig Burchard, IX), Brussels, London and New York 1971

AMSTERDAM-NEW YORK-TOLEDO (OHIO) 2003
Hendrick Goltzius (1558–1617): drawings, prints and paintings, exh. cat., Rijksmuseum, Amsterdam, The Metropolitan Museum of Art, New York, Toledo Museum of Art, Toledo (Ohio), 2003

ANDREAE 1991
B. Andreae, *Laokoon und die Kunst des Pergamon: Die Hybris der Giganten*, Frankfurt 1991

ANDREWS 1977
K. Andrews, *Adam Elsheimer. Paintings – Drawings – Prints*, London 1977

ANDREWS 1985
K. Andrews, *Catalogue of Netherlandish Drawings in the National Galleries of Scotland*, 2 vols, Edinburgh 1985

ANDREWS 1985A
K. Andrews, *Adam Elsheimer. Werkverzeichnis der Gemälde, Zeichnungen und Radierungen*, trans. A. Schweikhart, Munich 1985 (revised and translated edn of Andrews 1977)

ANTWERP 1993
Rubens Cantoor. Een verzameling tekeningen onstaan in Rubens' atelier, exh. cat., Rubenshuis, Antwerp, 1993

ANTWERP 2000
K.L. Belkin and C. Depauw, *Images of Death. Rubens copies Holbein*, exh. cat., Rubenshuis, Antwerp, 2000

ANTWERP 2004
K.L. Belkin and F. Healy, *A House of Art: Rubens as Collector*, exh. cat., Antwerp, 2004

BALIS 1986
A. Balis, *Rubens Hunting Scenes* (Corpus Rubenianum Ludwig Burchard, XVIII), 2 vols, London 1986

BALIS 2001
A. Balis, 'Rubens und Inventio. Der Beitrag seines theoretischen Studienbuches' in Heinen and Thielemann 2001, pp. 11–40

BAROLSKY 1979
P. Barolsky, *Daniele da Volterra, a catalogue raisonné*, New York and London 1976

BARTSCH
The Illustrated Bartsch, 96 vols, Norwalk, CT, 1978–

BARTSCH, 1854–1870
A. Bartsch, *Le peintre-graveur*, I-XXI, Leipzig 1854–1870

BAUDOUIN 1993
F. Baudouin in *The Cathedral of Our Lady in Antwerp*, ed. W. Aerts, Antwerp 1993

BAUDOUIN 2005
F. Baudouin, 'Rubens kinderjaren in Keulen en in Antwerpen', reprinted in *Rubens in Context. Selected Studies Liber memorialis*, Antwerp 2005, pp. 44–65

BAUMAN AND LIEDTKE 1992
G.C. Bauman and W.A. Liedtke, *Flemish Painting in America. A Survey of Early Netherlandish and Flemish Paintings in the Public Collections of North America*, Antwerp 1992

BELKIN 1989
K.L. Belkin, 'Rubens's Latin inscriptions on his Copies after Holbein's "Dance of Death"', *Journal of the Warburg and Courtauld Institutes*, 52 (1989), pp. 245–50

BELKIN AND DEPAUW 2000
K.L. Belkin and C. Depauw, *Images of Death. Rubens copies Holbein*, exh. cat., Rubenshuis, Antwerp, 2000

BELLORI 1672
G.P. Bellori, *Le Vite de' pittori, scultori e architetti moderni*, Rome 1672

BELLORI (1976)
G.P. Bellori, *Le Vite de' pittori, scultori e architetti moderni*, (Rome 1672), ed. E. Borea, Turin 1976

BERZAGHI 1984
R. Berzaghi, 'I dipinti della Chiesa di Susano presso Castel d'Ario' Civilita', *Mantovana*, 5 (1984), pp. 85–107

BOBER 1986
P. Bober and R. Rubinstein, *Renaissance artists & antique sculpture: a handbook of sources*, London and Oxford 1986

BOLTEN 1985
Jaap Bolten, *Method and practice. Dutch and Flemish drawing books. 1600-1750*, Landau 1985

BROWN 1983
C. Brown, *Rubens: Samson and Delilah*, exh. cat., National Gallery, London, 1983

BRUNSWICK 2004
N. Büttner and U. Heinen et al., *Peter Paul Rubens, Barocke Leidenschaften*, exh. cat., Herzog Anton Ulrich-Museum, Brunswick, Munich, 2004

BRUNSWICK, MAINE 1985
D.P. Becker, *Old Master Drawings at Bowdoin College*, Bowdoin College Museum of Art, Brunswick, Maine 1985

BRUSSELS-ROME 1995
Fiamminghi a Roma 1508–1608: kunstenaars uit de Nederlanden en het prinsbisdom Luik te Rome tijdens de Renaissance, exh. cat., Paleis voor Schone Kunsten, Brussels, Palazzo delle esposizioni, Rome, 1995

BURCHARD AND D'HULST 1963
L. Burchard and R. d'Hulst, *Rubens Drawings*, 2 vols, London 1963

BURCKHARDT 1928
J. Burckhardt, *Erinnerungen aus Rubens*, ed. H. Kauffmann, Leipzig 1928

BURCKHARDT (1950)
Burckhardt, *Recollections of Rubens*, (Basel 1858), London 1950

CANBERRA-MELBOURNE 1992
Rubens and the Italian Renaissance, D. Rowan et al., exh. cat., Australian National Gallery, Canberra, National Gallery of Victoria, Melbourne, 1992

COCCOLINI AND RIGACCI 2004
G. Coccolini and C. Rigacci, 'Il "Codice Piccolo" di Padre Resta. Tecniche e tematiche nella conservazione di opere d'arte legate al collezionismo', *Rivista dell'Opificio delle Pietre Dure e Laboratori di Restauro di Firenze*, 16 (2004), pp. 52–68

COHEN 2003
S. Cohen, 'Rubens's France: Gender and Personification in the Marie de Médicis Cycle', *Art Bulletin* 85 (2003), pp. 490–522

COLOGNE 1977
Peter Paul Rubens 1577–1640. Katalog I. Rubens in Italien. Gemälde, Ölskizzen, Zeichnungen; Triumph der Eucharistie. Wandteppiche aus dem Kölner Dom, exh. cat., Wallraf-Richartz-Museum, Cologne, 1977

COLOGNE-ANTWERP-VIENNA 1992
Van Bruegel bis Rubens: Das goldene Jahrhundert der flämischen Malerei, eds. E. Mai and H. Vlieghe, exh. cat., Wallraf-Richartz-Museum, Cologne, Koninklijk Museum voor Schone Kunsten, Antwerp, Kunsthistorisches Museum, Vienna, 1992

CONNECTICUT-CINCINNATI-CALIFORNIA 2004-5
P. Sutton, M. E. Wieseman and N. Van Hout, *Drawn by the Brush: Oil Sketchs by Peter Paul Rubens*, exh. cat., Bruce Museum of Arts and Science, Greenwich, Berkeley Art Museum and Pacific Film Archive, Cincinnati Art Museum, 2004-5

CORRESPONDANCE DE RUBENS 1887-1909
Correspondance de Rubens et documents épistolaires concernant sa vie et ses oeuvres, eds C. Ruelens and M. Rooses, 6 vols, Antwerp 1887-1909

COX REARICK 1996
J. Cox Rearick, *The Collection of Francis I*, Antwerp and New York 1996

DEINHARD 1970
H. Deinhard, *Meaning and expression; toward a sociology of art*, Boston 1970

DENUCÉ 1932
J. Denucé, *Inventare von Kunstsammlungen zu Antwerpen im 16. u. 17. Jahrhundert*, Quellen zur Geschichte der Flämischen Kunst, Antwerp 1932

DENUCÉ 1949
J. Denucé, *Na Peter Pauwel Rubens, Documenten uit den kunsthandel te Antwerpen in de 17. eeuw van Matthijs Musson*, Antwerp 1949

DREIER 1977
Franz Adrian Dreier 'Anmerkungen zur "Frierenden Venus" von Peter Paul Rubens' *Niederdeutsche Beitrage zur Kunstgeschichte*, 16 (1977), pp. 45-52

DUVERGER 1984-2004
E. Duverger, *Antwerpse kunstinventarissen uit de zeventiende eeuw* (Fontes Historiae Artis Neerlandicae / Bronnen voor de Kunstgeschiedenis van de Nederlanden), 13 vols, Brussels 1984-2004

EDINBURGH-NOTTINGHAM 2002
J. Wood, *Rubens. Drawing on Italy*, exh. cat., National Gallery of Scotland, Edinburgh, Djanogly Art Gallery, Nottingham, 2002

EKSERDJIAN 1997
D. Ekserdjian, *Correggio*, New Haven and London 1997

ERTZ 1979
K. Ertz, *Jan Brueghel der Ältere (1568-1625). Die Gemälde. Mit kritischem Oeuvrekatalog*, Cologne 1979

ESSEN-VIENNA-ANTWERP 1997-8
Pieter Breughel der Jüngere-Jan Brueghel der Ältere. Flämische Malerei um 1600. Tradition und Fortschritt, eds K. and C. Nitze-Ertz, exh. cat., Kulturstiftung Ruhr, Villa Hügel Essen, Kunsthistorisches Museum, Vienna, Koninklijk Museum voor Schone Kunsten, Antwerp, 1997-8

EVERS 1942
H. G. Evers, *Peter Paul Rubens*, Munich 1942

EVERS 1943
H.G. Evers, *Rubens und sein Werk*, Brussels 1943

FALDI 1954
I. Faldi, *Galleria Borghese: le sculture dal secolo XVI al XIX*, Rome 1954

FARINA 2002
V. Farina, *Giovan Carlo Doria, promotore delle arti a Genova nel primo Seicento*, Florence 2002

FESTSCHRIFT MÜLLER HOFSTEDE 1994
Festschrift für Prof. Dr. Justus Müller Hofstede. 'Studien zur niederländischen Kunst', *Wallraf-Richartz-Jahrbuch*, LV (1994), Cologne 1994

FLORENCE 2002
Venus and Love: Michelangelo and the new ideal of beauty, eds F. Falletti and J. Katz Nelson, exh. cat., Accademia Gallery, Florence, 2002

FRANCO 1611
Giacomo Franco, *De excellentia et nobilitate delineationis libri duo*, Venice 1611

FRANKLIN 2004
D. Franklin, *Dutch and Flemish drawings from the National Gallery of Canada*, Ottawa 2004

FREEDBERG 1984
D. Freedberg, *The Life of Christ after the Passion* (Corpus Rubenianum Ludwig Burchard, VII), London 1984

FUBINI AND HELD 1964
G. Fubini and J. Held, 'Padre Resta's Rubens Drawings after Ancient Sculpture' in *Master Drawings* 2, no. 2 (1964), pp. 123-41

GARFF AND PEDERSEN 1988
J. Garff and E. de la Fuente Pedersen, *Rubens Cantoor: the drawings of Willem Panneels: A Critical Catalogue*, Department of Prints and Drawing. The Royal Museum of Fine Arts, I-II, Copenhagen 1988

GENOA 2004
L'Età di Rubens: Dimore, Committenti e Collezionisti Genovesi, P. Boccardo et al., exh cat., Palazzo Ducale, Genoa, 2004

GLÜCK AND HABERDITZL 1928
G. Glück and F. M. Haberditzl, *Die Handzeichnungen von Peter Paul Rubens*, Berlin 1928

GOEDDE 1989
L. Goedde, *Tempest and Shipwreck in Dutch and Flemish Art: Convention, Rhetoric and Interpretation*, Philadelphia 1989

GOELER VON RAVENSBURG 1882
F. Goeler von Ravensburg, *Rubens und die Antike. Seine Beziehungen zum Classischen Alterhum und seine Darstellungen aus der classischen Mythologie und Geschichte*, Jena 1882

GOLAHNY 1990
A. Golahny, 'Rubens's Hero and Leander and its Poetic Progeny', *Yale University Art Gallery Bulletin* (1990), pp. 19-37

GORDON 2003
G. Gordon, 'The Massacre of the Innocents', *Old Master Paintings*, Sotheby's, London, 10 July 2003, lot 6

GÖTTLER 1997
C. Göttler, '*Nomen mirificum*. Rubens' *Beschneidung Jesu* für den Hochaltar der Jesuitenkirche in Genua', *Zeitsprünge. Forschungen zur Frühen Neuzeit* 1 (1997), pp. 796-844

HARTT 1958
F. Hartt, *Giulio Romano*, New Haven 1958

HASKELL AND PENNY 1981
F. Haskell and N. Penny, *Taste and the Antique: The Lure of Classical Sculpture. 1500-1900*, New Haven and London 1981

HEALY 1997
F. Healy, *Rubens and the Judgement of Paris: a question of choice*, Turnhout 2001

HEINEN 1989
Ulrich Heinen, *Beiträge zur Ikonologie einiger Passionsdarstellungen des Peter Paul Rubens*, Hausarbeit zur Ersten Staatsprüfung, Wuppertal 1989

HEINEN 1996
Ulrich Heinen, *Rubens zwischen Predigt und Kunst*, Weimar 1996

HEINEN AND THIELEMANN 2001
Rubens passioni: Kultur der Leidenschaften im Barock (Rekonstruktion der Künste, 3), eds U. Heinen and A. Thielemann, Göttingen 2001

HELD 1957
J. S. Held, 'Comments on Rubens' Beginnings' in Roggen 1957, pp. 125-35

HELD 1959
J. S. Held, Rubens, *Selected Drawings*, 2 vols, London 1959

HELD 1967
J. S. Held, *The Oil Sketches of Peter Paul Rubens: A Critical Catalogue*, 2 vols, Princeton 1980

HELD 1980
J. S. Held, *The Oil Sketches of Peter Paul Rubens: A Critical Catalogue*, 2 vols, Princeton 1980

HELD 1983
J. S. Held, 'Thoughts on Rubens's Beginnings' in *Ringling Museum of Art Journal*, 1983, pp. 14-35

HELD 1959 (1986)
J. S. Held, Rubens: *Selected Drawings*, 2nd edn, Oxford 1986

HELD 1987
J. S. Held, *Rubens-Studien*, Leipzig 1987

HENKEL AND SCHÖNE 1967
A. Henkel and A. Schöne, *Emblemata. Handbuch zur Sinnbildkunst des 16. und 17. Jahrhunderts*, Stuttgart 1967

HIMMELMANN 1985
N. Himmelmann, *Ideale Nacktheit*, Opladen 1985

HINZ 1987
B. Hinz, 'Amorosa Visione', *Städel-Jahrbuch*, 11 (1987), pp. 127-46

HIRST AND DUNKERTON 1994

M. Hirst and J. Dunkerton, *The Young Michelangelo*, *Making and Meaning Series*, exh. cat., National Gallery, London, 1994

HOLLSTEIN 1949–

F.W.H. Hollstein *Dutch and Flemish Etchings, Engravings and Woodcuts, about 1450–1700*, Amsterdam, 1949–

HÖPER 1997

Corinna Höper, 'Zu den Anatomiebüchern von Bartolomeo Passarotti und Peter Paul Rubens' in *L'Art del disegno*, *Christel Thiem*, Munich 1997

HUEMER 1977

F. Huemer, *Portraits* (Corpus Rubenianum Ludwig Burchard, XIX), London and New York 1977

HUEMER 1996

F. Huemer, *Rubens and the Roman Circle. Studies of the First Decade*, New York and London 1996

D'HULST AND VANDENVEN 1989

R. D'Hulst and M. Vandenven, *Rubens, The Old Testament*, (Corpus Rubenianum Ludwig Burchard, III), London and New York 1989

HUTTER 1977

H. Hutter, *Peter Paul Rubens in der Gemäldegalerie der Akademie der Bildenden Künste in Wien*, Vienna 1977

JAFFÉ 1958

M. Jaffé, 'Rubens in Italy, Part I: Rediscovered Works', *The Burlington Magazine*, 100 (1958), pp. 411–22

JAFFÉ 1959

M. Jaffé, 'The Second Sketchbook by Van Dyck', *The Burlington Magazine*, 101 (1959), pp. 317–21

JAFFÉ 1966

M. Jaffé, *Van Dyck's Antwerp sketchbook*, 2 vols, London 1966

JAFFÉ 1968

M. Jaffe, 'Rubens in Italy Part II: some rediscovered works of the first phase' in *The Burlington Magazine*, 110 (1968), pp. 180–3

JAFFÉ 1970

M. Jaffé, 'A Sheet of drawings from Rubens' Italian period', *Master Drawings*, 7 (1970), pp. 42–50

JAFFÉ 1971

M. Jaffé, 'Rubens and Optics: Some Fresh Evidence' in *Journal of the Warburg and Courtauld Institutes*, 34 (1971), pp. 362–6

JAFFÉ 1977

M. Jaffé, *Rubens and Italy*, Oxford 1977

JAFFÉ 1987

Michael Jaffé, 'Rubens's anatomy book', *Old Master Drawings*, Christie's, London, 6 July 1987, lots 56–83

JAFFÉ 1988

M. Jaffé, 'Rubens and Nicolò Pallavicino', *The Burlington Magazine*, 130 (1988), pp. 523–7

JAFFÉ 1989

M. Jaffé, *Rubens: Catalogo completo*, trans. G. Mulazzani, Milan 1989

JAFFÉ 1994

D. Jaffé, 'Peiresc-Wussenschaftlicher Betrieb in einem Raritäten-Kabinett' in *Macrocosmos in Microcosmo*, ed. A. Grote, Berlin 1994

JAFFÉ 2000

D. Jaffé, 'Rubens front and back: The care of the National Gallery Samson and Delilah', *Apollo*, 152 (August 2000), pp. 21–5

JAFFÉ AND BRADLEY 2003

D. Jaffé and A. Bradley, 'Rubens: *The Massacre of the Innocents*', exh. cat., *Apollo* and National Gallery, London, 2003

JUDSON 2000

R. Judson, *The Passion of Christ* (Corpus Rubenianum Ludwig Burchard, VI), Turnhout 2000

KASSEL-FRANKFURT 2004

Pan & Syrinx – Eine erotische Jagd. Peter Paul Rubens, Jan Brueghel und ihre Zeitgenossen, eds. J. Lange et al., exh. cat., Staatliche Museen Kassel, Städelsches Kunstinstitut, Frankfurt, 2004

KOSLOW 1996

S. Koslow, 'Law and Order in Rubens's Wolf and Fox Hunt', *Art Bulletin*, lxxviii (1996), pp. 681–706

LARSEN 1994

E. Larsen, 'Ein unbekanntes Hauptwerk des Peter Paul Rubens aus seiner italienischen Zeit: "Die Flucht des Äneas aus Troja"', *Pantheon*, LII (1994), pp. 79–85

LIEDTKE 1984

W.A. Liedtke, *Flemish Paintings in the Metropolitan Museum of Art*, 2 vols, New York 1984

LILLE 2004

Rubens, exh. cat., Palais des Beaux-Arts, Lille, 2004

LINNIK 1981

I. Linnik, 'The History of Rubens's work on Two Pictures in the Hermitage' in *Collected Papers of the Hermitage on Seventeenth-Century Western European Art*, St Petersburg 1981

LOGAN 1977

A.-M. Logan, 'Rubens Exhibitions, 1977', *Master Drawings*, 15 (1977), pp. 403–17

LOGAN 1987

A.-M. Logan, Review of Held 1959 (1986) in *Master Drawings*, 25 (1987), pp. 63–82

LONDON 1977

Rubens: Drawings and Sketches, John Rowlands, exh. cat., The British Museum, London, 1977

LONDON 1981–2

Splendours of the Gonzaga, eds D. Chambers and J. Martineau, exh. cat., Victoria and Albert Museum, London, 1981–2

LONDON 2002

Royal Treasures: A Golden Jubilee Celebration, ed. J. Roberts, exh. cat., The Queen's Gallery, Buckingham Palace, London, 2002

LONDON 2003–4

J. Woodall et al., *Peter Paul Rubens: a touch of brilliance. Oil Sketches and Related Works from the State Hermitage Museum and the Courtauld Institute Gallery*, exh. cat., Courtauld Institute of Art, London, 2003–4

LONDON-PARIS-BERN-BRUSSELS 1972

Flemish Drawings of the Seventeenth Century, from the collection of Frits Lugt, Victoria and Albert Museum, London, Institut néerlandais, Paris, Kunstmuseum, Bern, Royal Library of Belgium, Brussels, 1972

MAAS 1974

S. Maas, *Das Bildthema der 'Susanna' bei Rubens: Seine Bedingungen in der italienischen und niederländischen Malerei und seine unmittelbaren Auswirkungen*, Kiel 1974

MALEREI ANTWERPENS 1994

Die Malerei Antwerpens – Gattungen, Mesiter, Wirkungen, Studien zur flämischen Kunst des 16. und 17. Jahrhunderts (International Colloquium, Vienna 1993), eds E. Mai, K. Schütz and H. Vlieghe, Cologne 1994

MADRID 2004–5

A. Vergara, *Rubens: The Adoration of the Magi*, exh. cat., Museo Nacional del Prado, Madrid, 2004–5

MAGURN 1955

R.S. Magurn, *The Letters of Peter Paul Rubens*, Cambridge, MA, 1955

MANTUA 1989

Giulio Romano, E.H. Gombrich et al., exh. cat., Palazzo Te, Mantua, 1989

MANTUA 2002

Gonzaga, La celeste galleria: le raccolte, ed. R. Morselli, exh. cat., Palazzo Ducale, Mantua, 2002

MANTUA 2004–5

Natura e maniera tra Tiziano e Caravaggio: le ceneri violette di Giorgione, ed. V. Sgarbi, exh. cat., Palazzo Te, Mantua, 2004–5

MARINO 1620 (1979)

G. Marino, *La Galleria*, ed. M. Pieri, 2 vols, Padua 1979

MARTIN 1968

J. Martin, *The Ceiling Paintings for the Jesuit Church in Antwerp* (Corpus Rubenianum Ludwig Burchard, I), London 1968

MARTIN 1972

J.R. Martin, *The Decorations for the Pompa Introitus Ferdinandi* (Corpus Rubenianum Ludwig Burchard, XVI), Brussels, London and New York 1972

MARTIN 1986

G. Martin, *National Gallery Catalogues. The Flemish School: circa 1600 – circa 1900*, London 1986 (original edn 1970)

MAURER 1951

E. Maurer, *Jacob Burckhardt und Rubens*, Basel 1951

MCGRATH 1978

E. McGrath, 'The Painted Decoration of Rubens's House', *Journal of the Warburg and Courtauld Institutes*, 51 (1978), pp. 245–77

MCGRATH 1991

E. McGrath, '"Not even a fly": Rubens and the mad emperors', *The Burlington Magazine*, CXXXIII (1991), pp. 699–703

MCGRATH 1994

E. McGrath, 'Taking Horace at his Word. Two abandoned designs for Otto van Veen's *Emblemata Horatiana*', *Wallraf-Richartz-Jahrbuch*, 55 (1994), Festschrift for J. M. Hofstede, ed. H.-J. Raupp, pp. 115–26

MCGRATH 1997

E. McGrath, *Subjects from History* (Corpus Rubenianum Ludwig Burchard, XIII), ed. A. Balis, 2 vols, London 1997

MENDELSOHN 2001

L. Mendelsohn, 'The sum of the parts: recycling antiquities in the maniera workshops of Salviati and his colleagues' in *Francesco Salviati et la Bella Maniera, Actes des colloques de Rome et de Paris* (1998), Rome 2001, pp. 107–148

VAN DER MEULEN 1994

M. van der Meulen, *Copies after the antique*, ed. Arnout Balis (Corpus Rubenianum Ludwig Burchard, XXIII), 3 vols, London 1994

MIELKE AND WINNER 1977

H. Mielke and M. Winner, *Peter Paul Rubens. Kritischer Katalog der Zeichnungen. Originale – Umkreis – Kopien*, Staatliche Museen Preussischer Kulturbesitz, Berlin 1977

VON ZUR MÜHLEN 1990

I. von zur Mühlen, 'Nachtridentinische Bildauffassungen: Cesare Baronio und Rubens' Gemälde für S. Maria in Vallicella in Rom', *Münchner Jahrbuch der bildenden Kunst*, XLI (1990), pp. 23–60

VON ZUR MÜHLEN 1996

I. von zur Mühlen, 'S. Maria in Vallicella: Zur Geschichte des Hauptaltars', *Römisches Jahrbuch der Biblioteca Hertziana*, XXXI (1996), pp. 247–72

MULLER 1982

J. M. Muller, 'Rubens's Theory and Practice in the Imitation of Art', *Art Bulletin*, 64 (1982), pp. 229–47

MULLER 1989

J. M. Muller, *Rubens: The Artist as Collector*, Princeton 1989

MULLER 2004

J. M. Muller in Antwerp 2004

MÜLLER HOFSTEDE 1959

J. Müller Hofstede, *Otto van Veen. Der Lehrer des P. P. Rubens*, Ph. D. thesis, Freiburg 1959

MÜLLER HOFSTEDE 1962

J. Müller Hofstede, 'Zur Antwerpener Frühzeit von Peter Paul Rubens', *Münchener Jahrbuch der bildenden Kunst*, XIII (1962), pp. 179–215

MÜLLER HOFSTEDE 1965

J. Müller Hofstede, 'Rubens' St. Georg und seine frühen Reiterbildnisse', *Zeitschrift für Kunstgeschichte*, 28 (1965), pp. 69–112

MÜLLER HOFSTEDE 1966

J. Müller Hofstede, 'Zu Rubens' zweitem Altarwerk für Sta. Maria in Vallicella', *Nederlands kunsthistorisch jaarboek*, 17 (1966), pp. 1–78

MÜLLER HOFSTEDE 1968

J. Müller Hofstede, 'Rubens und Jan Brueghel: Diana und ihre Nymphen', *Jahrbuch der Berliner Museen*, 10 (1968), pp. 200–32

MÜLLER HOFSTEDE 1973

J. Müller Hofstede, 'Jacques de Backer. Ein Vertreter der florentinisch-römischen Maniera in Antwerpen', *Wallraf-Richartz-Jahrbuch*, XXXV (1973), pp. 227–60

MÜLLER HOFSTEDE 1974

J. Müller Hofstede, 'Two Unpublished Drawings by Rubens', *Master Drawings*, XII (1974), pp. 133–7

MÜLLER HOFSTEDE 1977A

J. Müller Hofstede, 'Rubens und die niederländische Italienfahrt. Die humanistische Tradition' in Cologne 1977, pp. 21–37

MÜLLER HOFSTEDE 1977B

J. Müller Hofstede, 'Italienorientierung und Italienreise. Vorübungen, Zeichnungen und Gemälde nach Kupferstichen' in Cologne 1977, pp. 38–49

MÜLLER HOFSTEDE 1977C

J. Müller Hofstede, 'Rubens und die Kunstlehre des Cinquecento. Zur Deutung eines theoretischen Skizzenblattes im Berliner Kabinett' in Cologne 1977, pp. 50–67

MÜLLER HOFSTEDE 1977D

J. Müller Hofstede, 'Anmerkungen zum Votivbild des Vincenzo Gonzaga' in Cologne 1977, pp. 100–5

MÜLLER HOFSTEDE 1984

J. Müller Hofstede, 'Non Saturatur Oculus Visu – zur Allegorie des Gesichts von Peter Paul Rubens und Jan Brueghel d. Ä' in *Wort und Bild in der Niederländischen Kunst und Literatur des XVI. und XVII. Jahrhunderts*, eds H. Vekemann and J. Müller Hofstede, Erftstadt 1984, pp. 243–89

MÜLLER HOFSTEDE 1989

J. Müller Hofstede, '"Stolide iudicium Paridis" Zur Ikonographie des Parisurteils bei Peter Paul Rubens', *Wallraf-Richartz-Jahrbuch*, L (1989), pp. 163–87

MUNICH 2002

K. Renger and C. Denk, *Flämische Malerei des Barock in der Alten Pinakothek*, Munich 2002

NESSELRATH AND LIVERONI 1994

A. Nesselrath and P. Liveroni, 'Marten van Heemskerck, View of the Belvedere Statue Court' in *High Renaissance in the Vatican: The Age of Julius II and Leo X*, eds M. Koshikawa and M. J. McClintock, exh. cat., National Museum of Western Art, Tokyo, 1994 (English text supplement)

NEW YORK 2005

A.-M. Logan and M. Plomp, *Peter Paul Rubens: The Drawings*, exh. cat., The Metropolitan Museum of Art, New York, 2005

PADRÓN 1996

M. D. Padrón, *El siglo de Rubens en el Museo del Prado: catálogo razonado de pintura flamenca ols*, Madrid 1996

PADUA-ROME-MILAN 1990

Rubens: Pietro Paolo Rubens (1577–1640), D. Bodart et al., exh. cat., Palazzo della Ragione, Padua, Palazzo delle Esposizioni, Rome, Società delle Belle Arti ed Esposizione Permanente, Milan, 1990

PARIS 2004-5

Primatice Maître de Fontainebleau, D. Cordellier et al., exh. cat., Musée du Louvre, Paris, 2004-5

DE PILES 1677

R. de Piles, *Conversations sur la connaissance de la peinture*, Paris 1677

PILO 1992

Rubens e l'eredità veneta. Arte Documento. Liber Extra I, ed. G. M. Pilo, Rome 1992

POESCHEL 2001

S. Poeschel, 'Rubens's Battle of the Amazons as a War-Picture. The Modernisation of a Myth', *Artibus et historiae*, 43 (2001), pp. 91–108

POPE-HENNESSY 1964

J. Pope-Hennessy, *Catalogue of Italian sculpture in the Victoria and Albert Museum*, 3 vols, London 1964

POSSE 1928

H. Posse, 'Hero und Leander von Peter Paul Rubens' in *Karl Koetschau von seinen Freunden und Verehrern*, Düsseldorf 1928, pp. 109–17

PRICE AMERSON JR. 1975

L. Price Amerson Jr., *The Problem of Ecorché: A Catalogue Raisonné of Models and Statuettes from the Sixteenth Century and Later Periods*, Pennsylvania State University 1975

RICHTER 1939

J. P. Richter, *The Literary Works of Leonardo da Vinci*, edn London-New York-Toronto 1939

ROGGEN 1957

D. Roggen, *Miscellanea*, Antwerp 1957

ROME 1983

S. Massari, Giulio Bonasona, exh. cat., 2 vols, Calografia, Rome 1983

ROOSES 1886–92
Max Rooses, *L'Oeuvre de P.P. Rubens. Histoire et Description de ses Tableaux et Dessins*, Antwerp 1886–92

ROSKILL 2000
M. Roskill, *Dolce's Aretino and Venetian Art Theory of the Cinquecento*, Toronto 2000

ROTTERDAM 2001
A.W.F.M. Meij with M. de Haan, *Rubens, Jordaens, Van Dyck and Their Circle: Flemish Master Drawings from the Museum Boijmans Van Beuningen*, exh. cat., Museum Boijmans Van Beuningen, Rotterdam 2001

ROWLANDS 1977
J. Rowlands, *Rubens, drawings, and sketches: catalogue of an exhibition at the Department of Prints and Drawings in the British Museum*, exh. cat., The British Museum, London, 1977

SÉRULLAZ 1978
A. Sérullaz, *Rubens, ses maîtres, ses élèves*, exh. cat., Musée du Louvre, Paris, 1978

SETTIS 1999
S. Settis, *Laocoonte, fama e stile*, Rome 1999

SPARTI 2003
D. Sparti, 'Cassiano Dal Pozzo, Poussin and the Making and Publication of Leonardo's Trattato', *Journal of the Warburg and Courtauld Institutes*, 66 (2003), pp. 143–8

TAYLOR 1992
P. Taylor, 'The Concept of Houding in Dutch Art Theory' in *Journal of the Warburg and Courtauld Institutes*, 55 (1992), pp. 210–32

THÉORIE 1773
Charles-Antoine Jombert, *Théorie de la figure humaine considerée dans ses principes soit en repos ou en mouvement. Ouvrage traduit du latin de Pierre-Paul Rubens, avec XLIV Planches gravés par Pierre Aveline*, Paris 1773

THØFNER 2003
M. Thøfner, 'Making a Chimera: Invention, Collaboration and the Production of Otto Vaenius's Emblemata Horatiana' in *Emblems of the Low Countries*, eds A. Adams and M. van der Weij, Glasgow 2003, pp. 17–44

TOKYO 1994
High Renaissance in the Vatican: The Age of Julius II and Leo X, eds M. Koshikawa and M.J. McClintock, exh. cat., National Museum of Western Art, Tokyo, 1994 (English text supplement)

TOKYO 1994A
Rubens and his Workshop: The Flight of Lot and His Family from Sodom, Toshiharu Nakamura et al., exh. cat., National Museum of Western Art, Tokyo, 1994

TORRITI 1984
Piero Torriti, *Pietro Tacca da Carrara*, Genoa 1984

VAENIUS 1607
O. Vaenius (van Veen), *Emblemata Horatiana*, Antwerp 1607

VARSHAVSKAYA 1989
M. Varshavskaya, *Rubens: Paintings from Soviet Museums*, Leningrad 1989

VASARI (1966)
G. Vasari, *Le vite de' più eccellenti pittori scultori e architettori: nelle redazioni del 1550 e 1568*, ed. R. Bettarini with commentary by Paola Barocchi, Florence and Sansoni 1966

VELLETRI AND NAPLES 2001
La Collezione Borgia: curiosita e tesori da ogni parte del mondo, eds Anna Germano and Marco Nocca, exh. cat., Palazzo Comunale, Velletri, and Museo Nazionale Archeologico, Naples, 2001

VERGARA 1999
A. Vergara, *Rubens and his Spanish Patrons*, Cambridge 1999

VIENNA 2004
Rubens in Vienna: the masterpieces: the pictures in the collections of the Prince of Liechtenstein, the Kunsthistorisches Museum, and the Gemäldegalerie der Akademie der bildenen Künste in Vienna, eds J. Kräftner, W. Seipel, R. Trnek, exh. cat., Kunsthistorisches Museum, Vienna, Gemäldegalerie der Akademie der bildenen Künste, Vienna, 2004

VIENNA 2004A
Peter Paul Rubens, eds K. A. Schröder and H. Widauer, exh. cat., Albertina, Vienna, 2004

VIRGIL (1964)
Virgil, *The Aeneid*, trans. W. F Jackson Knight (Penguin Classics), edn Harmonsworth 1964

VLIEGHE 1972
H. Vlieghe, *Saints* (Corpus Rubenianum Ludwig Burchard, VIII), vol. 1, London and New York 1972

VLIEGHE 1973
H. Vlieghe, [Rubens] *Saints* (Corpus Rubenianum Ludwig Burchard, VIII), vol. 2, London and New York 1973

VLIEGHE 1998
H. Vlieghe, *Flemish Art and Architecture, 1585–1700*, New Haven 1998

VLIEGHE, BALIS AND VAN DE VELDE 2000
Concept, Design and Execution in Flemish Painting (1550–1700), eds H. Vlieghe, A. Balis and C. Van de Velde, Turnhout 2000

VORAGINE (1993)
J. de Voragine, *The Golden Legend: Readings on the Saints*, trans. W. G. Ryan, 2 vols, Princeton 1993

WASHINGTON 1996
Paul Joannides, *Michelangelo and his influence: Drawings from Windsor Castle*, exh. cat., National Gallery of Art, Washington, 1996

WELLESLEY-CLEVELAND 1993–4
A.-M. Logan, *Flemish Drawings in the Age of Rubens. Selected Works from American Collections*, exh. cat., Davis Museum and Cultural Centre, Wellesley College, Wellesley, MA, The Cleveland Museum of Art, Cleveland, OH, 1993–4

WEPPELMANN 1998
S. Weppelmann, *Rubens: die Altarbilder für Santa Croce in Gerusalemme in Rom*, (Agenda Kunst, 1), Münster 1998

WERNER HOFMANN 1987
Werner Hofmann, *Zauber der Medusa. Europäische Manierismen*, exh. cat., Künslerhaus, Vienna, 1987

WESTFEHLING 2001
U. Westfehling, 'Drei verschollene Zeichnungen von Peter Paul Rubens', *Wallraf-Richartz-Jahrbuch*, LXII (2001), pp. 171–222

WHEELOCK 2005
A. Wheelock, *Flemish Paintings of the Seventeenth Century*, National Gallery of Art, Washington 2005

WHITE 1987
C. White, *Peter Paul Rubens: Man and Artist*, New Haven 1987

WINNER 1974
M. Winner, 'Zum Nachleben des Laokoon in der Renaissance', *Jahrbuch der Berliner Museen*, XVI (1974), pp. 83–121

WINNER 1998
M. Winner, *Il cortile delle statue der Statuenhof des Belvedere in Vatikan*, Acts of Conference, 21–3 October 1992, Maniz 1998

WOOD 2002
J. Wood in Edinburgh-Nottingham 2002

WOOD 2005
J. Wood, 'Rubens: New York and Greenwich CT', *The Burlington Magazine*, 147 (2005), pp. 280–3

ZÖLLNER 1991
F. Zöllner, 'Rubens Reworks Leonardo: *The Fight for the Standard*' *Achademia Leonardi Vinci: Journal of Leonardo Studies and Bibliography of Vinciana*, 4 (1991), pp. 177–90

Photographic Credits

Index